P9-BYK-695

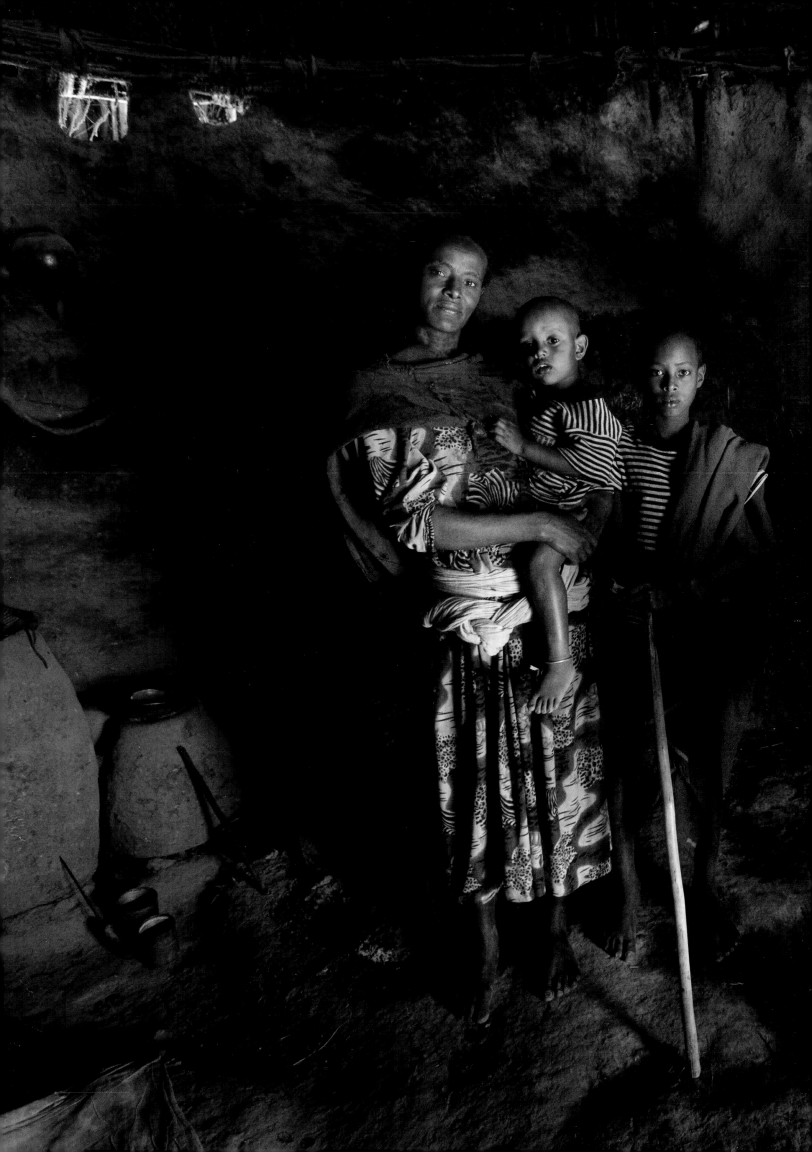

Being Born a Female is Dangerous to Your Health

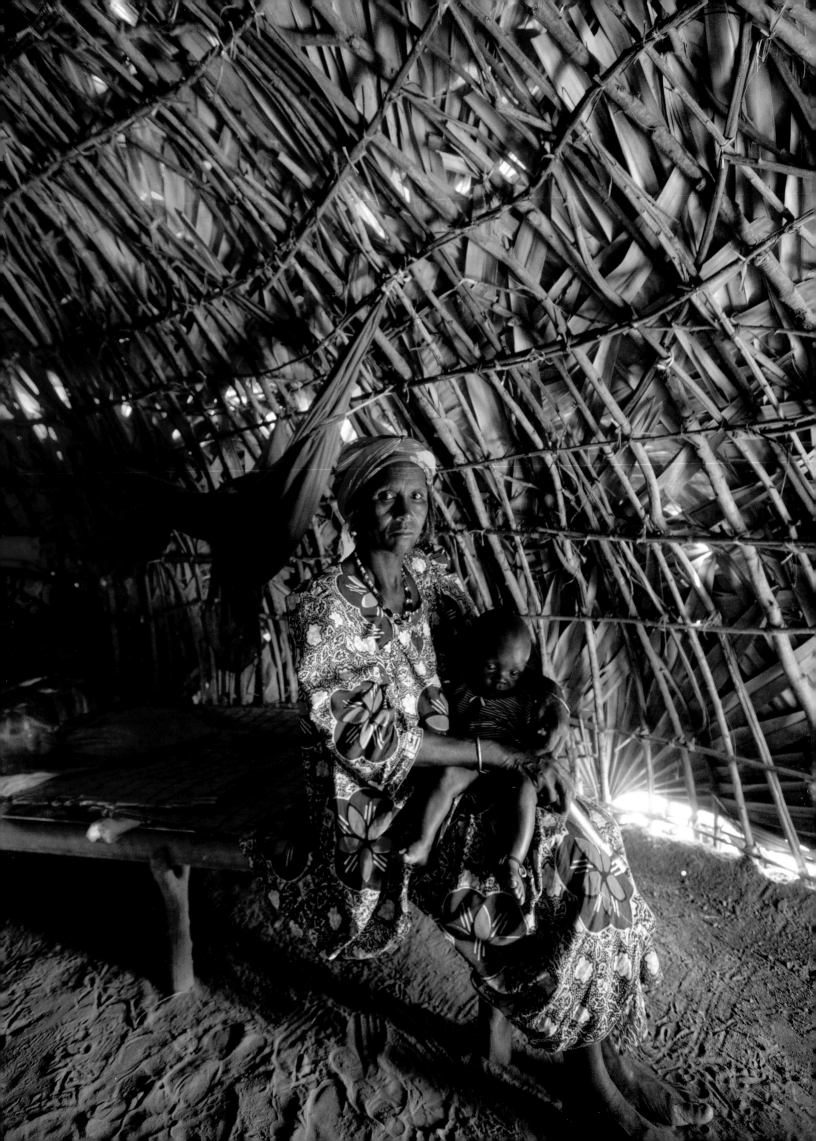

Faces of Courage

Intimate Portraits of Women on the Edge

by Mark Tuschman

Published by Val de Grace Books, Inc.
Napa, California

Copyright © 2015, Mark Tuschman

ISBN: 978-0-9848849-8-8

Library of Congress Number: 2015936301

Cover and Book Design by Milton Glaser and Sue Walsh, Milton Glaser Incorporated, New York, N.Y.

The book was produced and printed in keeping with the highest standards of environmental protection
and sustainability.

It is printed on 150 gsm Lumisilk matte art paper from Finland.

Printed and bound at Toppan Printing Company (HK), Ltd., China.

*For Jana, my soul mate, who has always given me the love
and support to follow my passion, and for Avi and Eva,
whose encouragement has been a constant source of inspiration.*

Introduction

I wish I had had this book years ago when we first began our journey to persuade governments of the tragic consequences of neglecting girls' and women's maternal and reproductive health. Hundreds of thousands of girls and women were dying each year, and most of their deaths were preventable. Twenty times that number were severely injured. These are appalling statistics! Change is finally happening, but more and faster change is necessary.

Through his powerful and absolutely spectacular photographs, Mark is able to capture what words alone cannot do. There have been so many times when we've spoken with people who have no idea of the reality of the lives of girls and women in different regions of the world. They could not see their faces and did not know their stories. Today we have the pictures and we have the facts. Tremendous progress is being made, but as Mark notes in his narrative, the work is far from done.

Many things make this book remarkable. It is not a coffee table book, although it could be; it is a book to spur action. Mark has put in his own words the case for investing in girls and women. He has made a complete package of facts, thoughts, and hopes, and he grounds all of them in his incredibly poignant photographs.

This is not a book about women and girls as victims. Mark has combined sadness with hope, problem with solution, and tears with smiles. He has shown us strength and resolution. In doing so, he has hit upon the magic combination necessary for making progress. We cannot just look at the problem—we have to inject hope and possibility into this reality. If we cannot, we would be unable to move forward.

I look at the faces of young girls in this book, and I smile. I smile at their joy and their potential.

If girls and women are healthy, educated, and have opportunity, if we recognize that they are key to development, then we have a certain formula for achieving progress. When we invest in girls and women, when they survive and thrive, there is a positive ripple effect throughout society: communities and economies grow stronger, environments become more resilient, and everybody wins.

At Women Deliver, Mark's work is an indispensable part of our advocacy. I hope that every advocate puts this book in their briefcase.

—Jill Sheffield
Women Deliver

Photographer's Statement

In Rajasthan, India, I am in the home of a child bride. Young Kala, elegantly dressed in a red sari, looks into the lens with great dignity, beauty, poise and sadness. She was married at the age of only three months, but is still living with her parents at the age of thirteen. Her neighbor Munni, who was married at sixteen, comes to visit. Munni's husband died six months earlier and now she is a widow for life.

In a hospital ward in Bangladesh, the beds are overflowing with young girls. They have come for operations to repair their fistulas, an injury that can occur during childbirth and devastate the life of the mother. Most of these girls are among the fortunate — help is on the way. Still, there are not enough beds, and some of the girls have to wait on the floor. Others lie in shock on their beds; their surgeries have not been successful, and their psychological trauma is agonizing to see.

In Tanzania, women are waiting to see a healthcare worker at an AIDS clinic. The women are terrified of being recognized and fearful that their husbands will discover that they have AIDS. If that happens, the women fear their husbands will beat them and, worse, abandon them and their children. The tragic irony: in all likelihood, their husbands are the ones responsible for infecting them with HIV.

In a small, dirt-floored room in a Delhi slum, Nazia, a young Indian woman, is trembling with fear. She's telling a women's support group how her husband tried to kill her — twice. He was attempting to blackmail her family because the dowry he received from them, a motorcycle, wasn't sufficient. What he wanted — and was demanding — was a full-sized car.

Over the past decade, I have dedicated my life to meeting women such as these and documenting the many challenges they face. Each village I visit, each woman I meet leaves an indelible mark on my consciousness and on my heart. Still, in my travels around the world, not all the scenes I have witnessed are as bleak as those I describe above. I have also spent time in uplifting classrooms in Asia, Africa, and Latin America where girls are learning and filled with joy. Even when the girls are bent over in concentration, their enthusiasm comes shining through and I could feel feel their growing sense of pride and empowerment. That simple fact gives me great hope. And there's more: In

villages and towns across the developing world, I found doctors, nurses, teachers, aid workers, and NGO officers—all working to support millions of women in danger and to bring them vital medicine, counseling, and support. More than that, they also bring these women essential hope and encouragement. Over and over again I was humbled, even awed, by the noble work these aid workers do. In my eyes, these workers are humanity at its very best.

The intent of this book is simple: I want to pay tribute to the women I have met and to the millions of other women who share their fate and their lack of autonomy over their own lives and bodies. Through my art and my heart, I want to bring these women and their stories to the forefront of world consciousness. I want people to see their faces, feel their pain, and understand both their powerlessness and their magnificent, unshakeable dignity and courage. I also want to pay tribute to the people and organizations that are working heroically to bring positive advances in healthcare, education, and personal empowerment to women and girls. This book is my way of honoring them and also of speaking out on their behalf.

This book was not easy to do. Working with these women, hearing their stories, feeling their pain, has been both humbling and enraging. Over and over, I was shocked and saddened by their complete subjugation, by the insecurity of their lives, and by the way they have been stripped of their status as full human beings.

This work has taught me a profound lesson: The human condition is wrought with great uncertainty and suffering, yet the human spirit and the hope for a better life can withstand terrible hardships and even grow stronger in the face of adversity. The women you will meet in these pages have constantly inspired me, and I've come to understand that their cause is our cause, their humanity is our humanity. It is my fervent hope that we in this country, blessed as we are with freedom and great material wealth, can join hands to support the legitimate aspirations of these forgotten women and offer them a real and enduring sense of hope and justice.

Mark Tuschman

"Being born a female is dangerous to your health. This reality may not be true for many readers, but for most women living in poorer countries around the globe, it is devastating."

Anne Firth Murray
From Outrage to Courage

To Be Born Female

I started working on women's rights issues in the summer of 2001, when I went to China, Mongolia, and Thailand on my first assignment for the Global Fund for Women. It was a stunning experience: for the first time I witnessed the harsh, unrelenting reality that tens of millions of women face every day of their lives.

On that trip, I met first with physically abused women in a shelter in Ulan Bator, Mongolia, and through my lens I saw their pain. Their faces and their stories are with me still. After that, in scores of other locales, I met with women who have no control over when to get married, whom to marry, or how many children they bear. These are women who are systematically denied their basic human rights, first and foremost the right to maintain control over their own bodies.

The raw truth is brutal and inescapable: Each time a woman in a poor developing country gets pregnant, with minimal access to healthcare, she is risking her life. In fact, more than half a million women die each year from complications during childbirth. And many young girls who do survive their pregnancies wind up with debilitating fistulas. Adolescent girls and young women also have the highest risk of contracting HIV/AIDS. On top of that, the physical abuse of women is widespread; if we could amass accurate statistics, domestic violence would probably be considered a major worldwide pandemic.

Are there any easy answers? No. In many parts of the developing world, the lack of economic and educational opportunities keeps millions of women locked into a vicious cycle of poverty, and far too often deeply entrenched cultural and religious practices condemn women to an almost sub-human social status. The upshot is painfully clear: the campaign to restore the basic human rights of these women, starting with their basic health and reproductive rights, is both extremely difficult and vitally important to the future of our planet and our common humanity.

To my eye, the quintessential image of poverty is that of a woman with her child or children. With this in mind, I have chosen to open this book with a collection of such images. I prefer to begin by looking at individuals, since I believe that every person counts. It is important to realize that these impoverished women have the potential to transform the world. A woman who has autonomy over her own life, a woman who owns her own voice, can create ripples of positive change that go far beyond her own immediate family and community. And these are the ripples that will change the world.

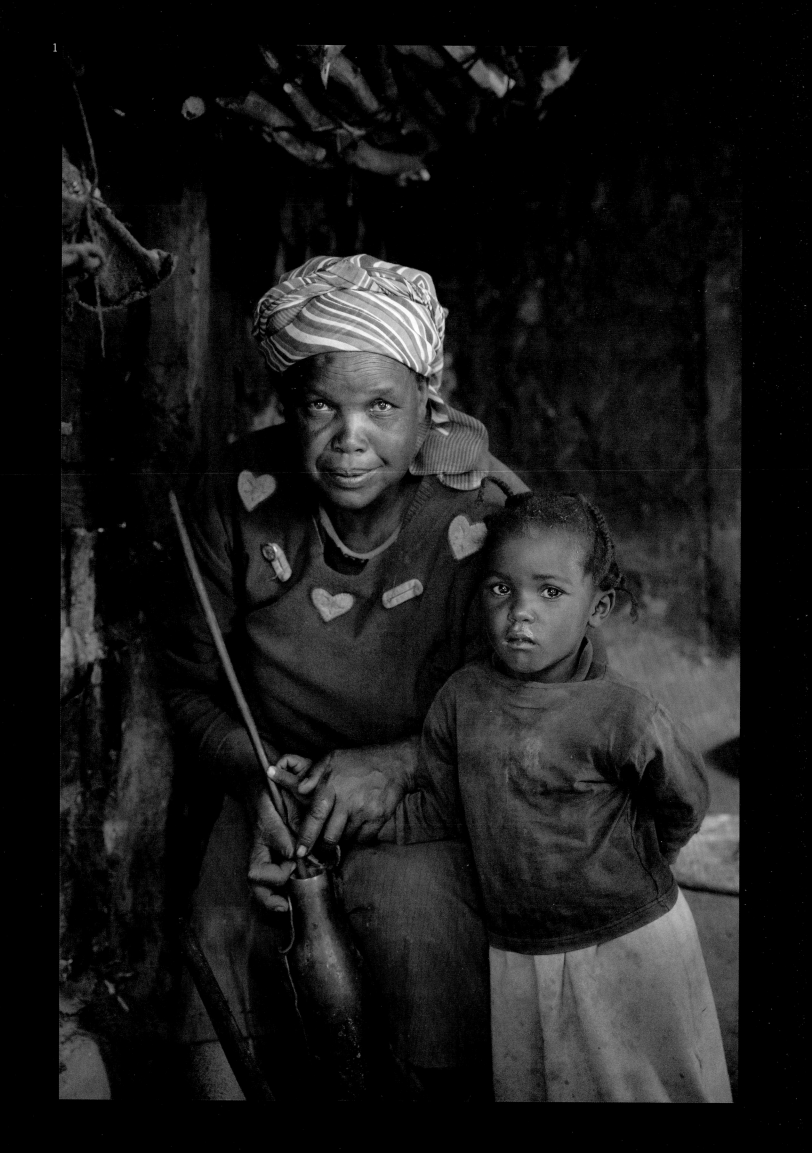

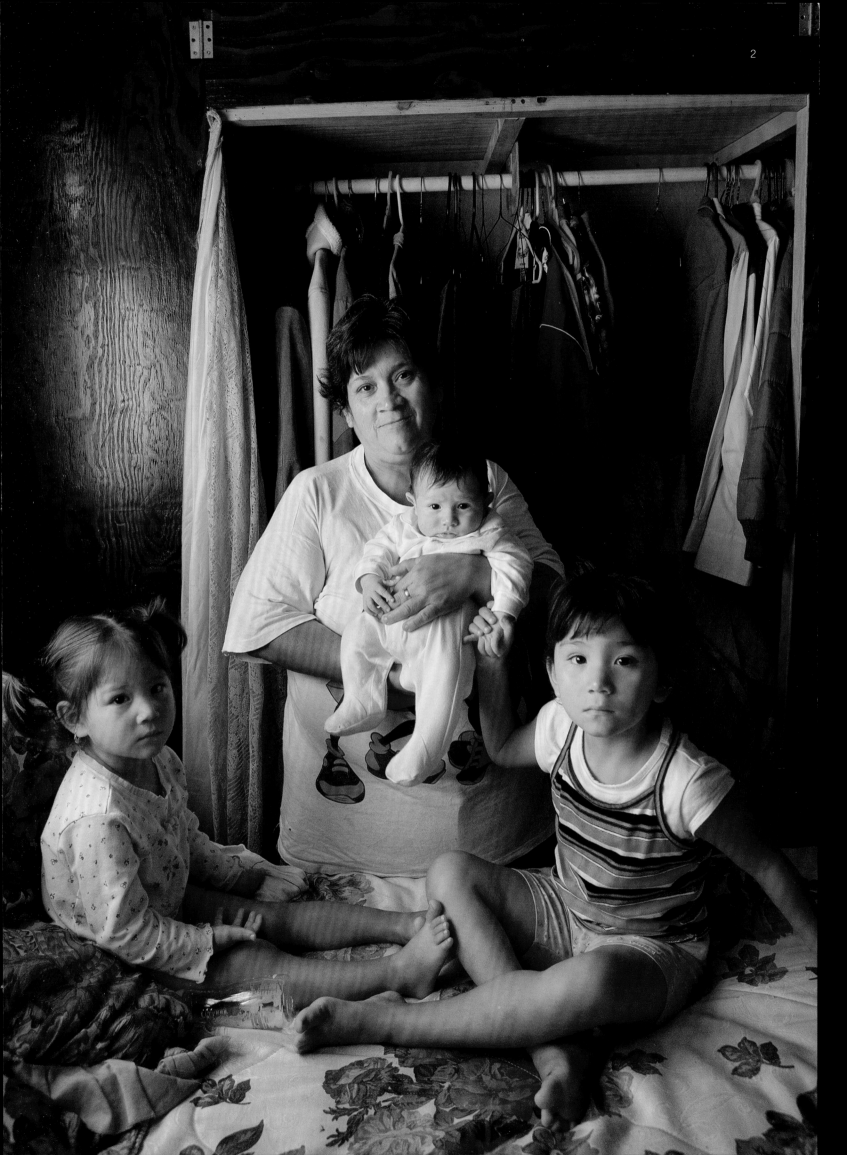

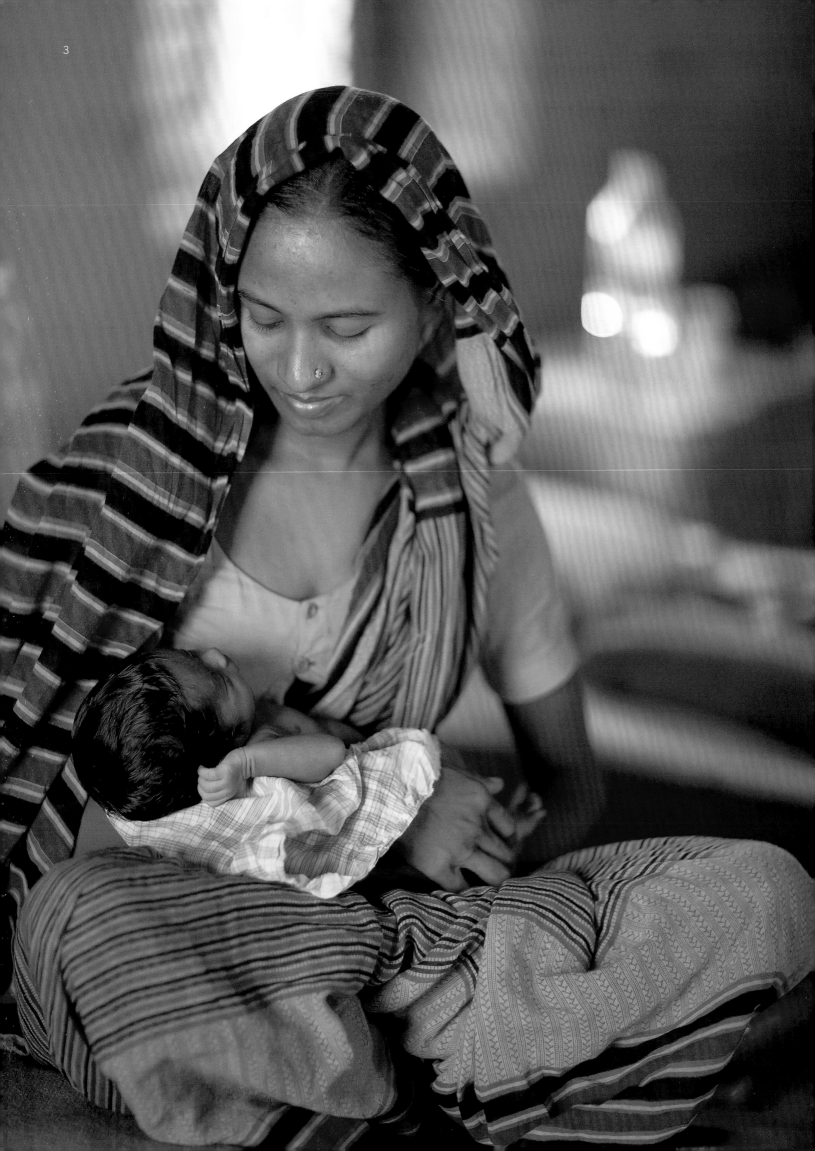

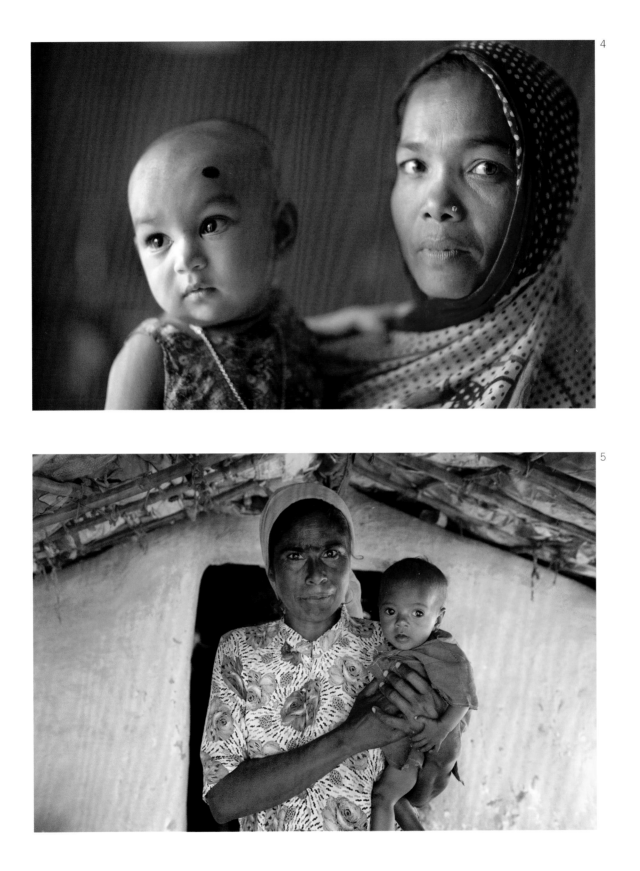

TO BE BORN FEMALE

6

7

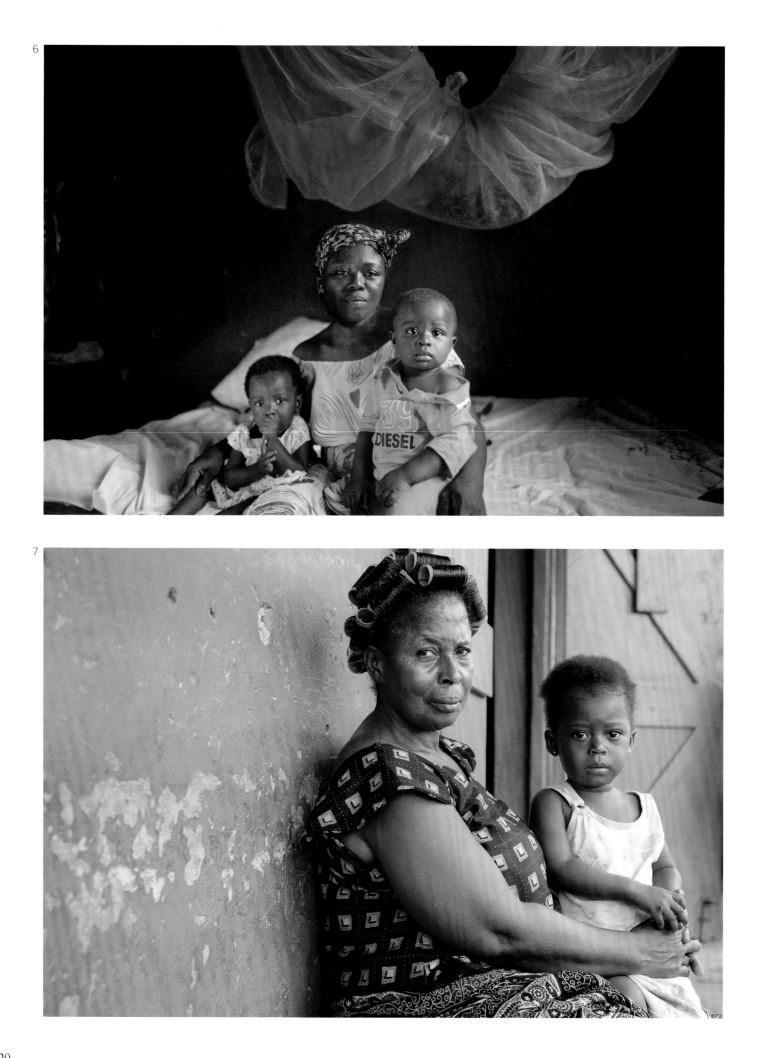

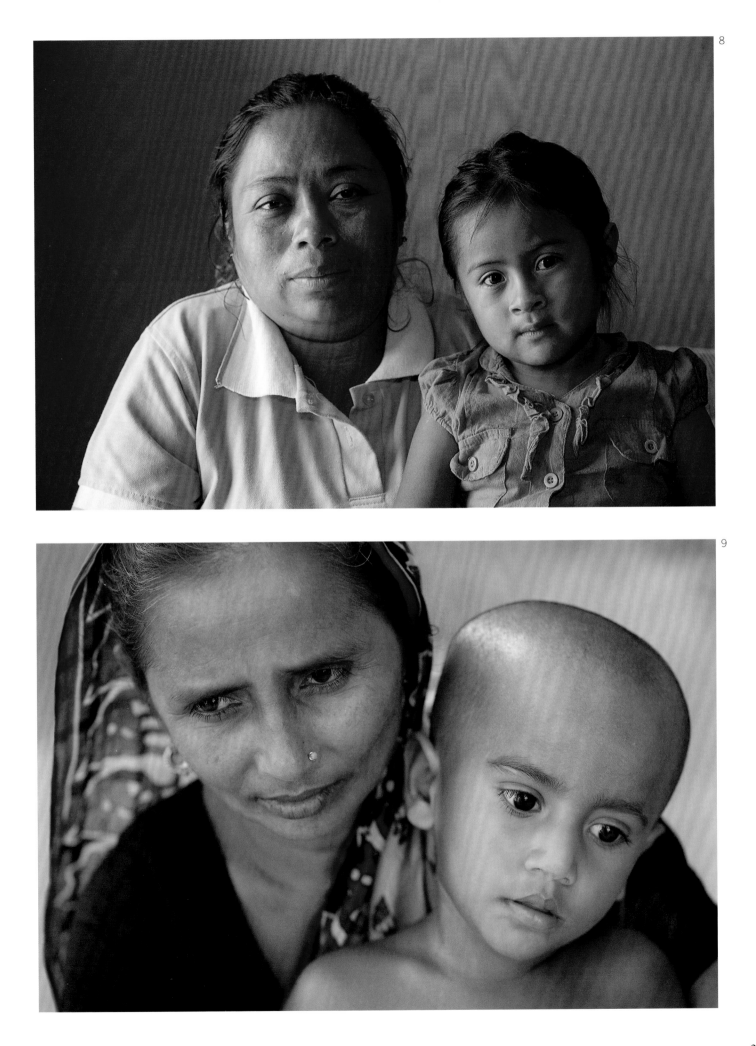

TO BE BORN FEMALE

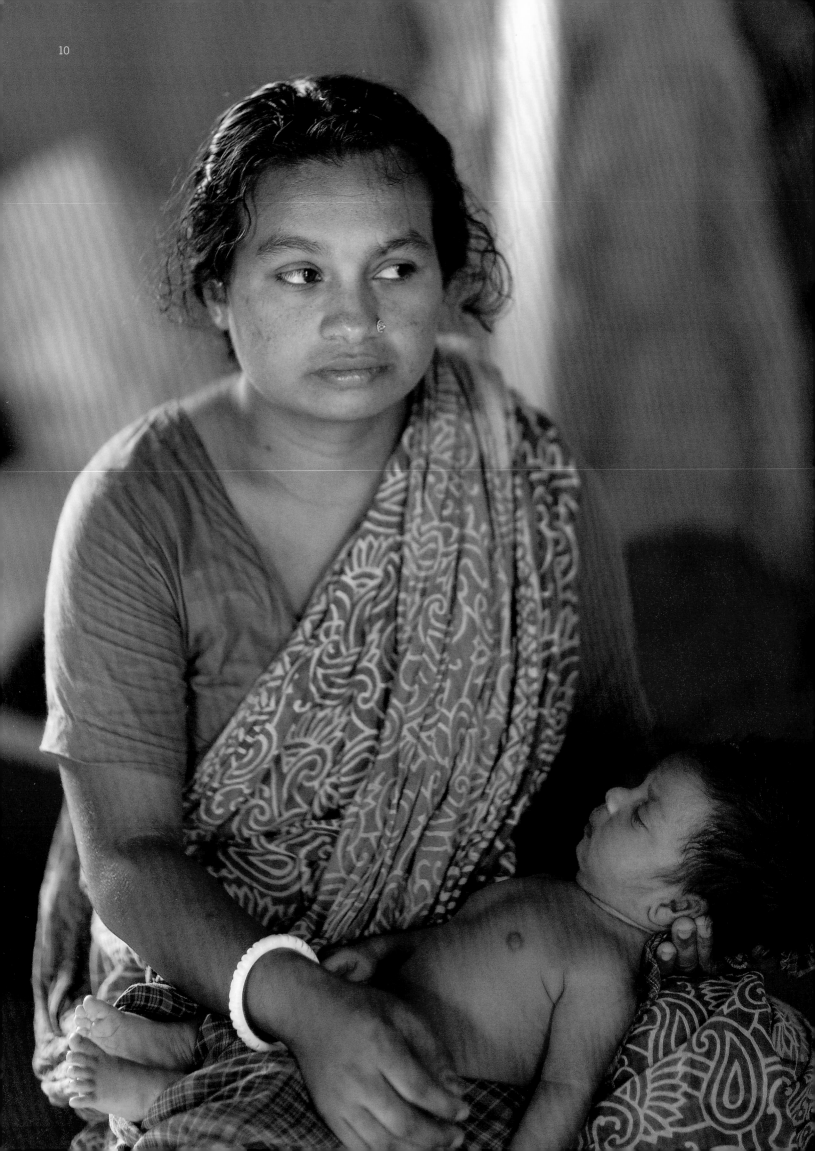

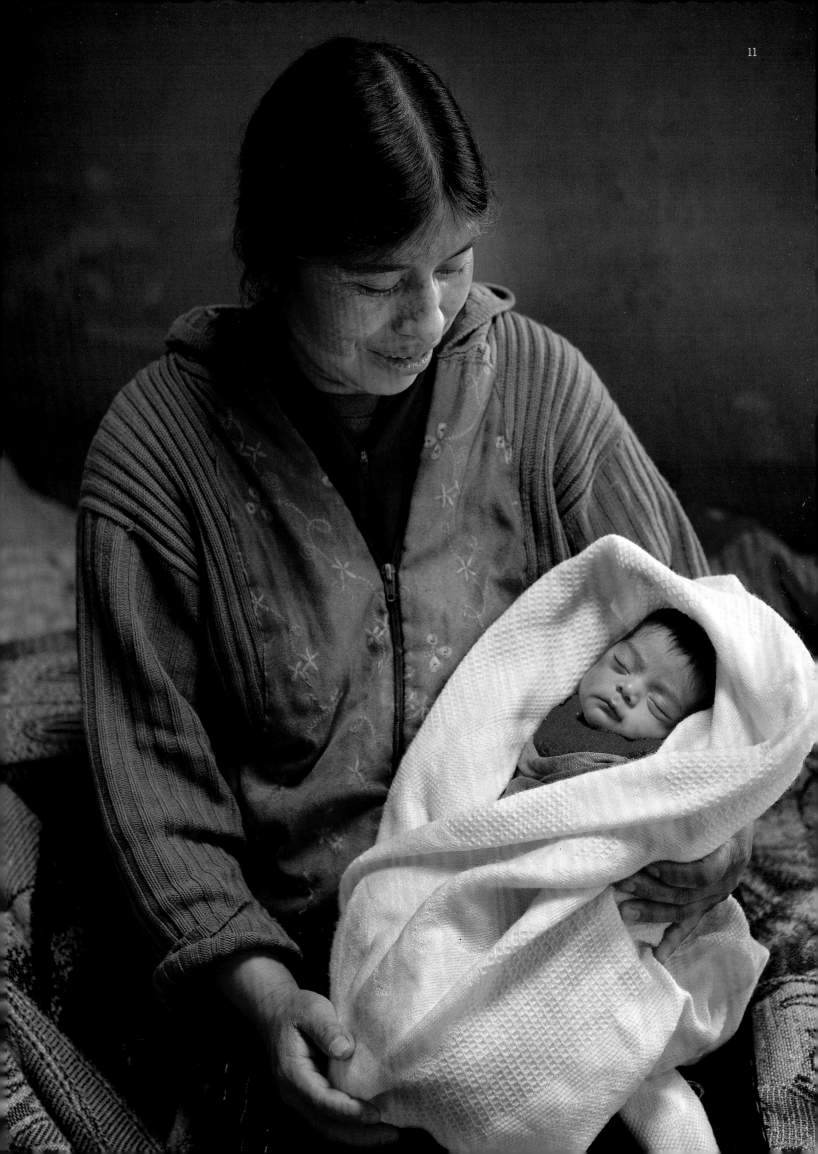

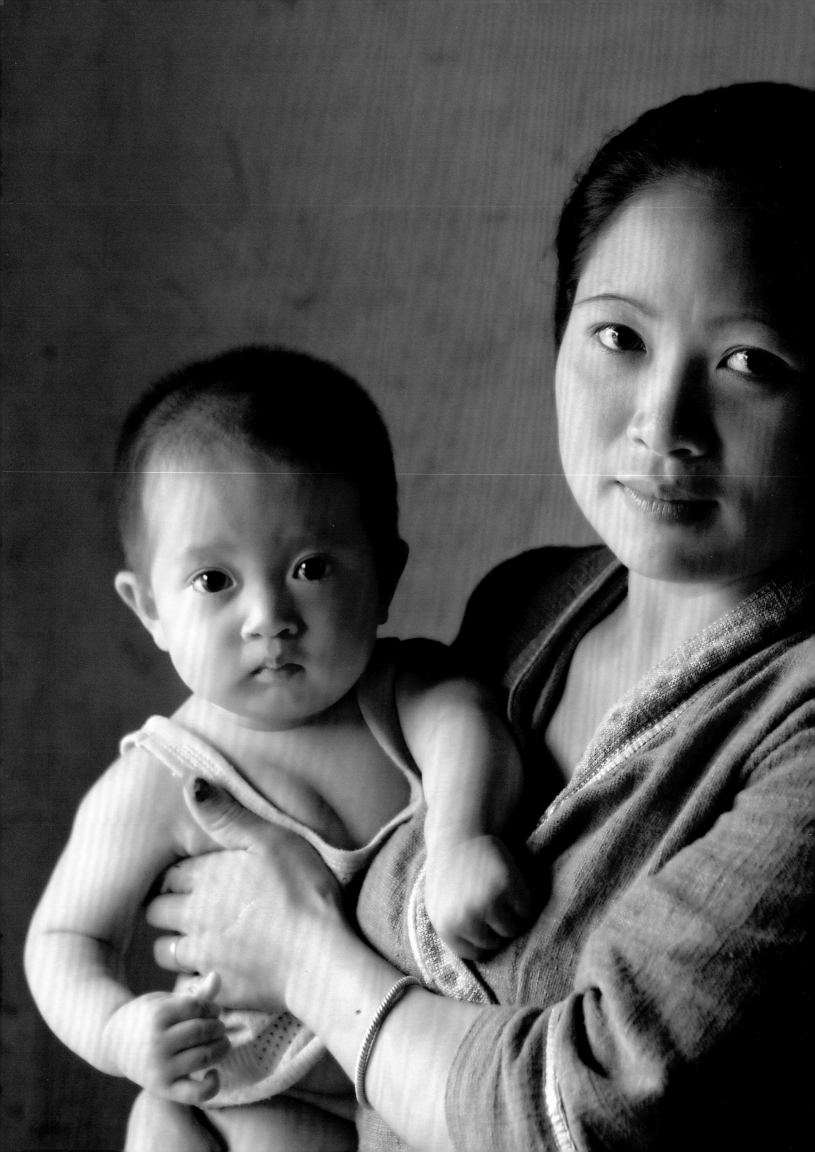

She was a girl who arrived
when everyone was expecting
a boy. So since she was such
a disappointment
To her parents,
To her immediate family,
To her tribe,
Nobody thought of recording
her birth.
She was so insignificant.

Buchi Emicheta
Nigeria, 1983

Women in Danger: Harsh Realities

A day does not go by without news of atrocities that befall women and girls; yet these headlines are only the tip of a very large iceberg. In many parts of the world, girls and women suffer in silence simply because they were unfortunate enough to be born in societies that value them more as unpaid domestic labor, sexual objects, and reproductive vessels than for their full human potential. Their lives do not make headlines or trend on social media because their experiences and suffering are not breaking news, but rather regular, daily occurrences. As a result, they suffer in silence and figure only in abstract statistics in reports that seek to raise some awareness of their plight.

The chapters in this section tell the stories of women and girls in the developing world, faced with the all-too-common tribulations of minimal access to healthcare, teen pregnancy, obstetric fistulas, and HIV/AIDS.

Waiting for Healthcare

"The equivalent of five jumbo jets worth of women die in labor each day...life time risk of maternal death is 1,000 times higher in a poor country than in the west. That should be an international scandal."

Nicholas D. Kristof
Half the Sky

In my travels, I have seen it over and over: maternal healthcare clinics with waiting rooms packed with pregnant young women and girls, holding their infants or their toddlers in their arms. These clinics are often so crowded and understaffed that young women have to wait all day to see a healthcare worker, and far too often that worker is the only person on staff in the entire clinic.

The consequences of this situation are often deadly: every two minutes a woman dies from a potentially avoidable or preventable problem in pregnancy or childbirth. That translates to upwards of 800 women dying needlessly every day—and 99 percent of these maternal deaths occur in developing countries.

The issue here is not just over-crowding and under-staffing. In many countries, poor roads and infrastructure make it difficult for women to travel to healthcare clinics. Also, many women are simply too poor to pay for even basic healthcare services. Worse, in many countries the political leadership simply will not allocate the resources and funding necessary to maintain clinics, especially those that provide services to women.

One of the most devastating factors, which is arguably the most difficult to change, is the array of cultural barriers that prohibit women from accessing the facilities they need to control their pregnancies and enjoy safe and healthy births. The harsh truth is that in far too many parts of the world women are not able to exercise the same basic rights as men. Their voices are stifled, their basic needs are ignored, and their human rights are violated on a daily basis. And far too many women are ruled by fear. I once visited a family planning clinic in Addis Ababa, and out of the twelve women who came in for counseling, only one opted for an easily administered form of long-term birth control. And what about the other eleven? They were afraid of their husbands' response to long-term contraception practices.

Consequently, many women in developing countries have numerous pregnancies that begin at an early age. In some regions, the lifetime risk of dying during childbirth can be as high as one in six. Unfortunately, the women we see lined up in these photographs, waiting patiently to see a healthcare worker, are not the majority; millions more never have access to any form of medical services. In 2014, less than half of births in low-income countries were attended by a skilled professional. As a result, women's lifetime risk of dying from a maternity-related cause in these regions is approximately twenty-three times higher than for women living in developed countries (WHO).

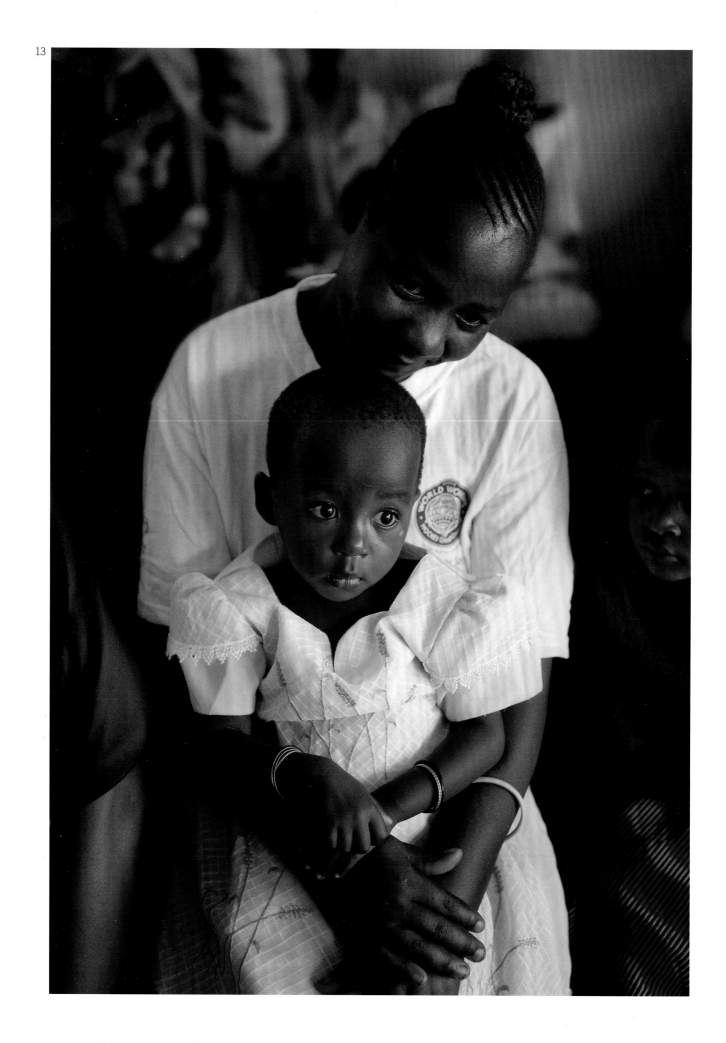

WOMEN IN DANGER: HARSH REALITIES

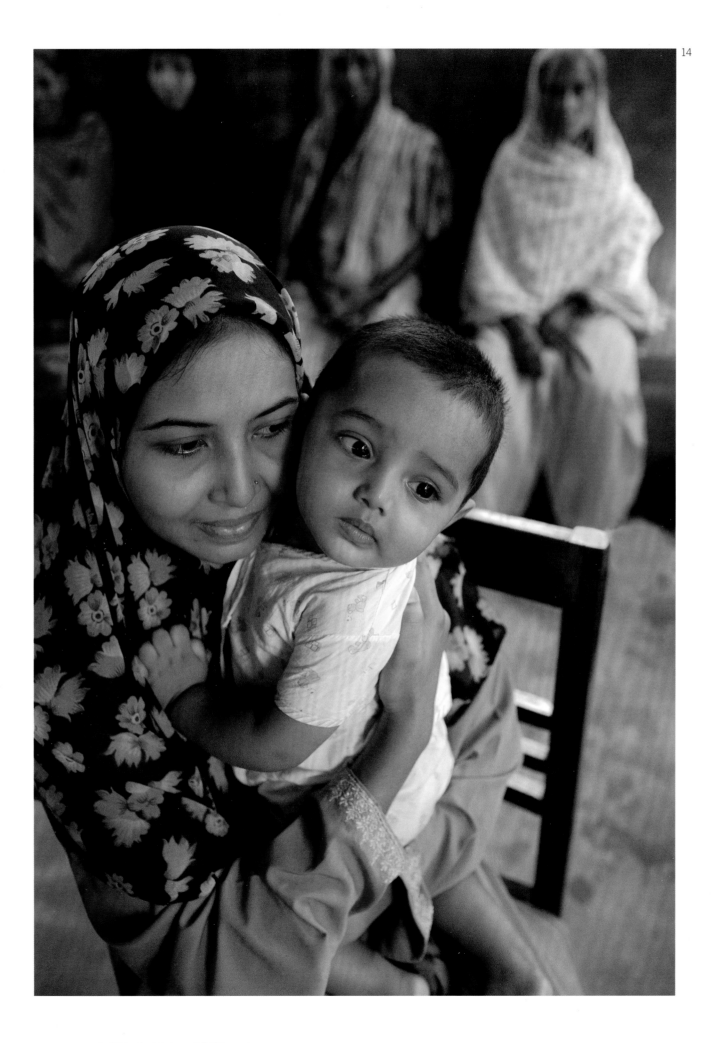

WAITING FOR HEALTHCARE

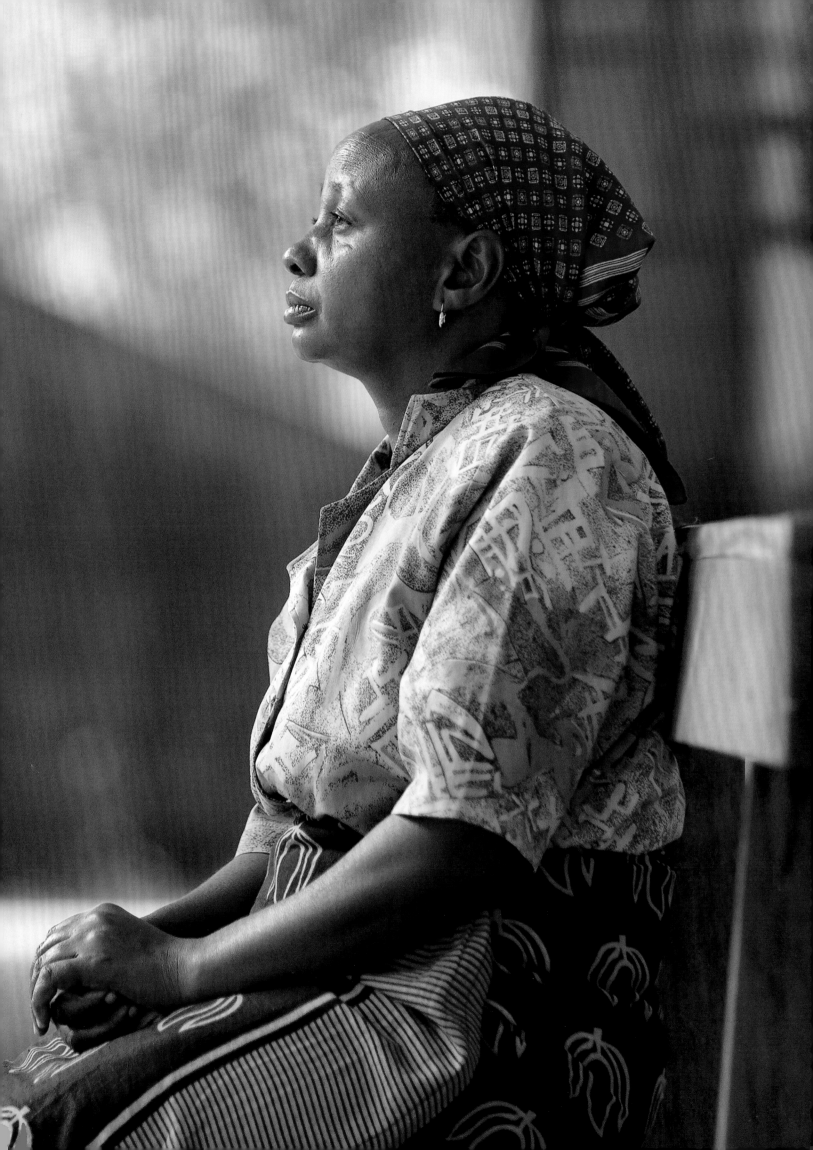

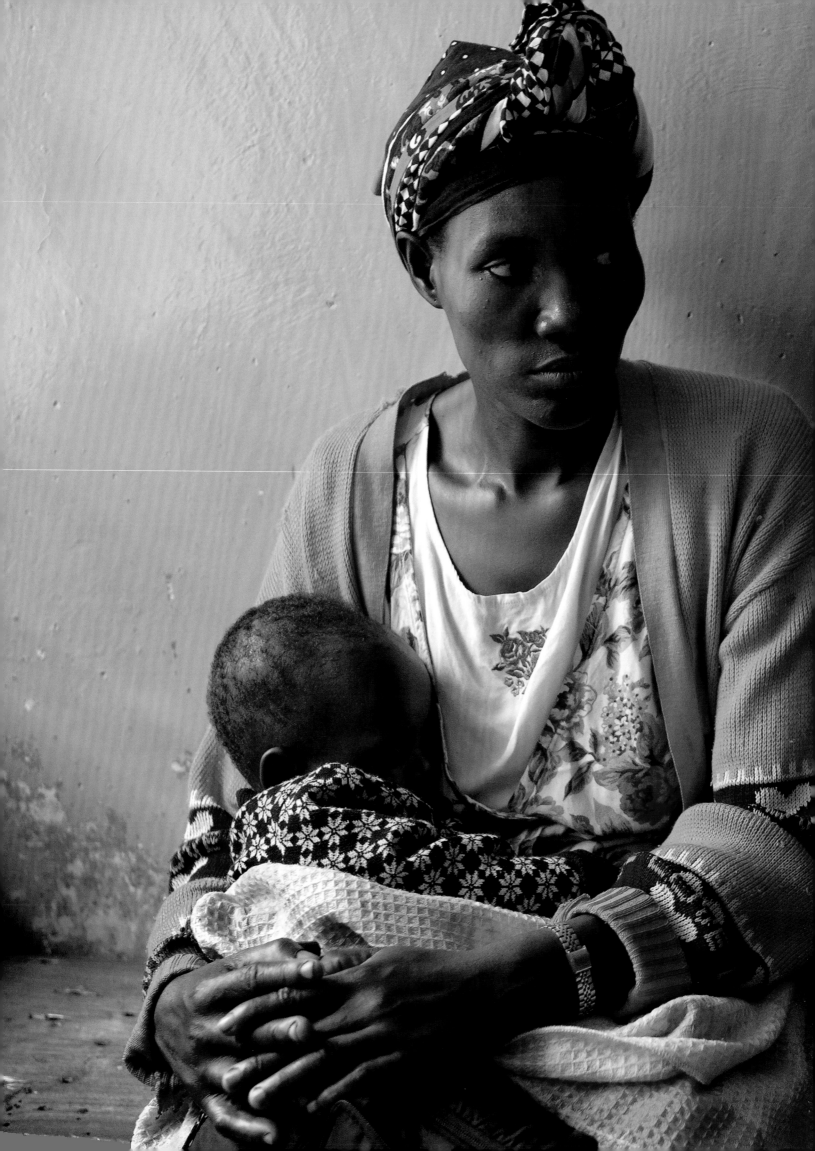

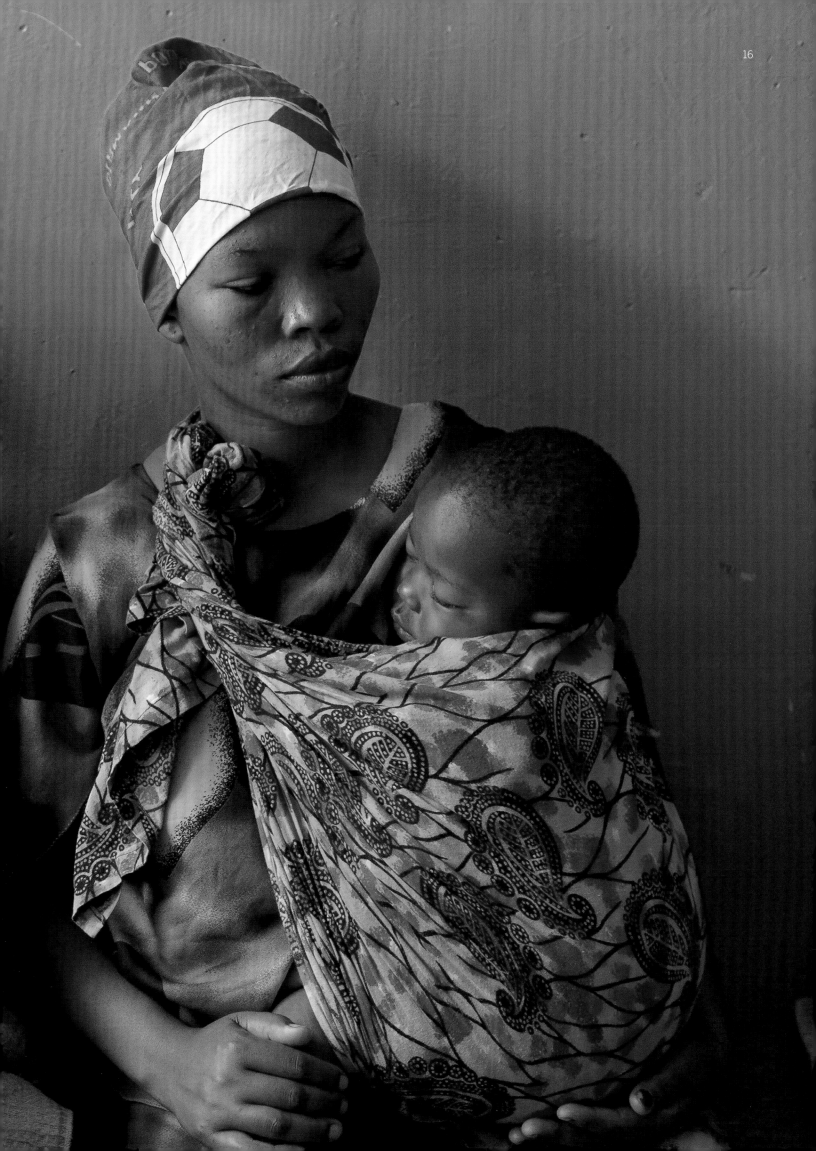

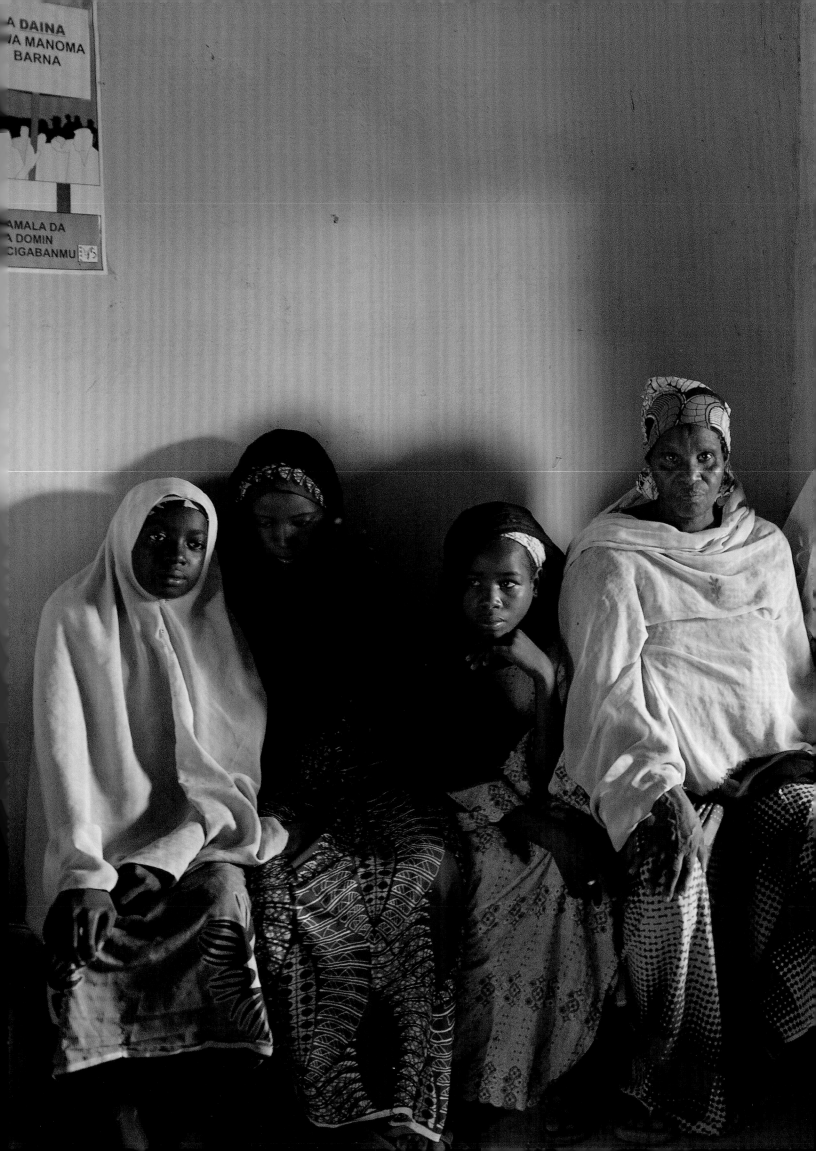

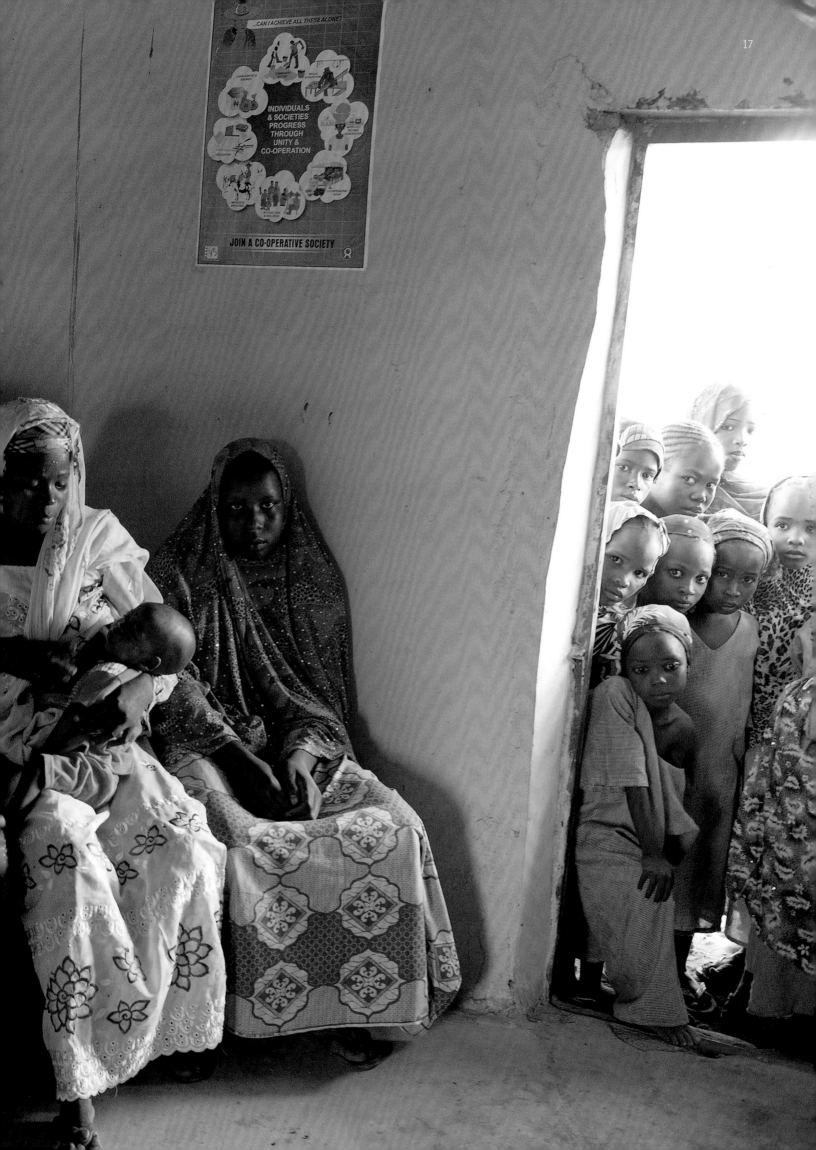

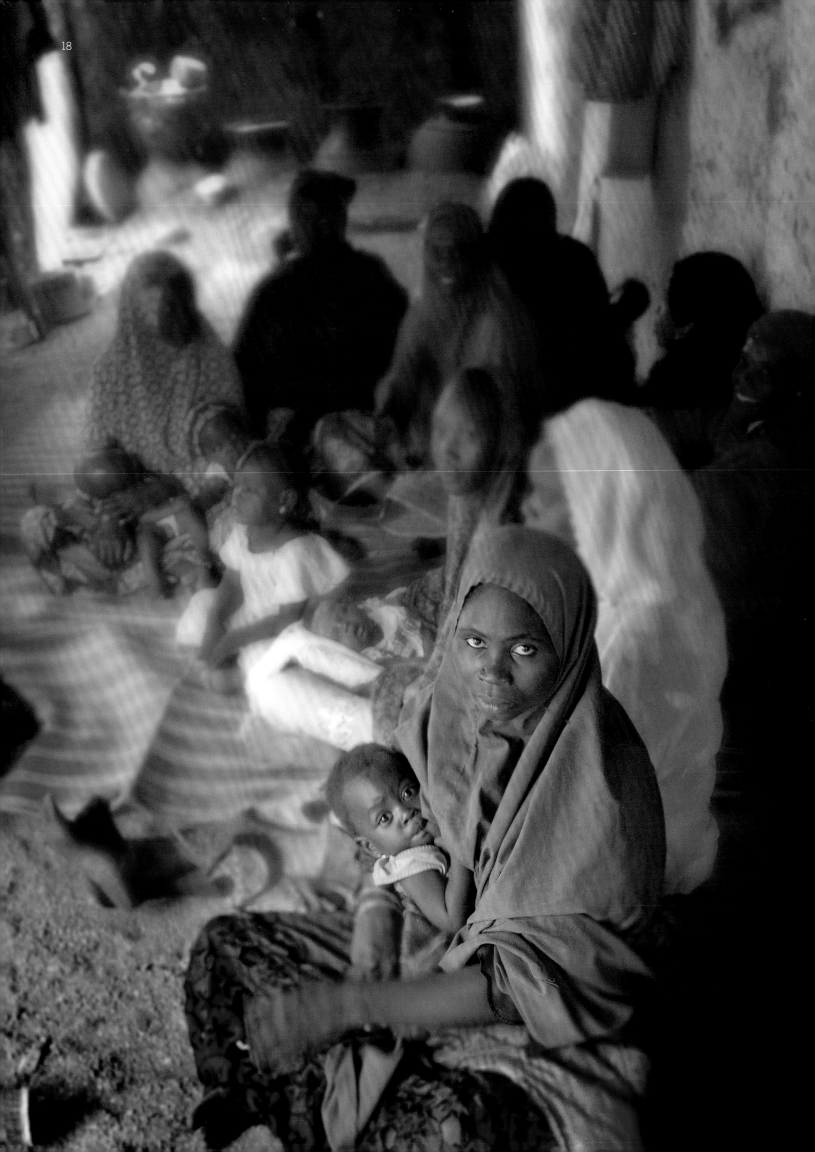

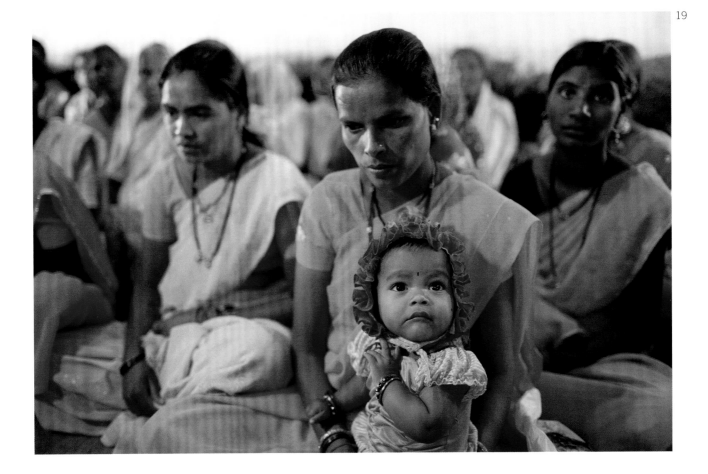

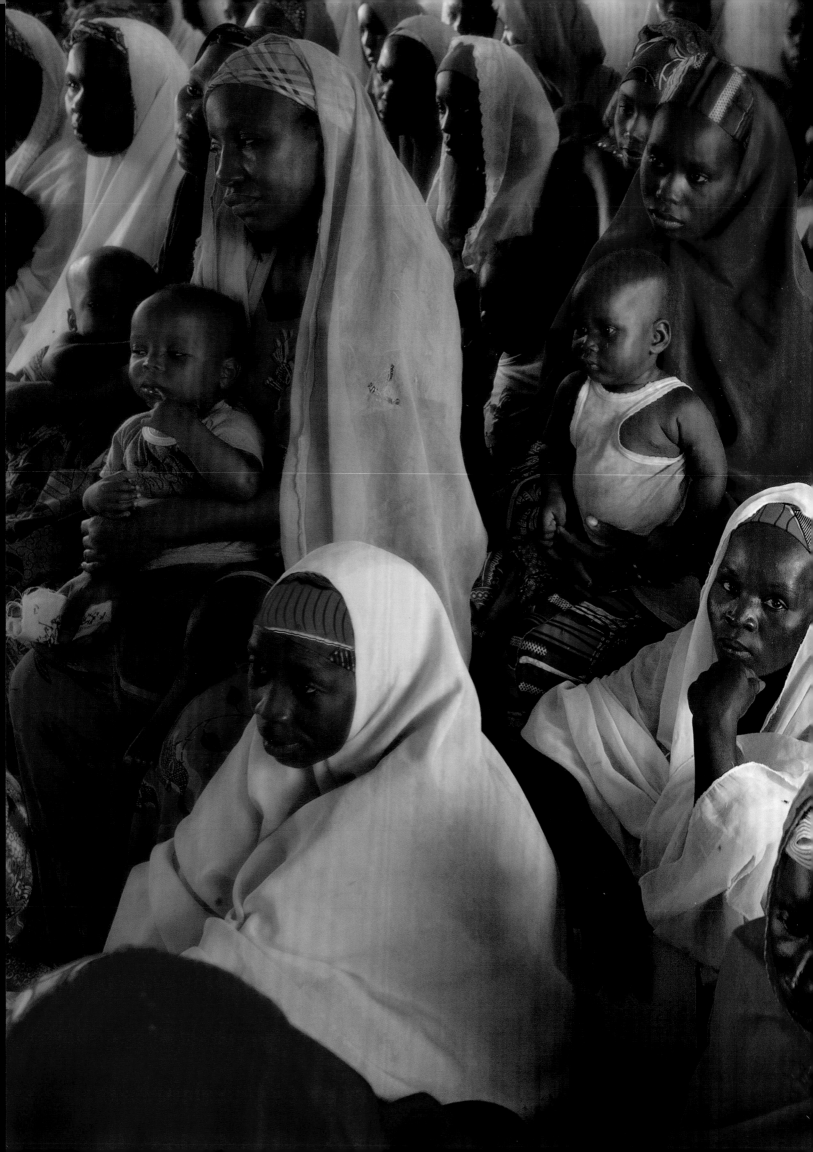

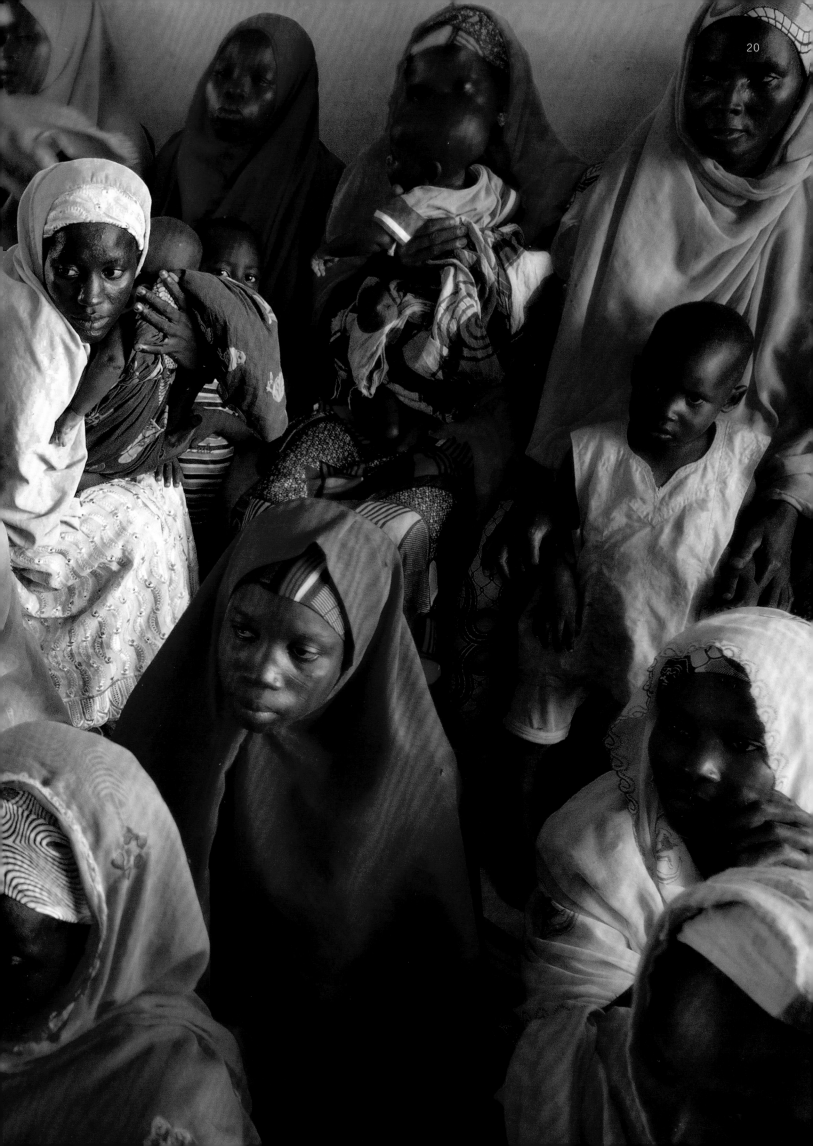

21

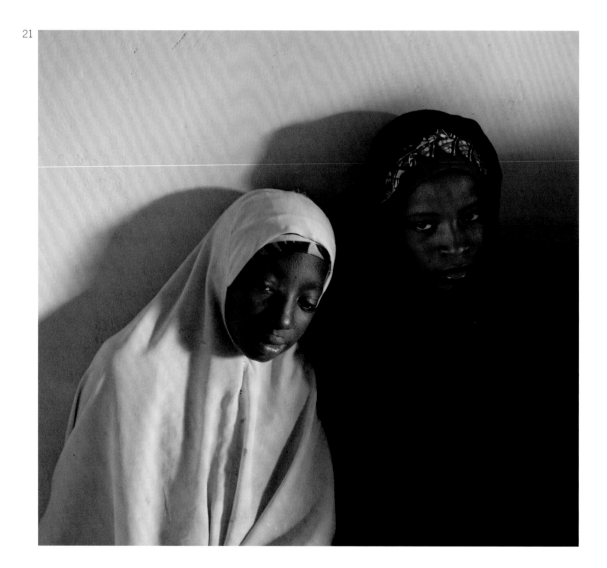

WOMEN IN DANGER: HARSH REALITIES

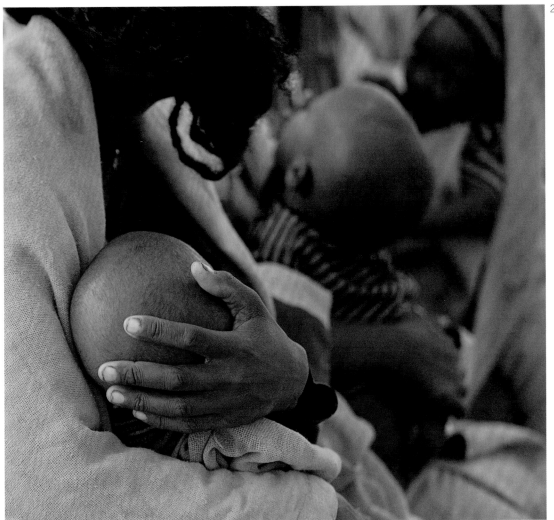

22

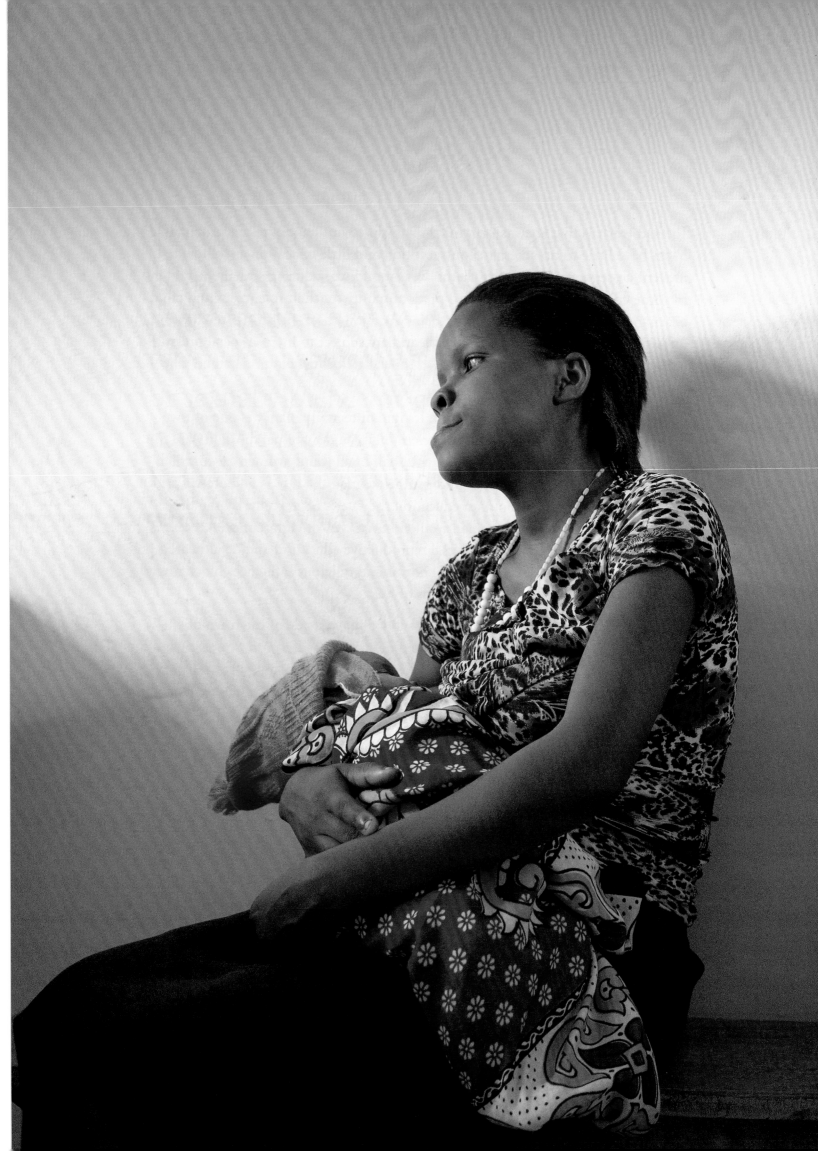

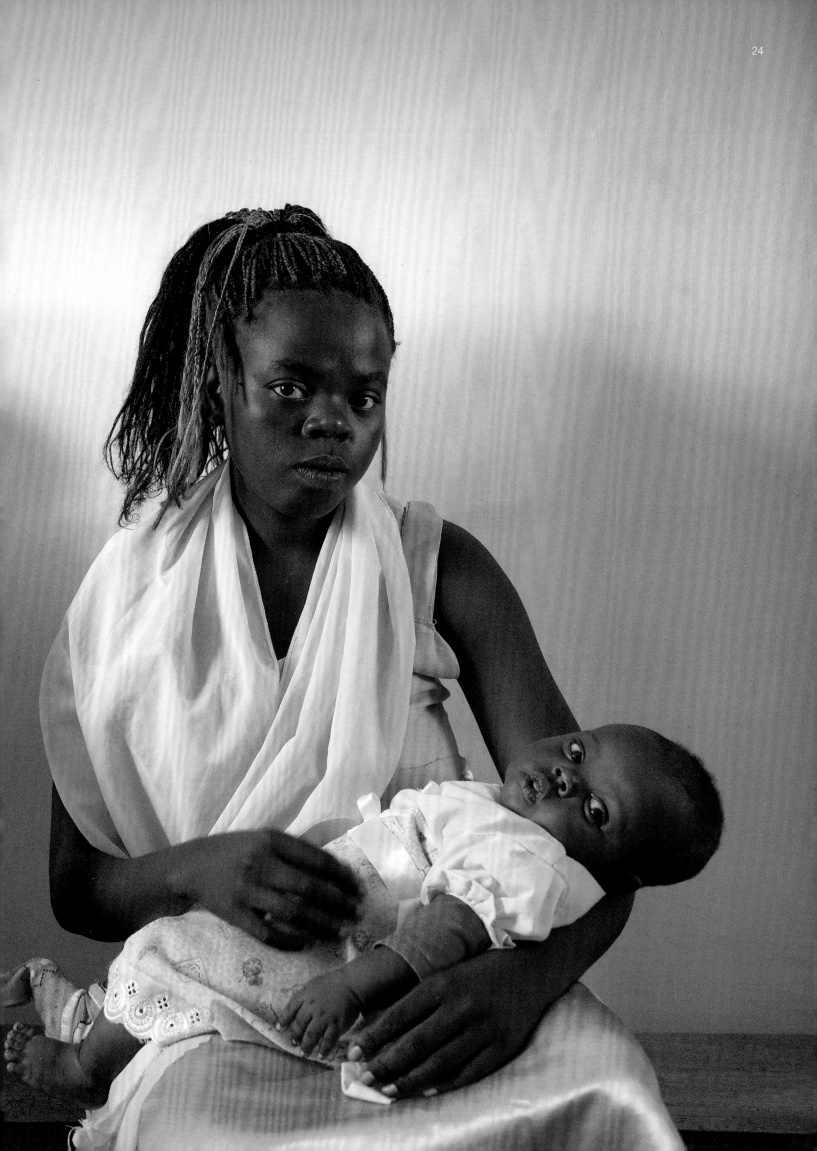

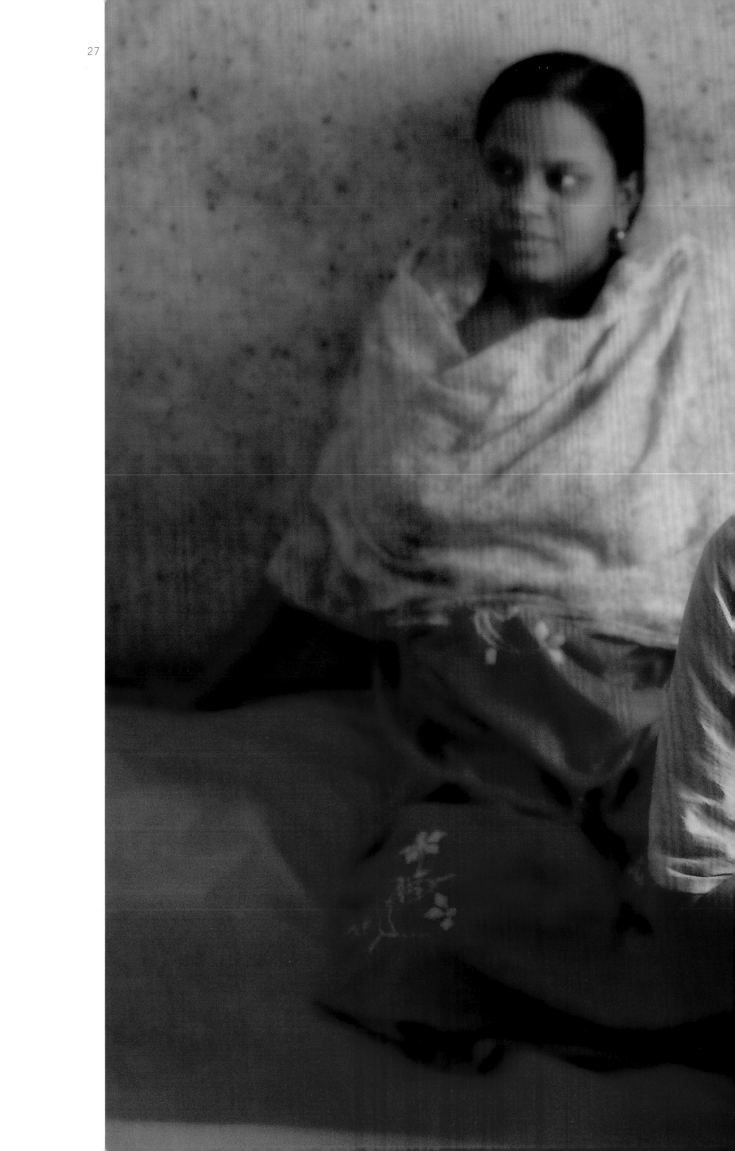

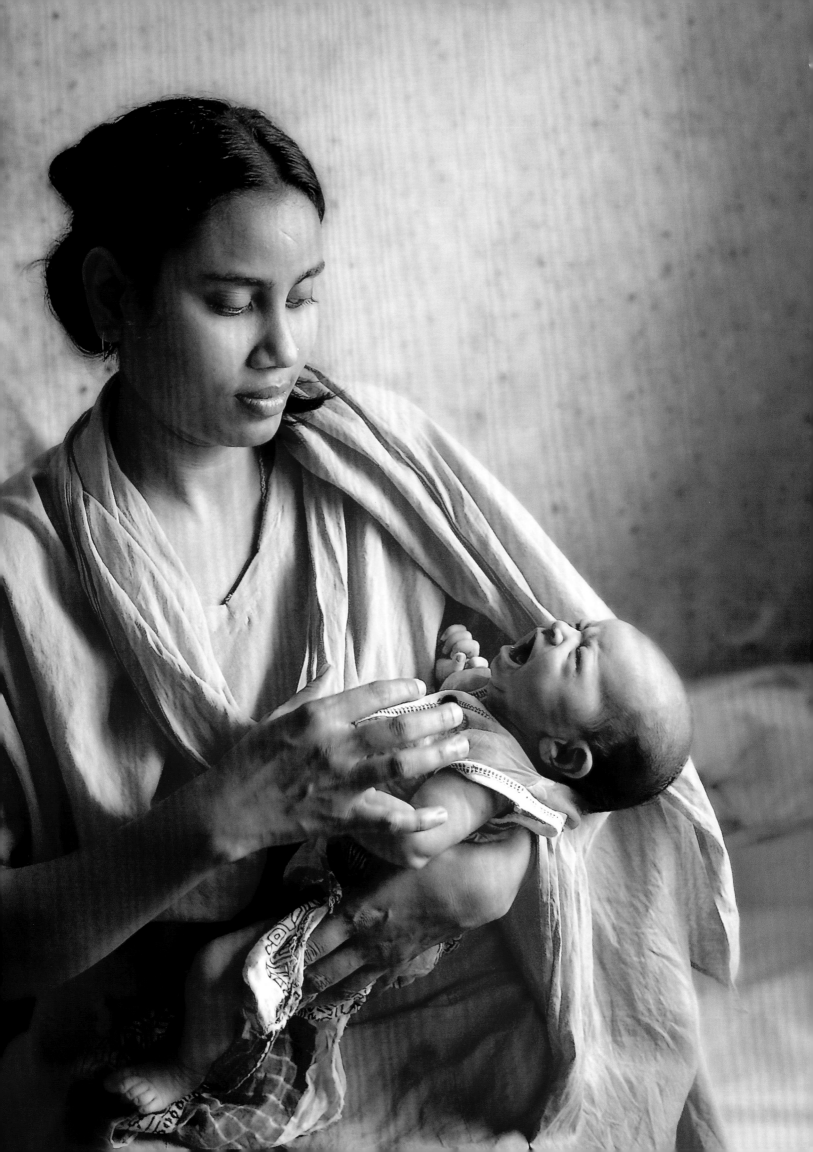

28

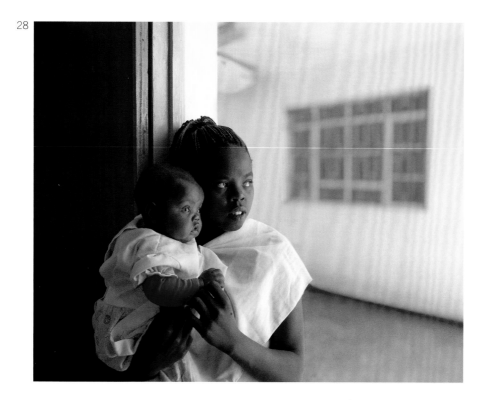

29

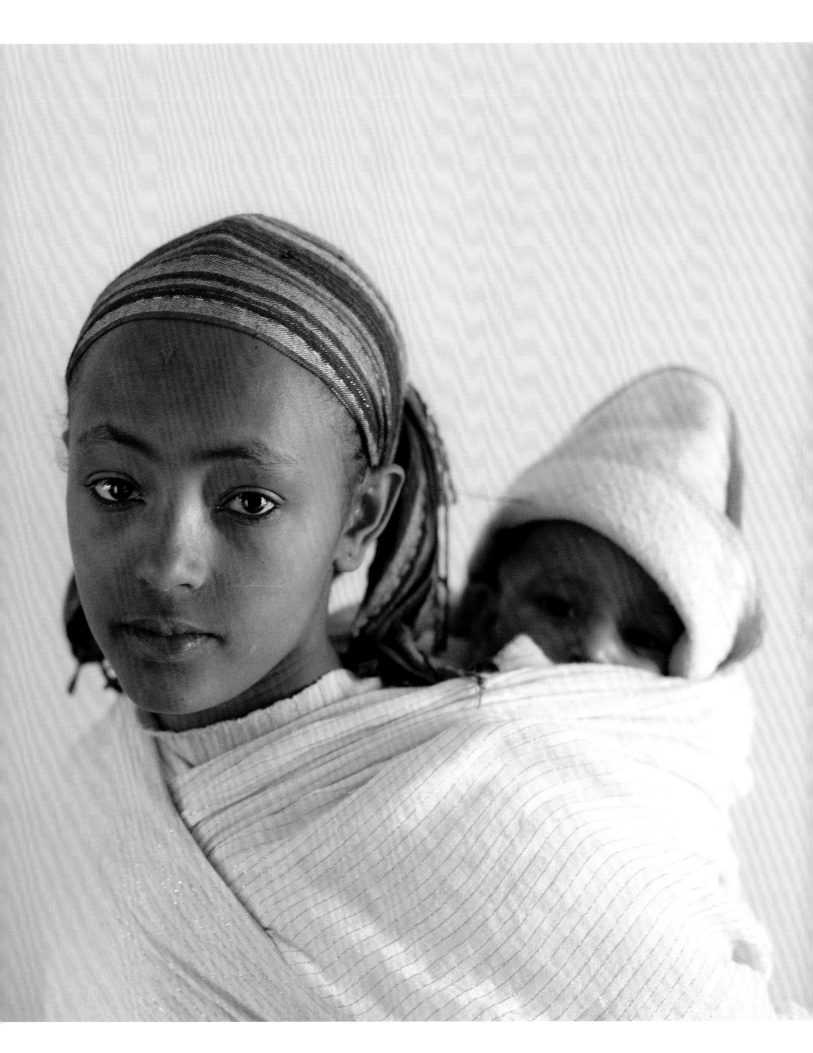

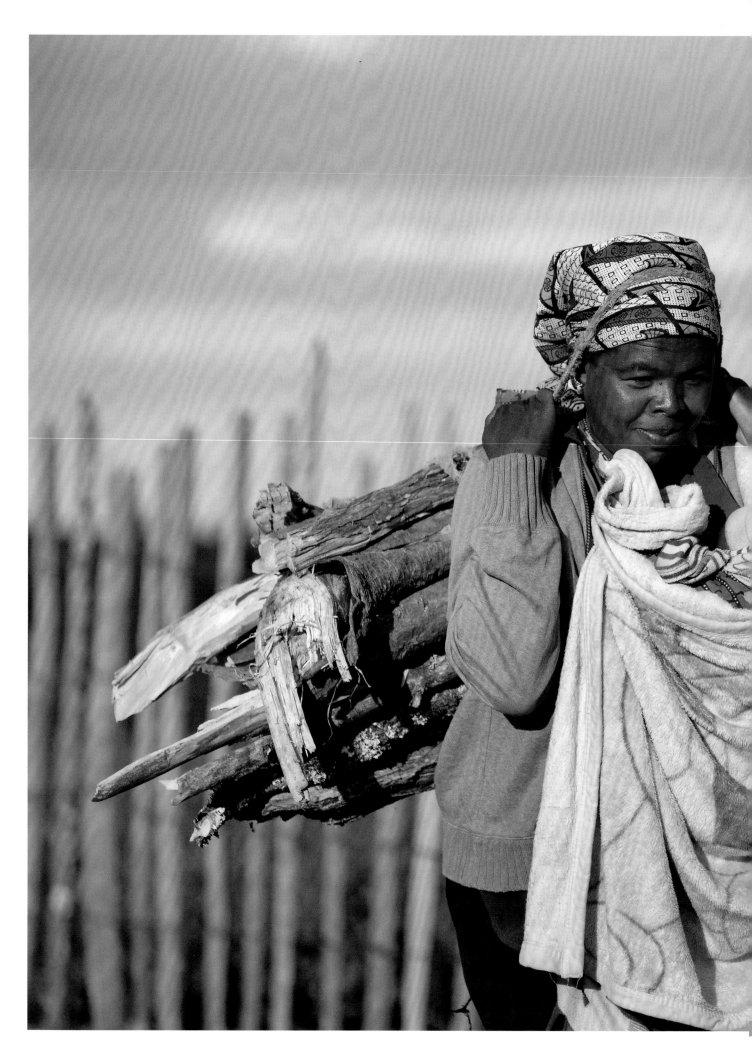

WOMEN IN DANGER: HARSH REALITIES

Fistula

"One million women suffer from obstetric fistula. Of every 50 women in need, only one gets treatment."

Fistula Foundation

It was in Bangladesh and Ethiopia that I had my first encounters with patients suffering from the condition known as fistula. For those who may not know, an obstetric fistula is a tear that opens during childbirth or other trauma, located between the birth canal and either the bladder or the rectum. The result is a constant leaking of urine or feces through the vagina.

Every year, between 50,000 and 100,000 women develop this preventable condition, and most of the two million young women now living with the consequences of obstetric fistulas live in rural, impoverished regions of South Asia and sub-Saharan Africa.

Young adolescent girls are particularly susceptible to fistulas. Many are physically too immature to have a child, and many receive no obstetric care during delivery. These young girls often come from the most marginalized sectors of society; they tend to be poor and illiterate and to live in remote areas. Poverty and malnutrition also contribute to the condition known as "stunting," where a young girl's skeleton — and her pelvis in particular — is not large enough for her to have an unobstructed birth.

Fistulas are often referred to as a modern-day leprosy, for understandable reasons. A woman living with a fistula is unable to control the leakage of her bodily waste, and frequently the unpleasant smells and the unsightly appearance cause her to become ostracized from society. So in addition to the crippling trauma to her body, and the impact on her newborn child, the woman suffers a terrible social stigma. This can result in abuse and even abandonment by her husband,

family, and the entire community. Many times, women and girls with a fistula find themselves totally isolated and forced to live on their own in a makeshift shelter, away from everyone and everything. Without proper treatment, their lives become a living nightmare.

At a fistula repair center in rural Ethiopia, I saw women whose faces and stories haunt me still. Many of them suffered fistulas as teenagers and lived with the trauma for many years before they were able to receive proper care and treatment. Even then there are no guarantees: one young woman I met had had one unsuccessful surgery and was now hoping that a second surgery would finally repair her body. Another woman had been suffering for nearly twelve years before she found her way to a hospital that performed the corrective procedure.

The need for corrective surgery is great, but the allocated resources are not. As of now, there are over one million women suffering from obstetric fistulas, but we have the capacity to perform only 16,000 fistula-repair surgeries per year. As a result, only one percent of women living with a fistula actually undergo this life-changing surgery.

Treating fistula is not rocket science: the surgery has a 90-percent success rate, it is readily available in modern health clinics, and it costs only about $300 to perform. With surgery, these women have the ability to return to a normal lifestyle, and even to have more children. Sadly, though, in those cultures that treat women as third-class citizens, there is little willingness to help.

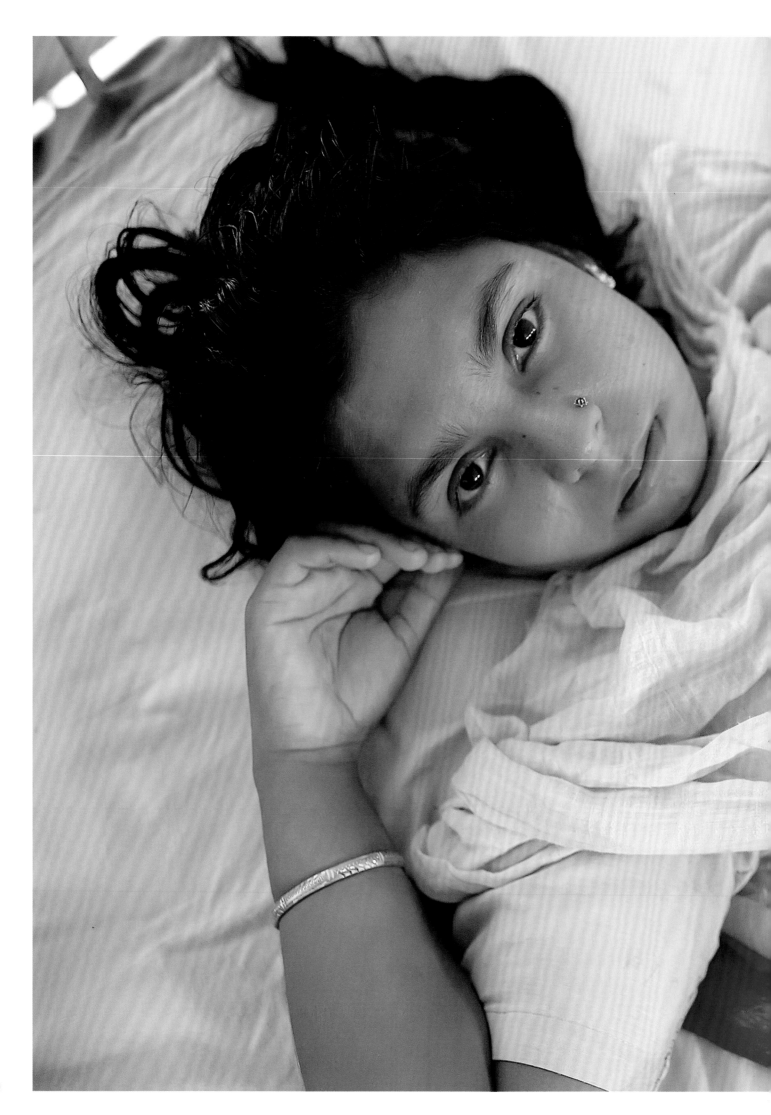

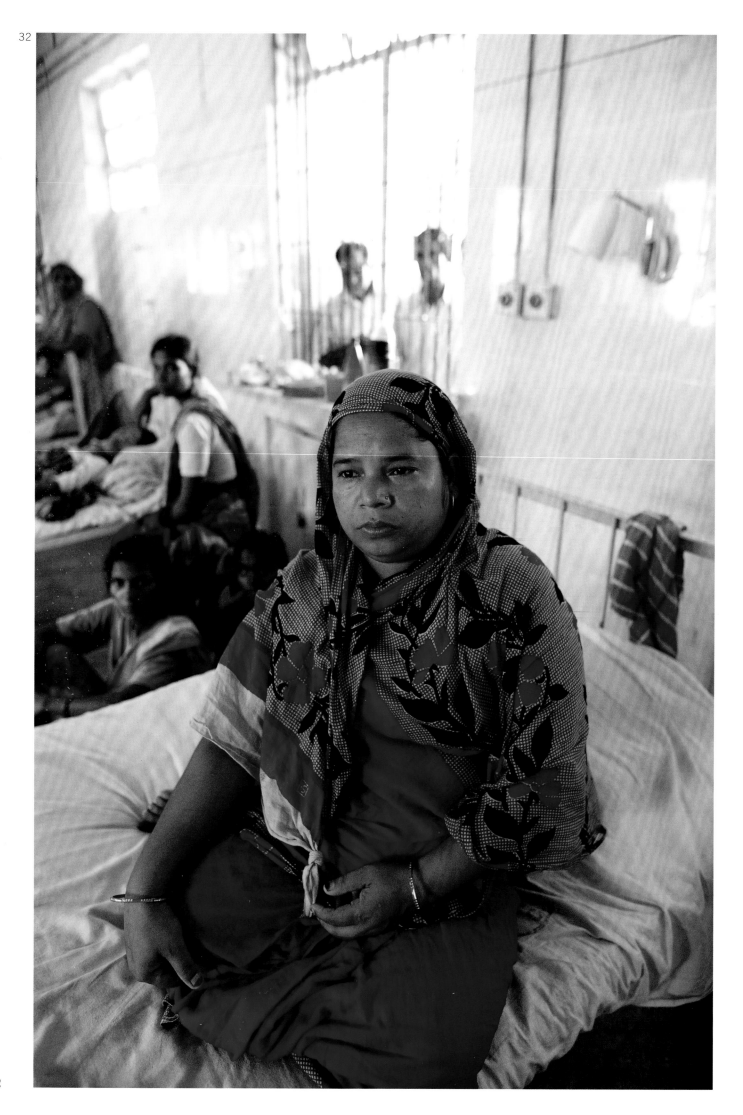

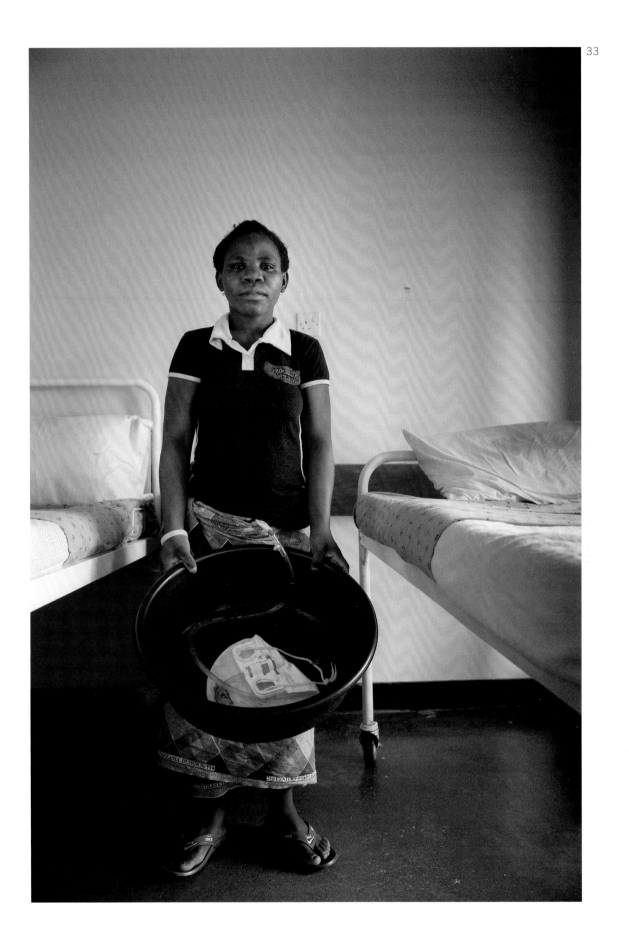

WOMEN IN DANGER: HARSH REALITIES

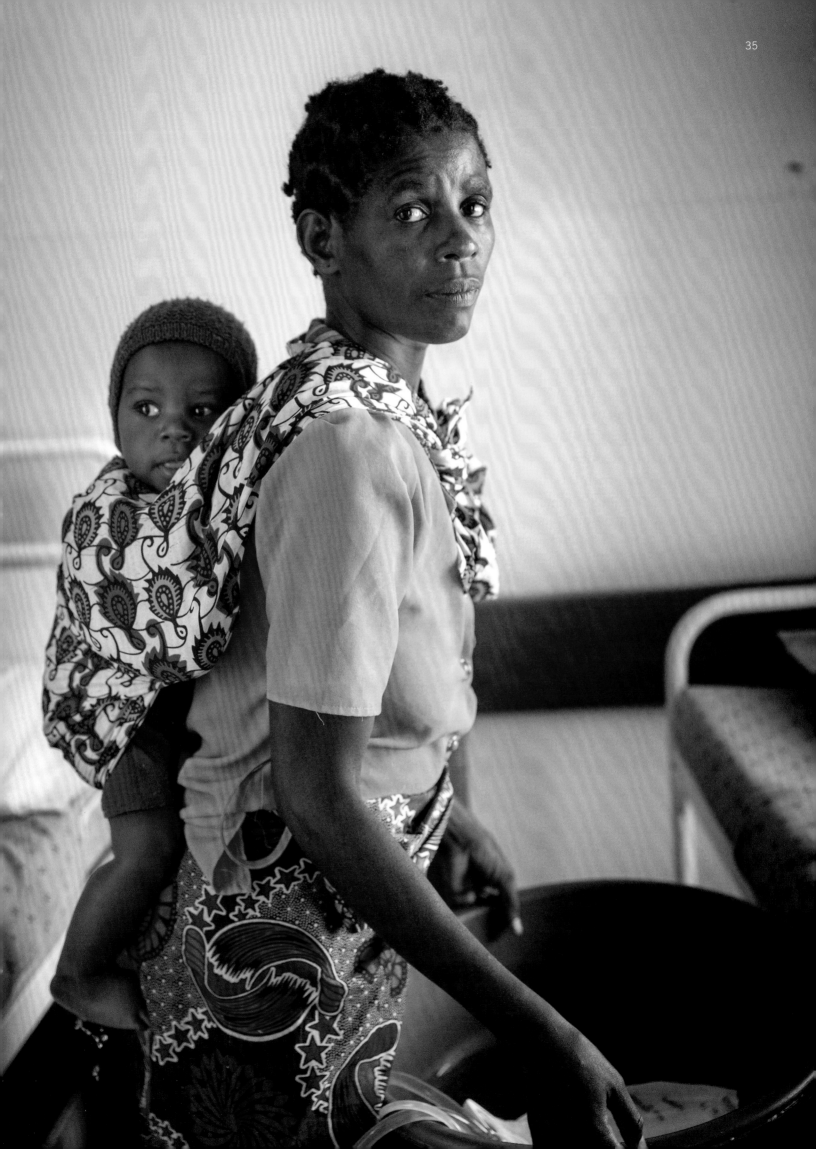

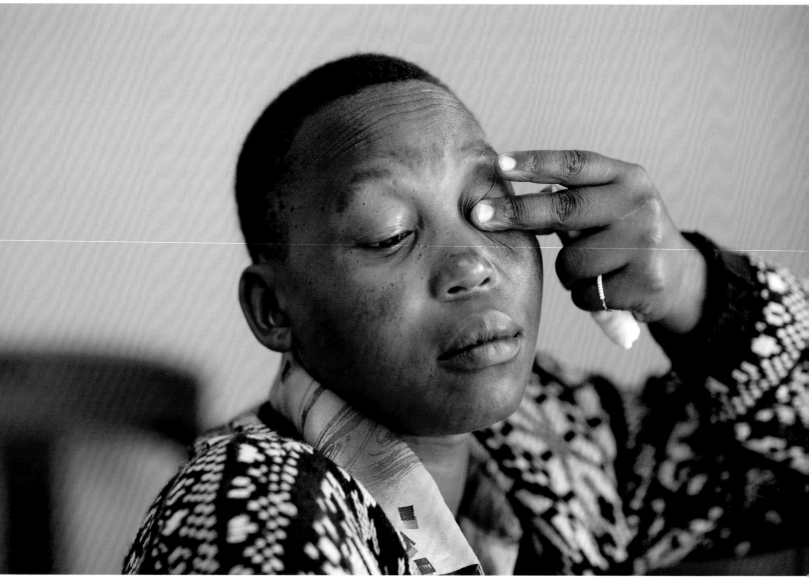

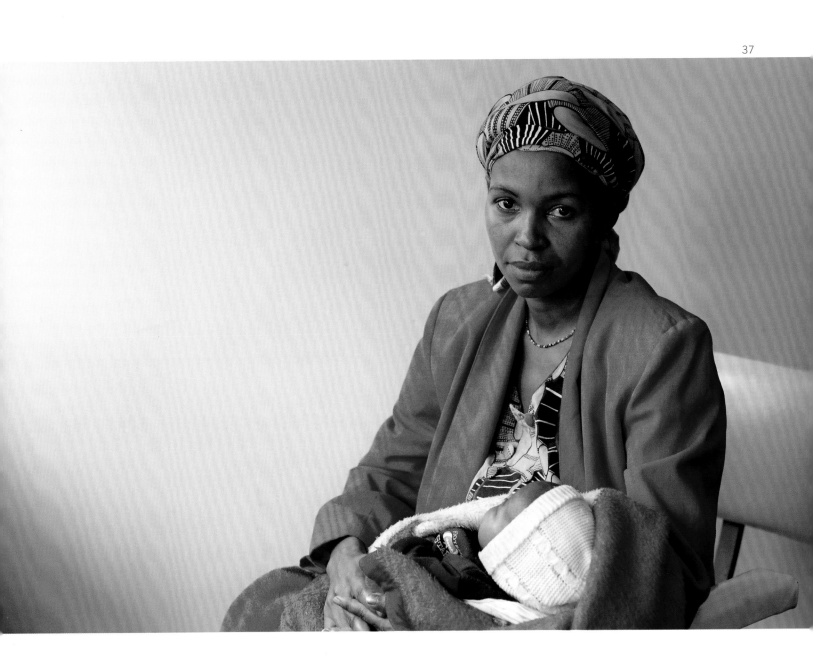

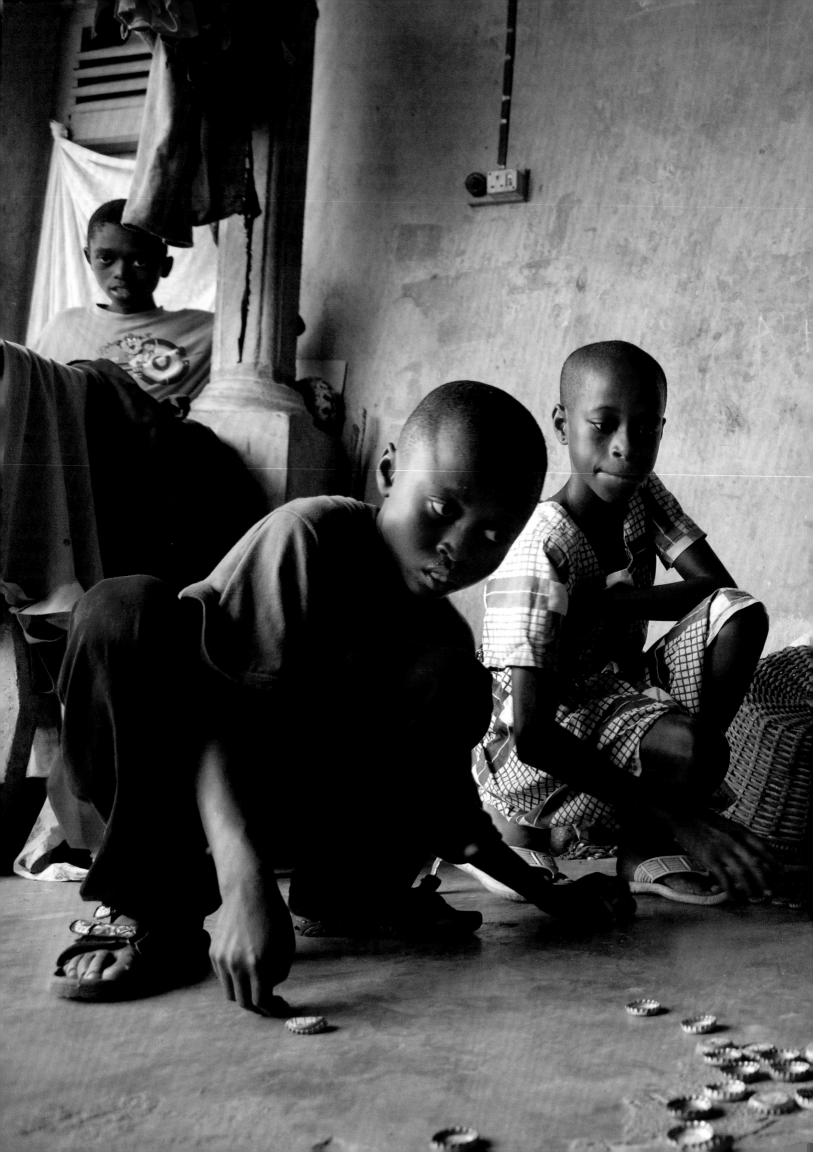

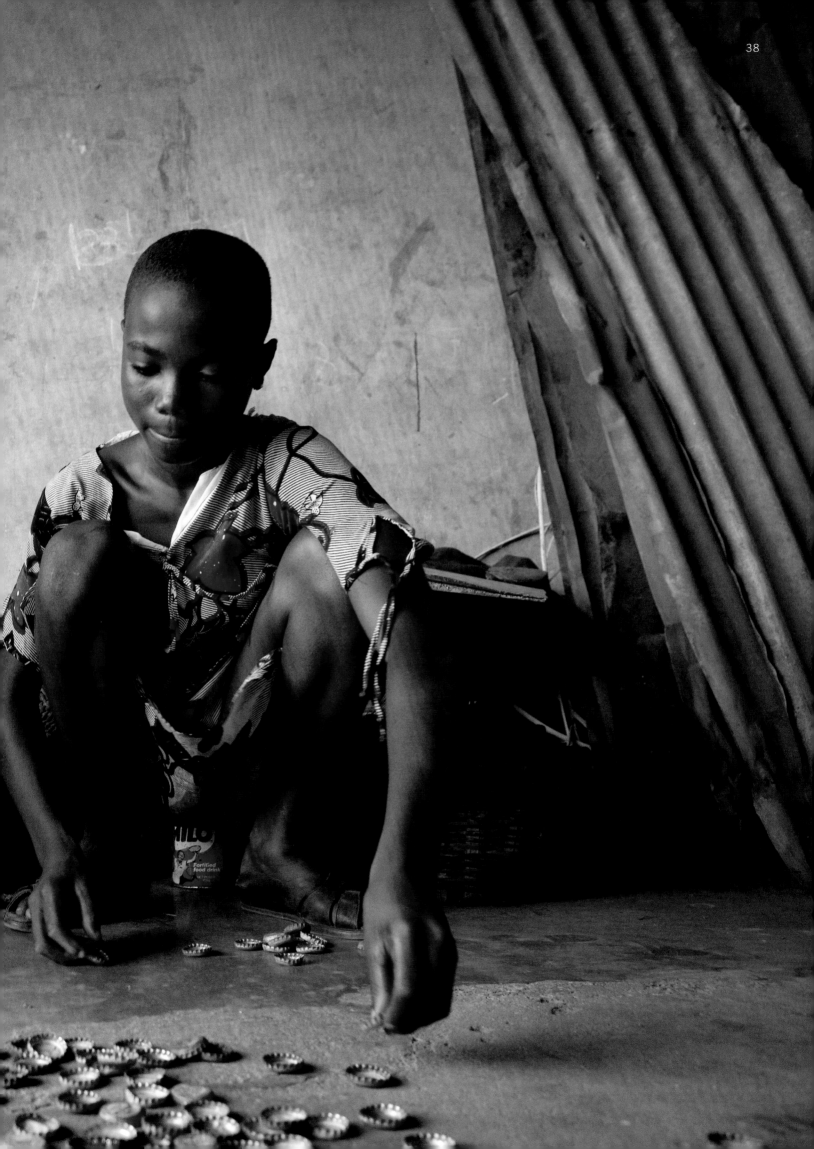

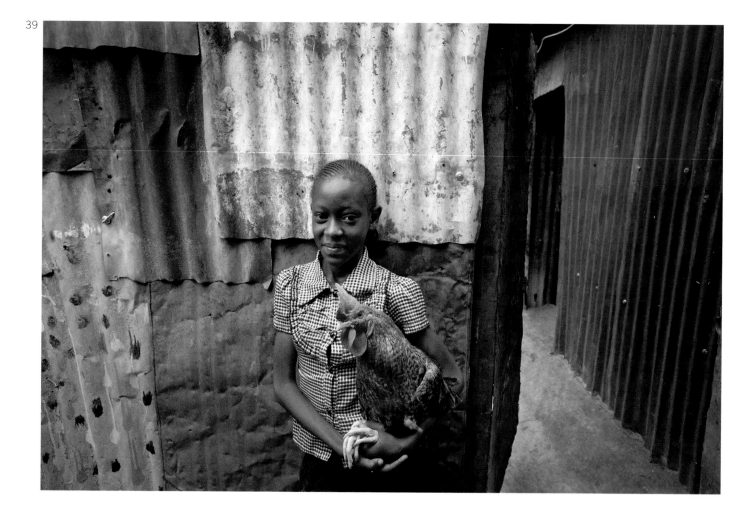

WOMEN IN DANGER: HARSH REALITIES

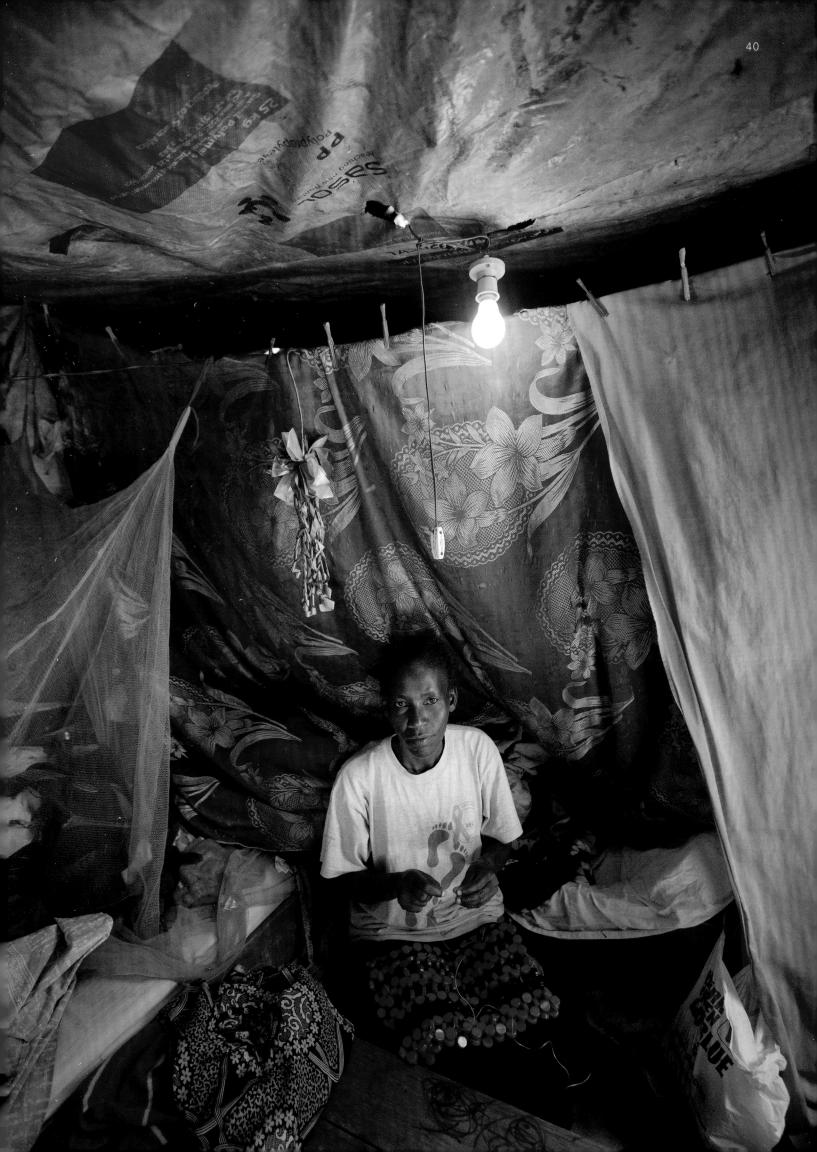

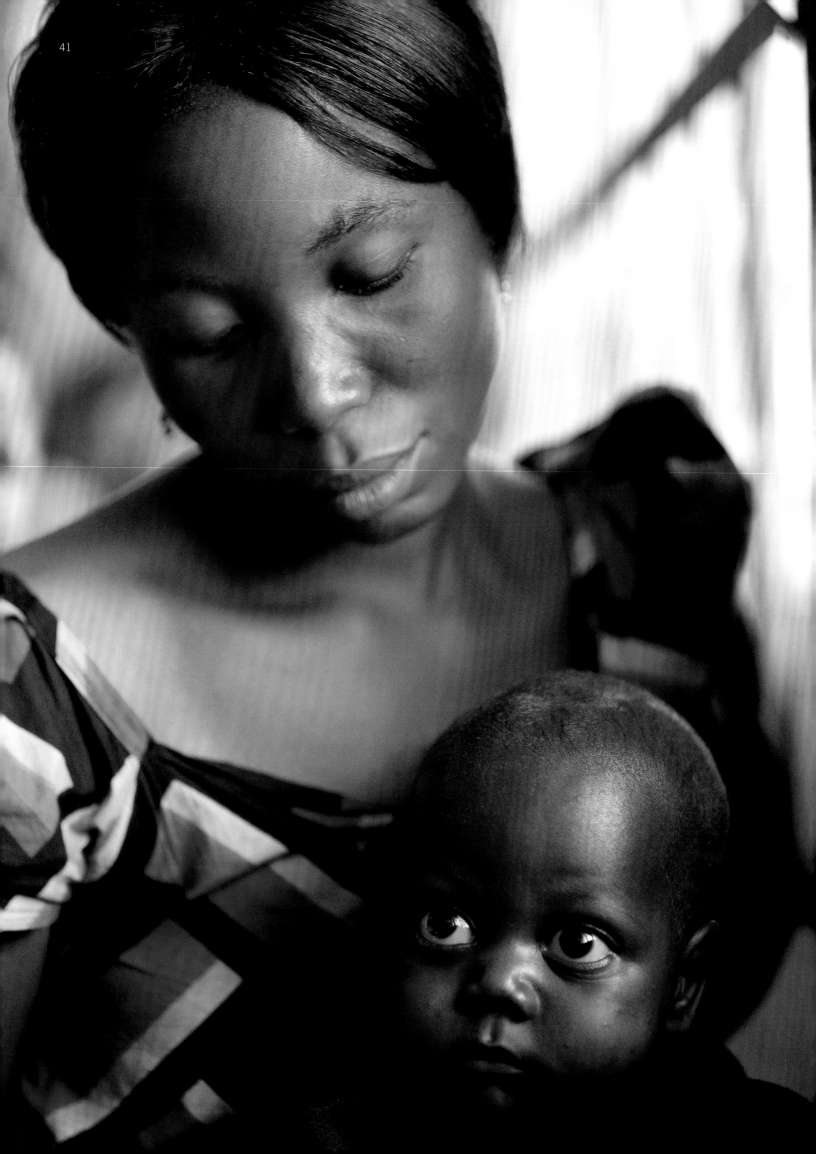

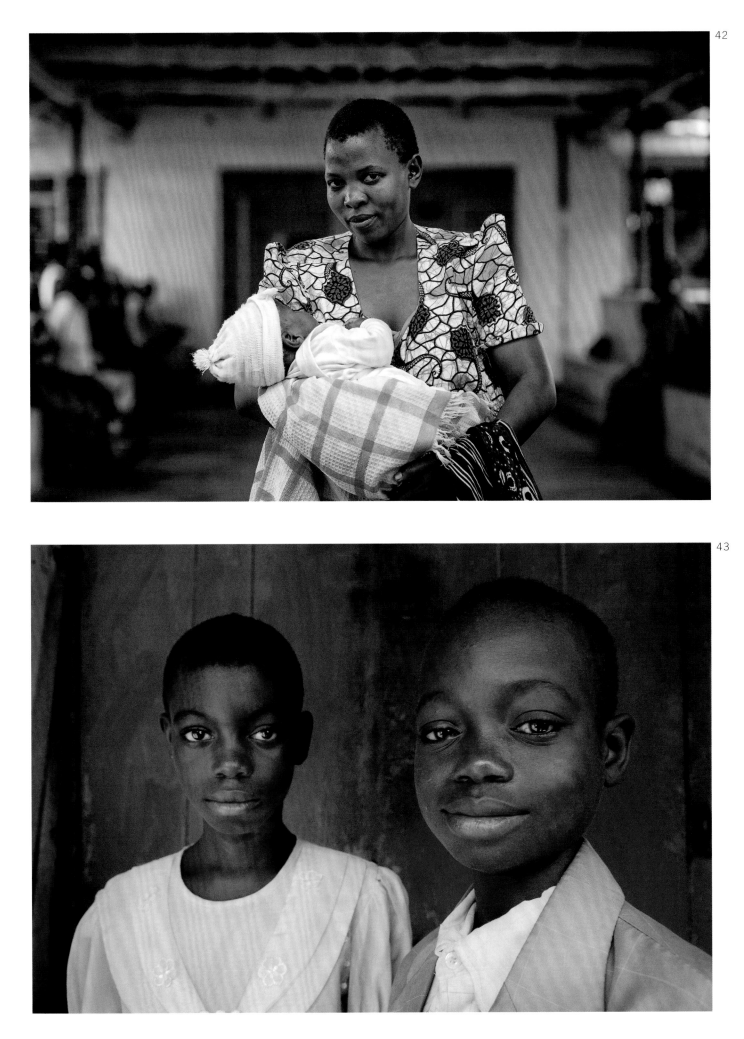

HIV/AIDS

"A woman's ability to plan how many children she wants and when she wants them is central to the quality of her life. Furthermore, in places where emergency obstetric care is not available, access to contraception can literally be a matter of a woman's life or death. Each pregnancy multiplies a woman's chances of dying from complications of pregnancy or childbirth."

Anne Firth Murray,
From Outrage to Courage

Women's Healthcare

The chapters in this section show how even minimally trained healthcare workers, family planning programs, and peer sexual education can dramatically improve women's health and well-being.

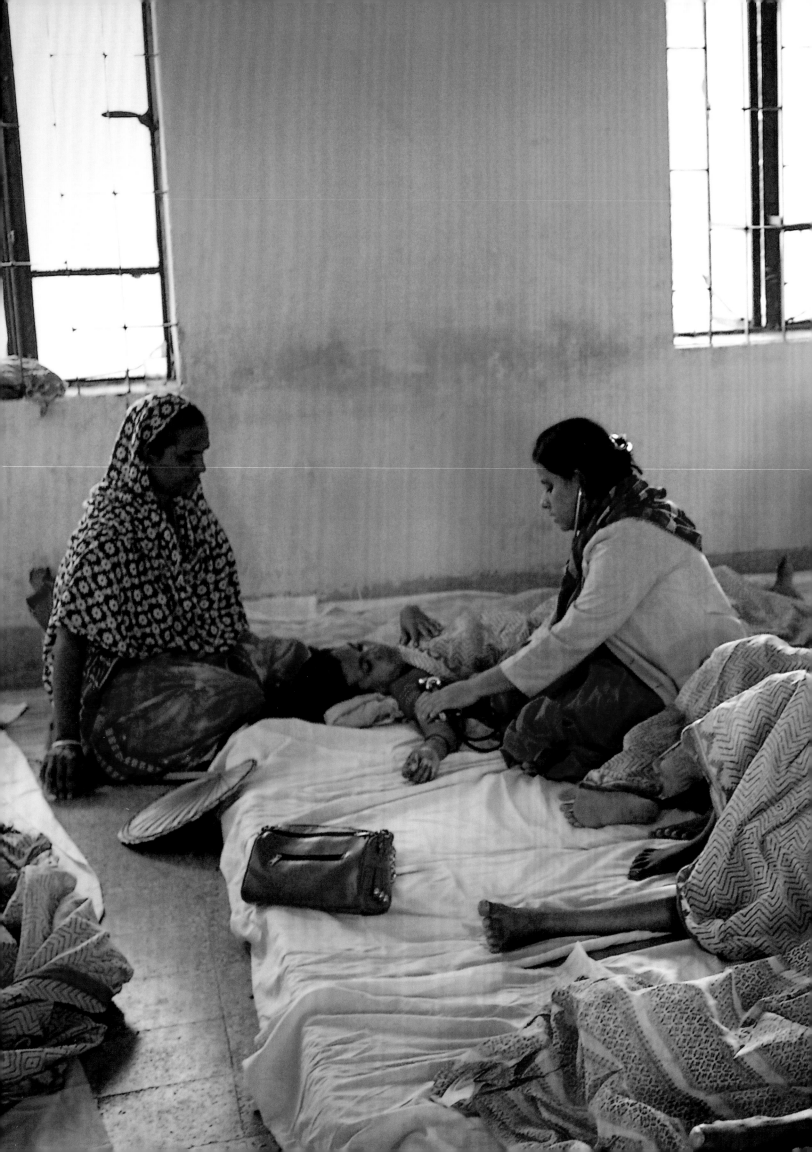

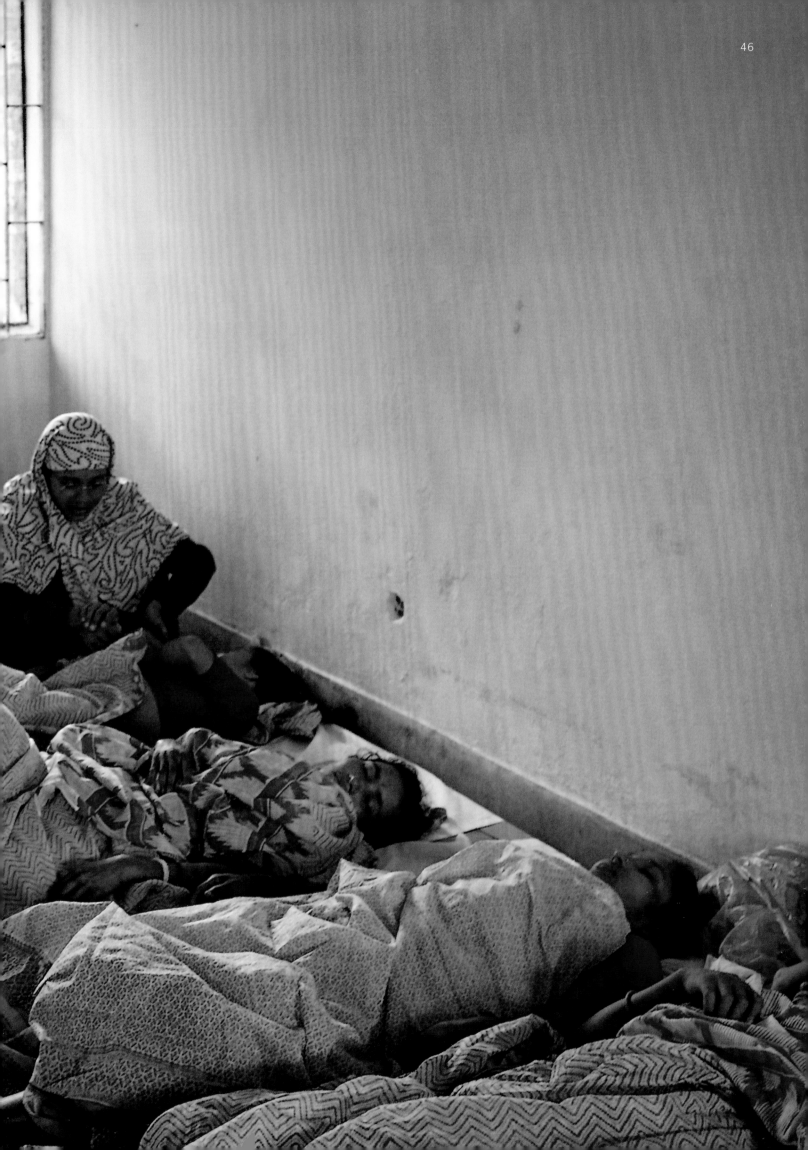

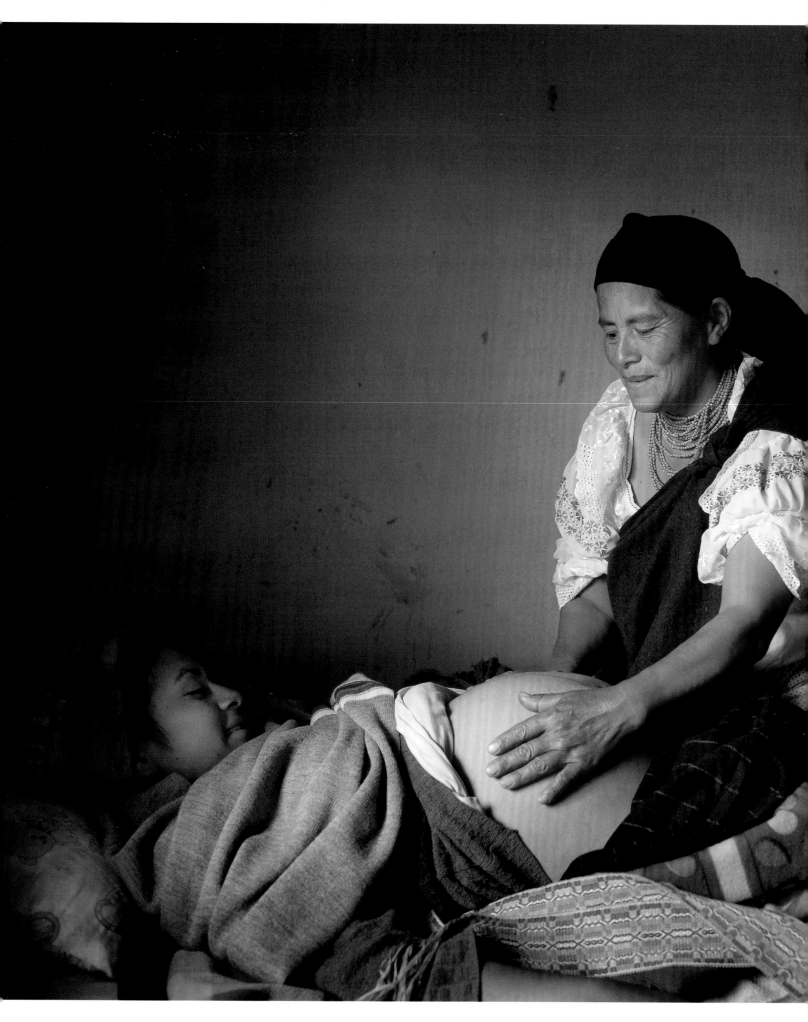

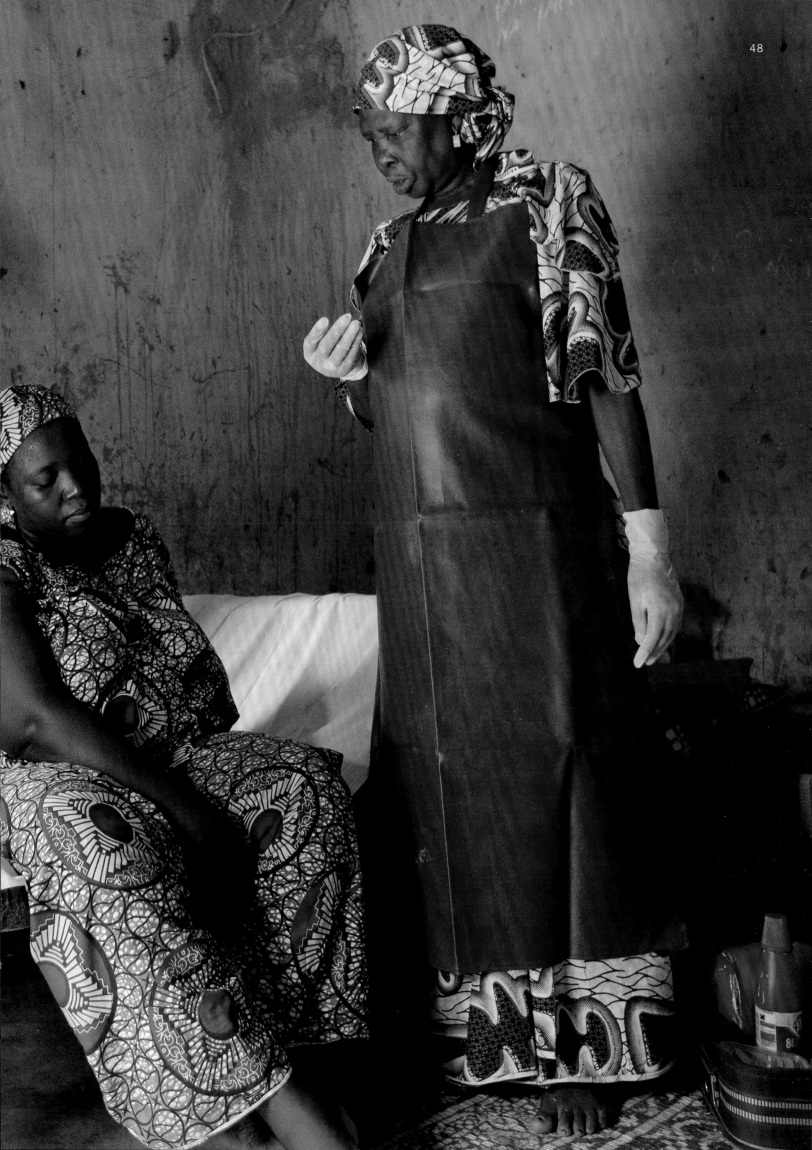

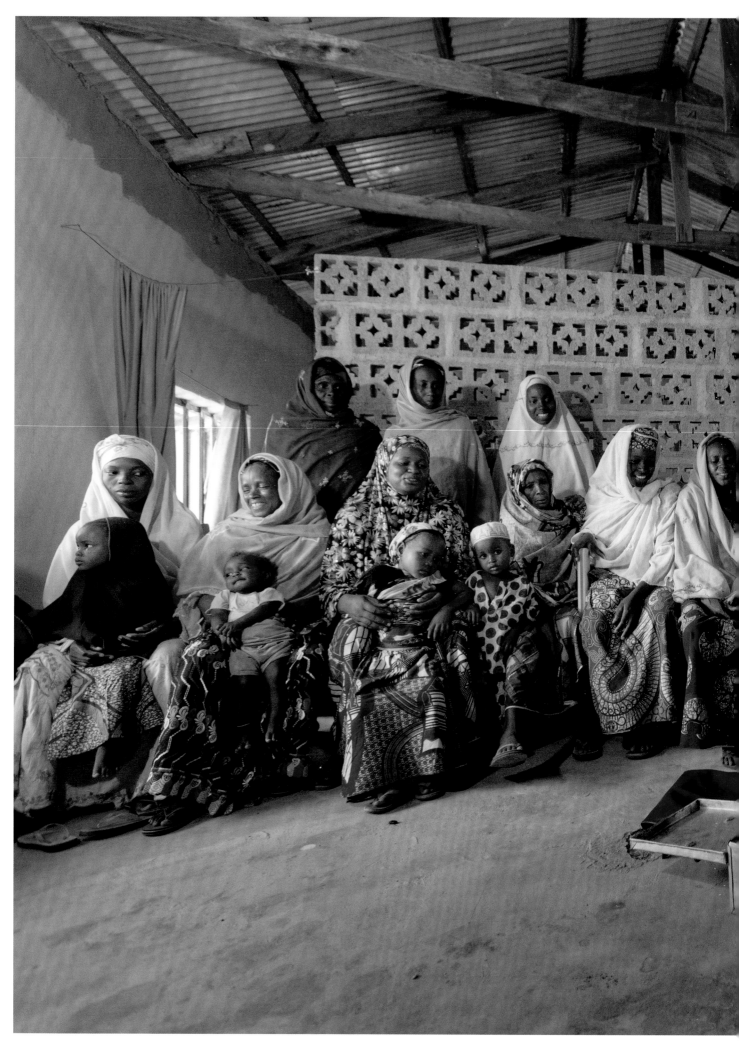

WOMEN'S HEALTHCARE

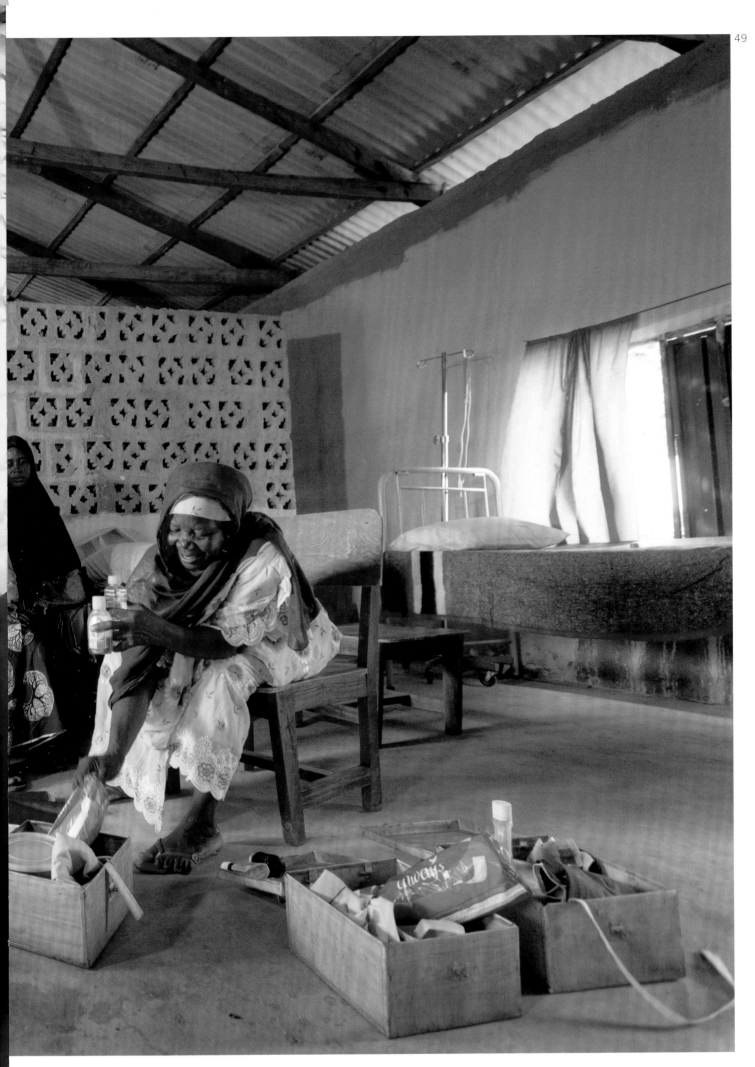

HEALTHCARE WORKERS, SILENT HEROES

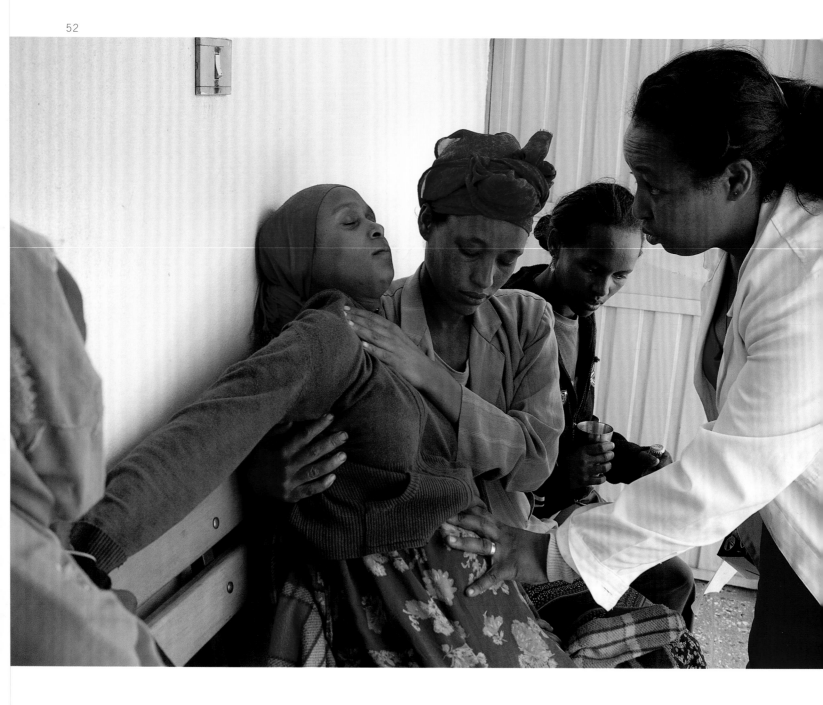

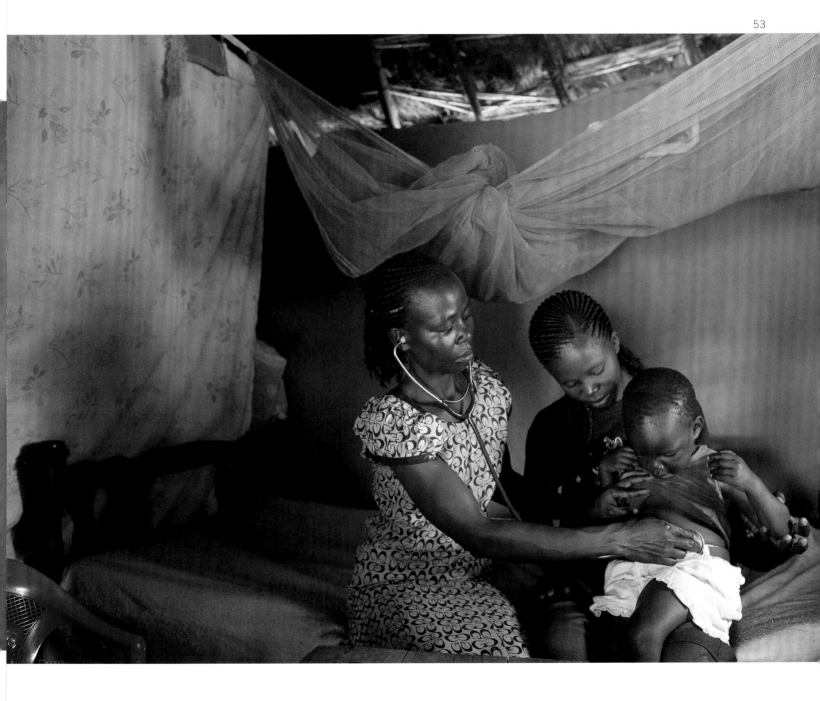

HEALTHCARE WORKERS, SILENT HEROES

WOMEN'S HEALTHCARE

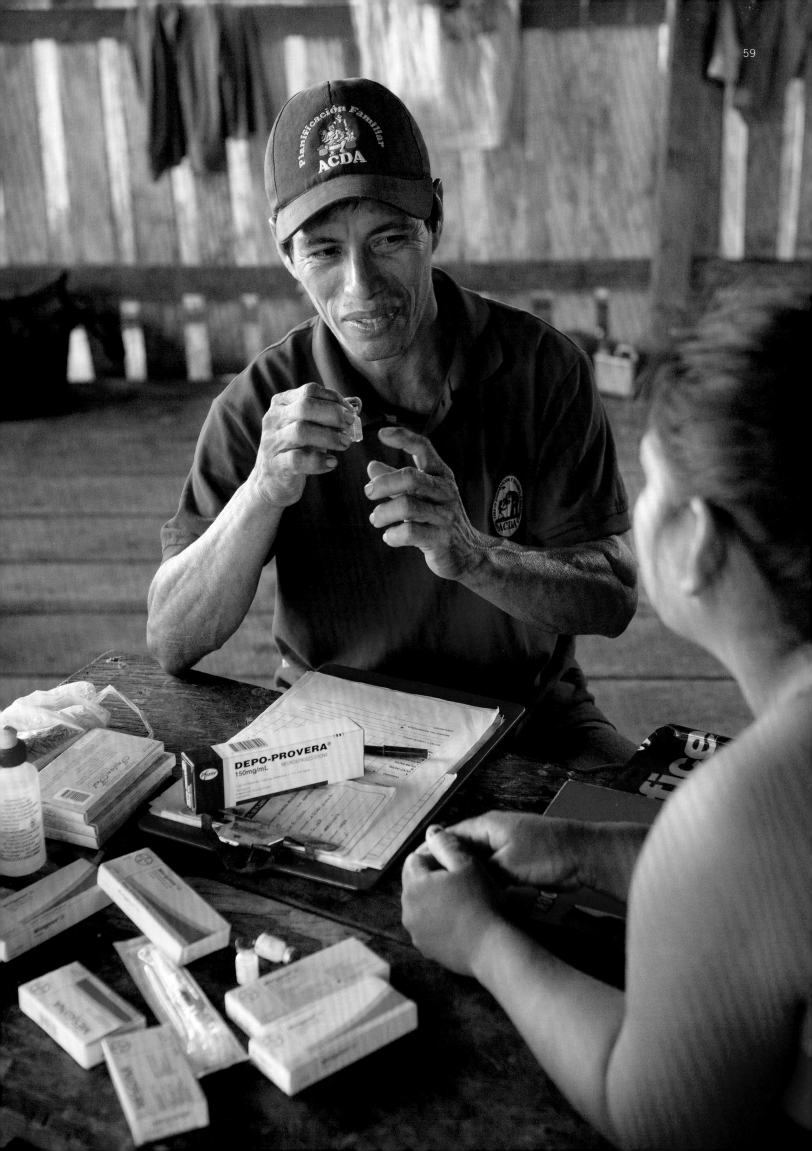

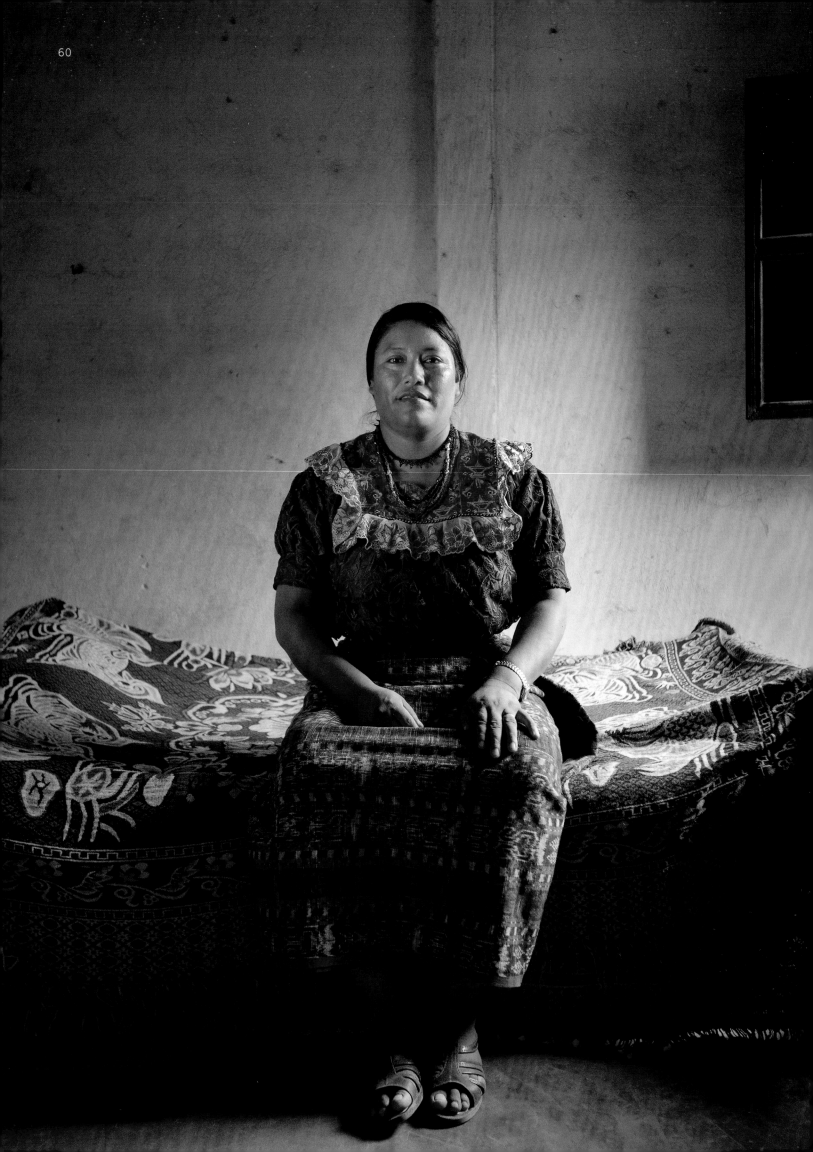

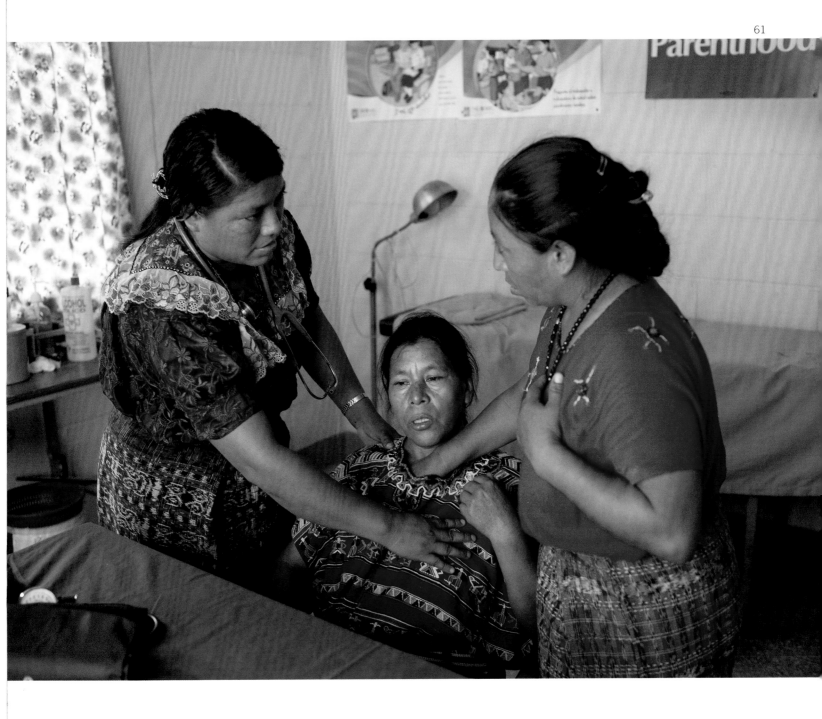

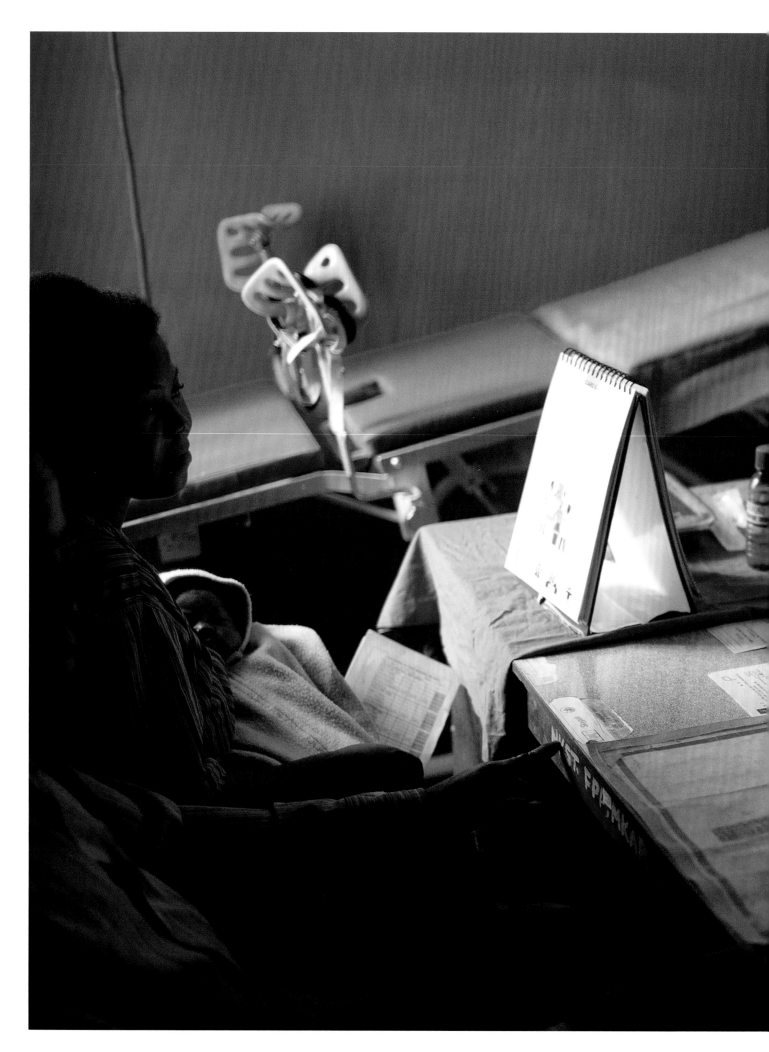

WOMEN'S HEALTHCARE

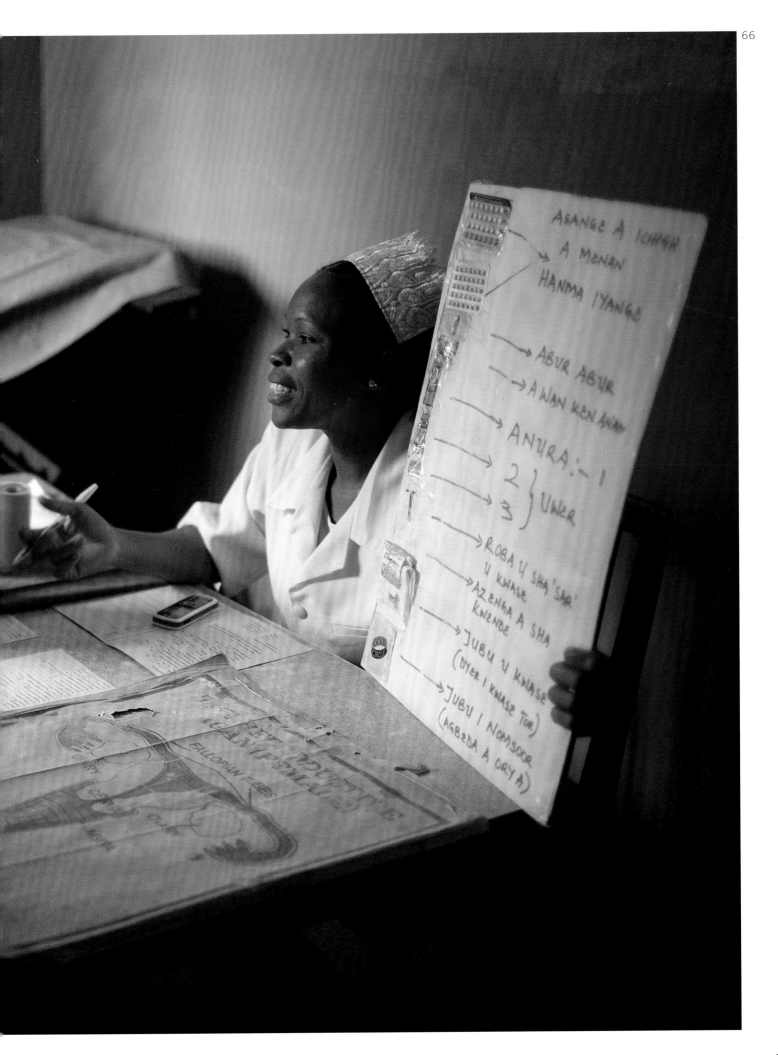

FAMILY PLANNING

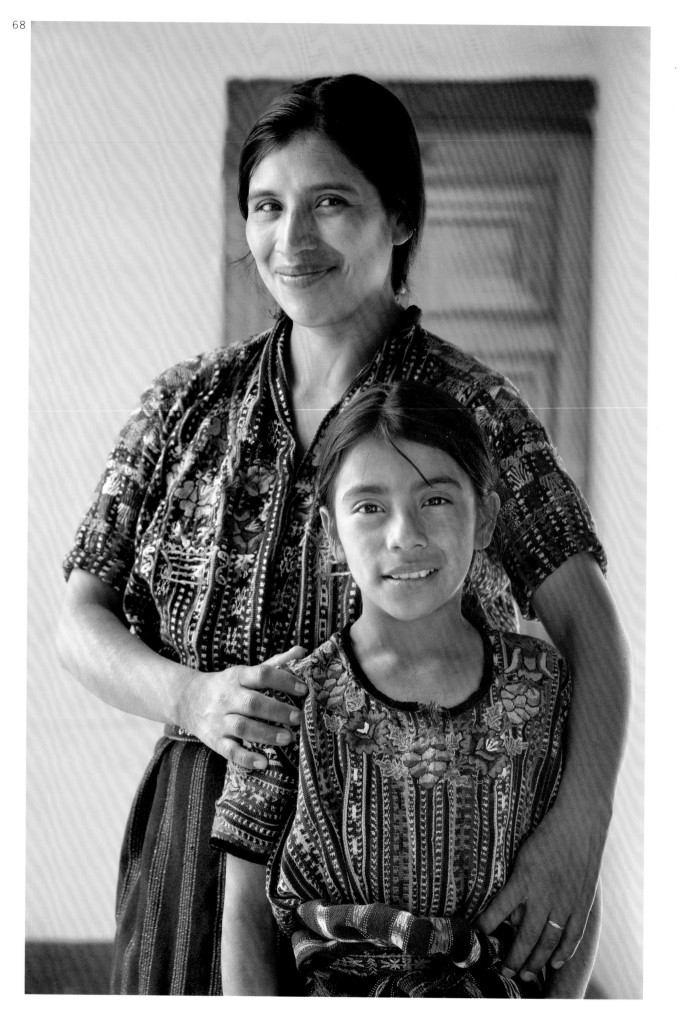

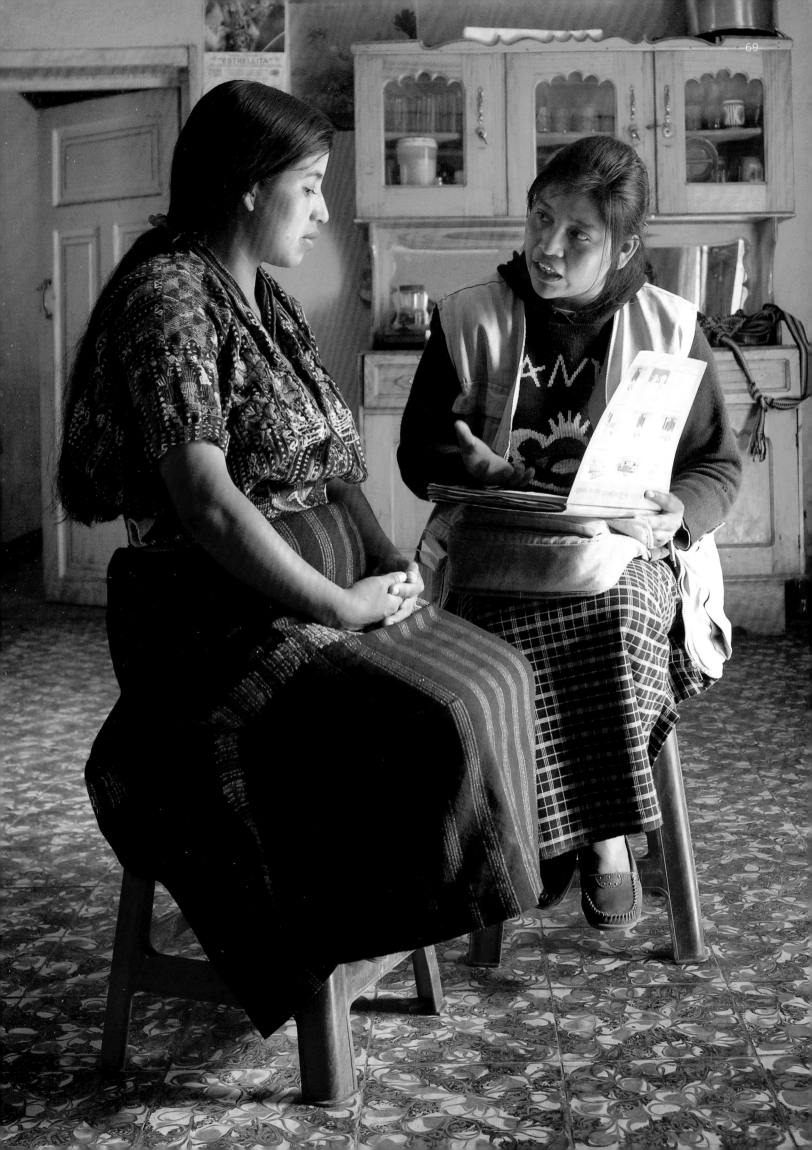

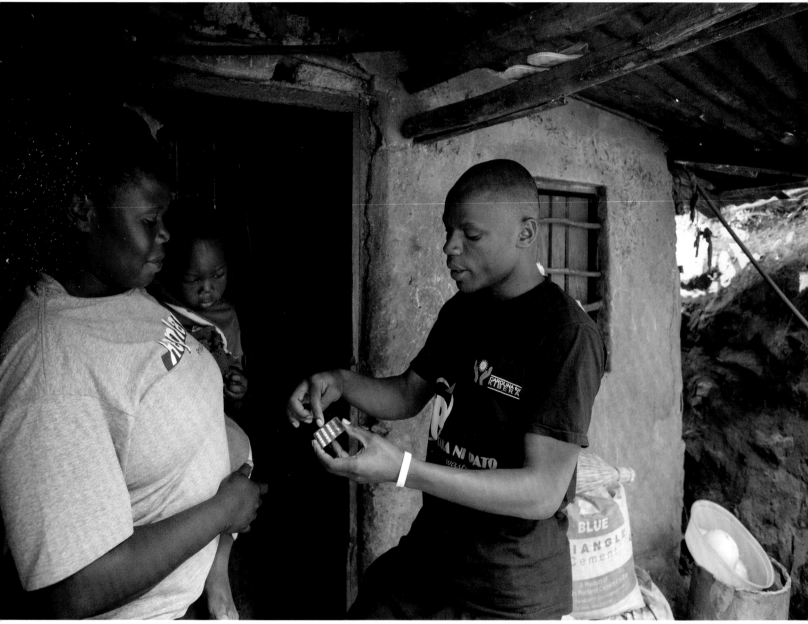

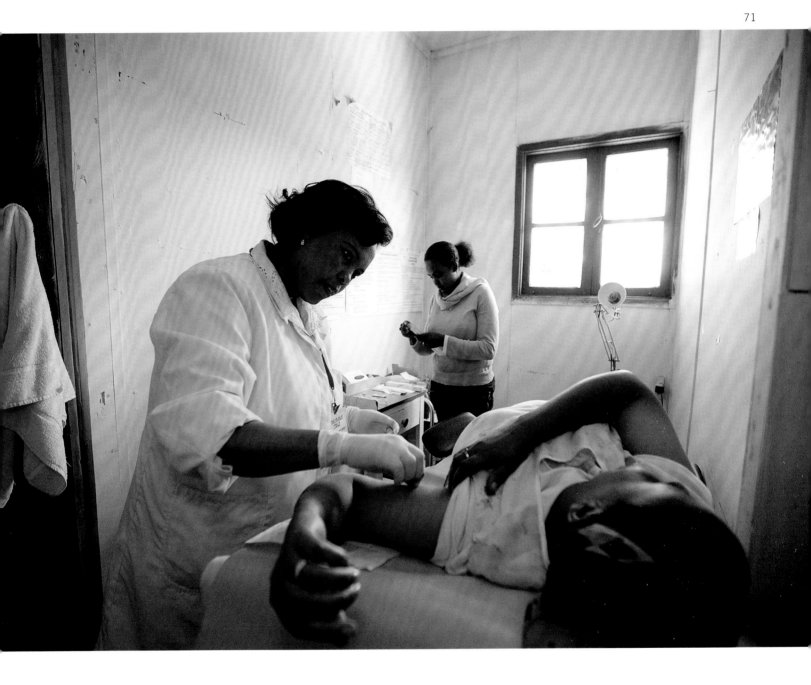

FAMILY PLANNING

WOMEN'S HEALTHCARE

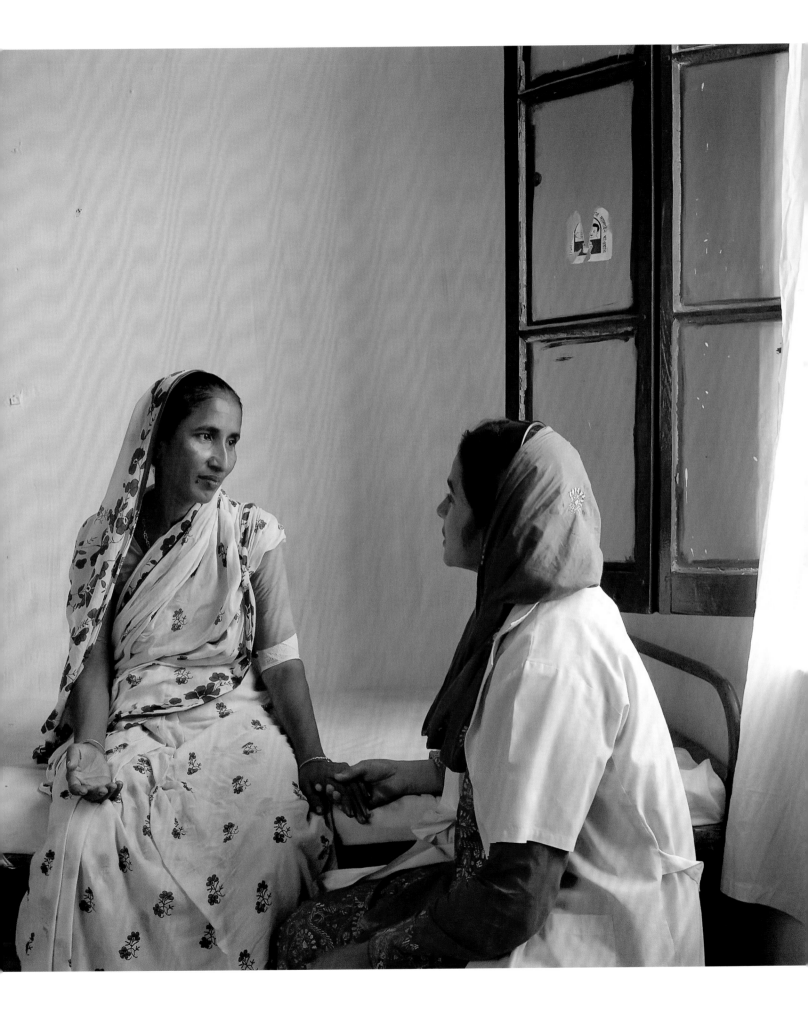

FAMILY PLANNING

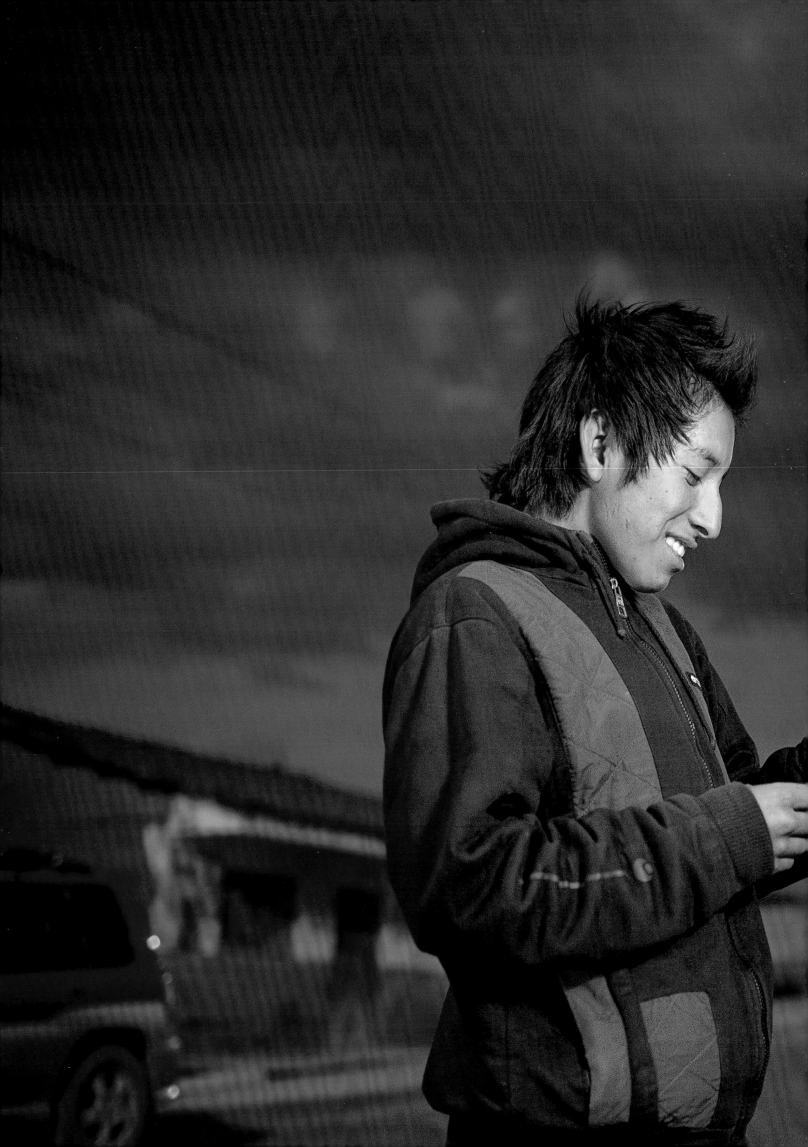

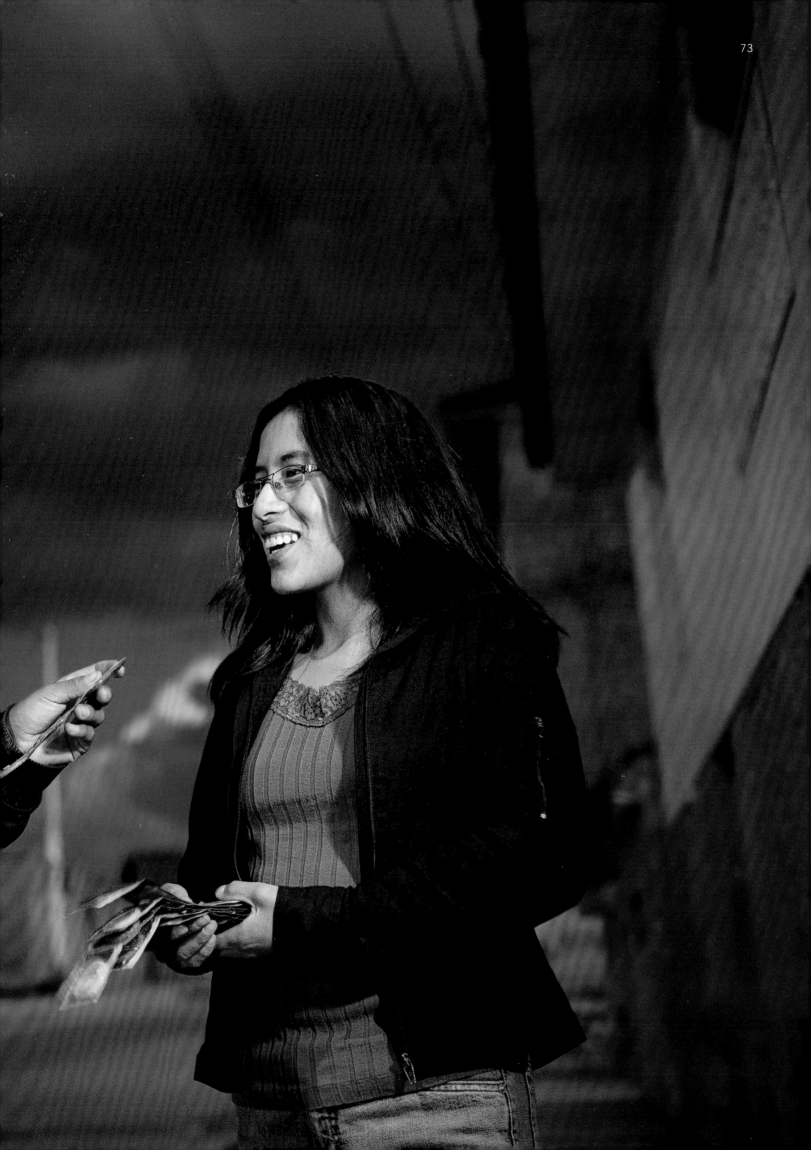

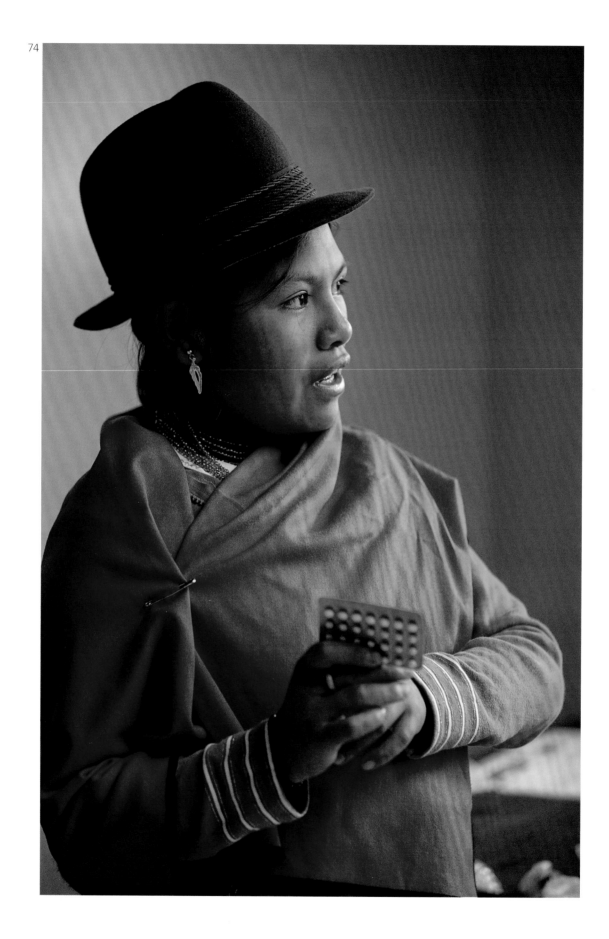

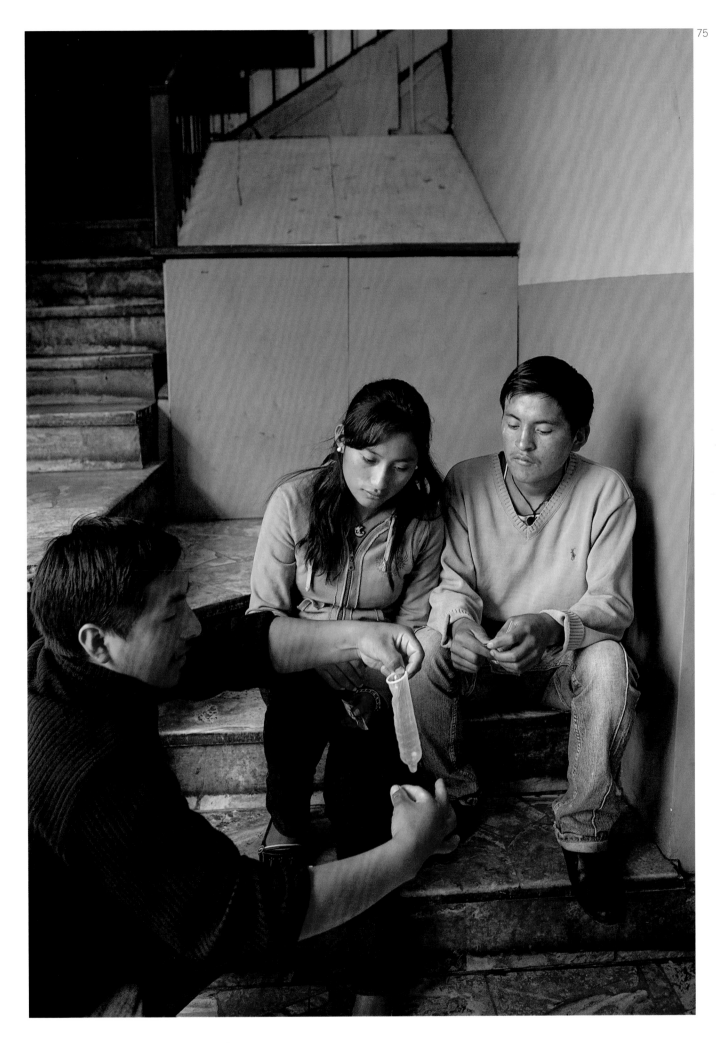

PEER SEXUAL EDUCATION

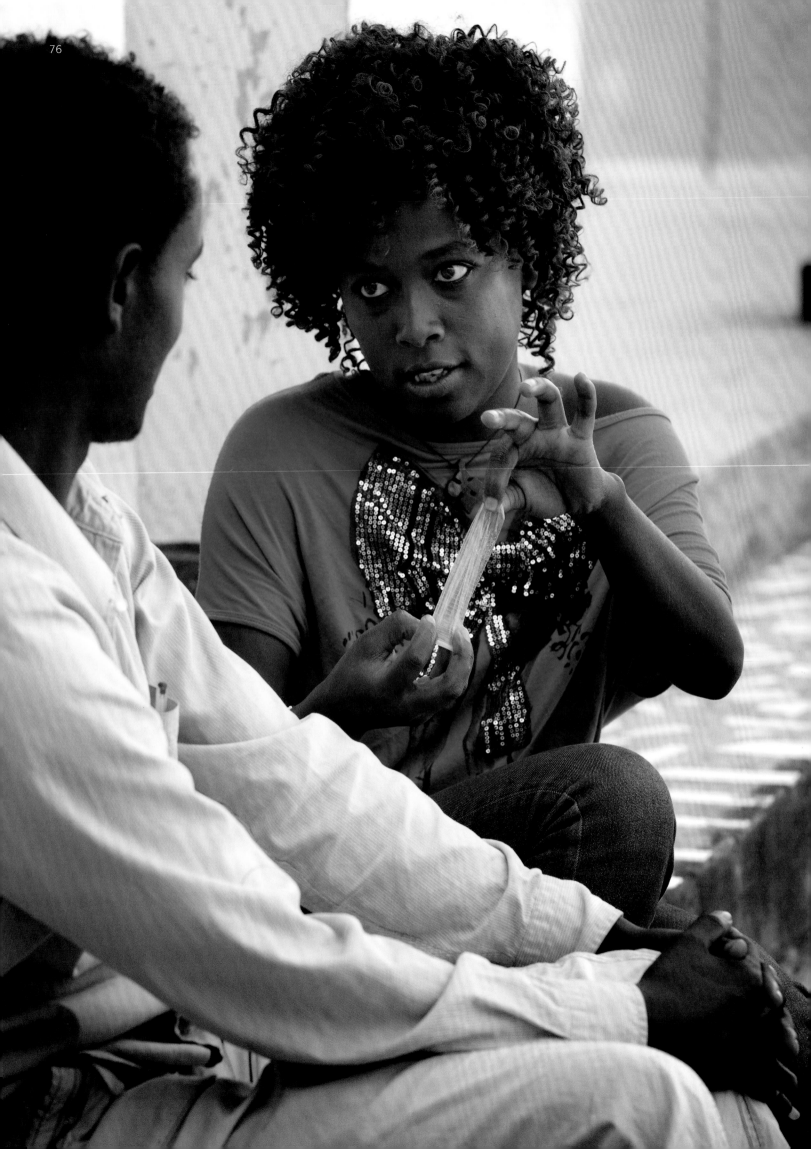

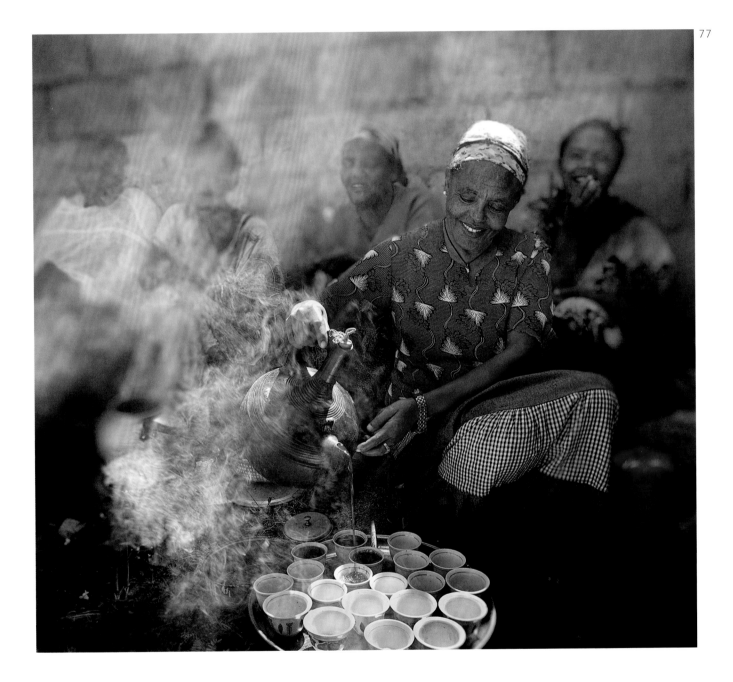

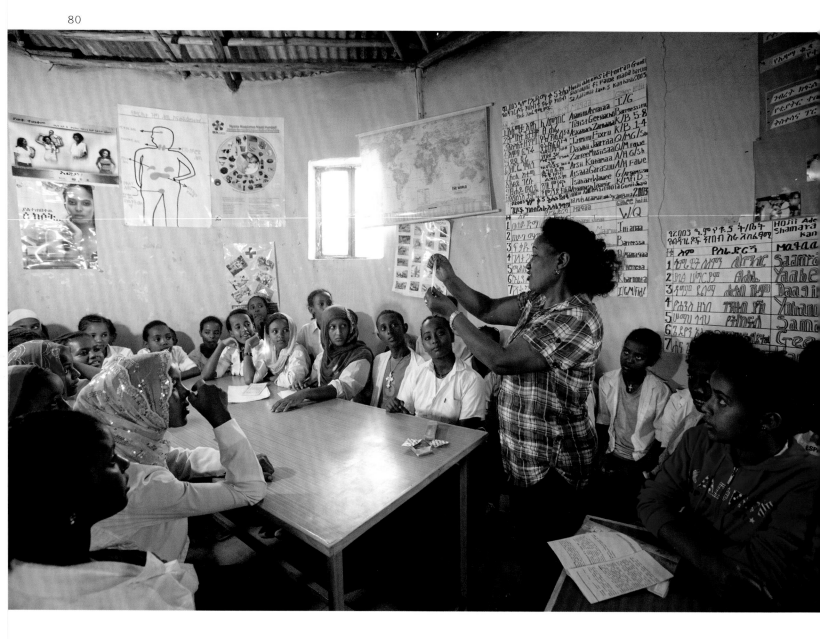

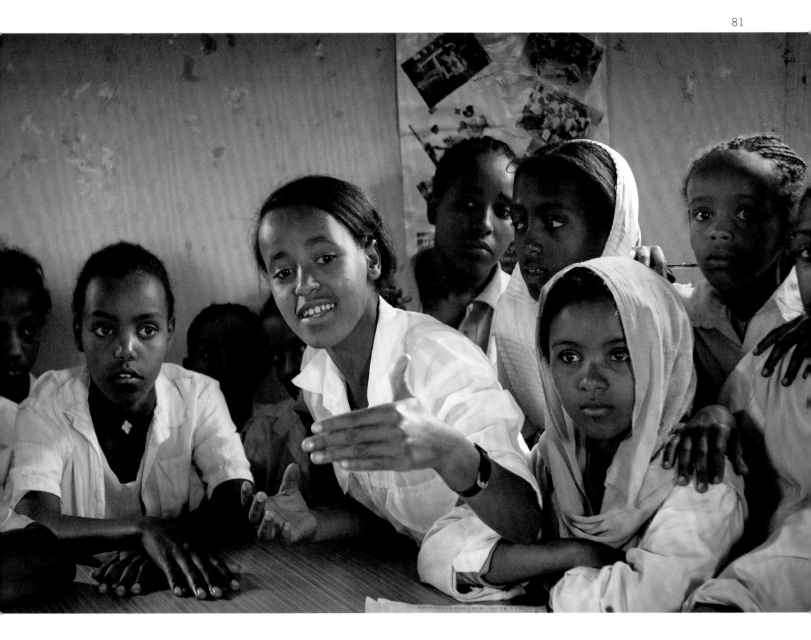

PEER SEXUAL EDUCATION

WOMEN'S HEALTHCARE

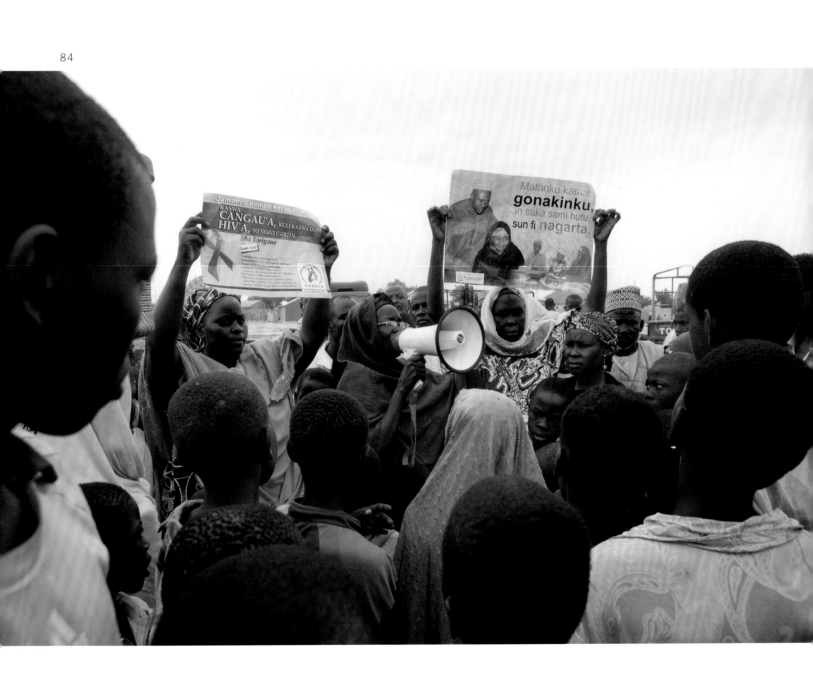

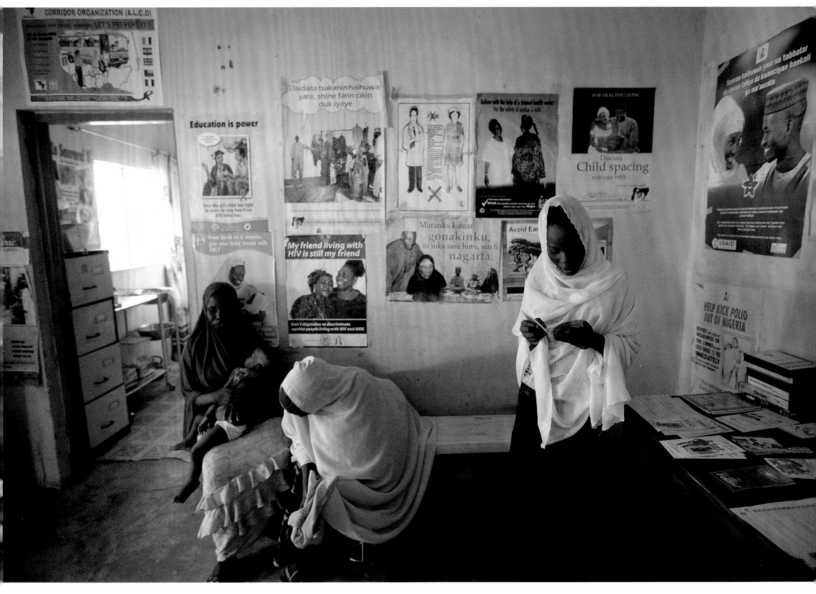

"One out of every three women in the world has experienced some form of physical or sexual violence."

World Health Organization

Violence

I don't think there is anything that disturbs me more than hearing the stories of women and young girls who have been violently abused. I have come to the conclusion that I will never understand why men physically abuse women and girls. It seems like there must be a disconnect in the minds of males who rape and beat women. After all, these men have mothers and sisters, and most likely these perpetrators would be incensed if someone dealt with their own family members in such a brutal, unspeakable manner.

With their extremely limited choices, and without an easy way out, the violence that many women endure on a daily basis is horrific and unconscionable. It takes myriad forms, from daily beatings by their marital partners to forced sexual trafficking. The individual stories of these invisible women and girls must be heard.

In this section, I expose the scope and depth of these problems. I hope the result will serve as a catalyst to mobilize a global campaign to reduce gender-based violence and inequality. Perhaps decades from now we will look back at this time and wonder how we could have tolerated all of the grave injustices that girls and women endure simply because they were born as females.

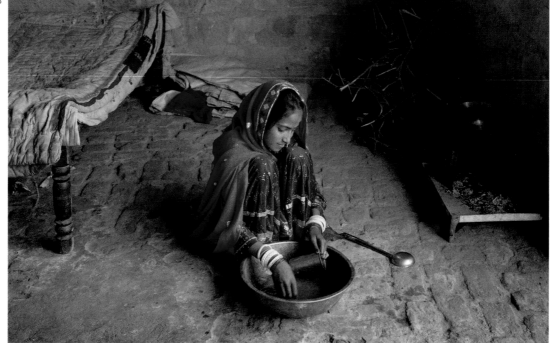

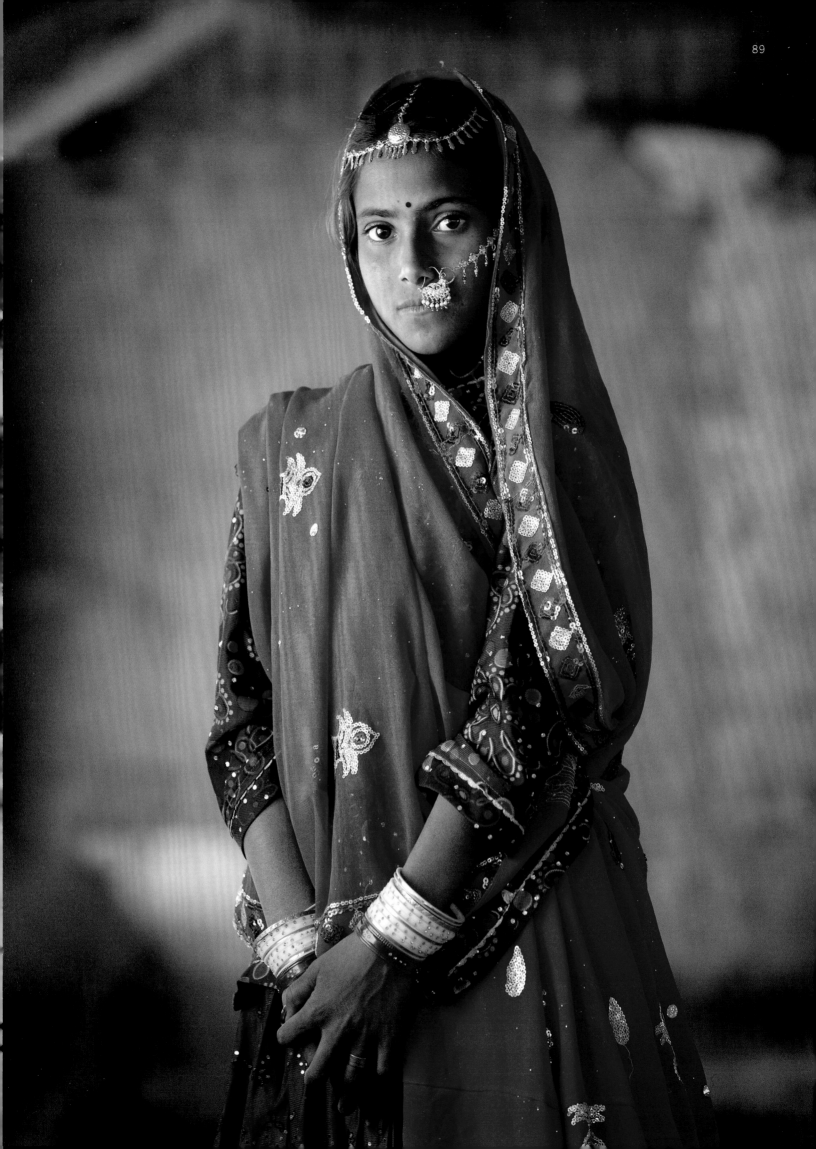

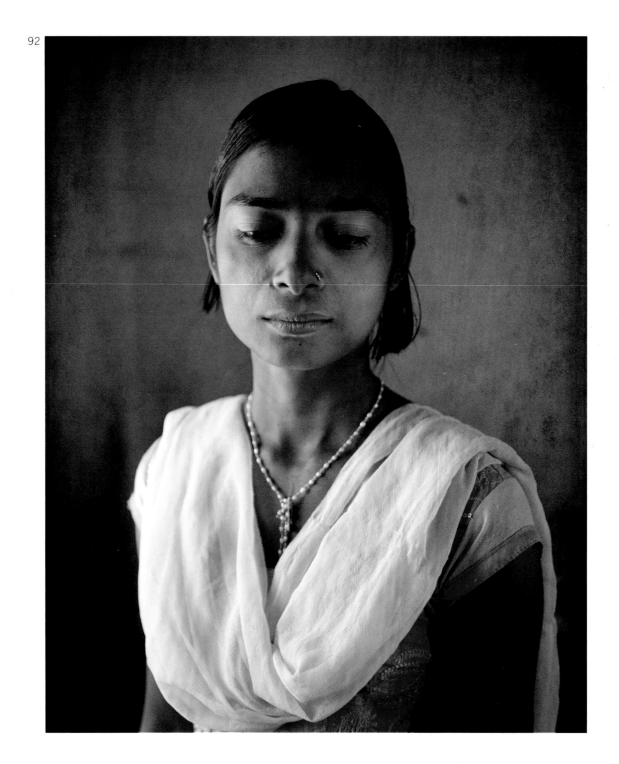

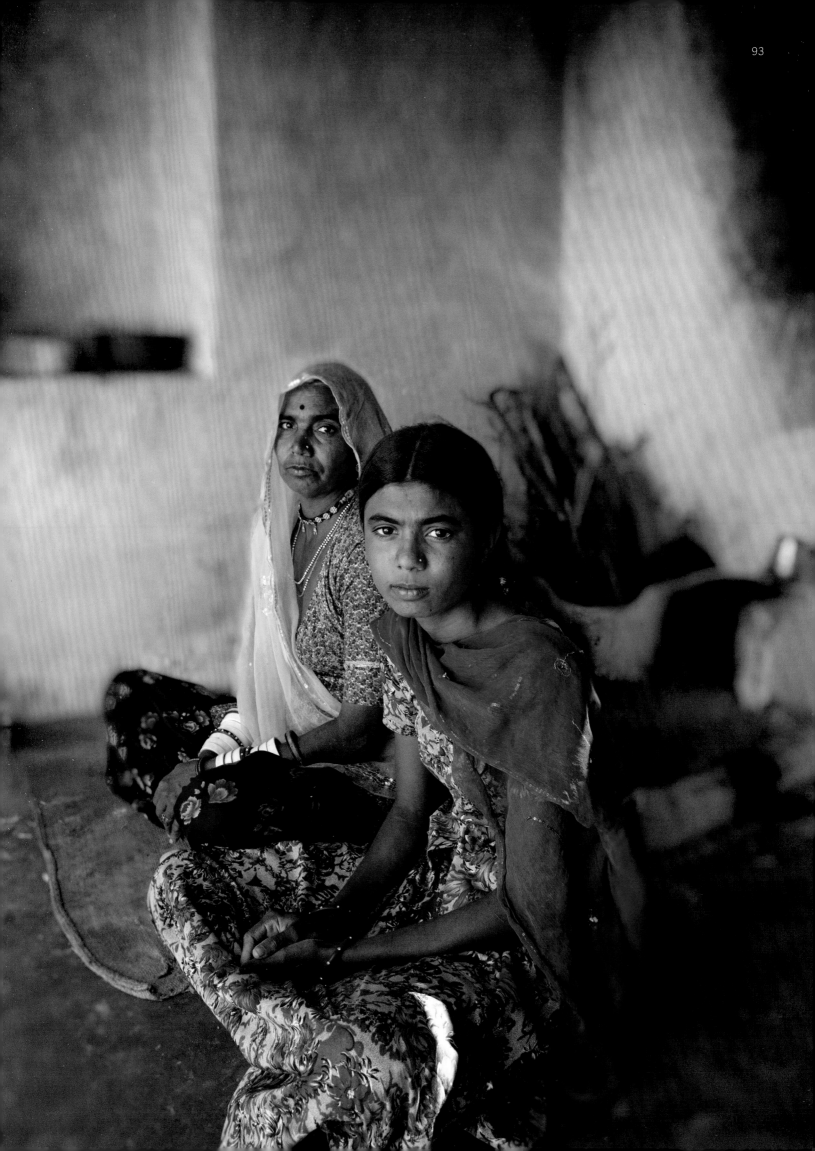

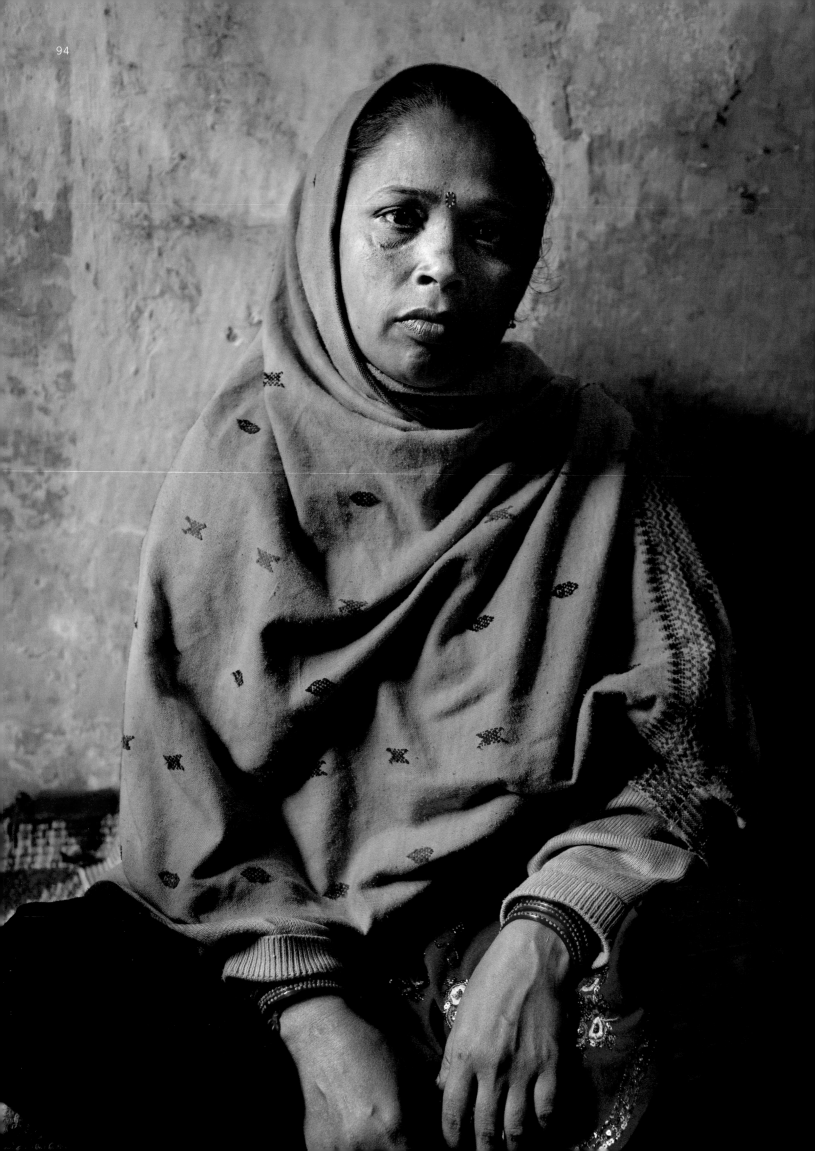

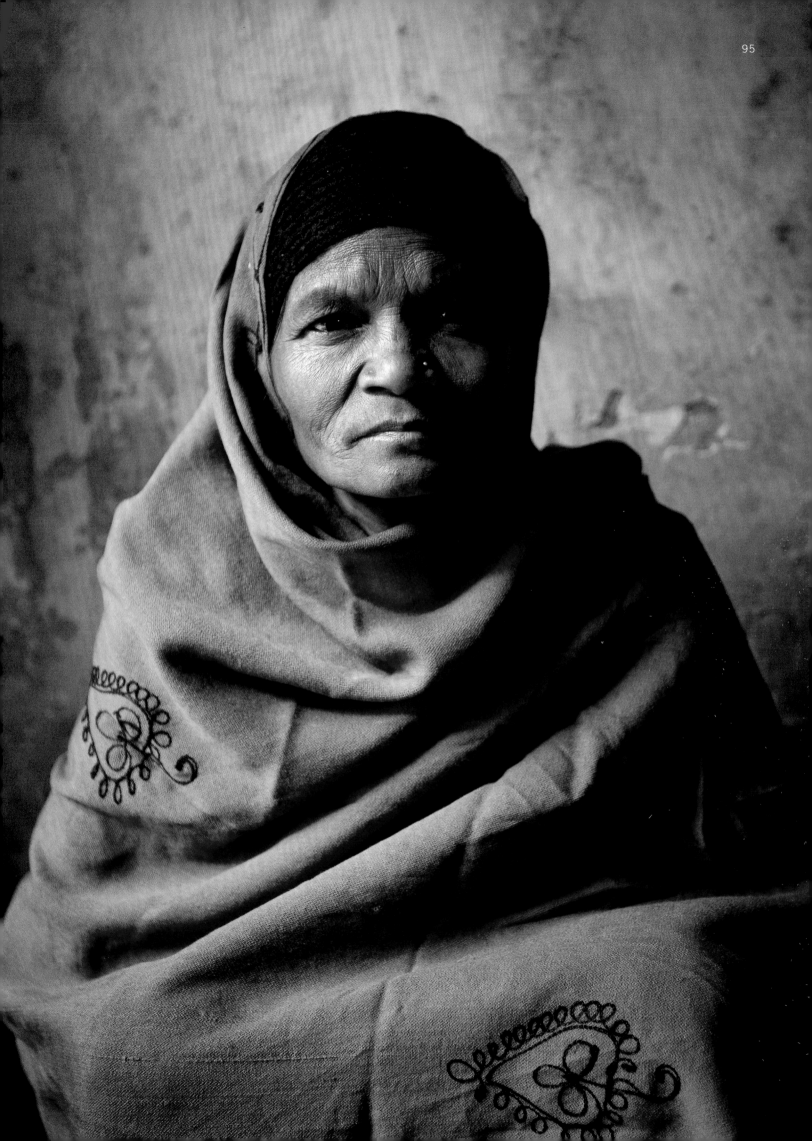

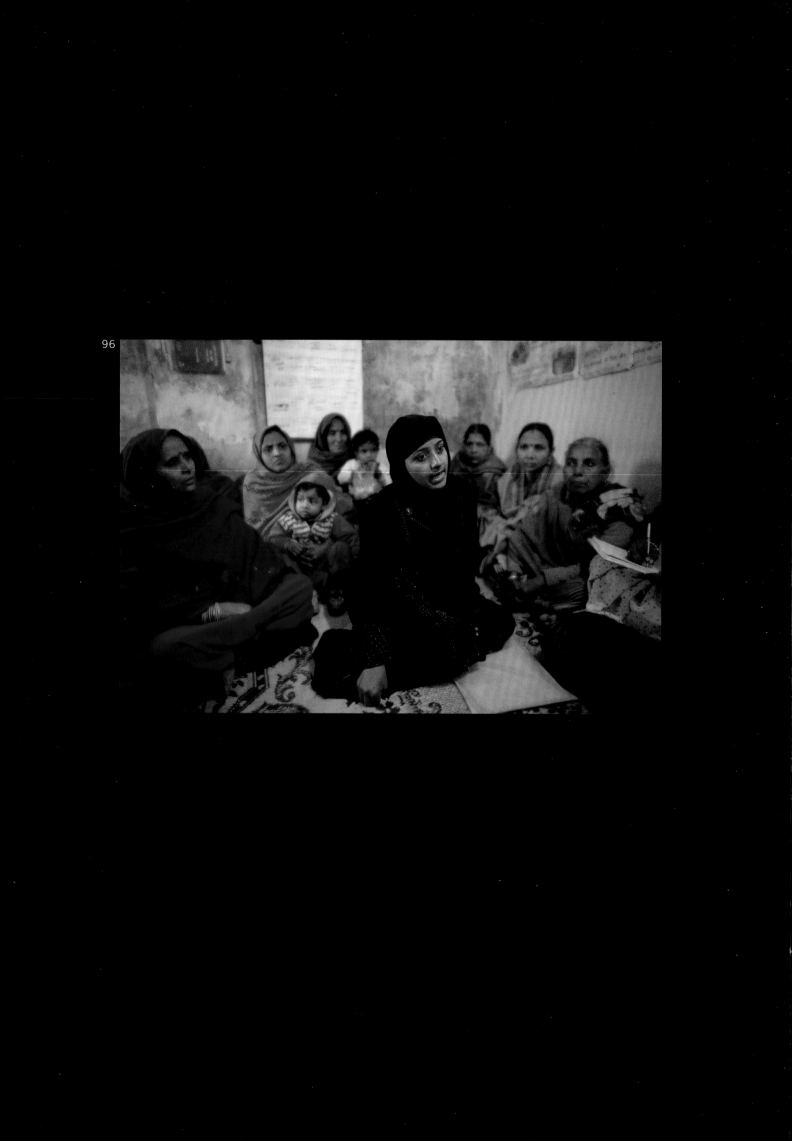

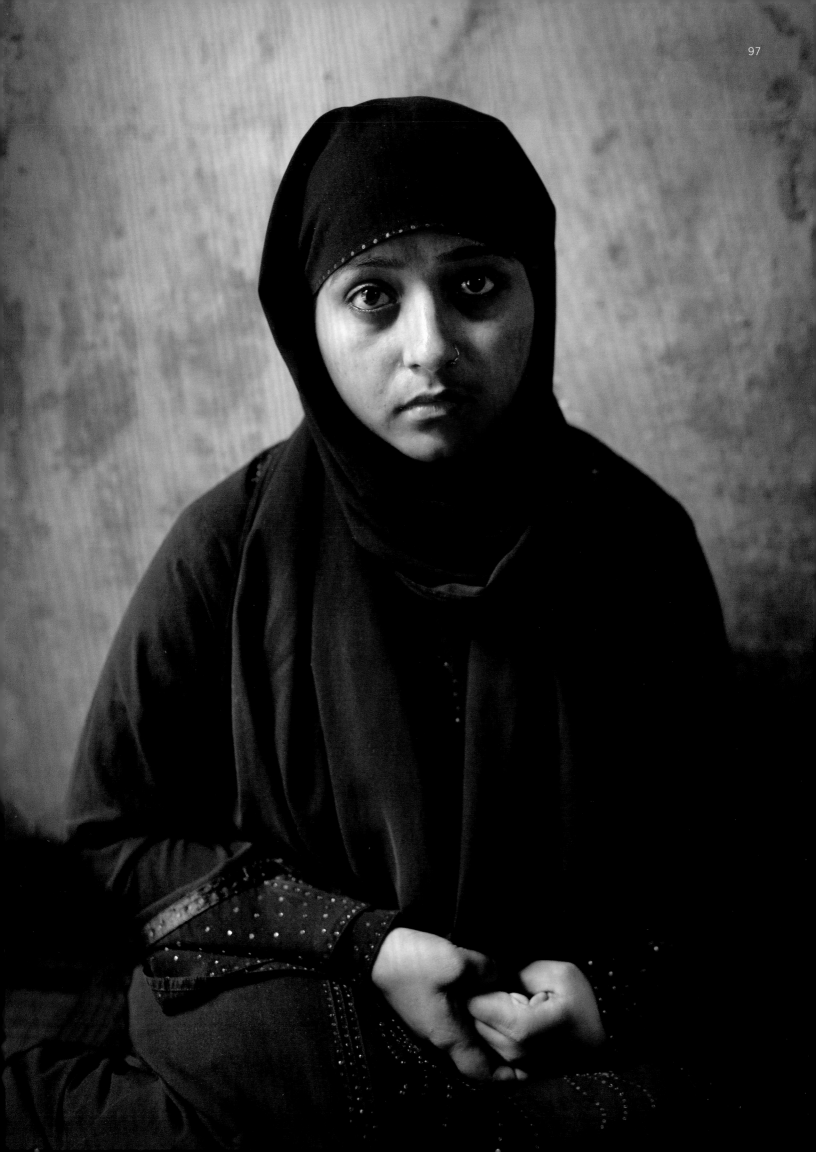

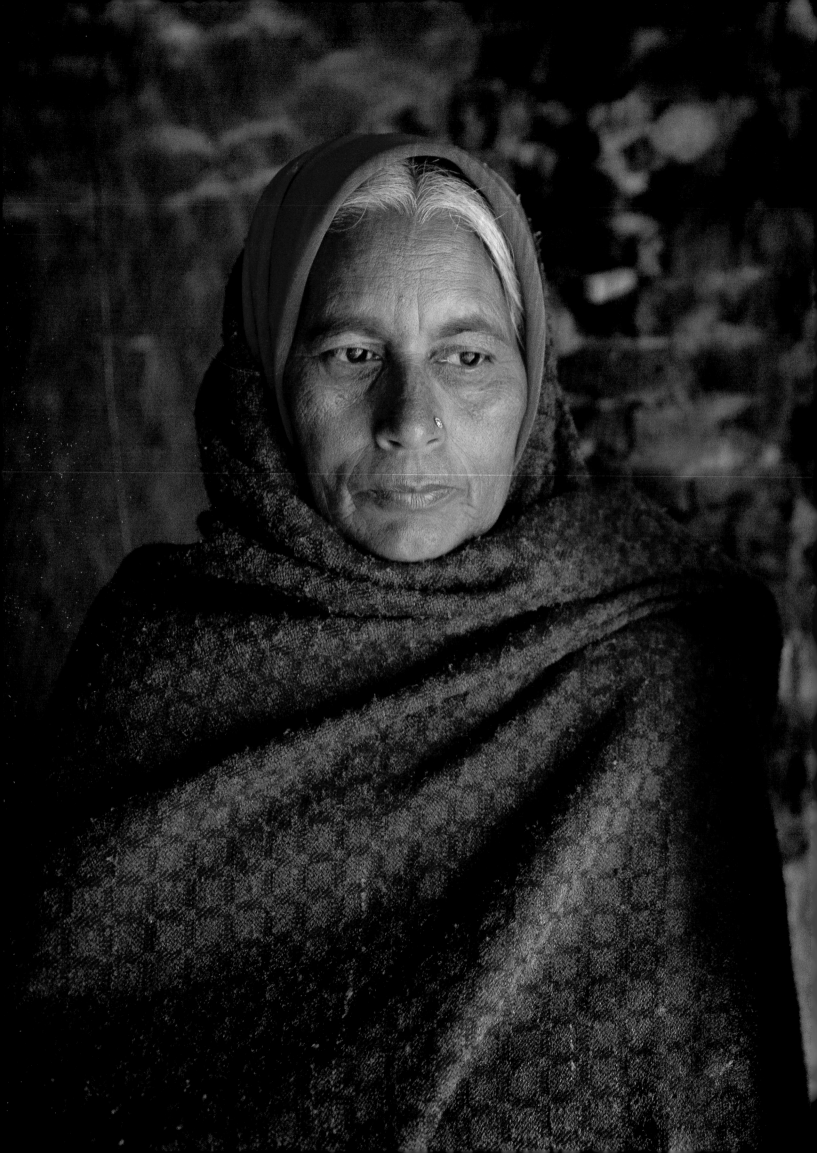

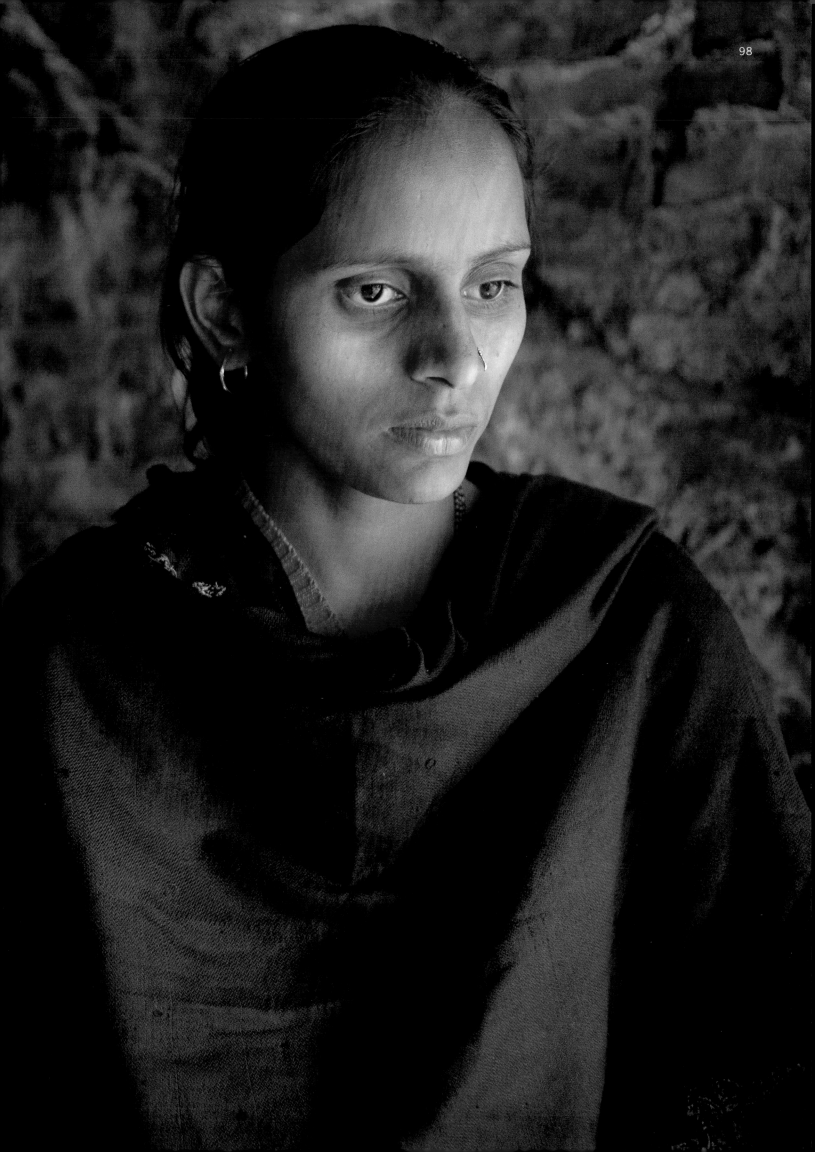

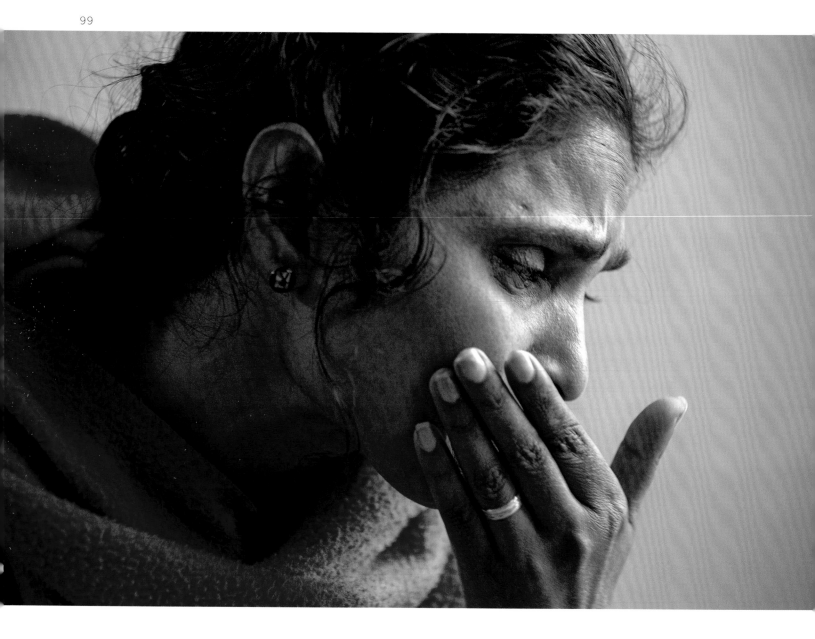

VIOLENCE

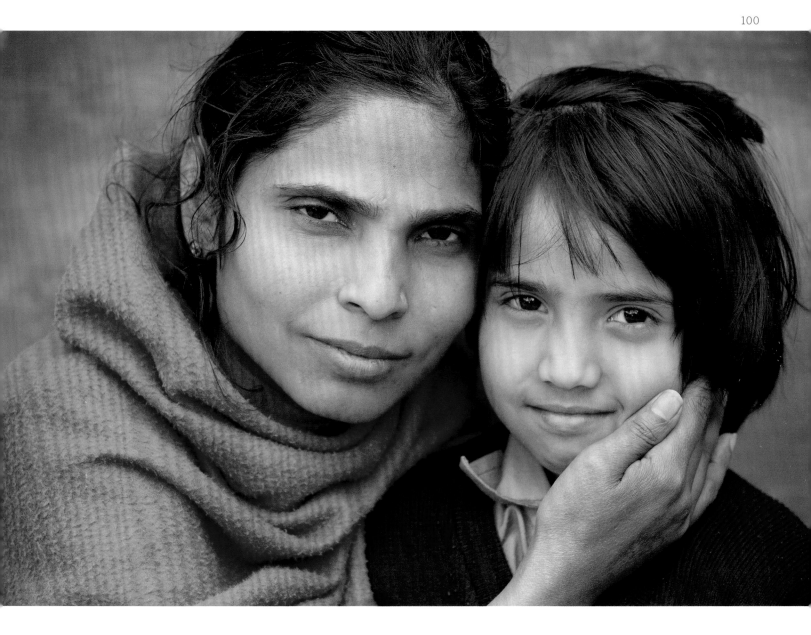

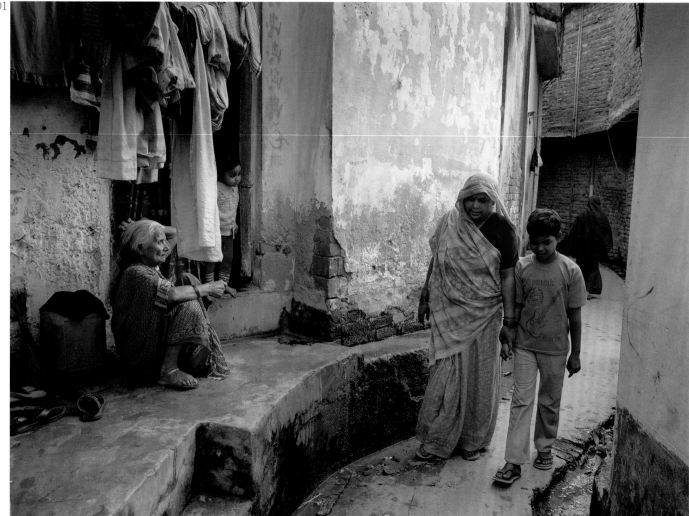

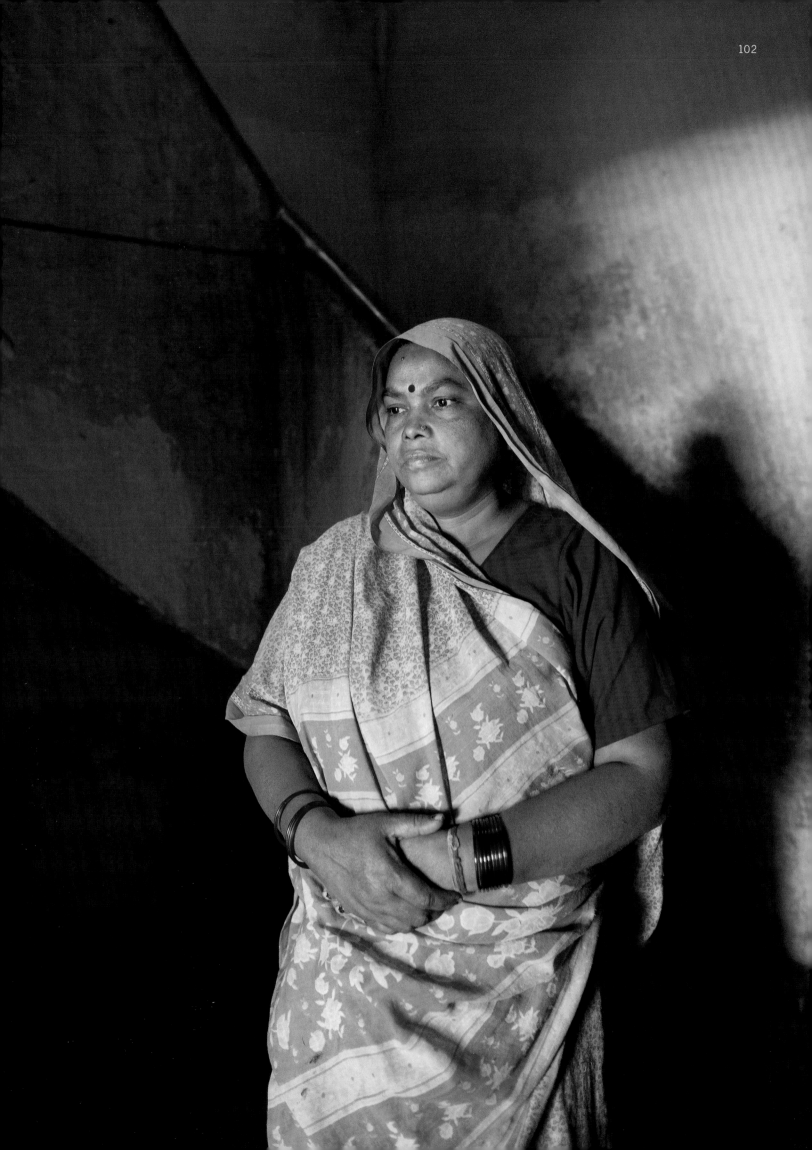

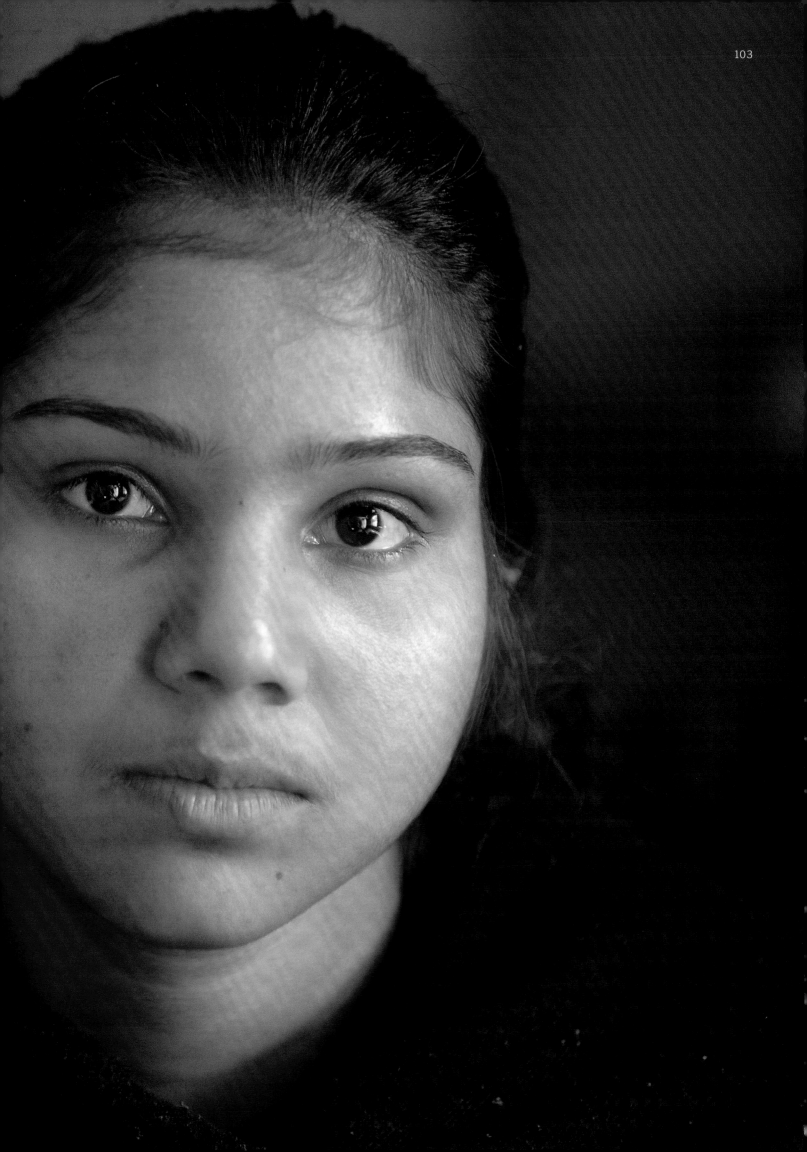

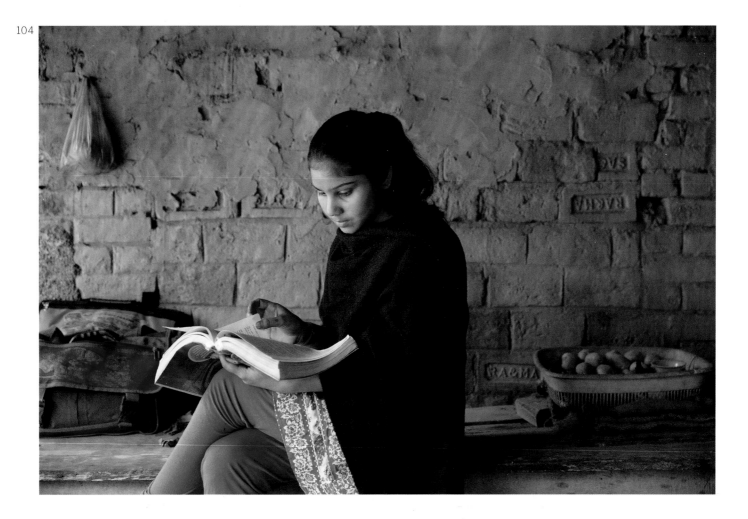

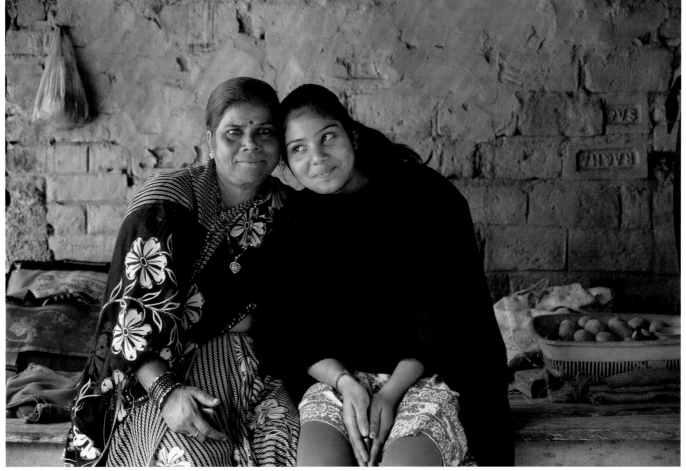

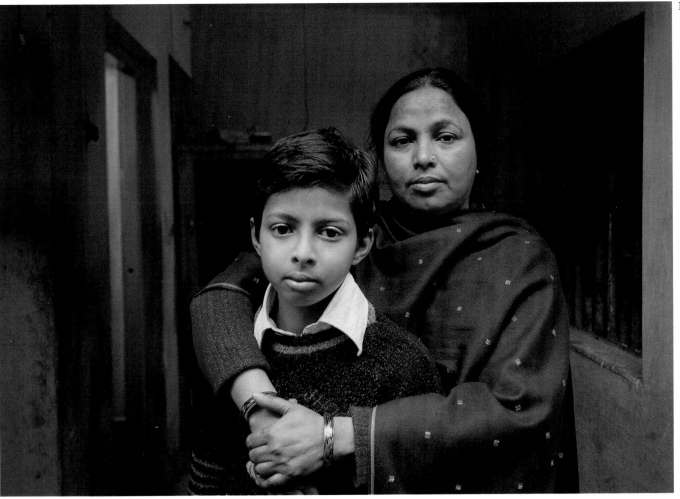

SCARS OF DOMESTIC VIOLENCE

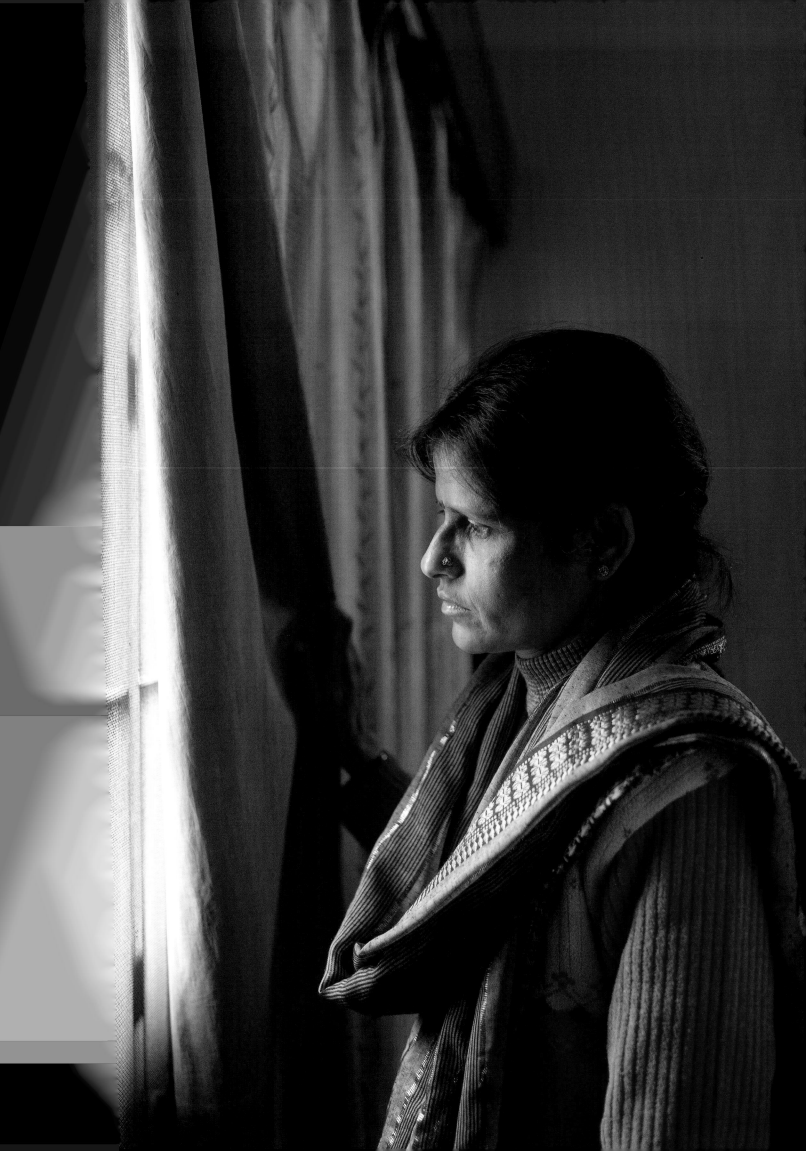

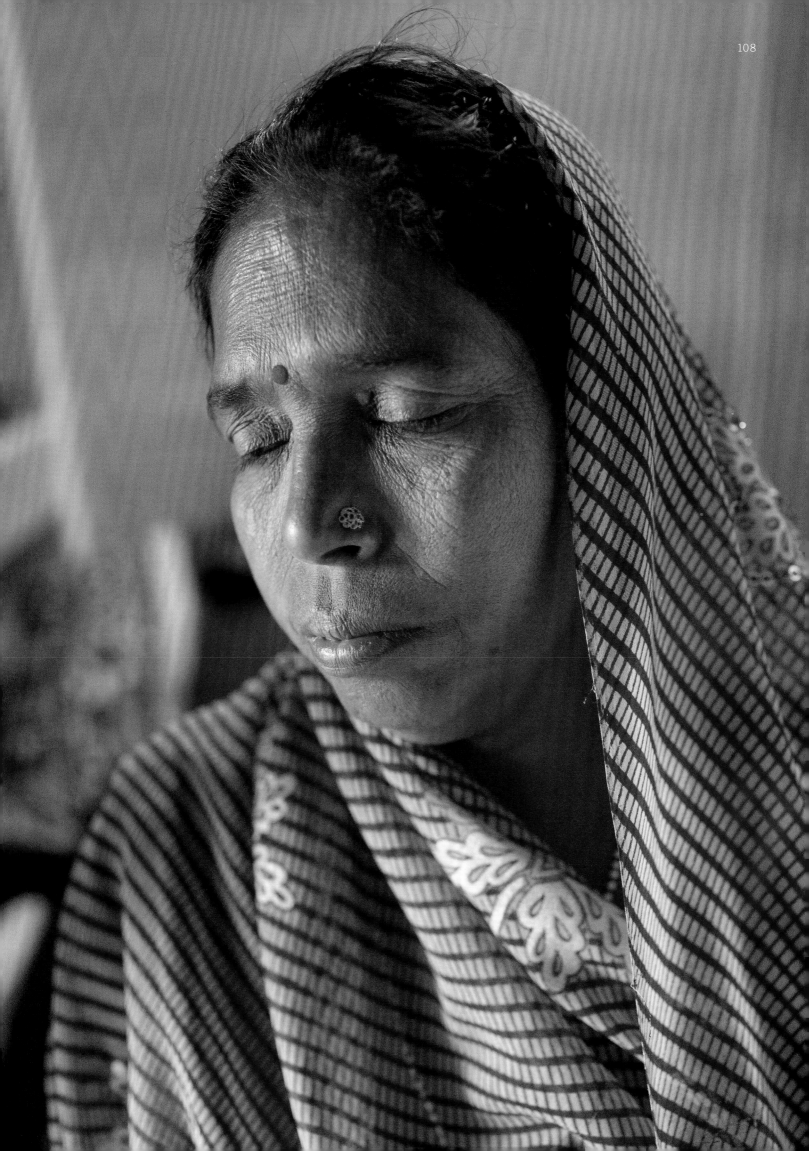

VIOLENCE

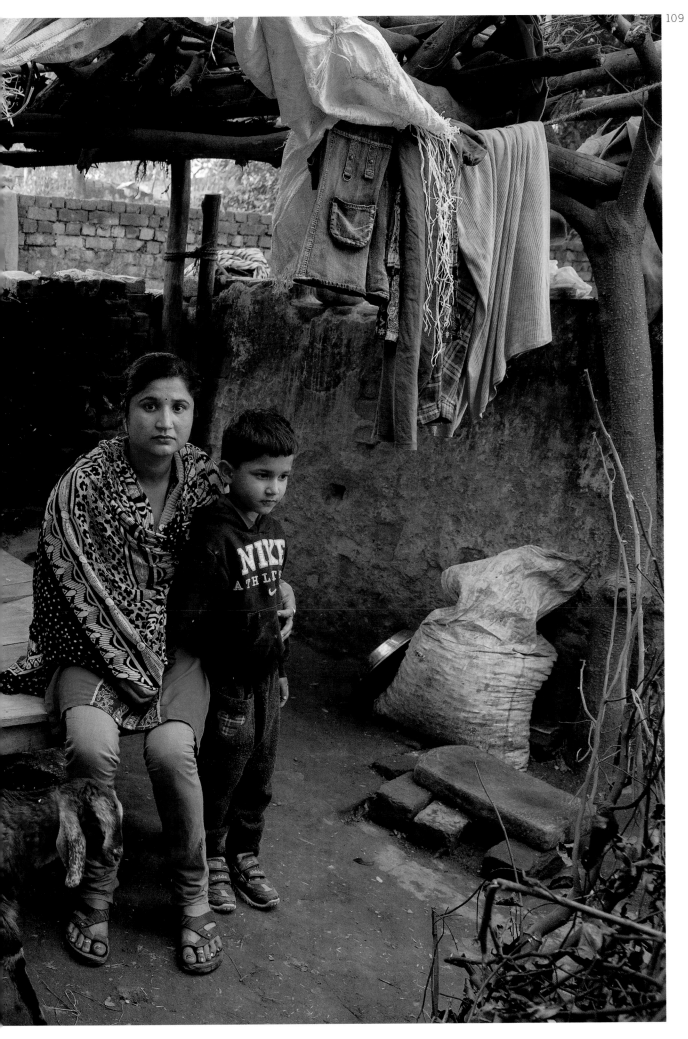

SCARS OF DOMESTIC VIOLENCE

Human Trafficking

Six million Indonesians, most of them women, have been trafficked to "work" as domestic servants in foreign countries. The reality of this statistic became very personal to me when I had the opportunity to interview two victims of this practice.

On the outskirts of Yogyakarta, I sat in the living room of Seni Mestri, a 27-year-old Indonesian woman who was accompanied by her husband, her son, and her mother. Seni told the story of how she was held as a domestic worker in slave-like conditions in Saudi Arabia for nearly three years without being able to communicate with her family.

Seni had recently been reunited with her family, but the psychological trauma that she and her family endured was quite evident. I had so many questions about how this enslavement could have been possible:

> *Why didn't her mother, Murjinem, try to contact her?*
> In fact, Murjinem did call many times, but Seni's employer simply hung up on her and never told Seni her mother had called.

> *Why didn't Seni try to run away?*
> Seni feared that a foreign woman alone in Saudi Arabia might be raped, and the thought of that kept Seni a prisoner.

> *Why didn't Murjinem try to contact the Indonesian Embassy to get help for her daughter?*
> Apparently she did, but received no response. Murjinem also tried to contact the agency that had sent her daughter to Saudi Arabia, but the "agency" no longer existed.

It was only through the efforts of Rifka Annisa, an NGO supported by the Global Fund for Women, that she was reunited with her family after three years.

Niawati is the second victim of trafficking whom I met. As is often the case, she also came from a small village and struggled to make ends meet. When her husband left her to live with another woman, she had to bear the economic

burden of supporting herself and her child. Nia, as she is commonly called, connected with illegal traffickers who smuggled her into Malaysia to work as a maid.

Nia began working as a domestic servant with a Pakistani family. The husband had two wives, an Indonesian wife and a Pakistani wife. Nia worked with this family for three years, suffering abuse from the Pakistani wife who beat her and withheld payment. All of Nia's salary had been sent directly to the trafficker as compensation for the expense of bringing Nia to Malaysia. She was in a desperate situation, as she was illegal and felt she had no legitimate means to denounce the abuse. She was also isolated and had no way to contact her parents back home. Then one day the Indonesian wife apparently took pity on Nia, and gave her $45 to buy a telephone, which she immediately used to call her parents.

Responding to the crisis, Nia's parents contacted the village leader, who contacted Rifka Annisa. Again, it took over a year to free Nia. Her ordeal, which began with a two-year contract in 2007, did not end until she returned home four years later, in 2011.

Nia is currently working as a maid in her new job back in Yogyakarta, Indonesia. She said her employer was treating her very well, yet it was clear that she had not overcome the trauma of the four years in Malaysia, where she had lived as a slave without any of the most basic human freedoms.

Human trafficking is a form of modern-day slavery, which strips away an individual's right to freedom and choice. Around the world, nearly 30 million people are effectively held as modern-day slaves, according to the human-rights group International Justice Mission. Of this number, women represent 70 per cent of those coerced into forced labor worldwide, and 98 percent of those forced into sexual exploitation.

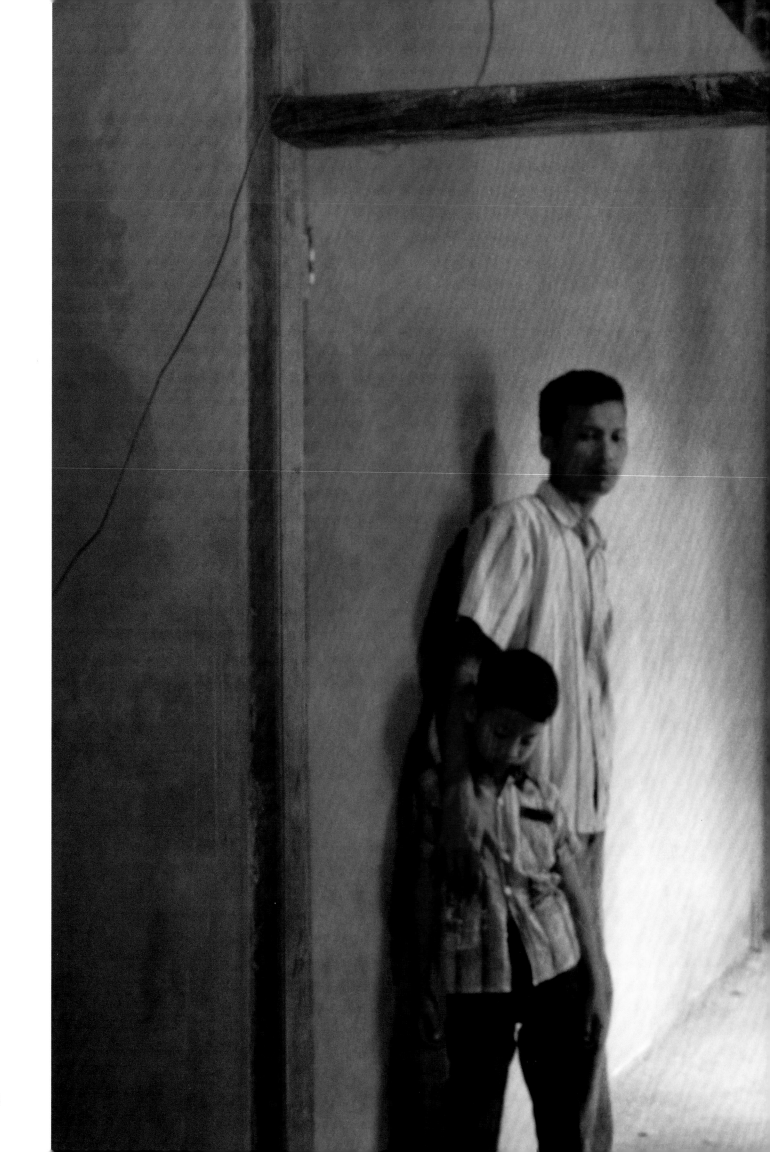

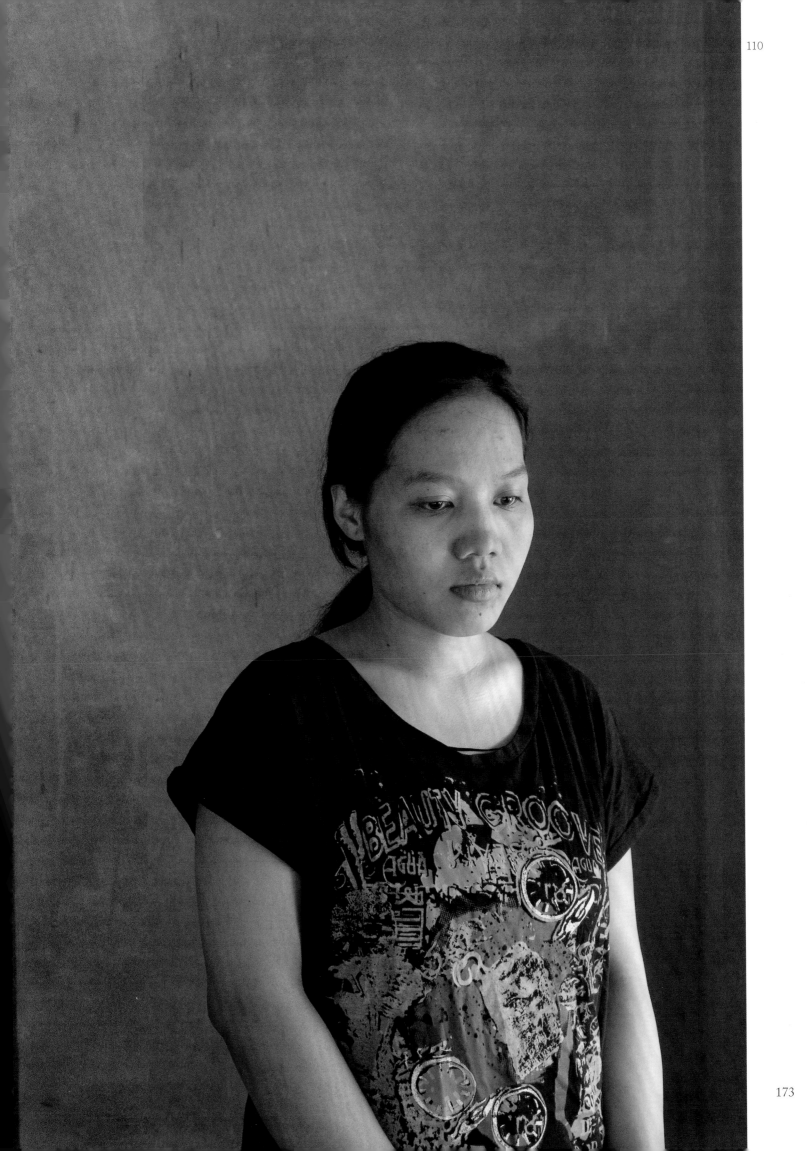

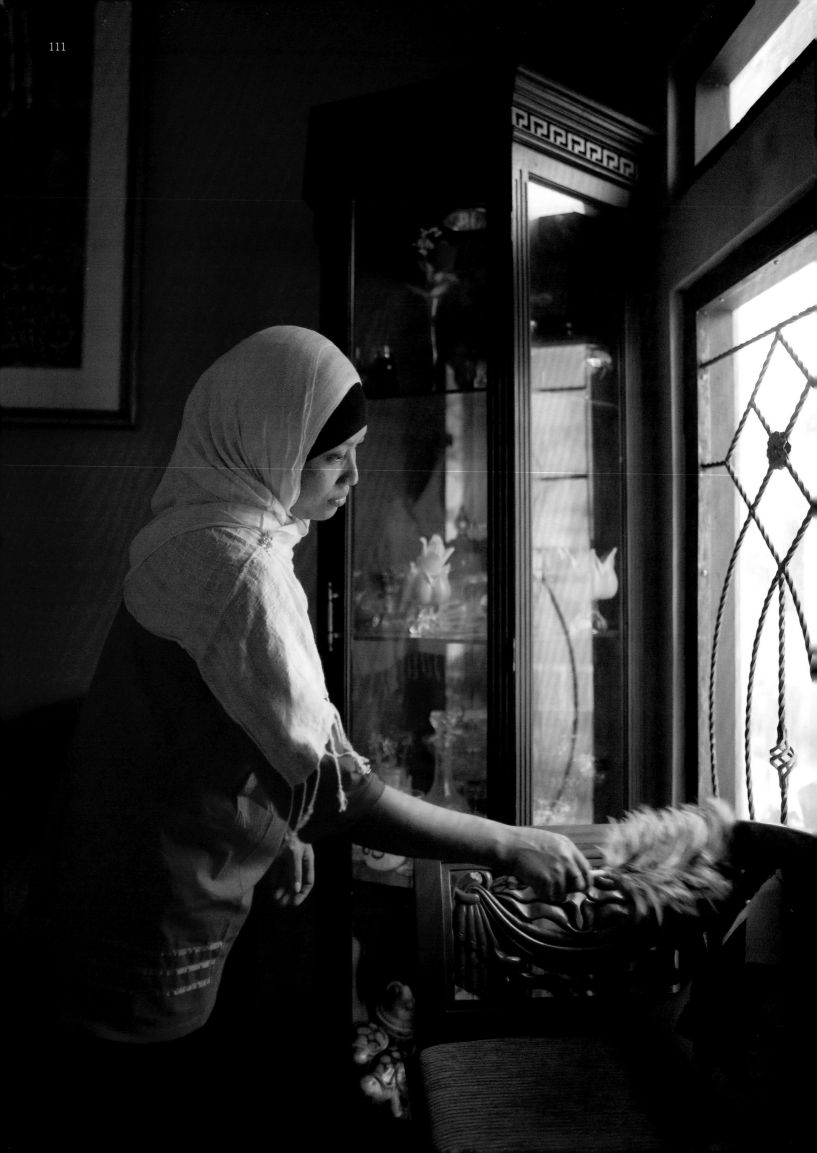

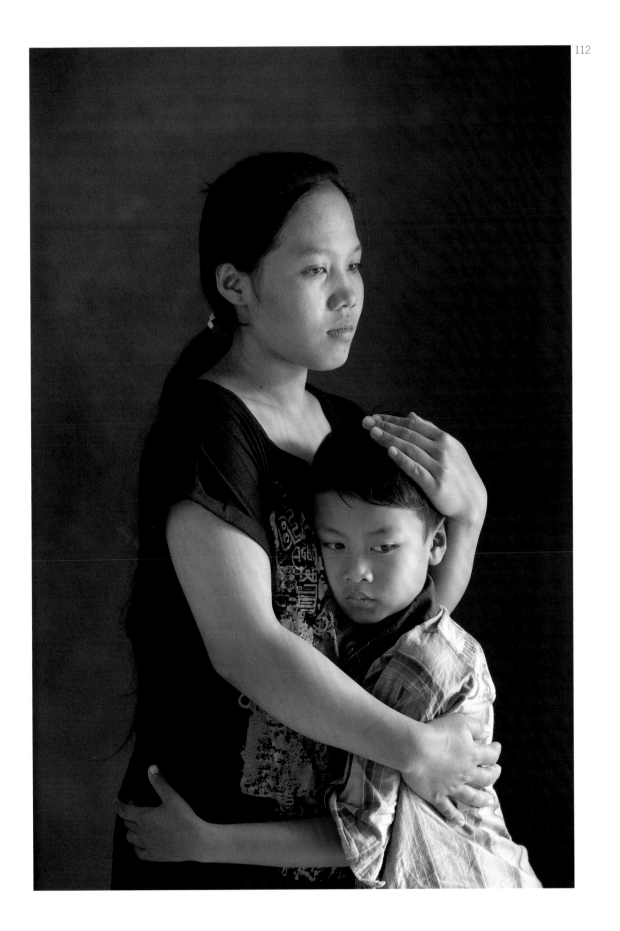

HUMAN TRAFFICKING

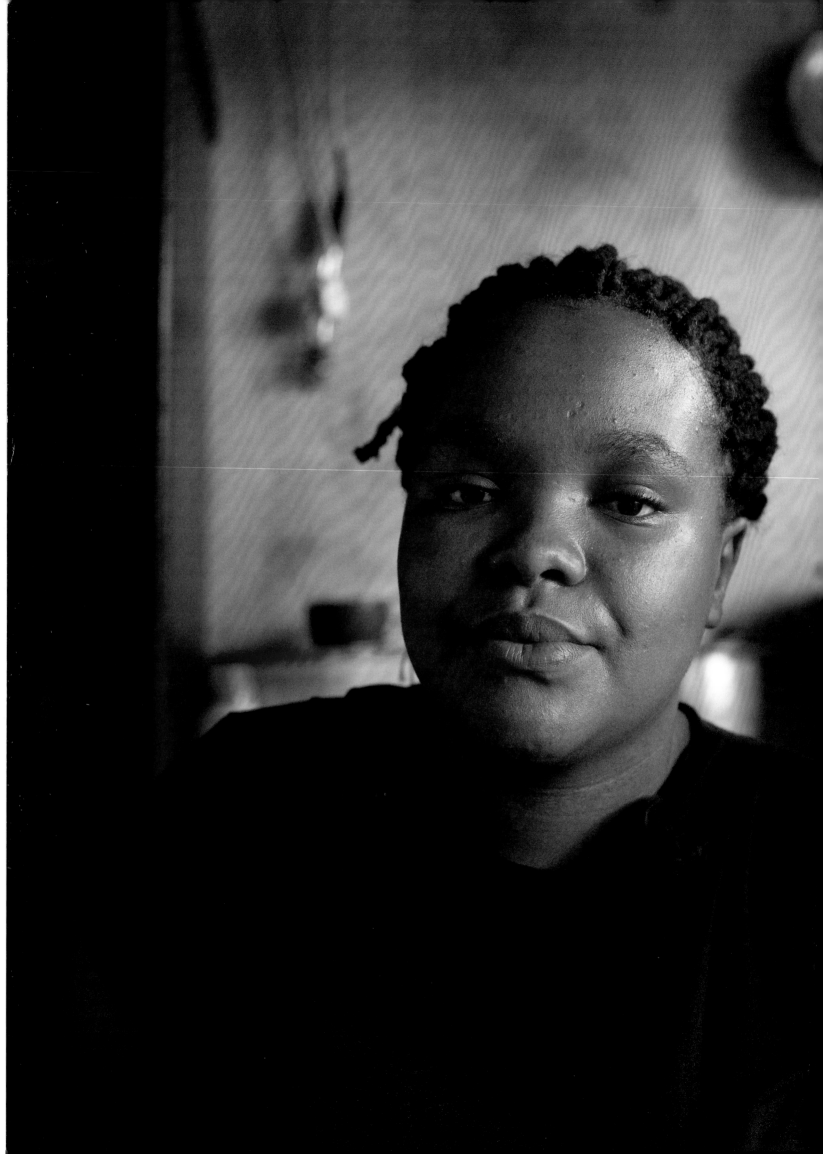

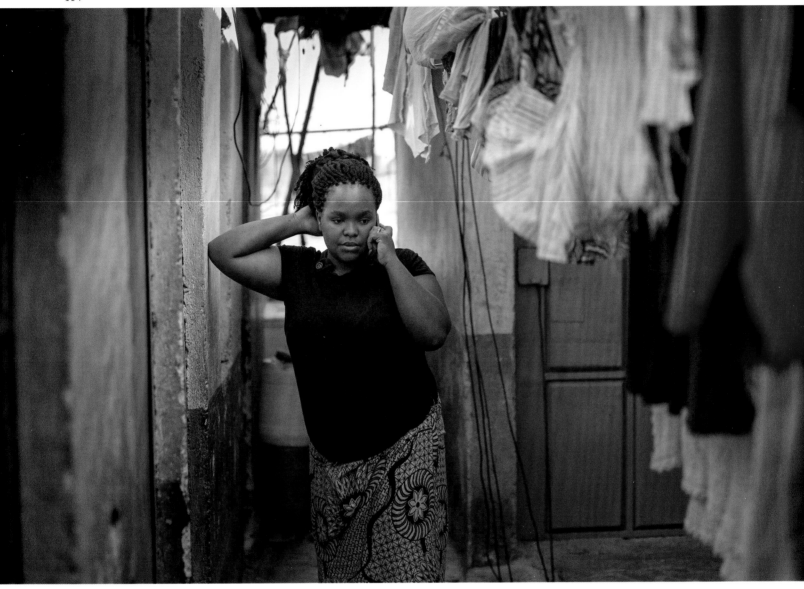

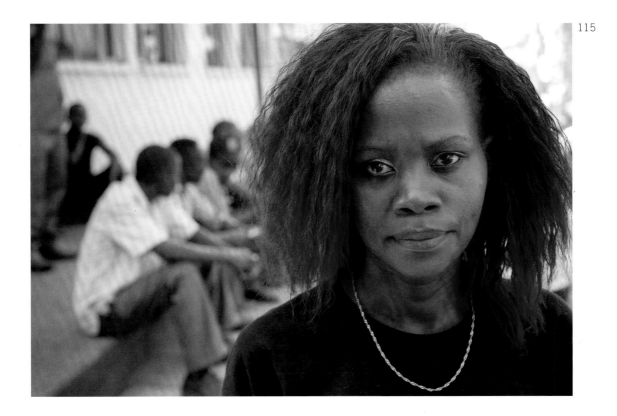

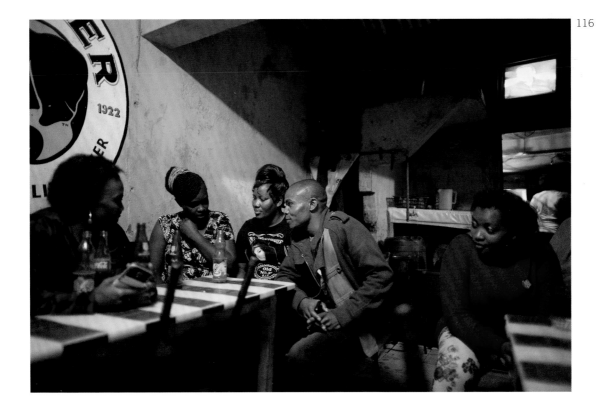

SEX WORKERS

"The key to ending extreme poverty is to enable the poorest of the poor to get their foot on the ladder of development…the poorest of the poor are stuck beneath it. They lack the minimum amount of capital necessary to get a foothold, and therefore need a boost up to the first rung."

Jeffrey Sachs, American Economist and Director of the Earth Institute at Columbia University

Tools of Empowerment

A Way Up: Learning A Trade

"Globally, 600 million girls struggle to escape grinding poverty. …Vocational training is a critical lever for change in adolescent girls' lives, helping them to gain financial independence, establish good saving habits, and improve their future employment prospects. As girls' lives improve, so does the well-being of their families and communities."

Denise Raquel Dunning, Ph.D. Founder and Executive Director of Let Girls Lead and Champions for Change

Let me tell you about a young woman named Jolie.

Jolie was born and raised amid the violence in her native Rwanda. After both her parents died, her father's family refused to take her in, and they forced her to live with another family. There, the man of the house sexually abused her, and soon she became pregnant. Again, now pregnant, she was put out on the street to fend for herself. In search of an aunt, Jolie somehow made her way to Kenya. To add further pain to her journey, Jolie's son was born with severe medical problems and died after a three-year struggle.

Somehow Jolie found her way to Heshima Kenya, a program devoted to protecting single, orphaned, and separated women and girls, many of whom come from war-torn areas of eastern and central Africa. Adolescent refugee girls are especially vulnerable, as they experience the highest rates of exploitation and abuse. According to Heshima Kenya, 60 percent of the women they treat have suffered some form of sexual violence.

When I first met Jolie at Heshima Kenya, I saw no immediate signs of what she had endured. To the contrary, I was struck by her cheerfulness and her vitality, and I could detect no traces of the abuse and discrimination she had suffered. What happened? What was the key to her almost miraculous rehabilitation? The answer: she learned a trade.

The specialists at Heshima Kenya took Jolie in, made her a part of their extended family, and they helped her develop into a skilled textile artist. Today Jolie produces beautiful, high-quality, handmade scarves for export. Her work has value, and, for the first time in her life, Jolie feels that she has value too. She now has a whole new life in a loving, supportive community, and she has a trade that sustains her both economically and spiritually. Learning a trade has been her way out and up from the depths of poverty.

Sadly, around the world there are millions of stories that begin just like Jolie's. Far too many girls are not allowed to attend school, develop their minds, or gain even a minimum of economic and personal independence. Their lives, and their futures, are condemned from the very start. As I saw time and again, though,

well-conceived vocational training programs can be a very effective first step in addressing the problem. And creating beauty and art seems to provide a very special accelerant for the healing process.

I found more proof of this via a program in Tanzania: The Mabinti Centre, a project run by an organization called Comprehensive Community-Based Rehabilitation in Tanzania, or CCBRT. Funded by Johnson & Johnson, The Mabinti Centre takes in young women recovering from corrective fistula surgeries and trains them in the arts of screen-printing, sewing, beading, and crochet. The Mabinti coursework runs for a year, and trainees develop the knowledge and skills they need to generate an income and become financially independent. At the end of their course, each graduate is supplied with a starter kit that contains a sewing machine, scissors, a supply of fabric, and a calculator. Armed with those tools and their new skills, the Mabinti women are ready and equipped to go out and start their own businesses.

In an earlier section of this book, I described the travails and stigma that affect women with fistulas. But through organizations like the Mabinti Center, women escape that depressing cycle and emerge with a true sense of accomplishment and self-worth and a renewed purpose in life. And here there is an added bonus: the new skills they learn will last them a lifetime.

A comparable program I visited is Action India. Located in the state of Uttar Pradesh, Action India teaches poorly educated girls from farming families how to design and produce attractive jewelry. In a sister program, they teach rural women the kind of modern agricultural practices that will help them produce healthy foods and grains for their families and livestock. This is empowerment that truly begins at the grassroots level, and, with a little luck, it might be sowing the seeds of far more than a green revolution.

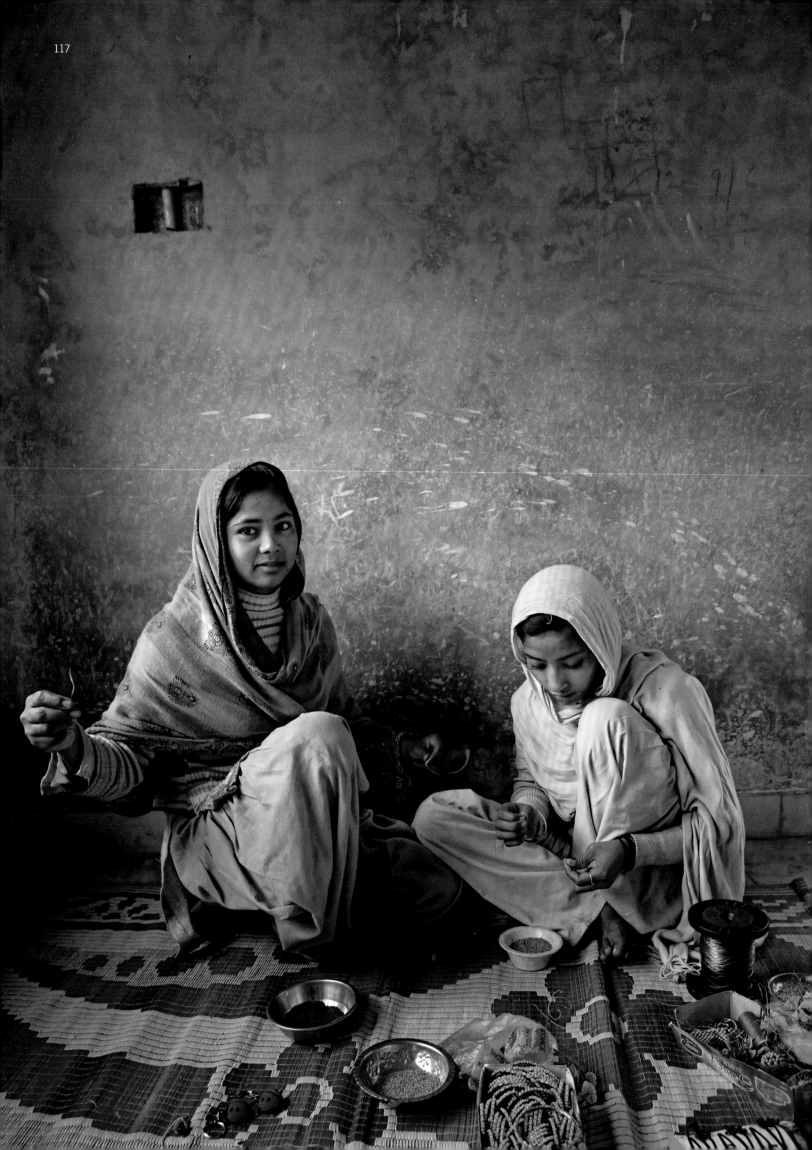

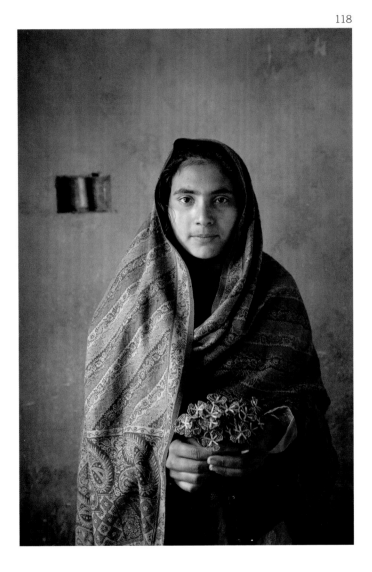

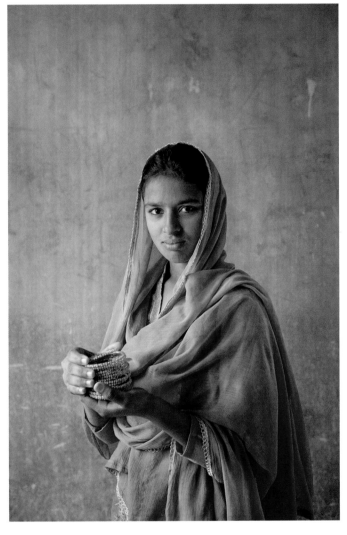

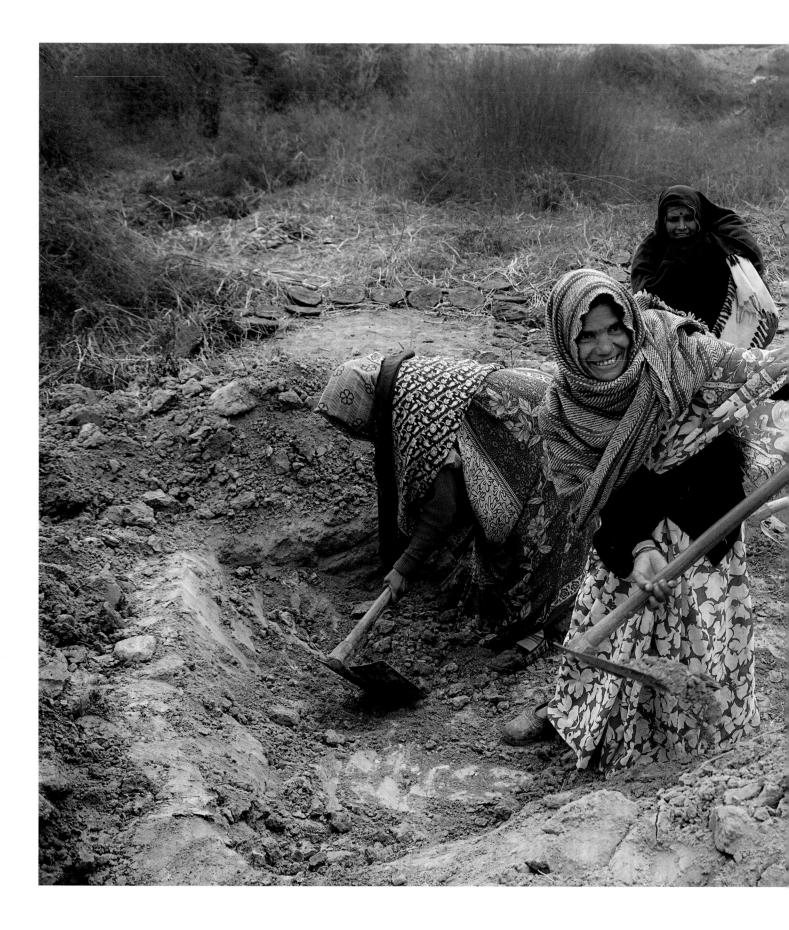

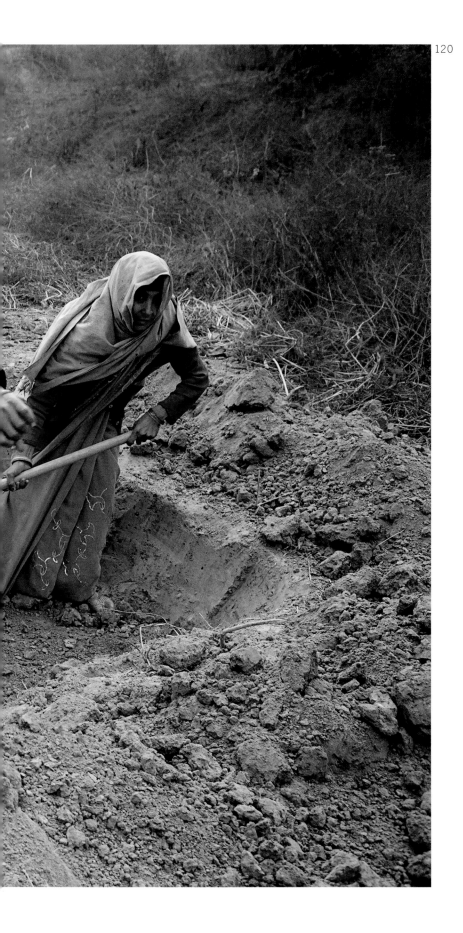

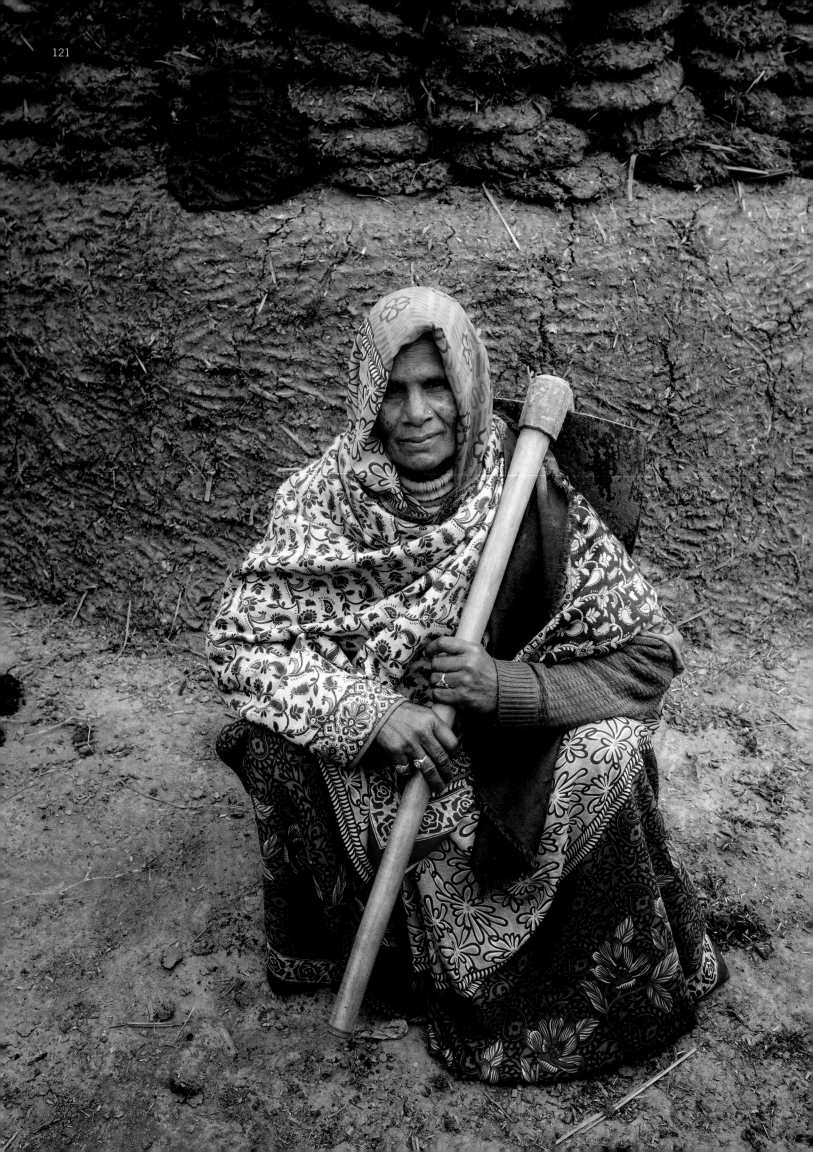

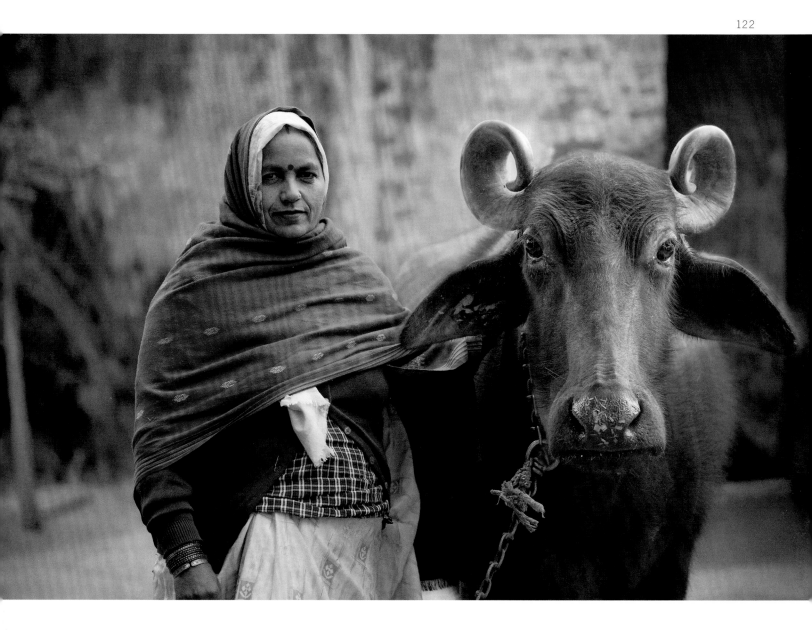

123

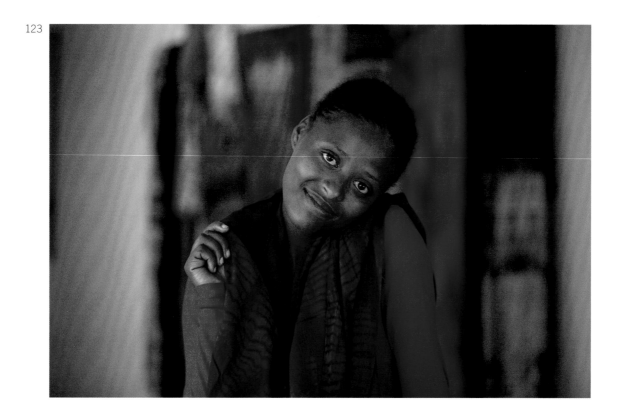

TOOLS OF EMPOWERMENT

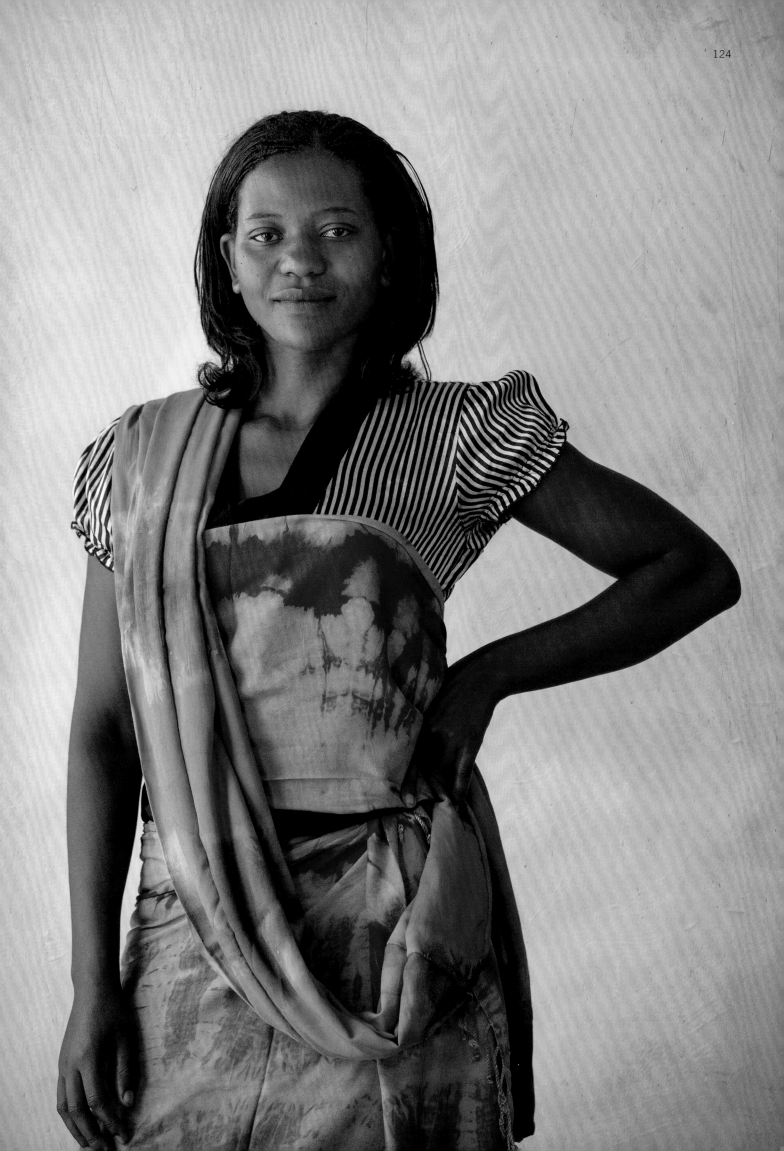

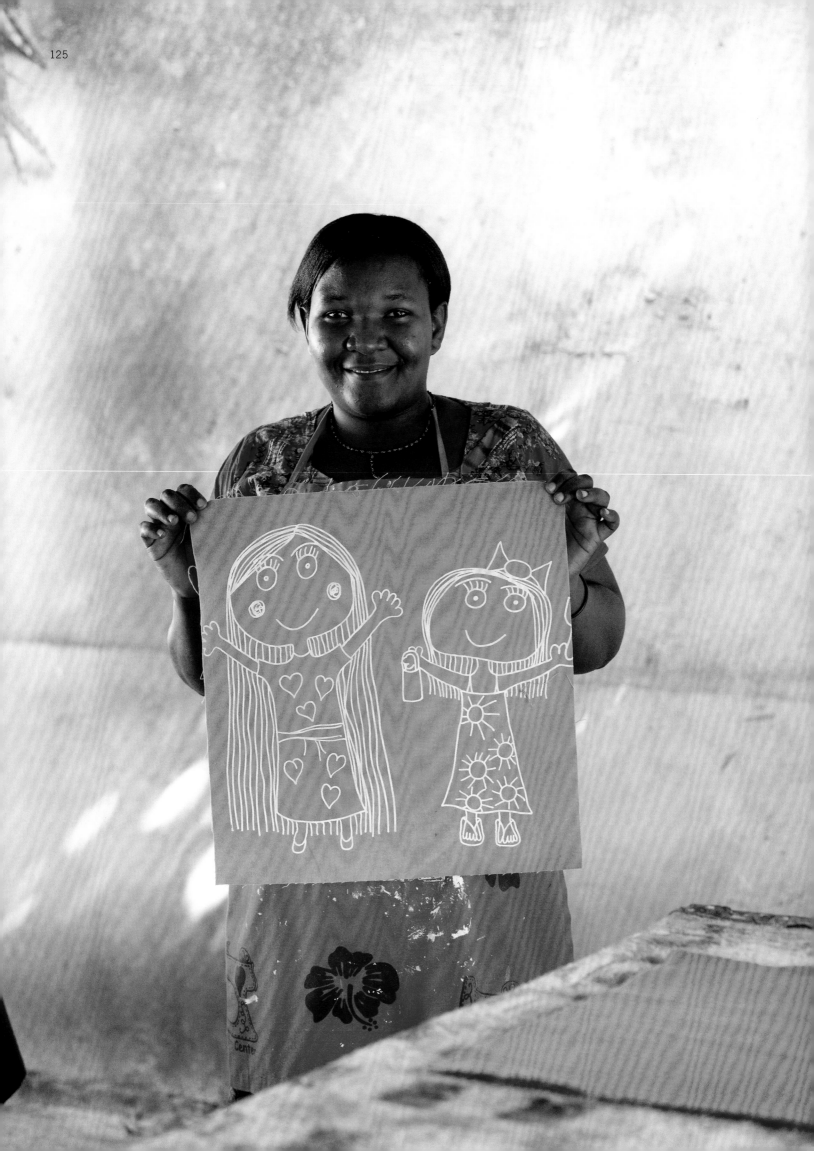

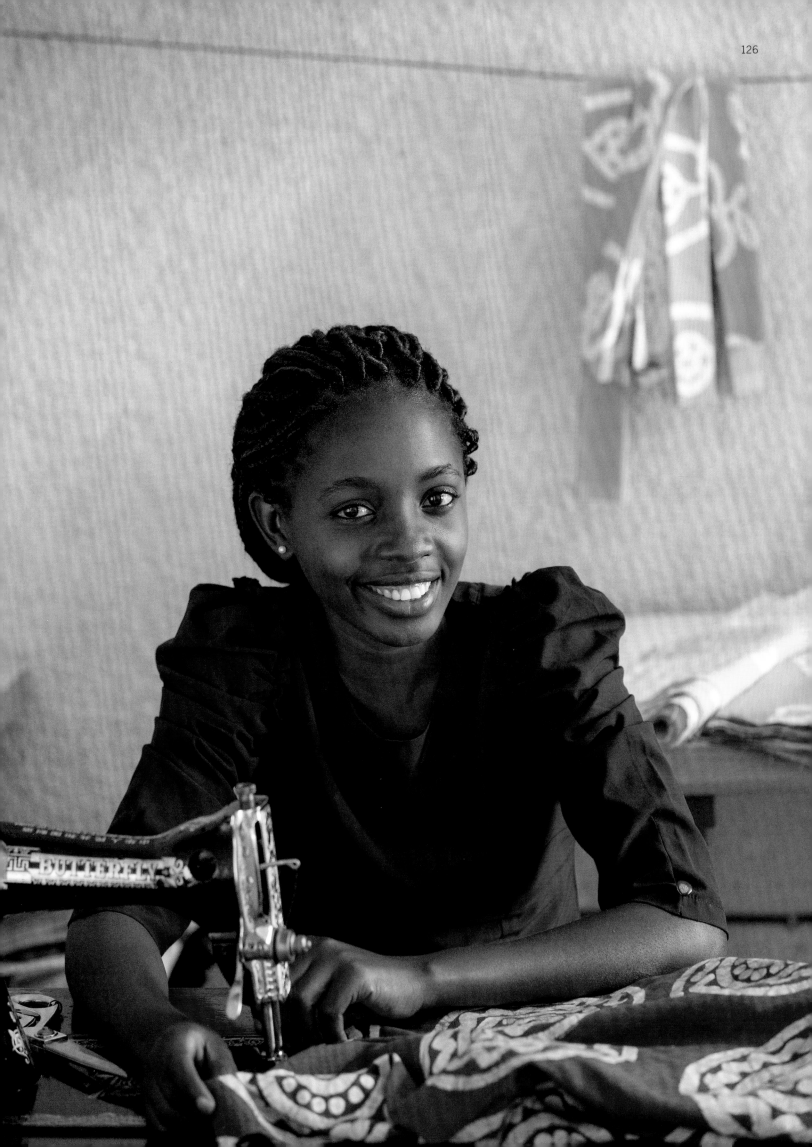

Judy's Design School

In the western-most part of India, in a remote corner of the state of Gujarat, you will find an unusual pioneer named Judy Frater.

Judy is an American anthropologist and museologist who has lived in the Kutch region of Gujarat for over 20 years. Initially, Judy came to the Kutch region to study its long tradition of producing high-quality textiles. In doing so, she also got to know many members of the Rabari community, one of the many indigenous tribes of India. Judy's passion for textiles and the Rabari perplexed the local people, and one day a woman asked her a stunning question: "Why are you studying us? Why don't you help us?"

In response, Judy created a foundation and a design school, in an effort to train young women and bring them whole new avenues of artistic expression and economic empowerment. At Judy's school, the Kala Raksha Vidhyalaya, young girls begin sewing as soon as they can hold a needle, and they learn in the best way possible: from their own mothers and grandmothers, who are highly skilled in the arts of embroidery and applique. This is women helping women, and keeping families close in the process.

Judy says her approach is carefully tailored to counter what she calls "design intervention." That is the practice whereby outside manufacturers come to the Kutch, deliver exact models of the goods they want replicated, and demand that the artisans render faithful copies of those designs. Judy believes this "design intervention" kills creativity and eventually depletes the skills and artistry so vital to the Kutch history and identity. Judy's students, by contrast, spend a full year learning the basics of color and design, they develop their own portfolios, and they learn presentation skills. They also learn how to create a brand identity and the core elements of marketing and sales. Their native artistry is heightened and so are their entrepreneurial skills. The quality of their work is beautiful and heartfelt.

Judy's school is believed to be the first design institution created uniquely for traditional artisans. Each year, the school also holds six, two-week enrichment courses. In this part of the program, her students travel long distances to see how

other indigenous groups pursue their own artistic traditions and native crafts. Here, the students are drawn from two distinct age groups: older women who no longer have the responsibility of caring for their children at home, and younger girls who have yet to have a family of their own. The young girls are chaperoned by one of the older women in the community.

The women graduating from Judy's school have the joyous obsession to create everyday. They are proud of their work and are empowered by both maintaining their cultural tradition and earning a decent livelihood. It would be ideal if many of the younger girls had the opportunity to go to school and gain a comprehensive education, but the perfect should not be the enemy of the good. In fact, the graduates of the design school have experienced the transformative power of education. It's women helping women, in the best possible way.

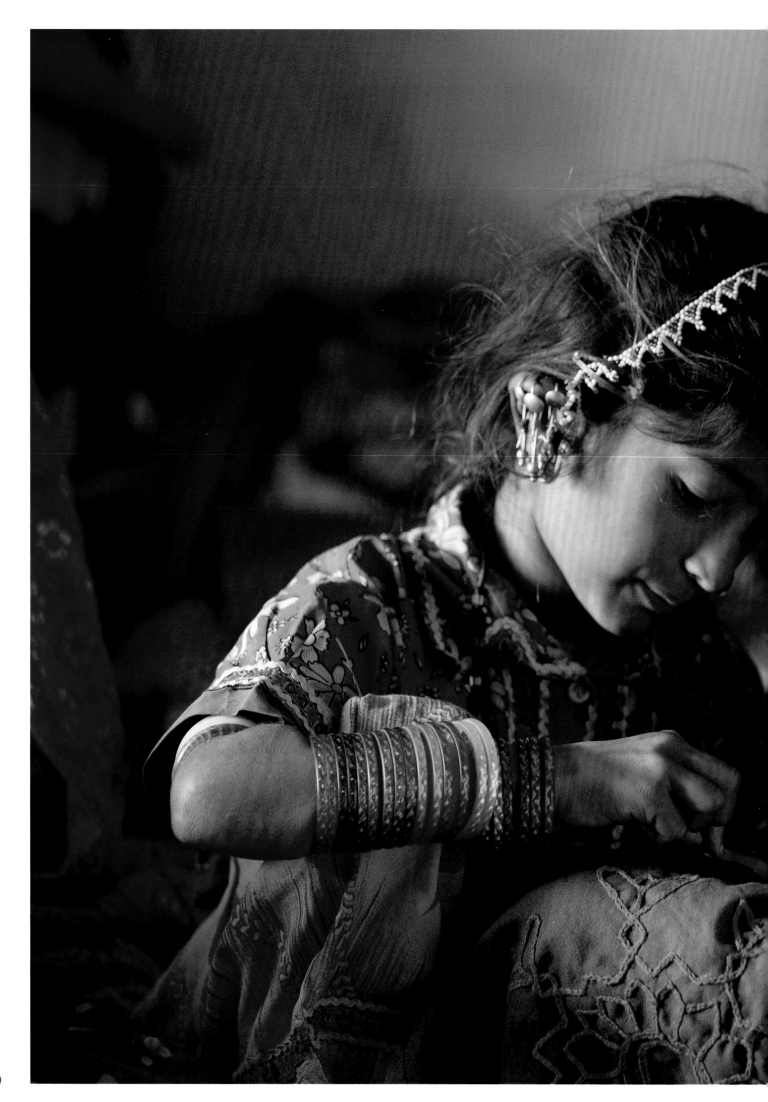

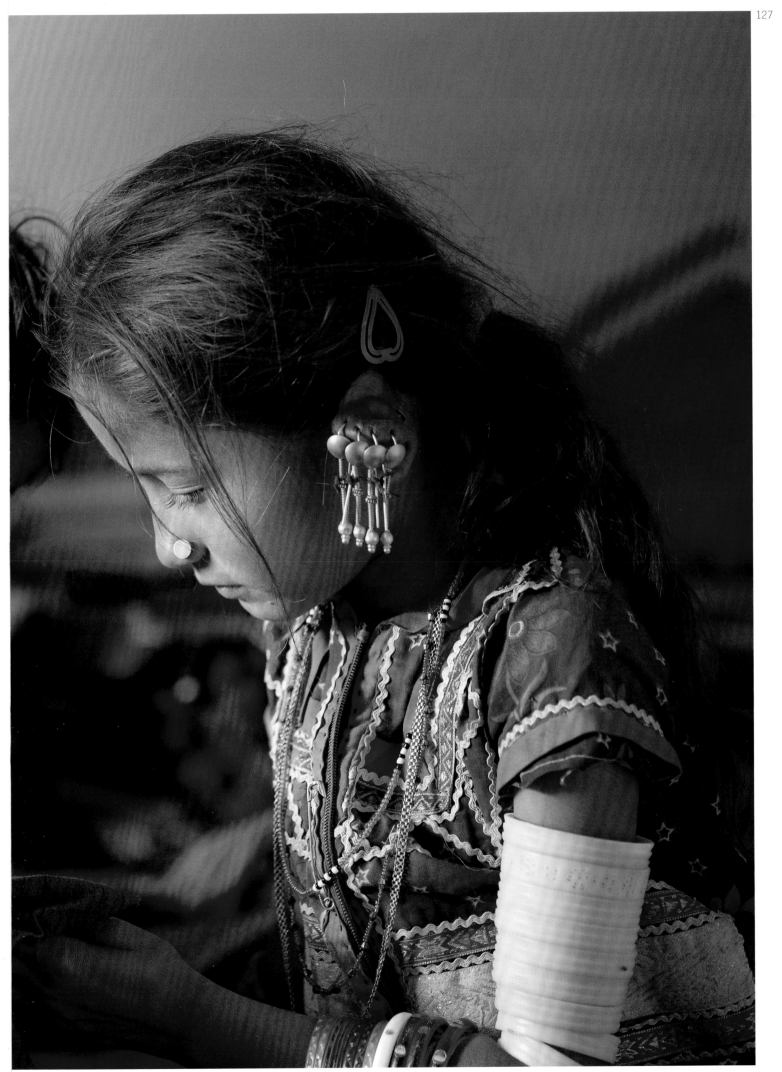

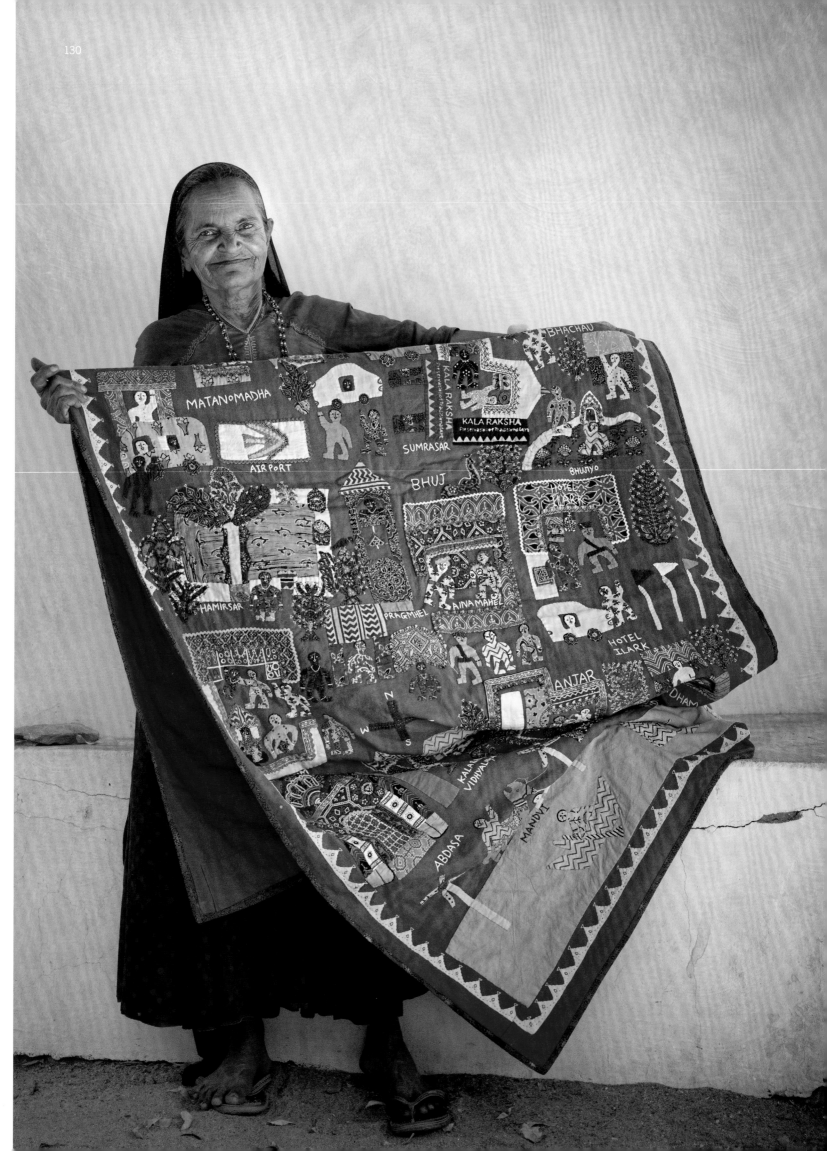

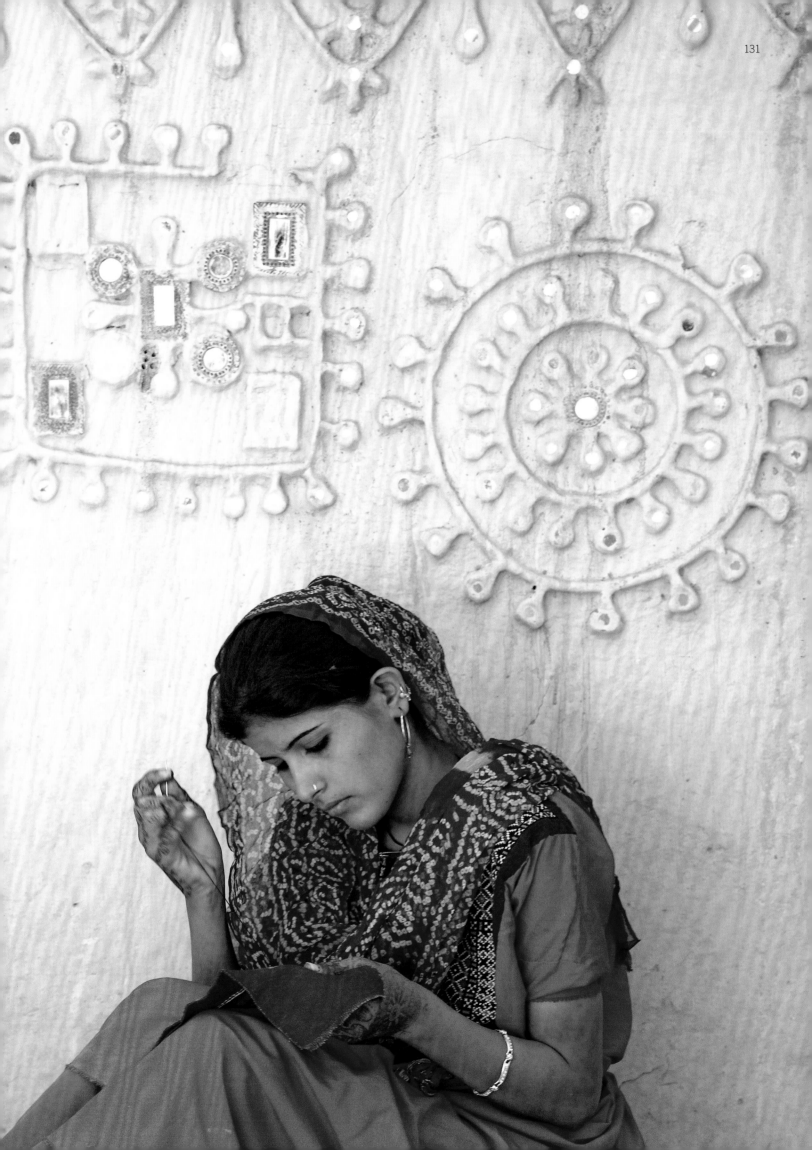

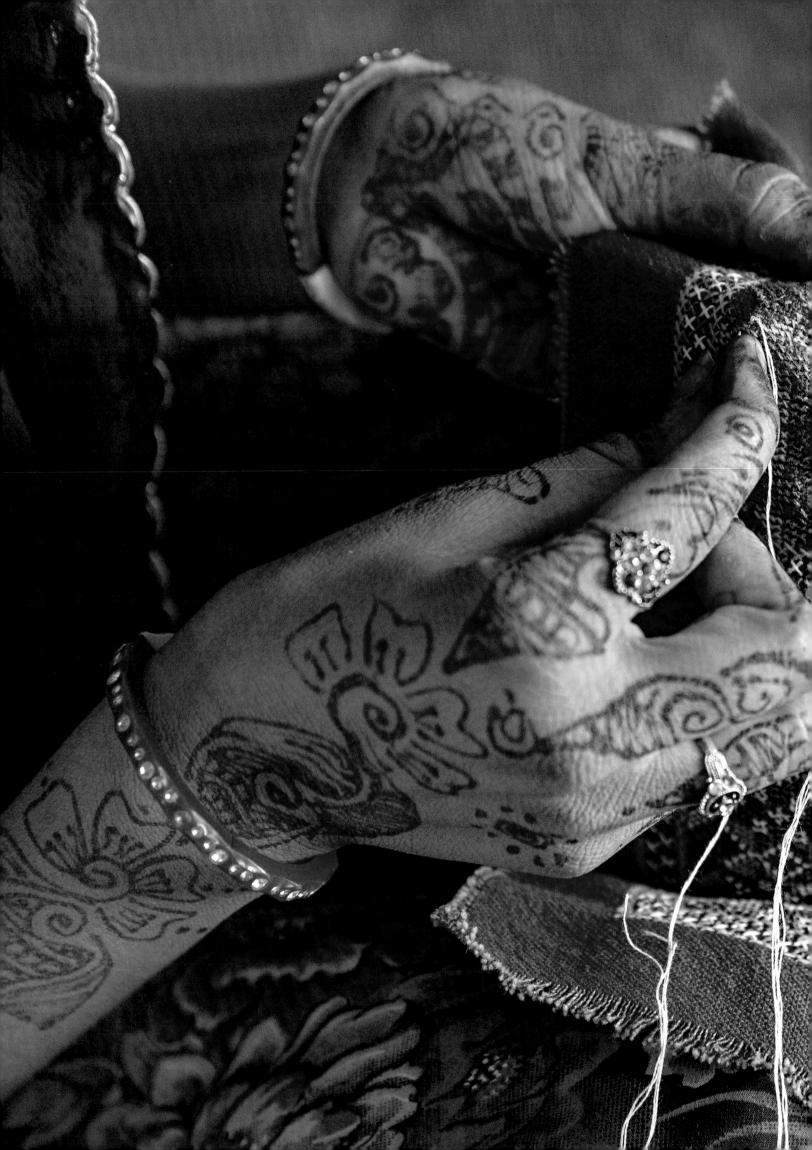

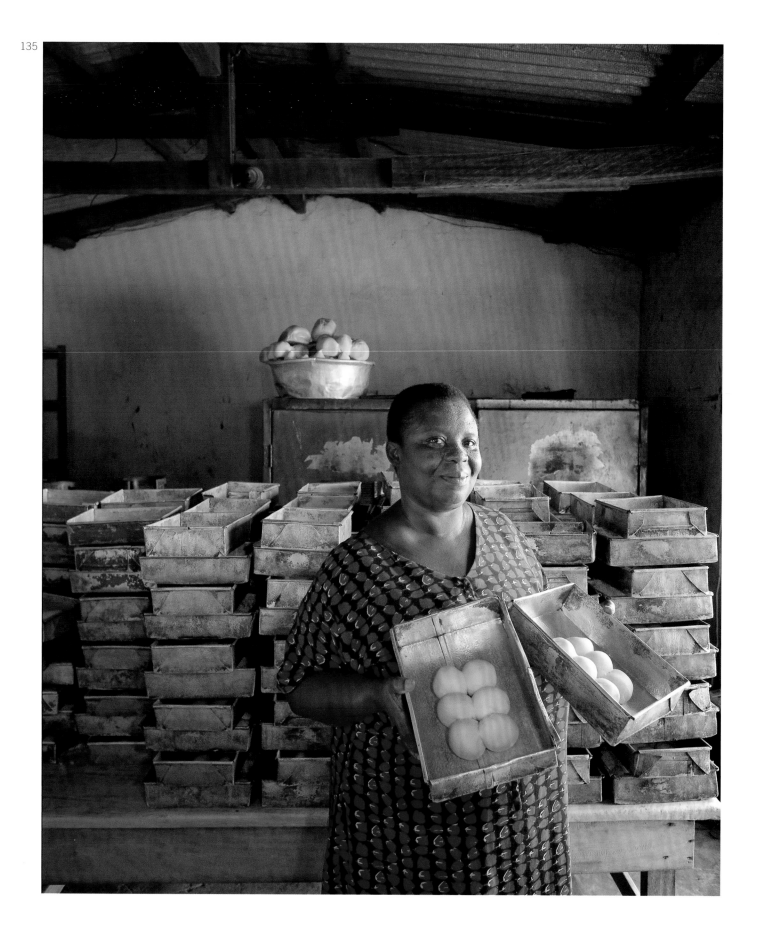

TOOLS OF EMPOWERMENT

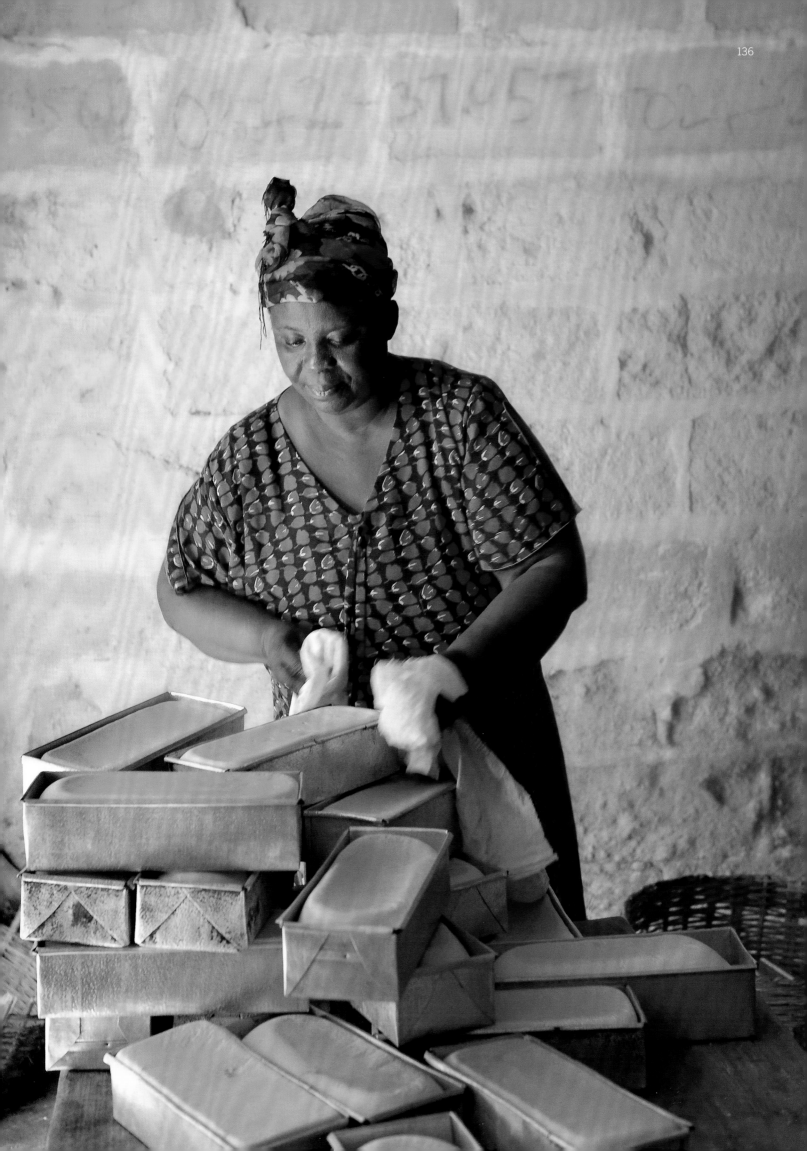

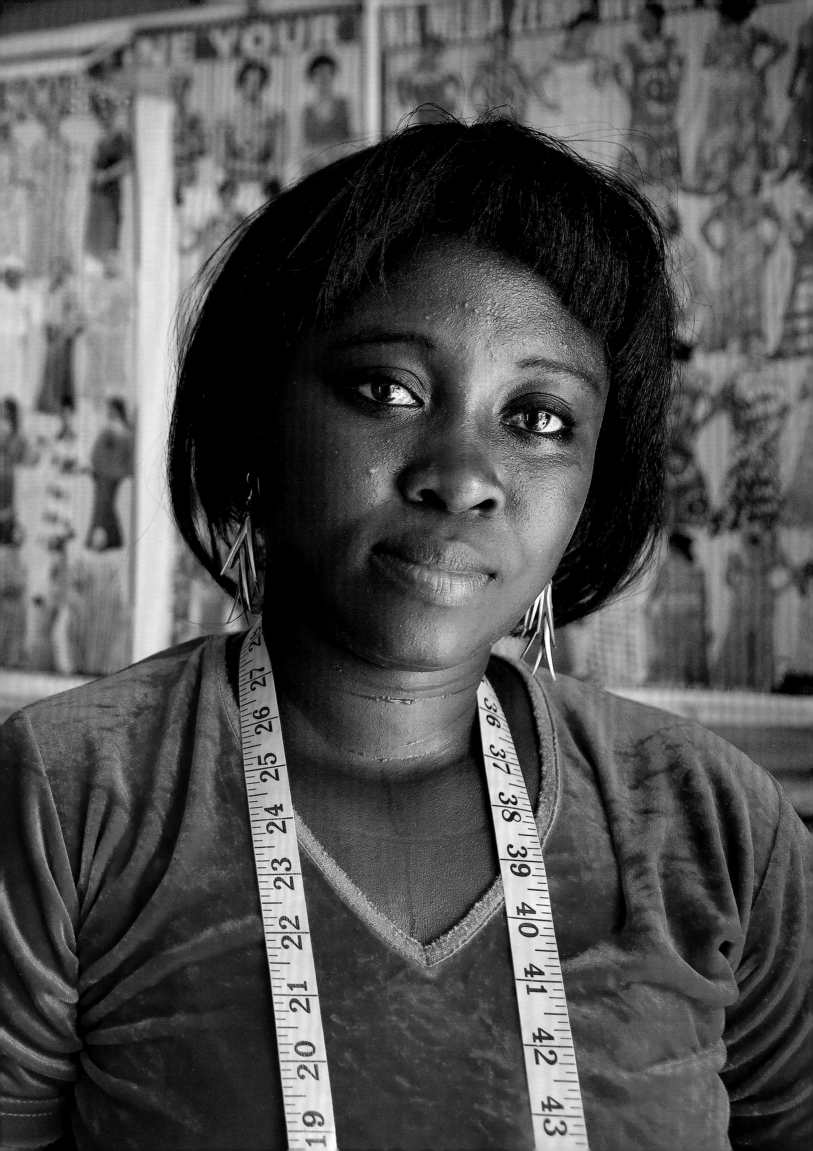

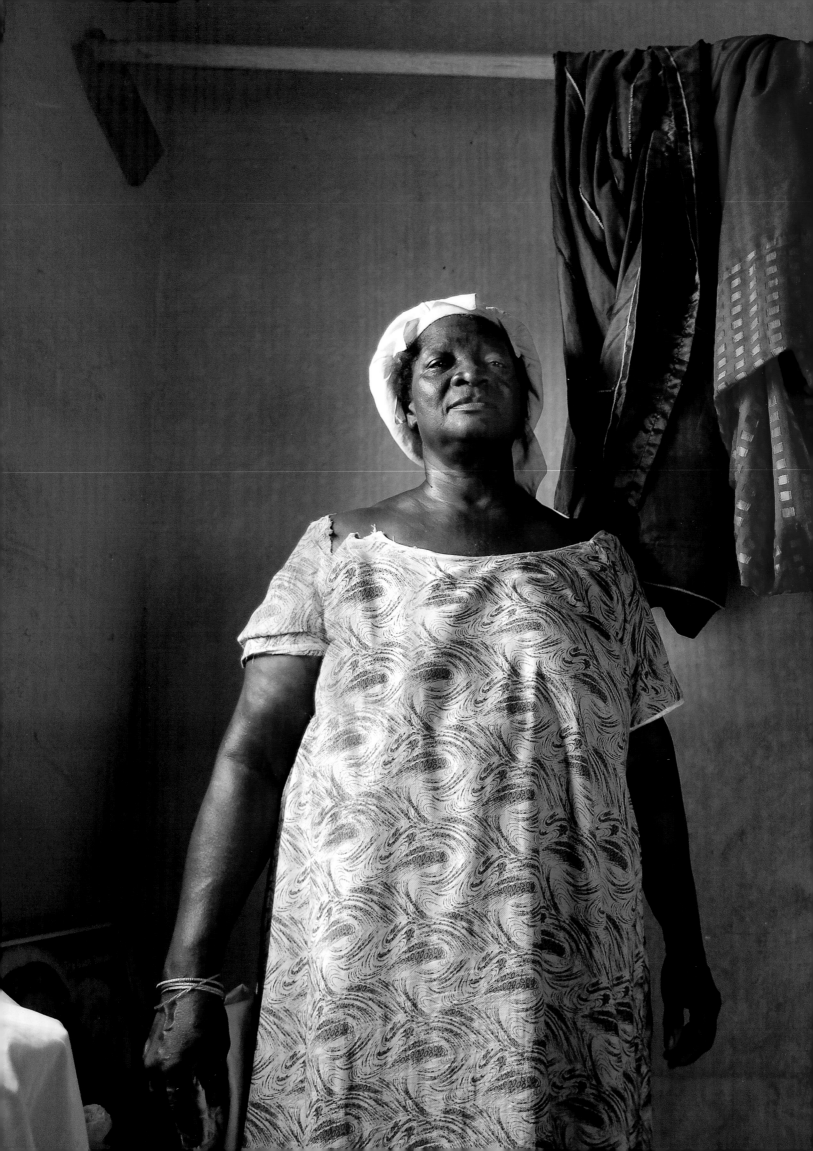

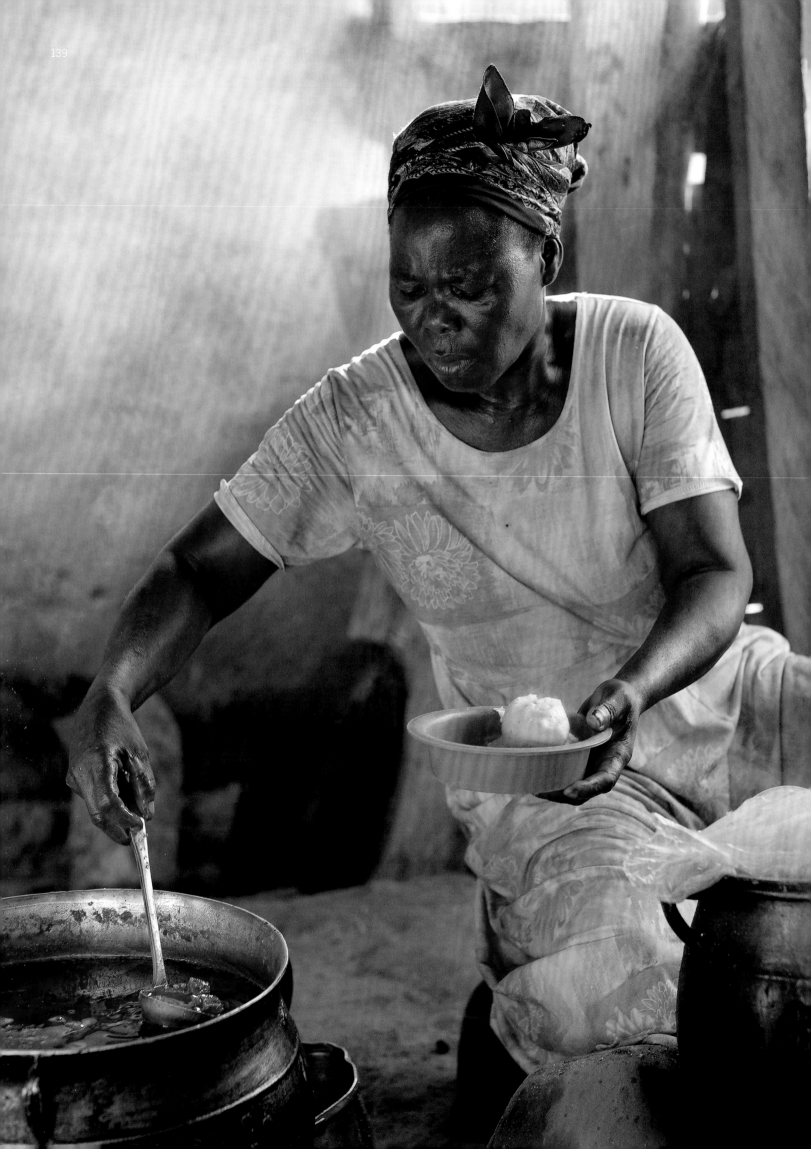

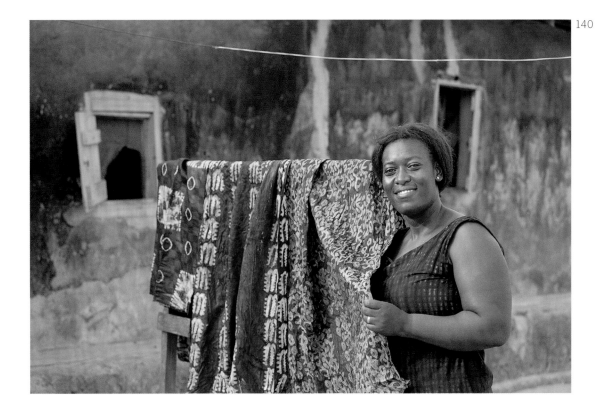

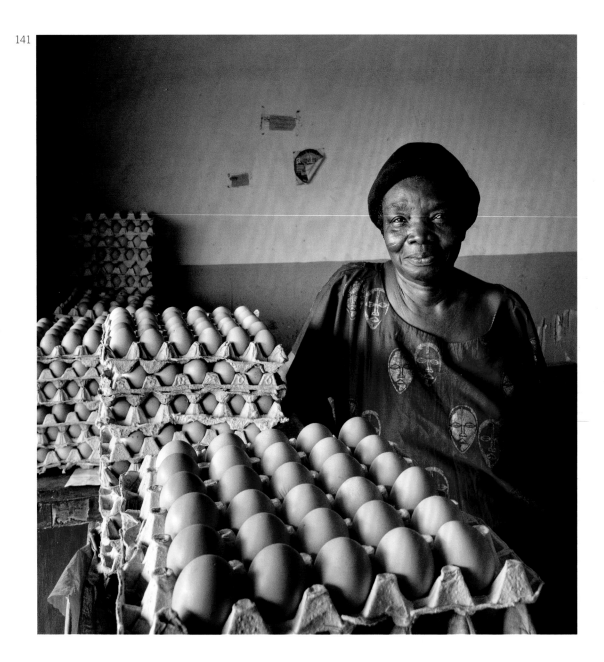

141

TOOLS OF EMPOWERMENT

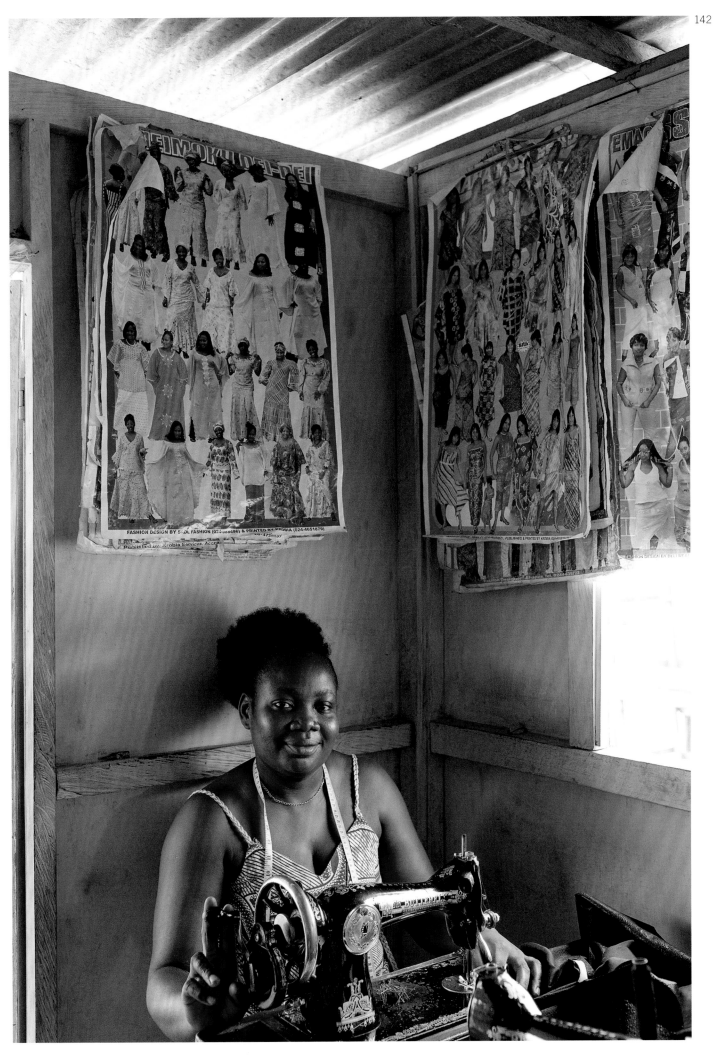

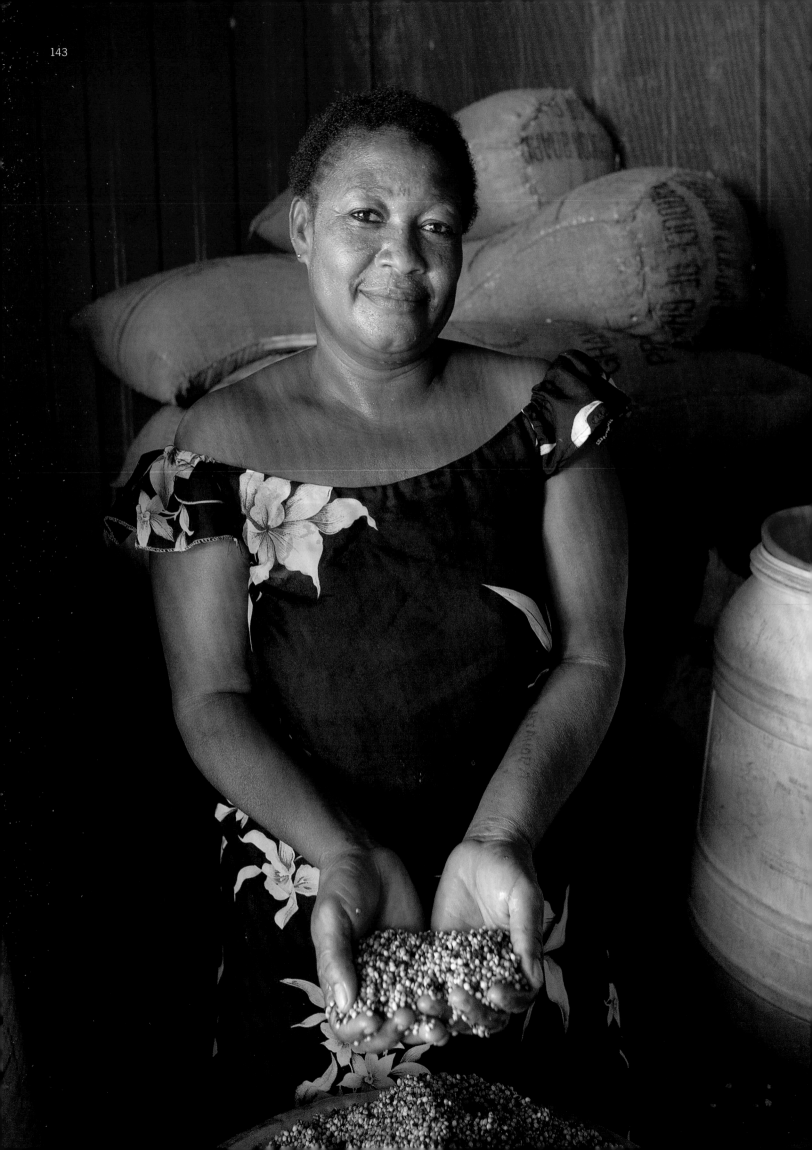

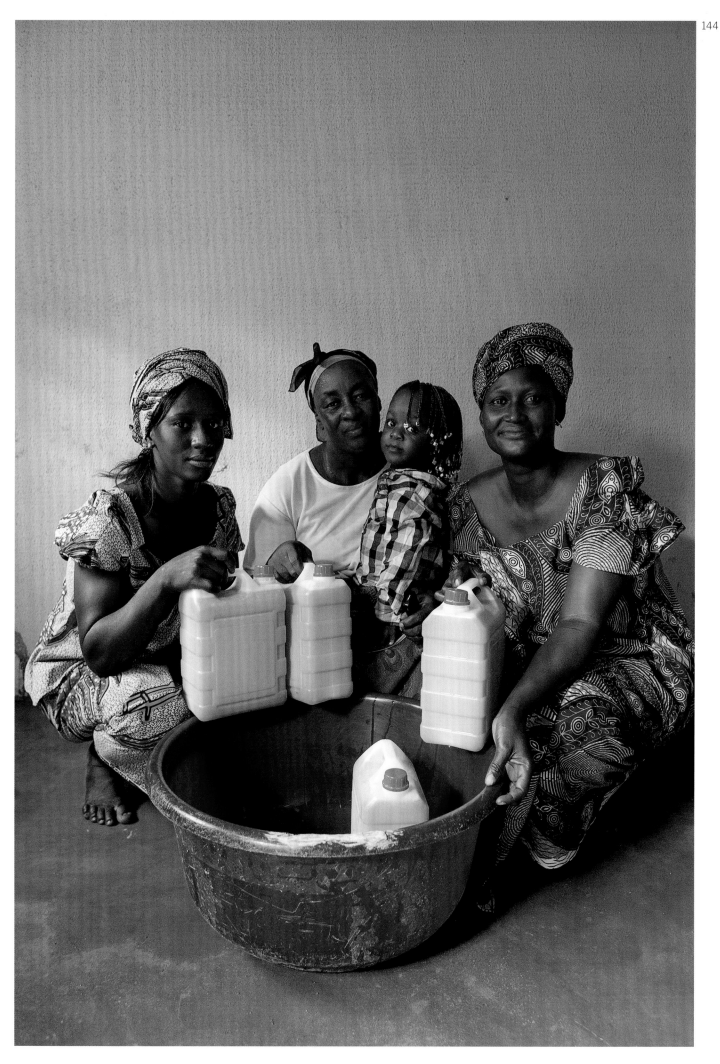

MICROFINANCE

"The surest way to keep a people down is to educate the men and neglect the women. If you educate a man, you simply educate an individual, but if you educate a woman, you educate a family—and a whole nation."

Dr. J. E. Kwegyir Aggrey, Ghanaian Educator

Let Us Pick Up Our Books and Our Pens

The one assignment that consistently lifts my spirit and gives me the greatest feeling of joy is photographing a classroom full of girls. Their optimism, eagerness to learn, and the hope in their eyes are palpable and deeply felt.

Few actions have been proven to do more for the human race than the education of female children. Offering girls basic education enables them to make genuine choices over the kinds of lives they wish to lead. And the overwhelming benefits of educating girls extend far beyond the classroom. The impact of giving a girl in a developing country a quality education can be felt in families, communities, and future generations.

Beyond economic development objectives, however, there is also a moral reason to educate girls, as Anne Firth Murray, founder of the Global Fund for Women, has rightly argued:

> "If we wish to transform the situation of human kind, we should be supporting girls' education not just to meet these development goals, but also because educating girls is the fair thing to do. It is only just that girls should have equal opportunities with boys to get a good education. Education is not only a powerful means to solve economic problems. It is also a route toward a more just society."

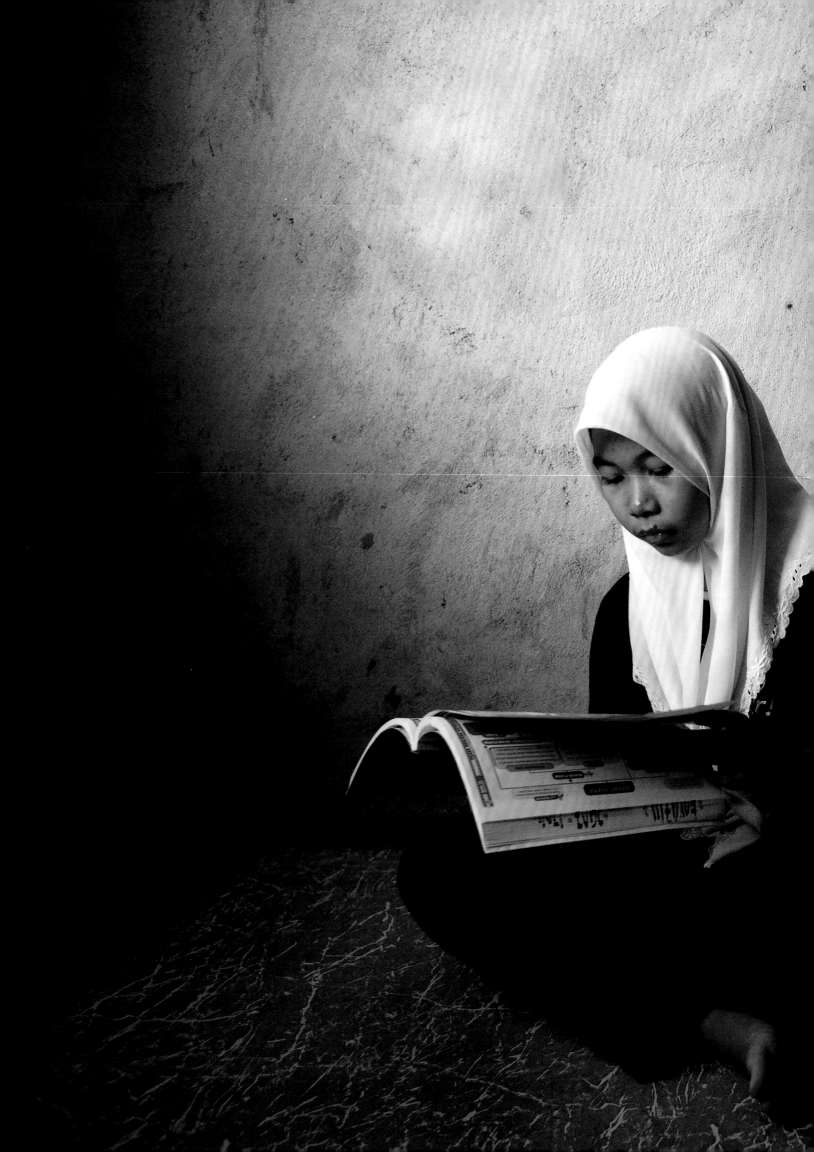

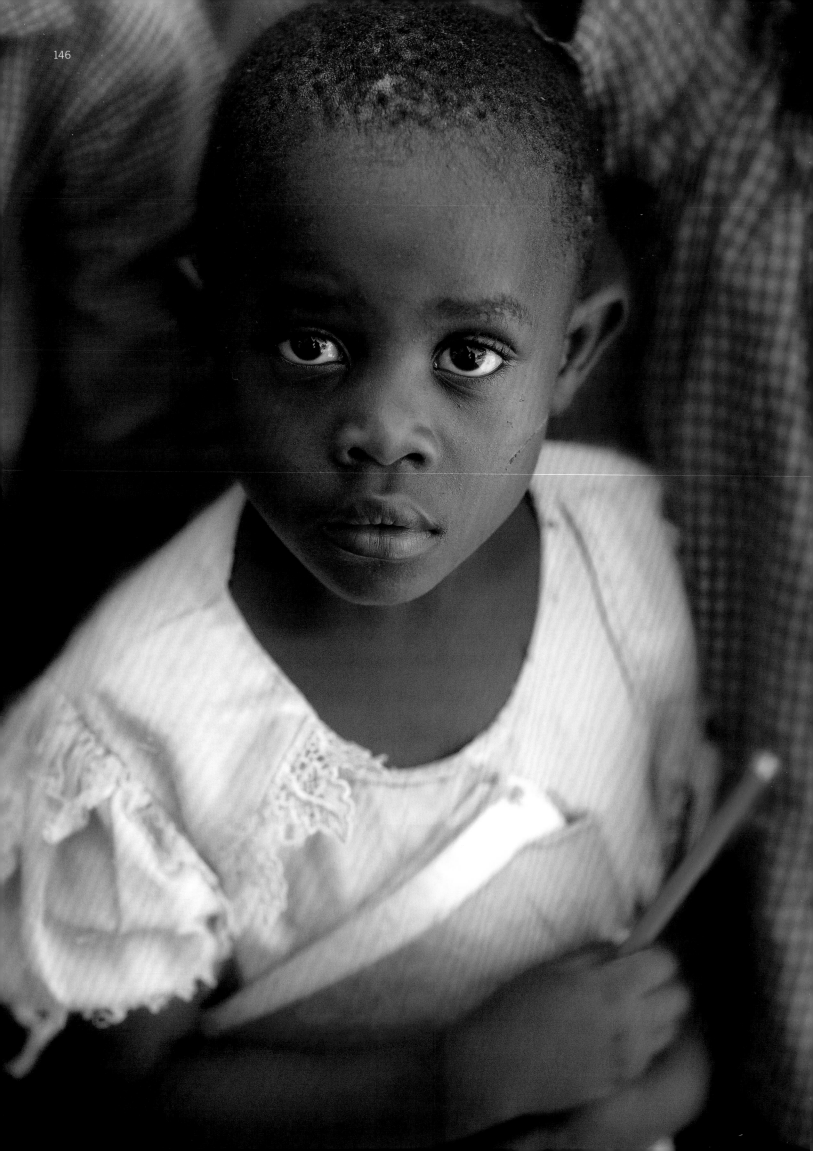

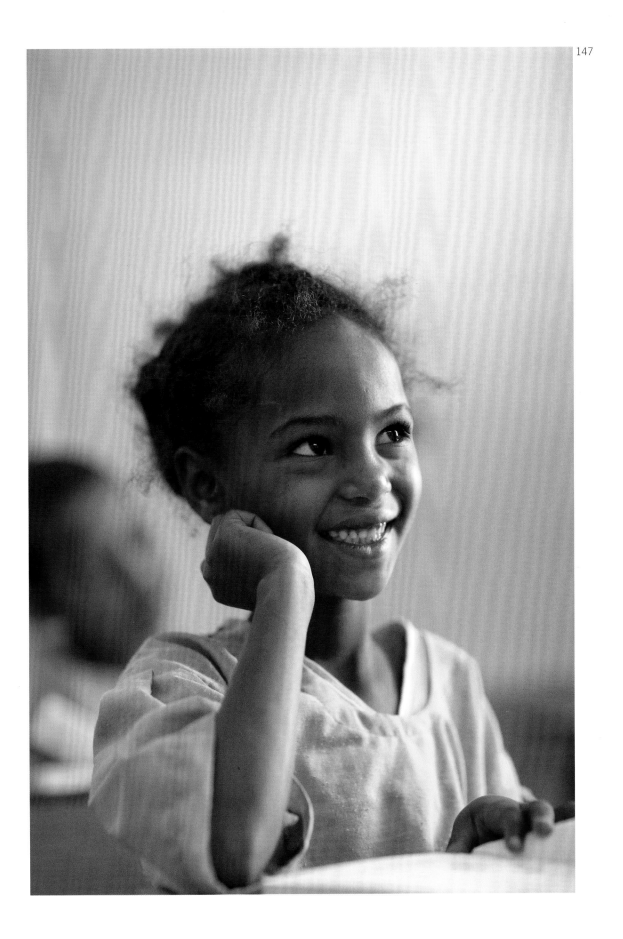

150

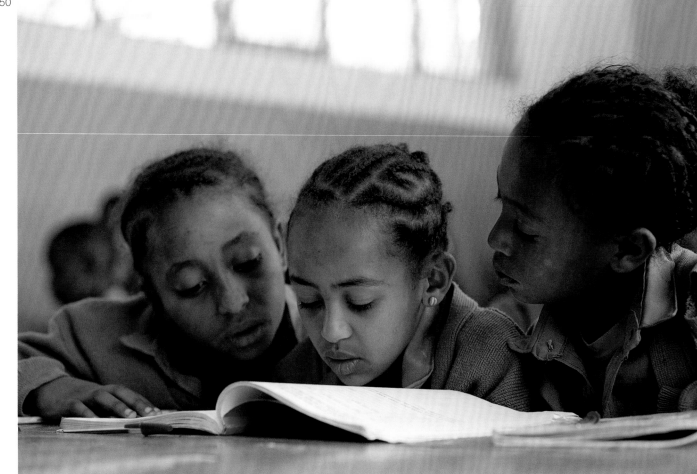

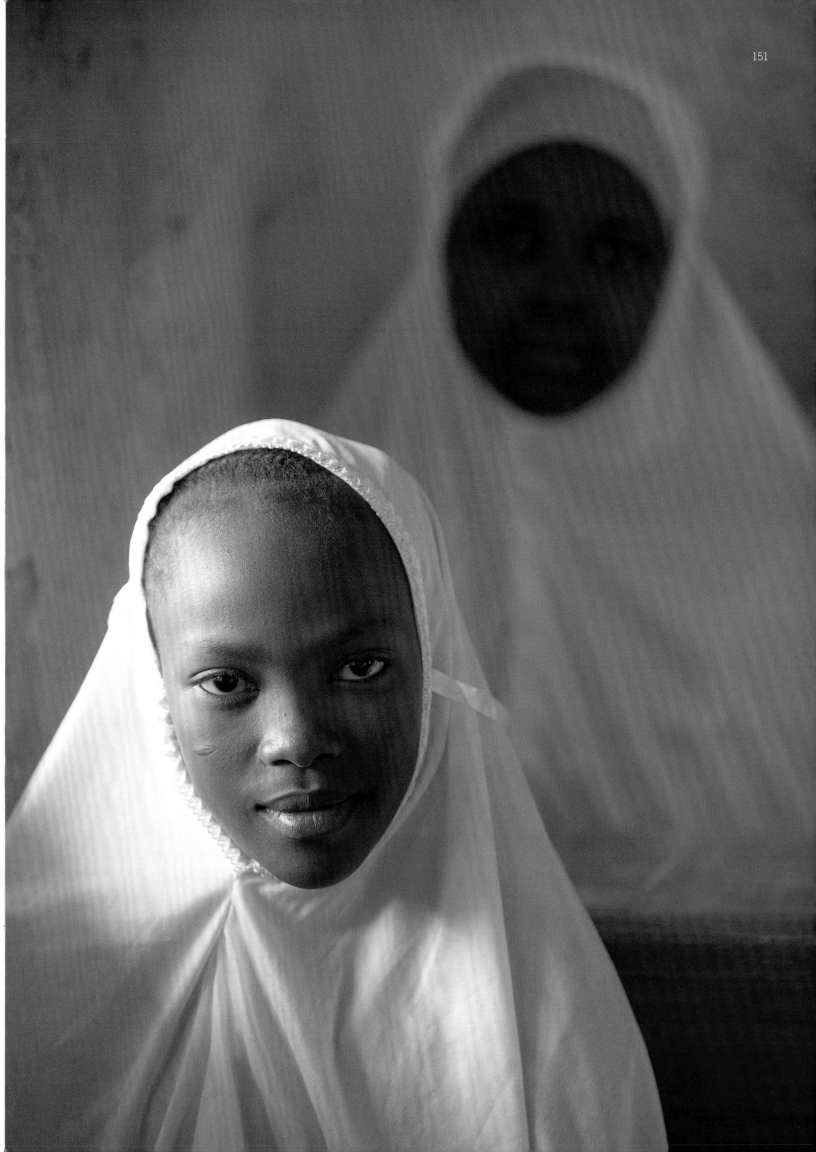

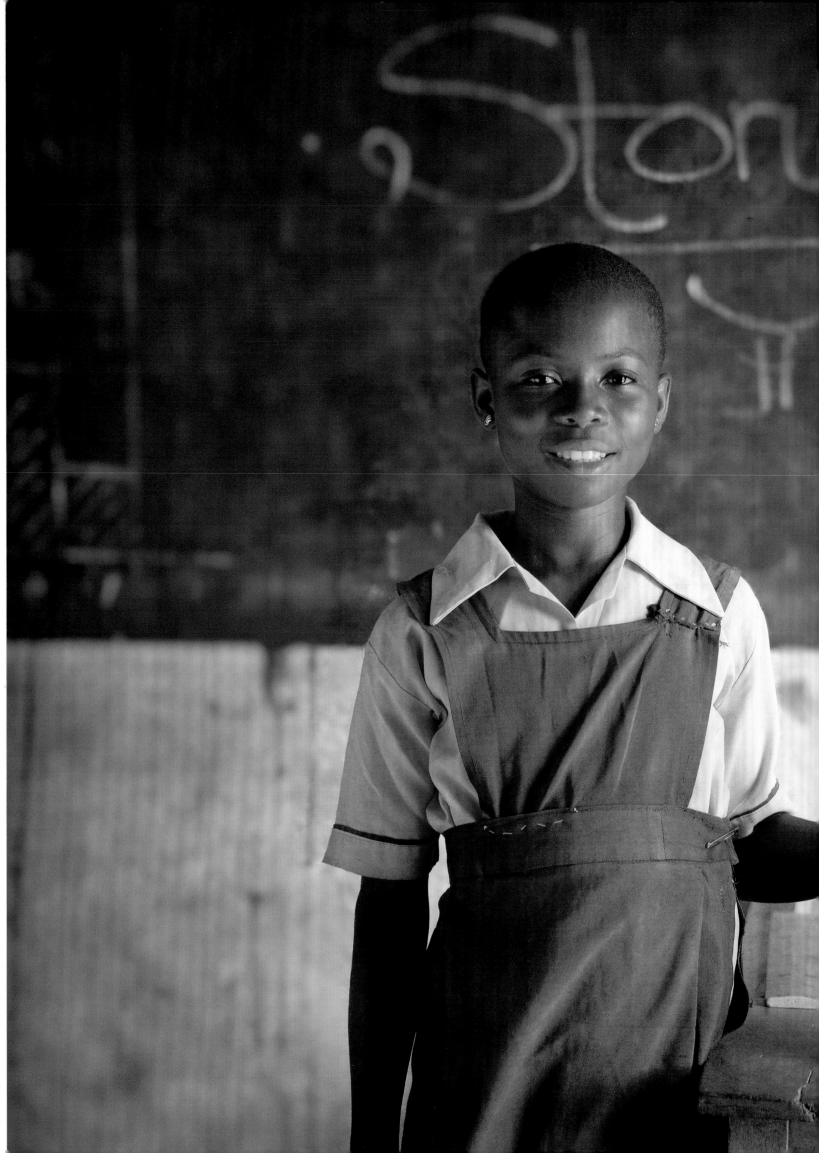

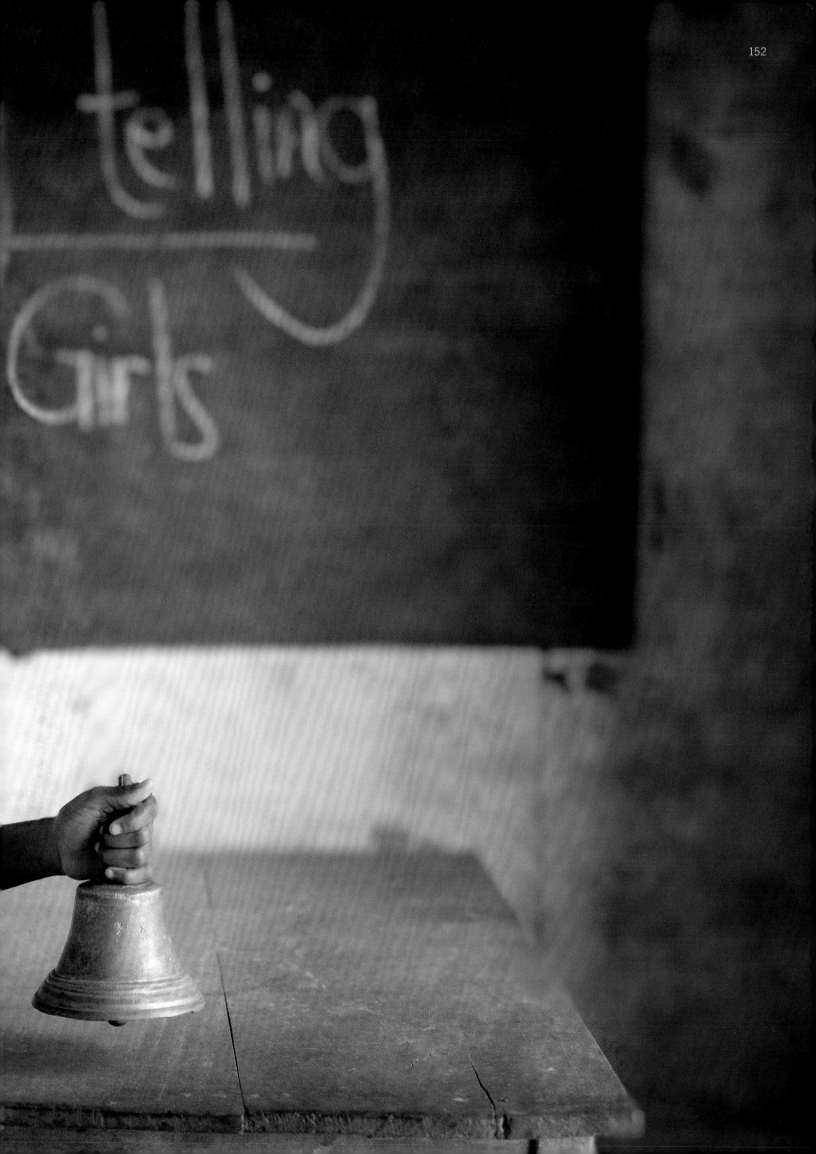

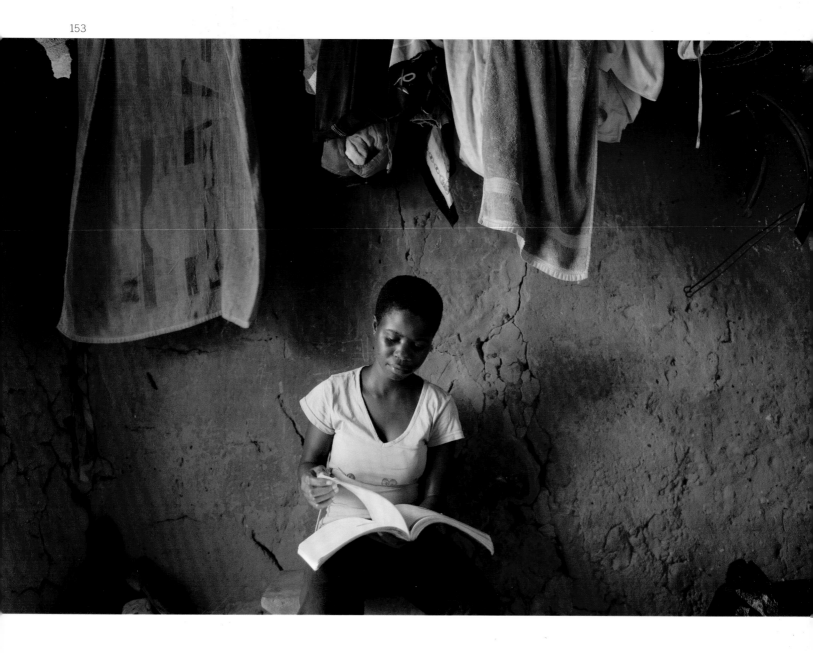

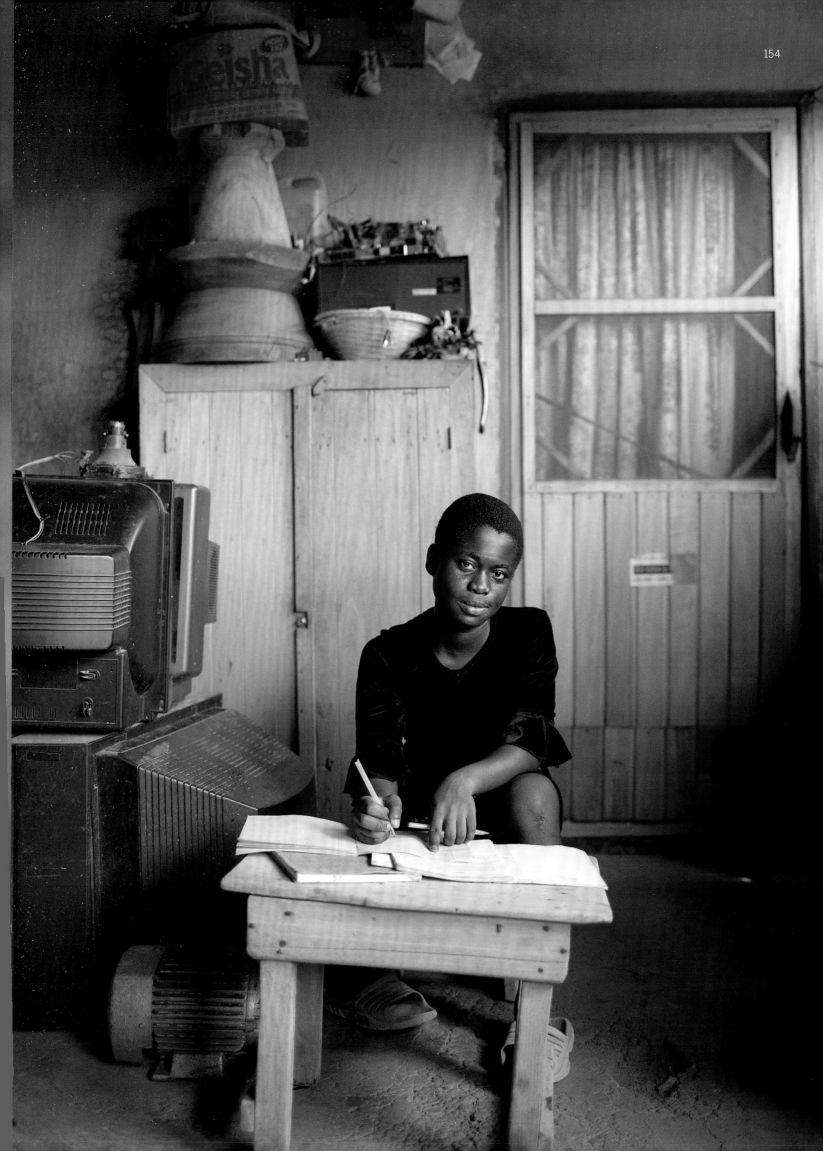

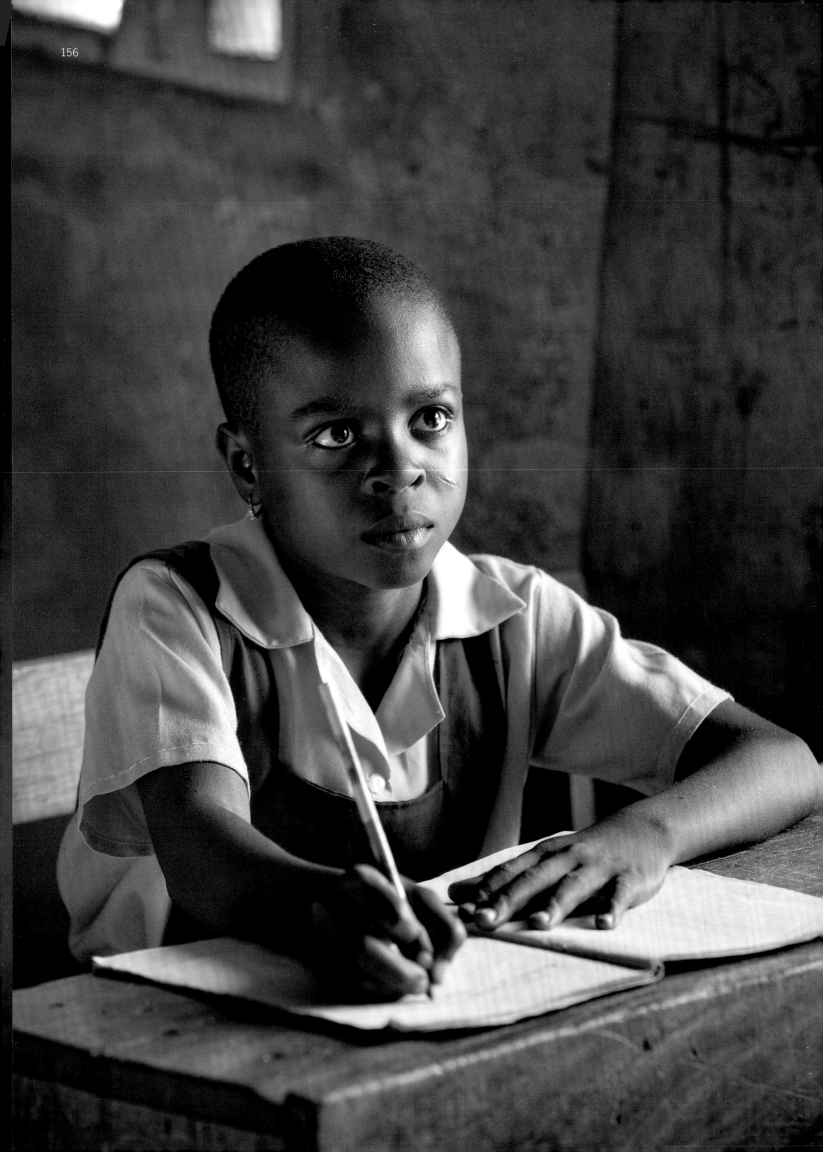

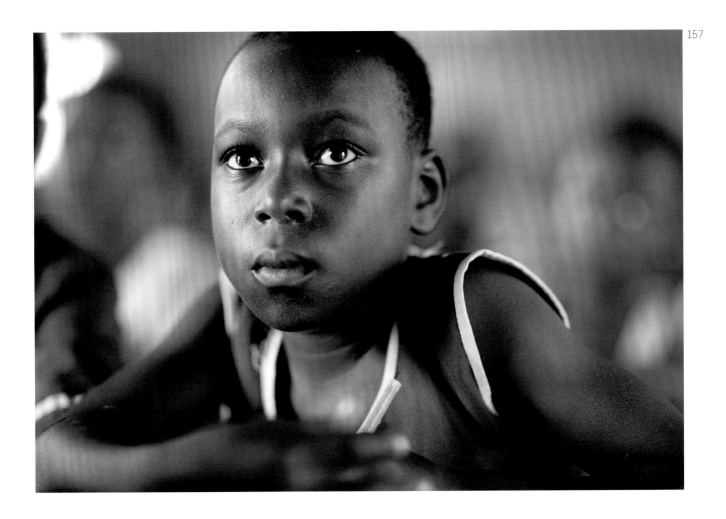

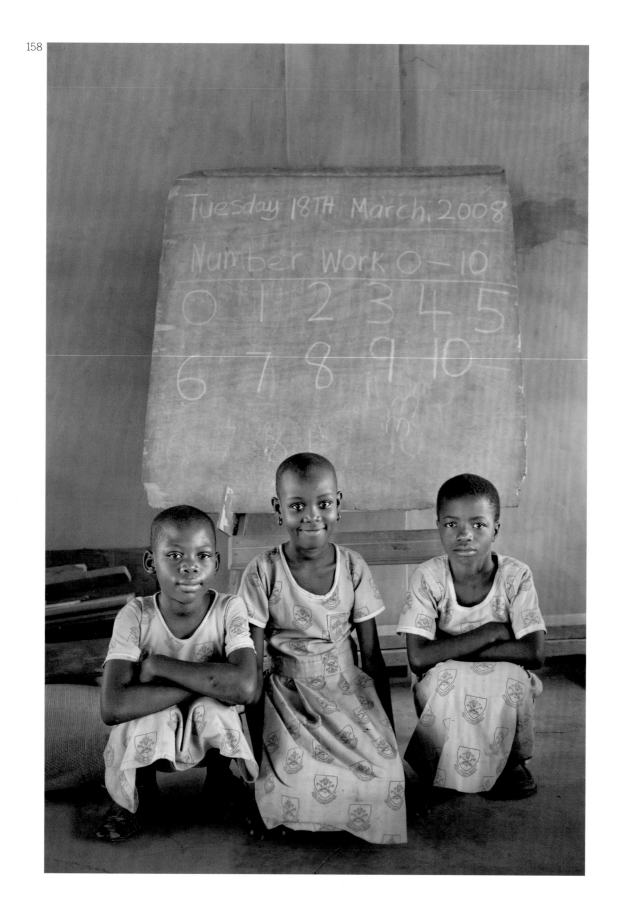

BOOKS AND PENS

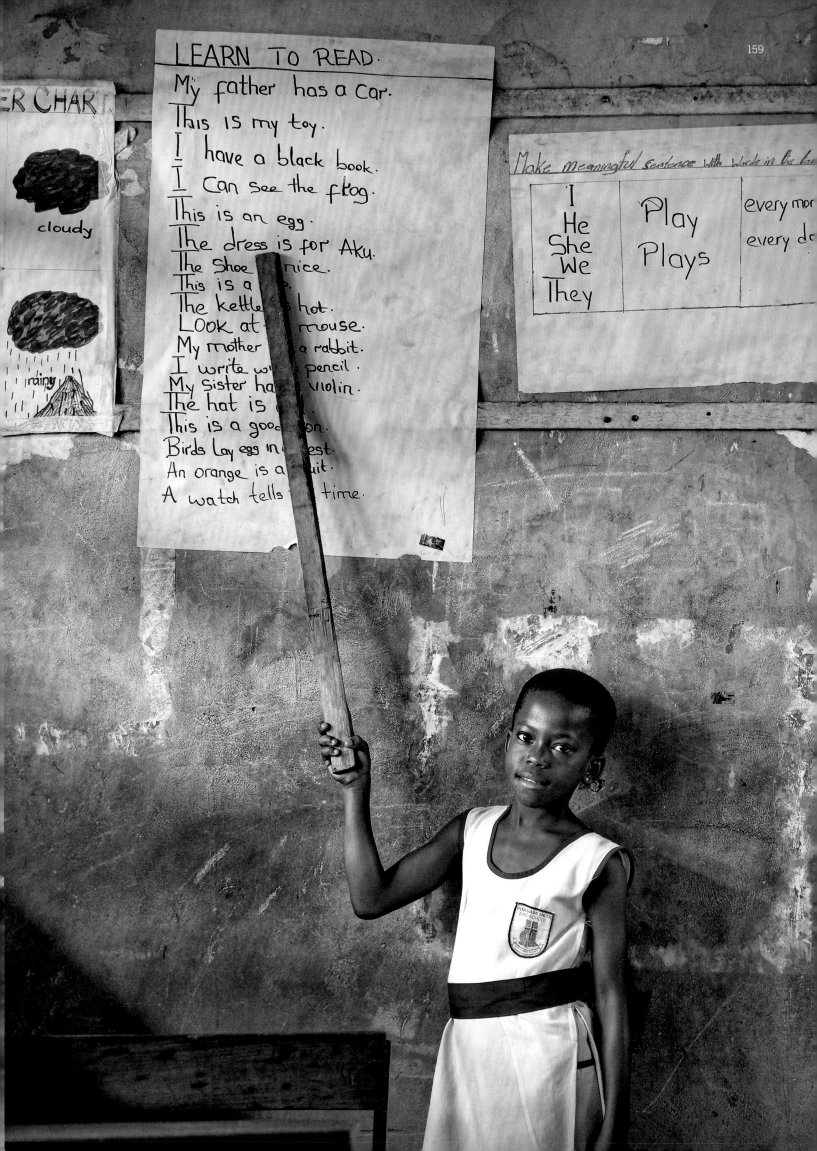

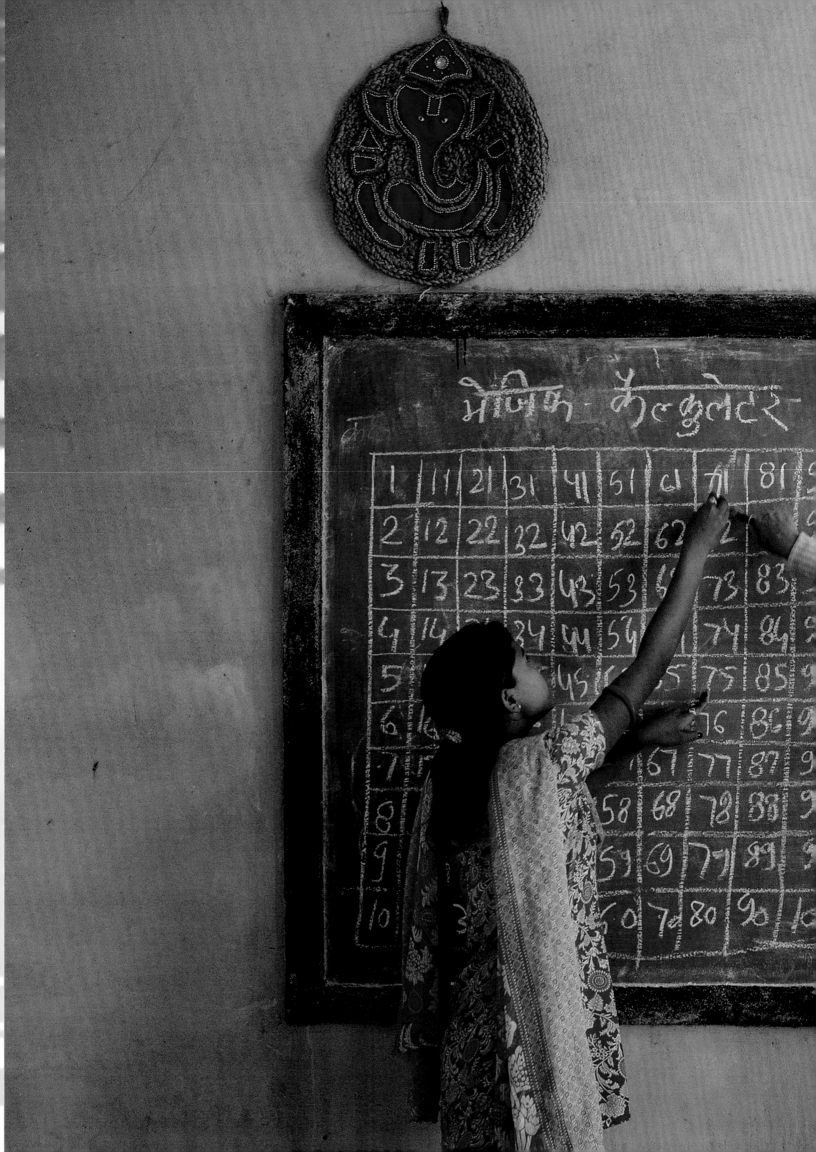

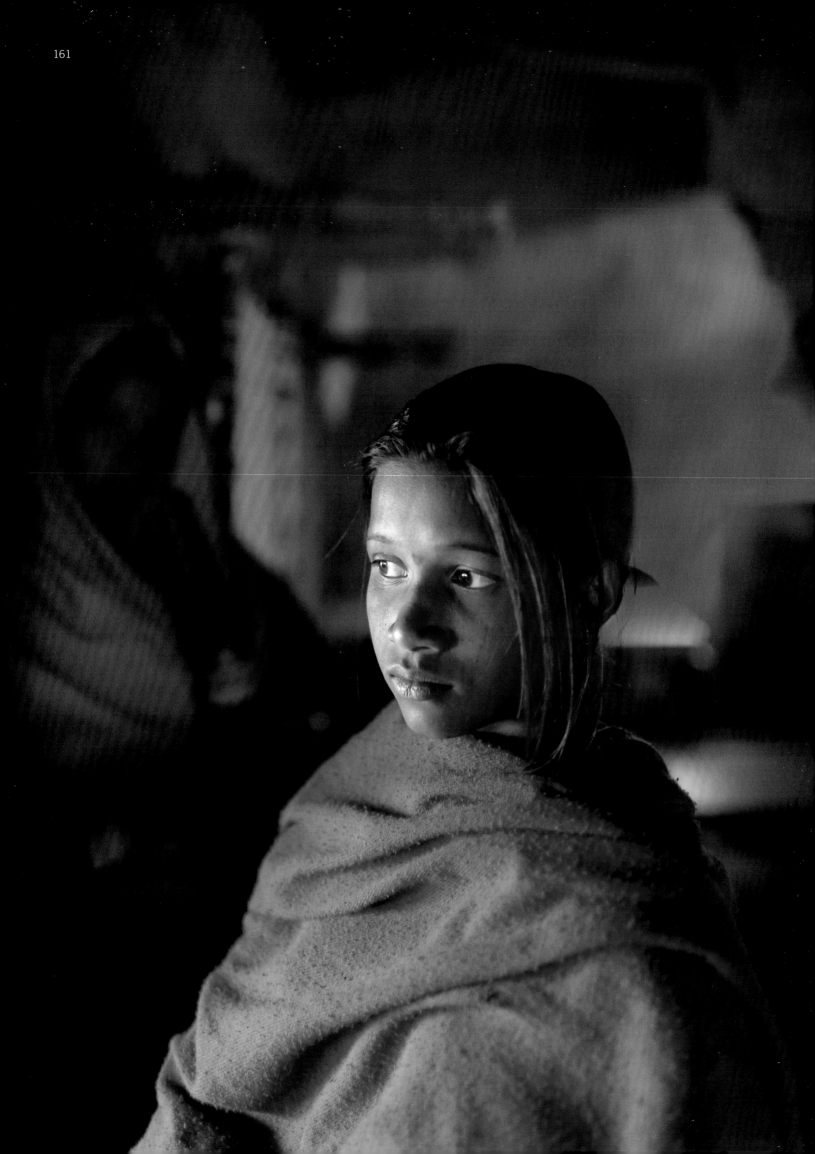

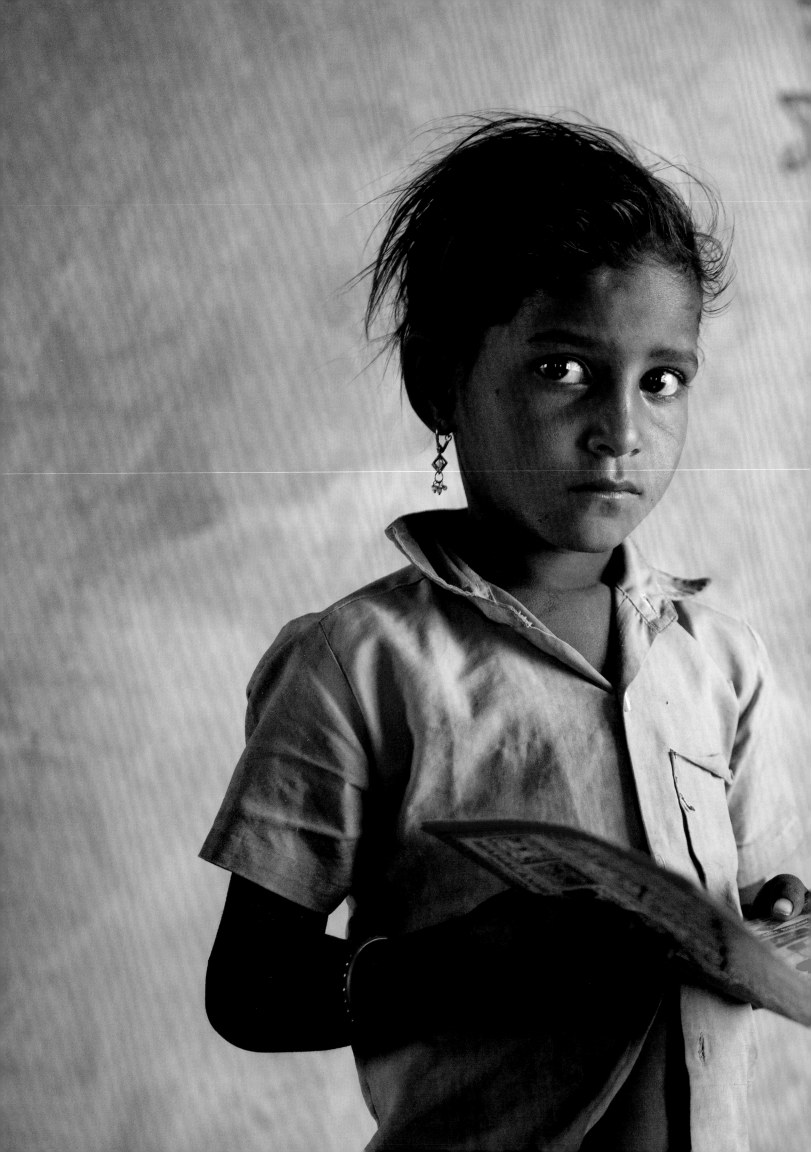

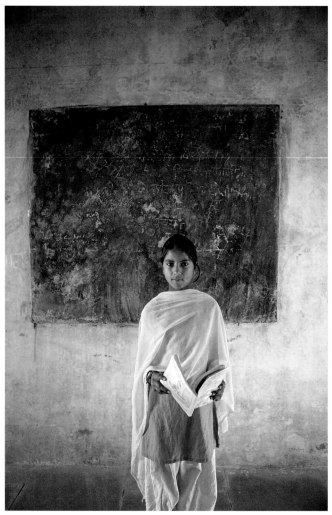

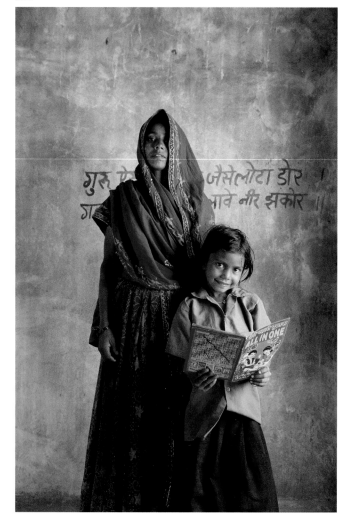

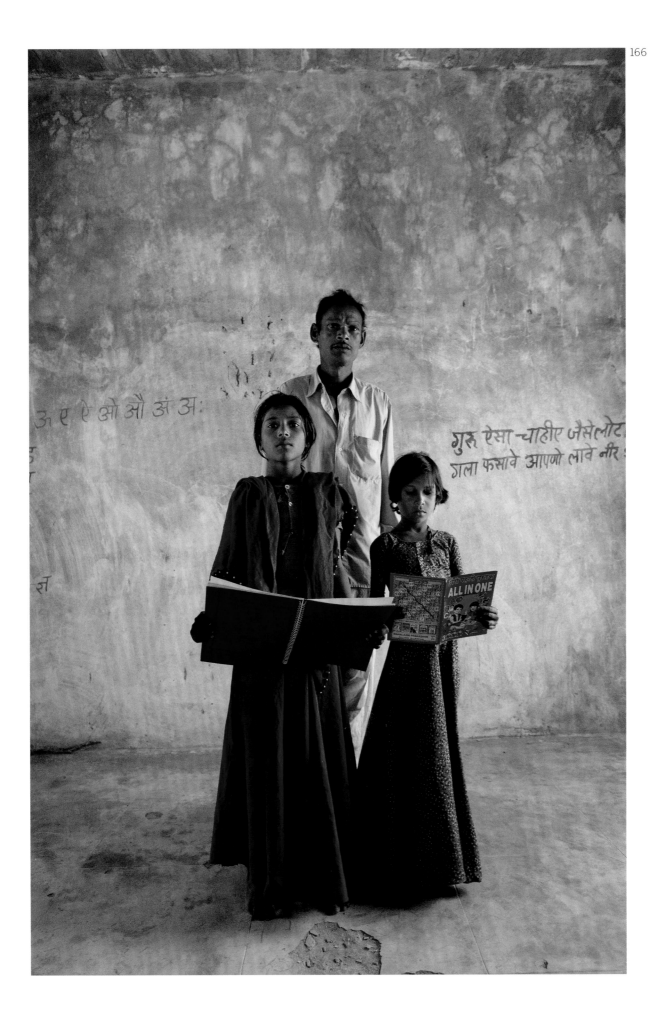

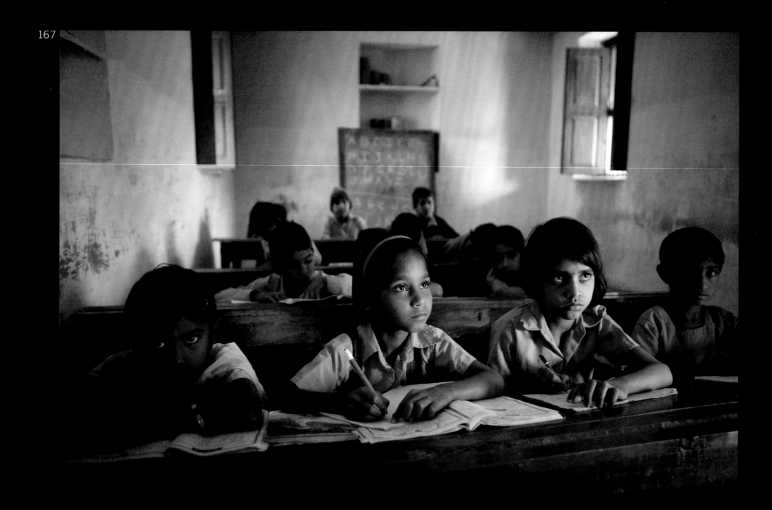

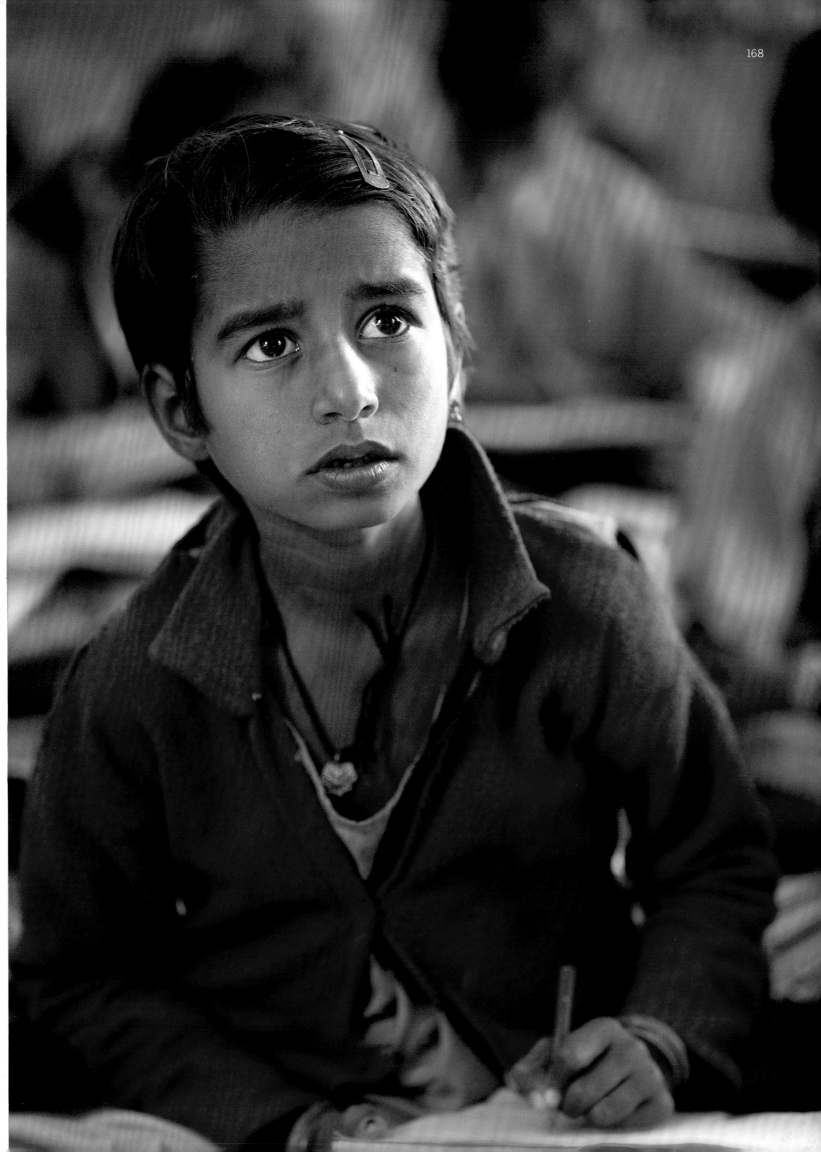

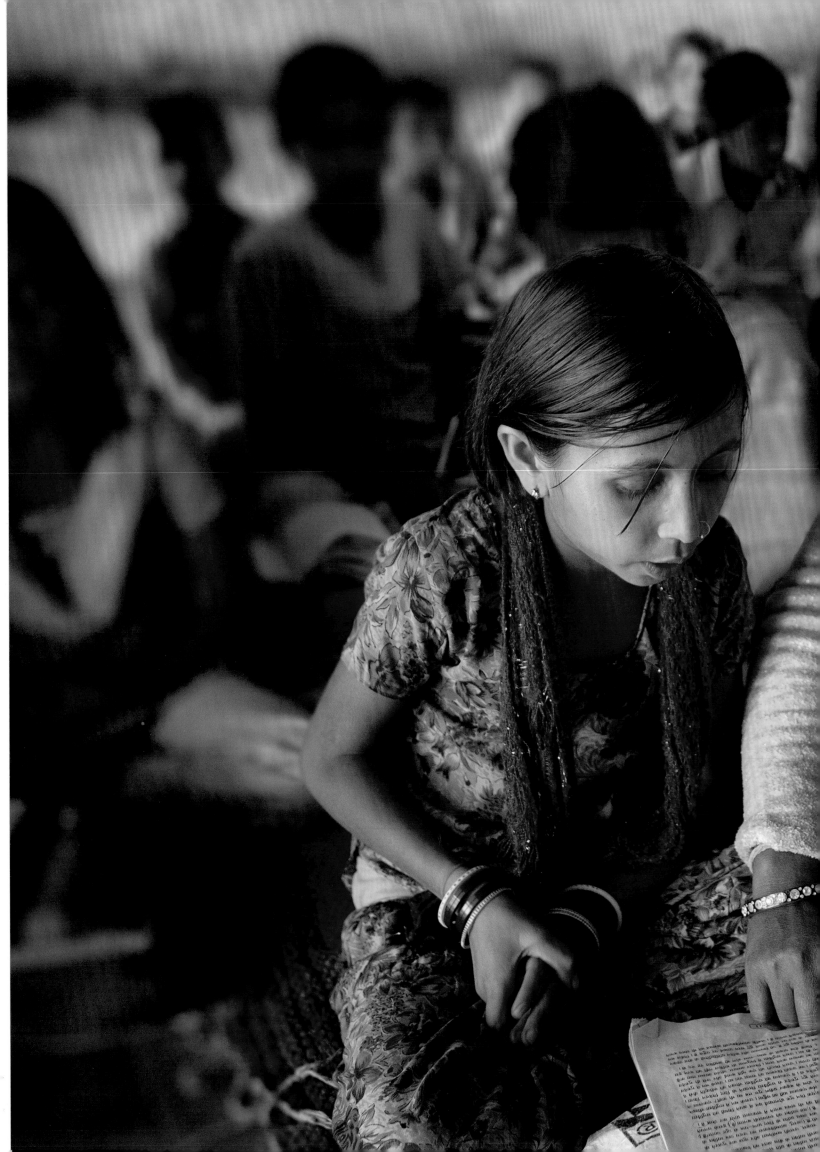

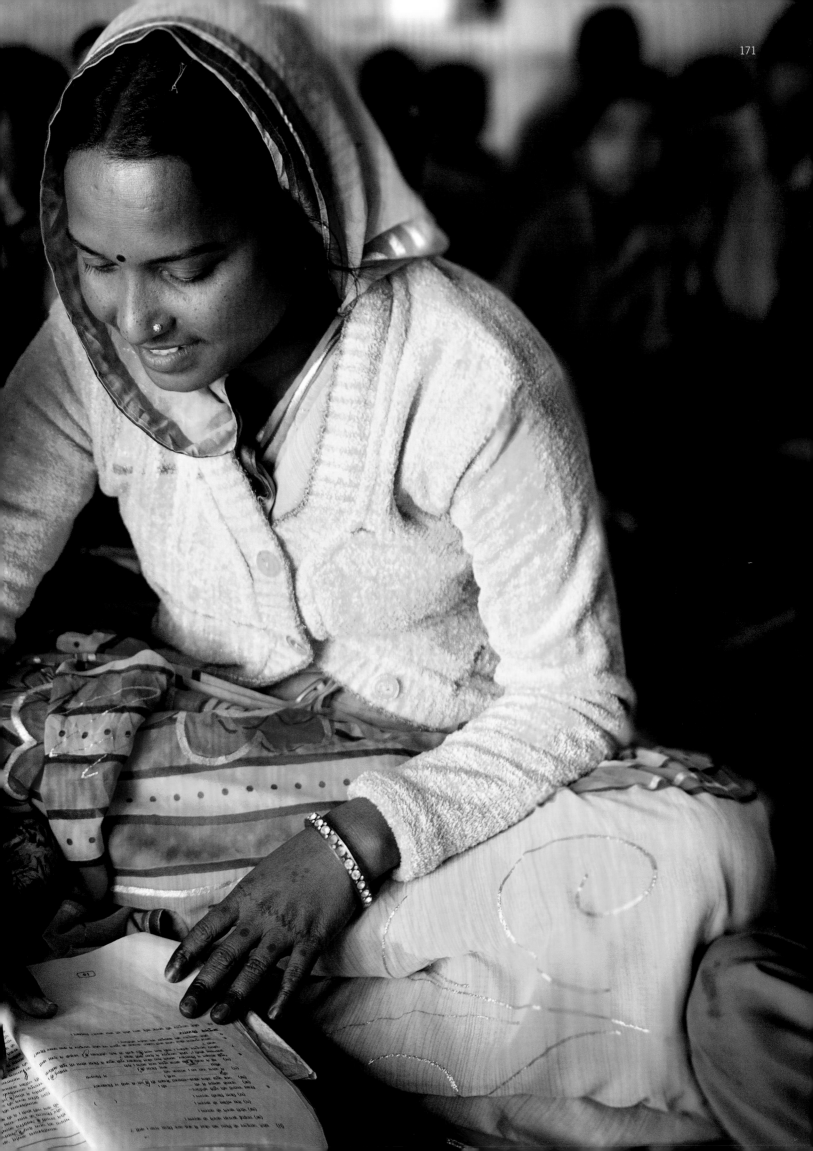

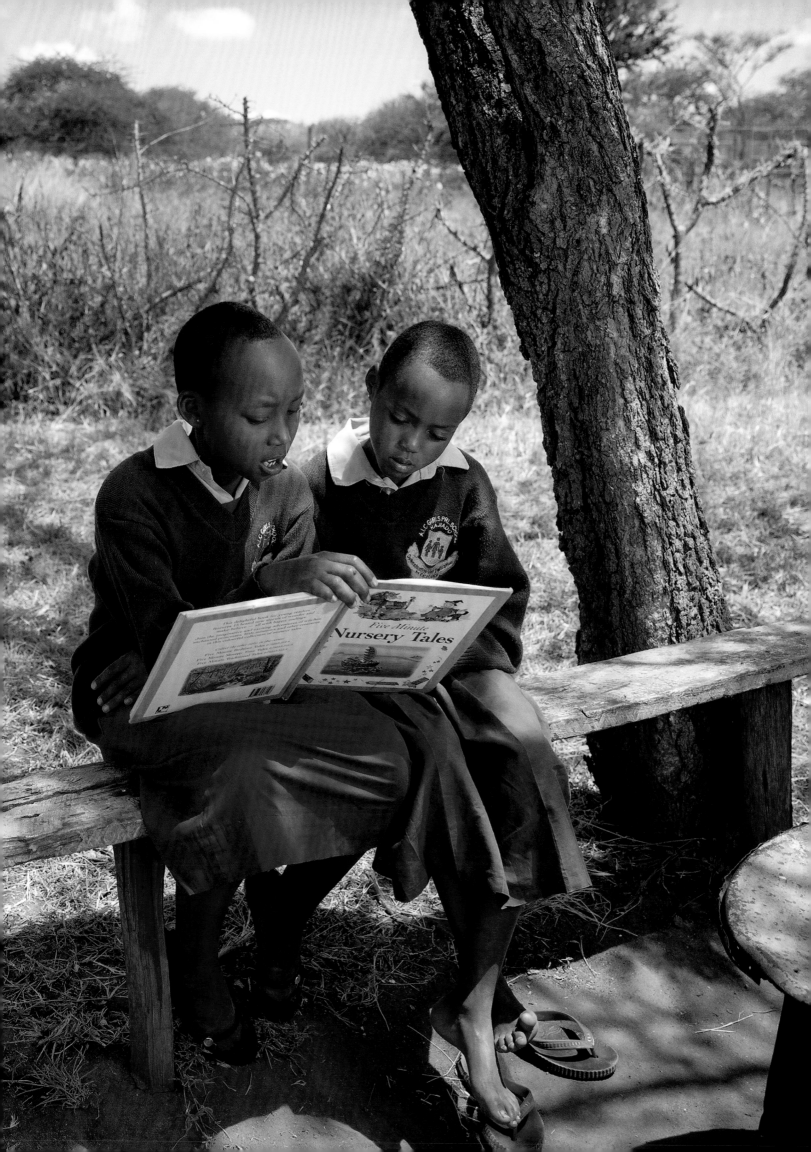

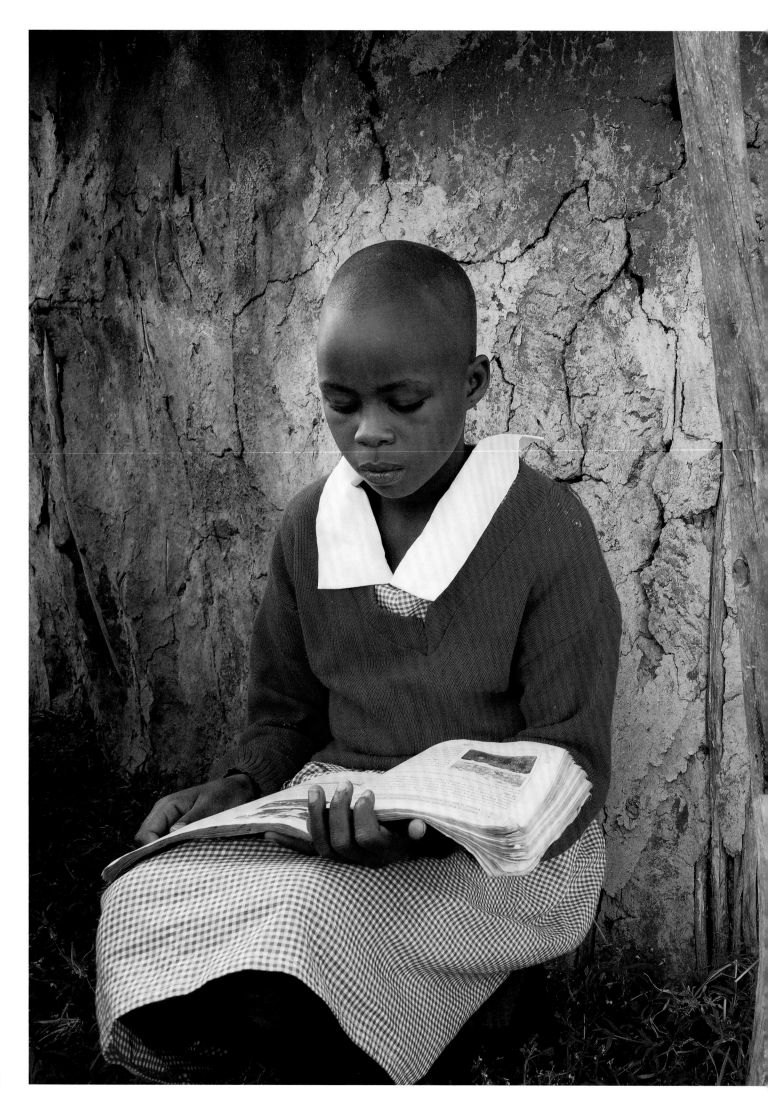

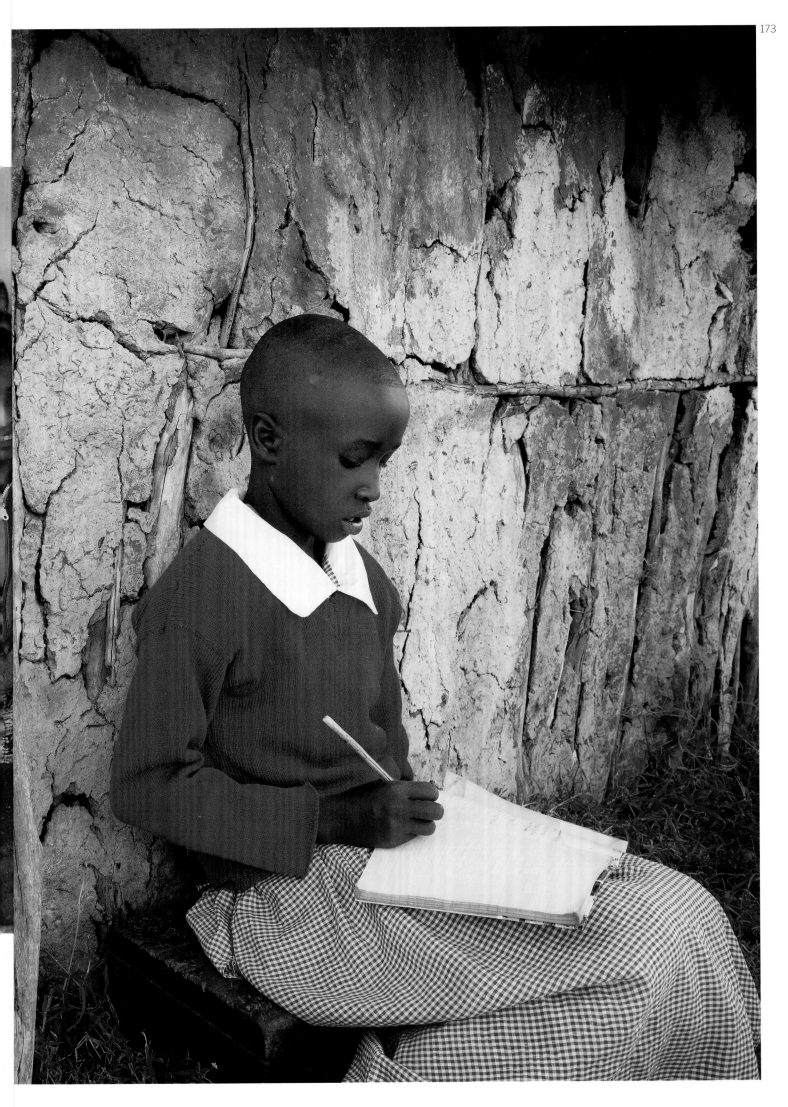

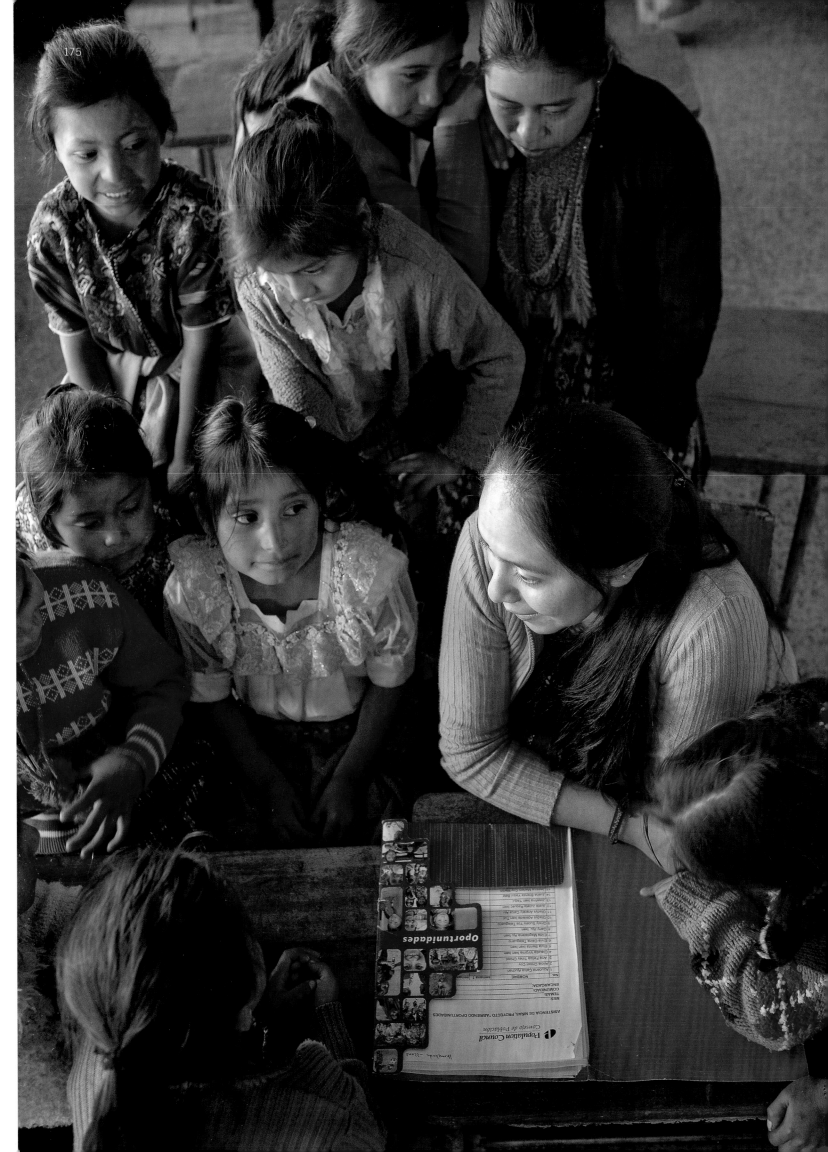

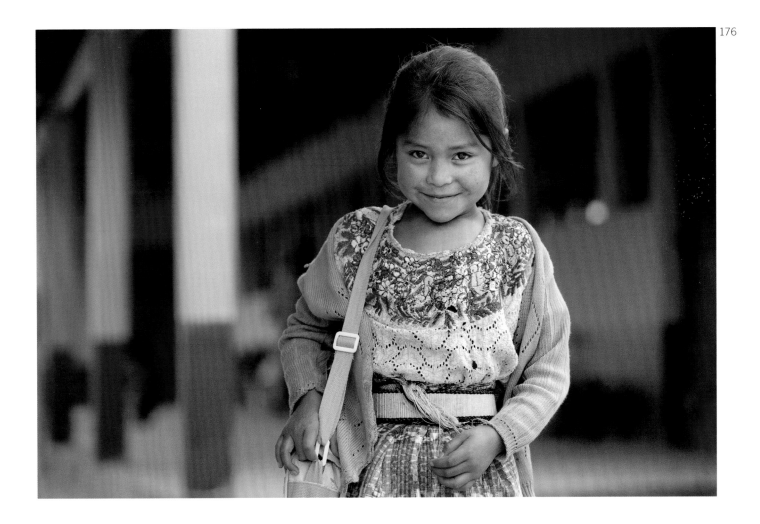

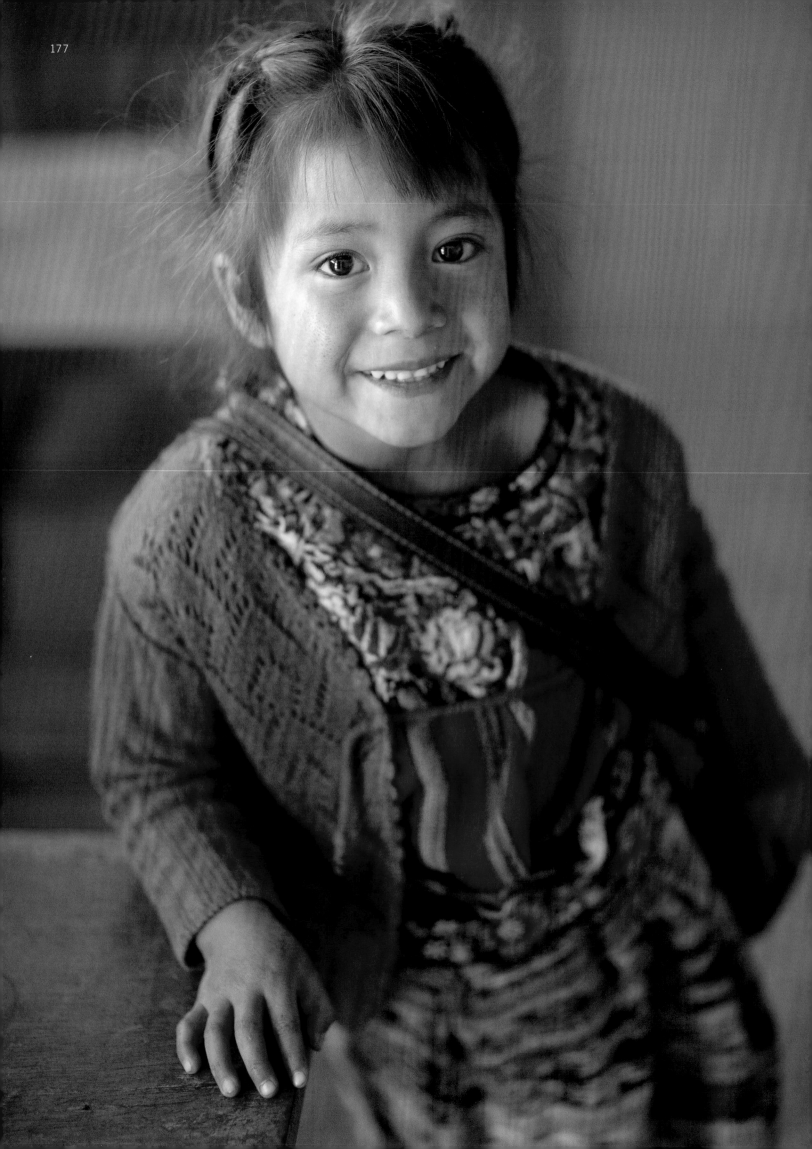

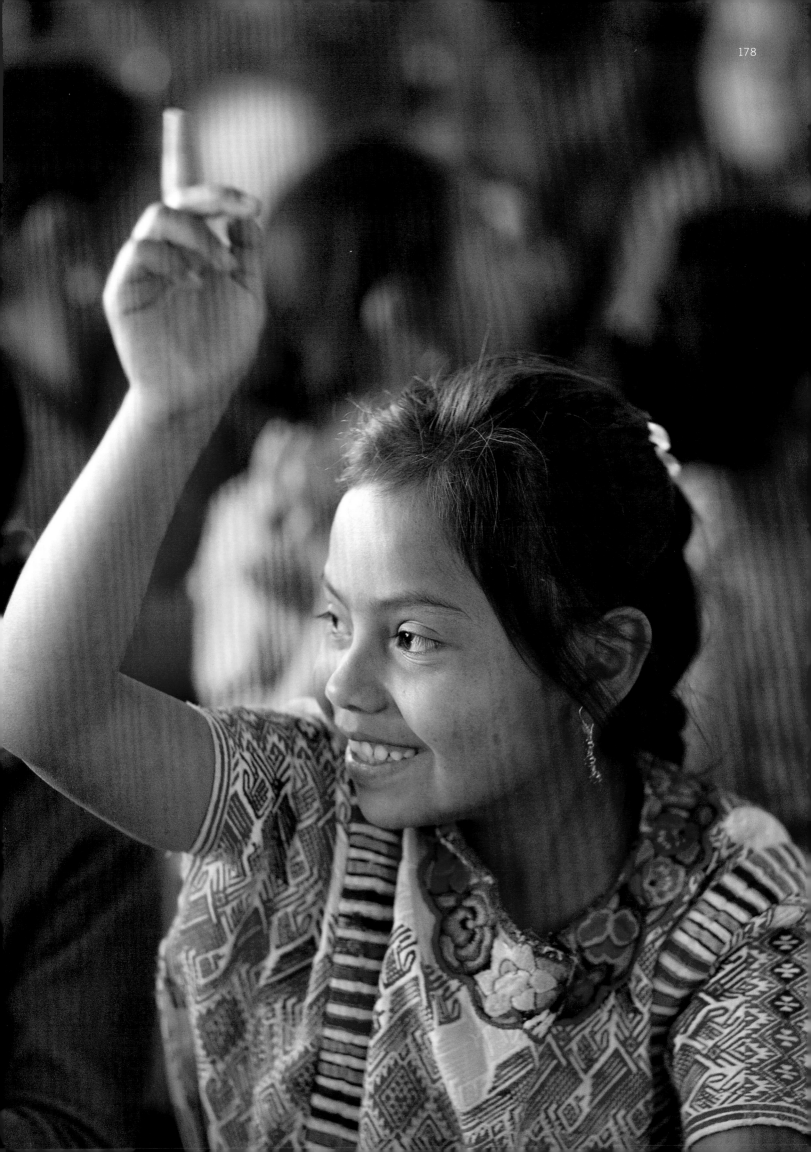

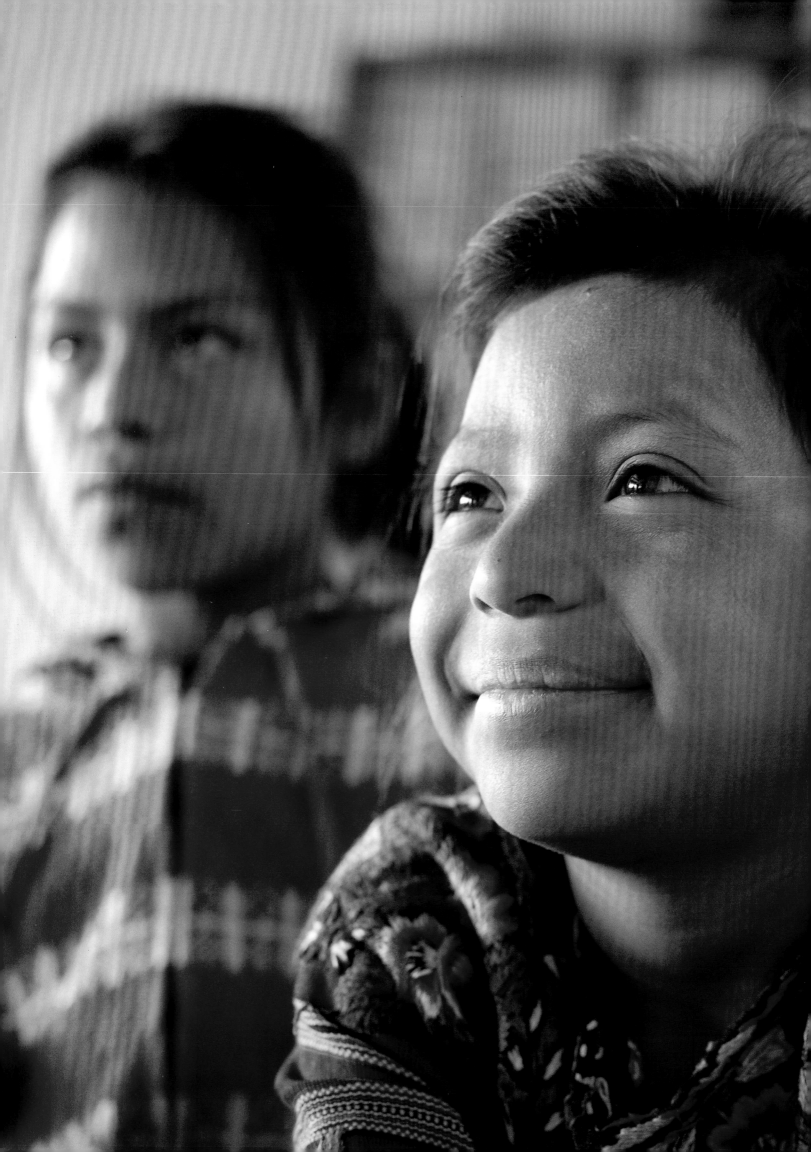

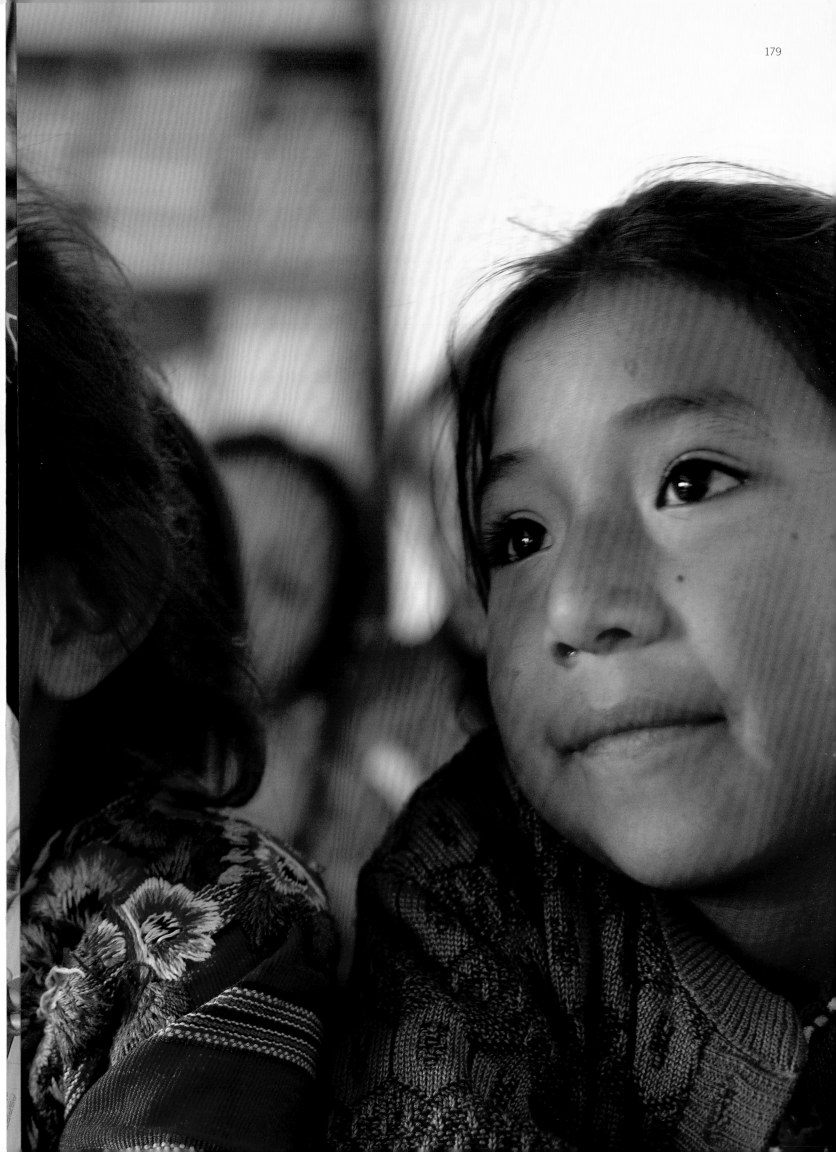

"When you change a girl's life you affect her vision of herself and her immediate world…. Because what girls do is they give back… Statistics show that when you empower a girl, you just don't change that one girl's life, you change the whole family… and the community."

–Oprah Winfrey

Teachers and Mentors

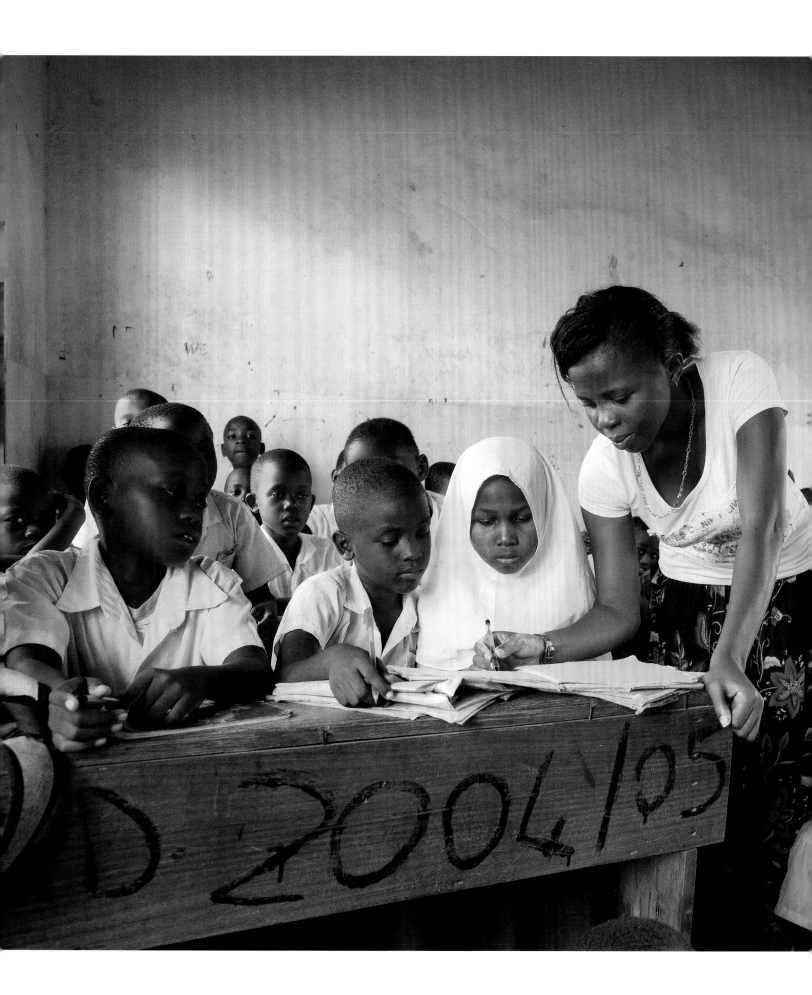

TEACHERS AND MENTORS

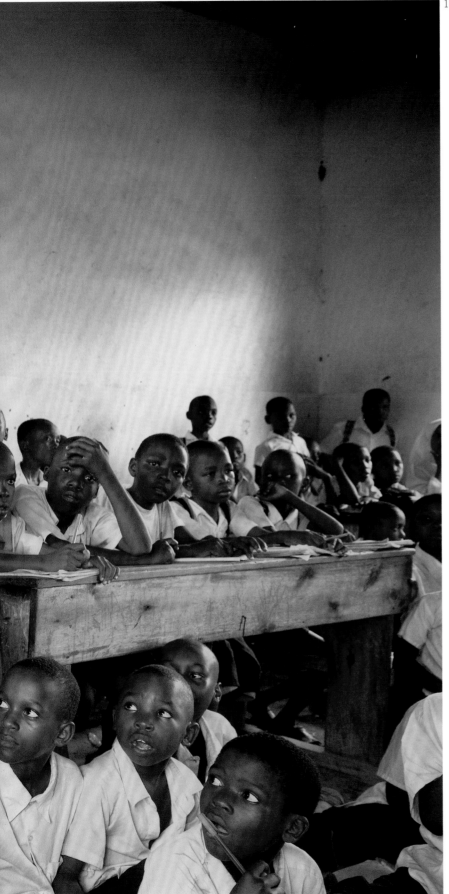

183

A TEACHER AND A NURSE WHO ROSE FROM THE SLUMS OF EAST AFRICA 291291

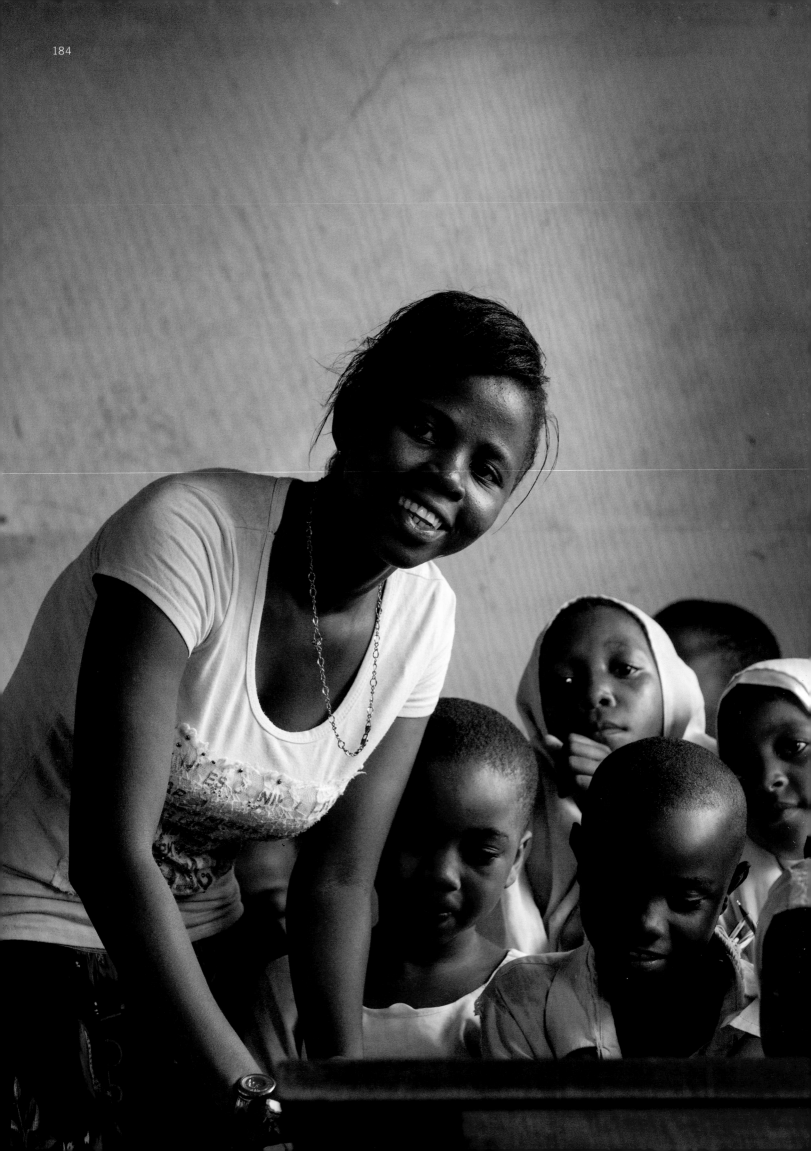

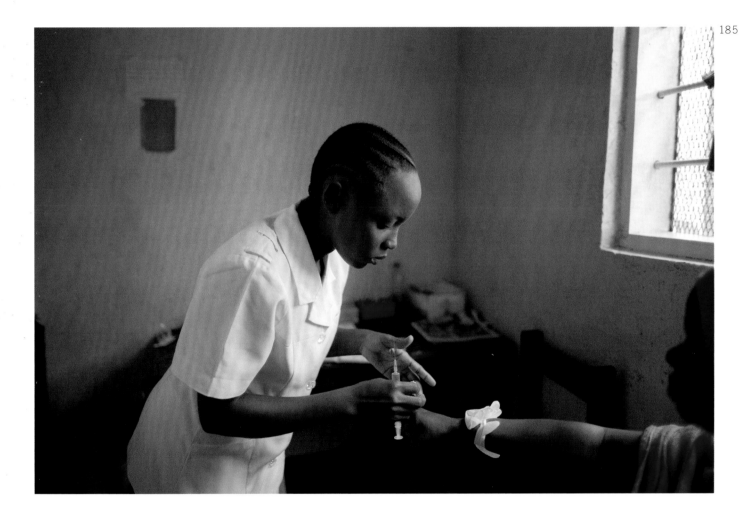

A TEACHER AND A NURSE WHO ROSE FROM THE SLUMS OF EAST AFRICA

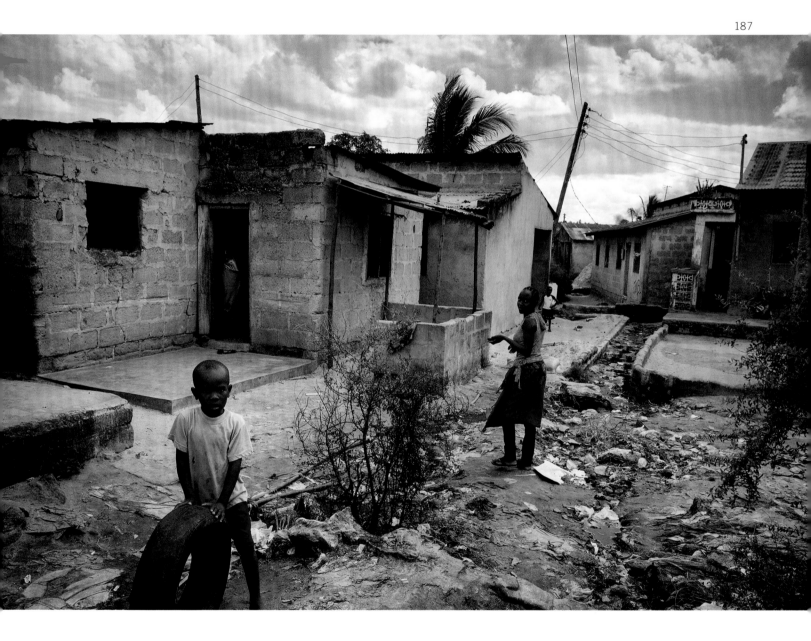

A TEACHER AND A NURSE WHO ROSE FROM THE SLUMS OF EAST AFRICA

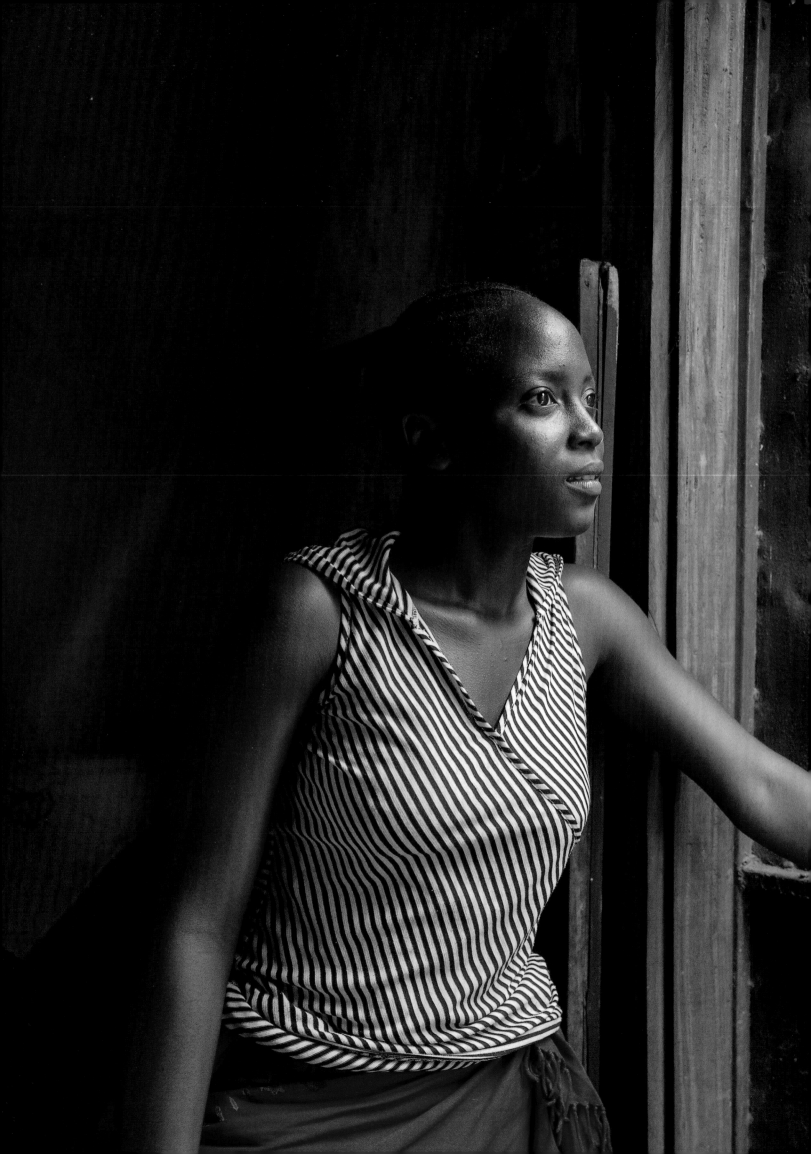

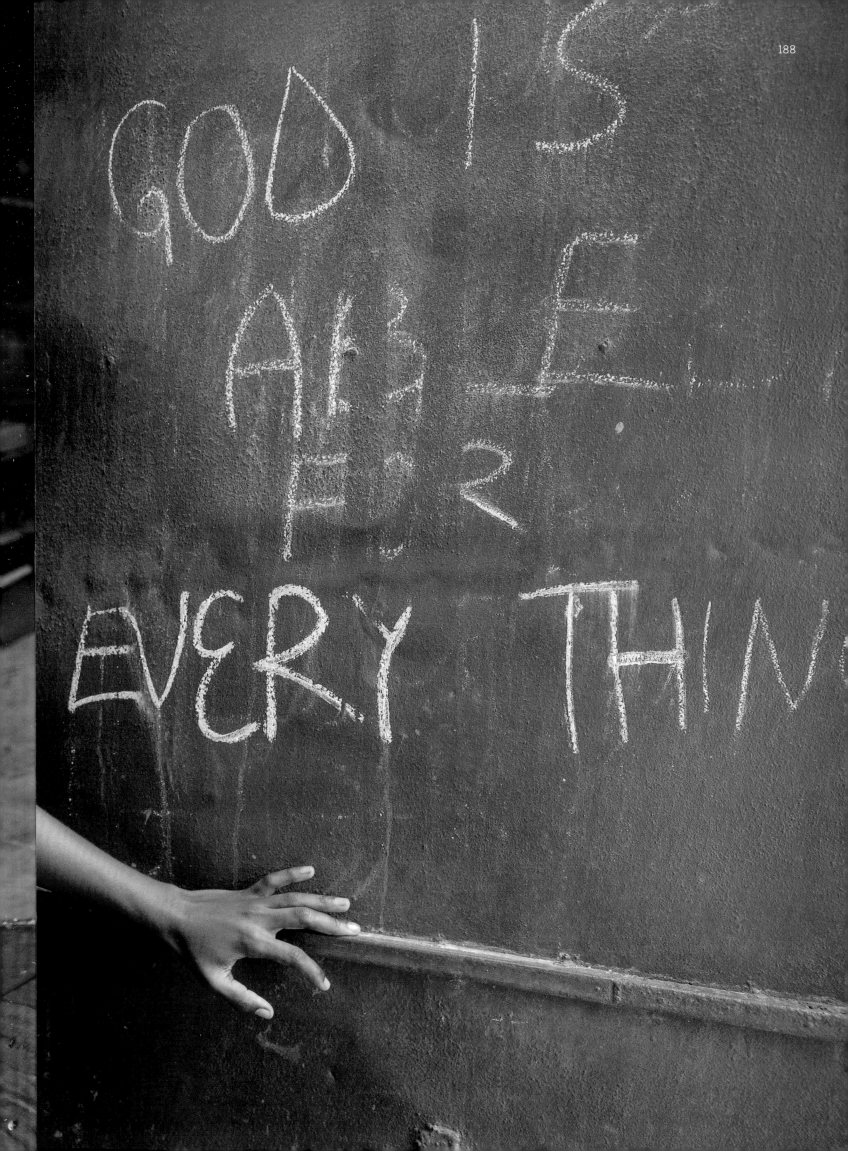

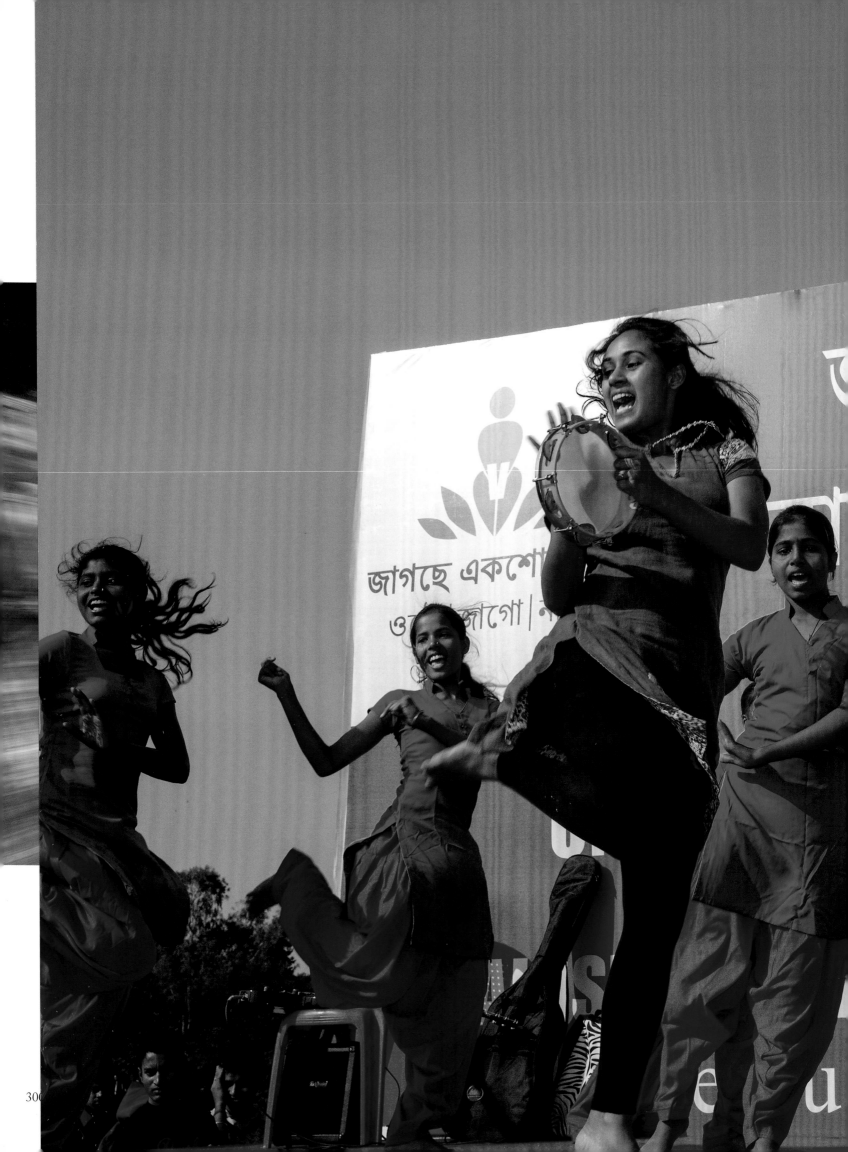

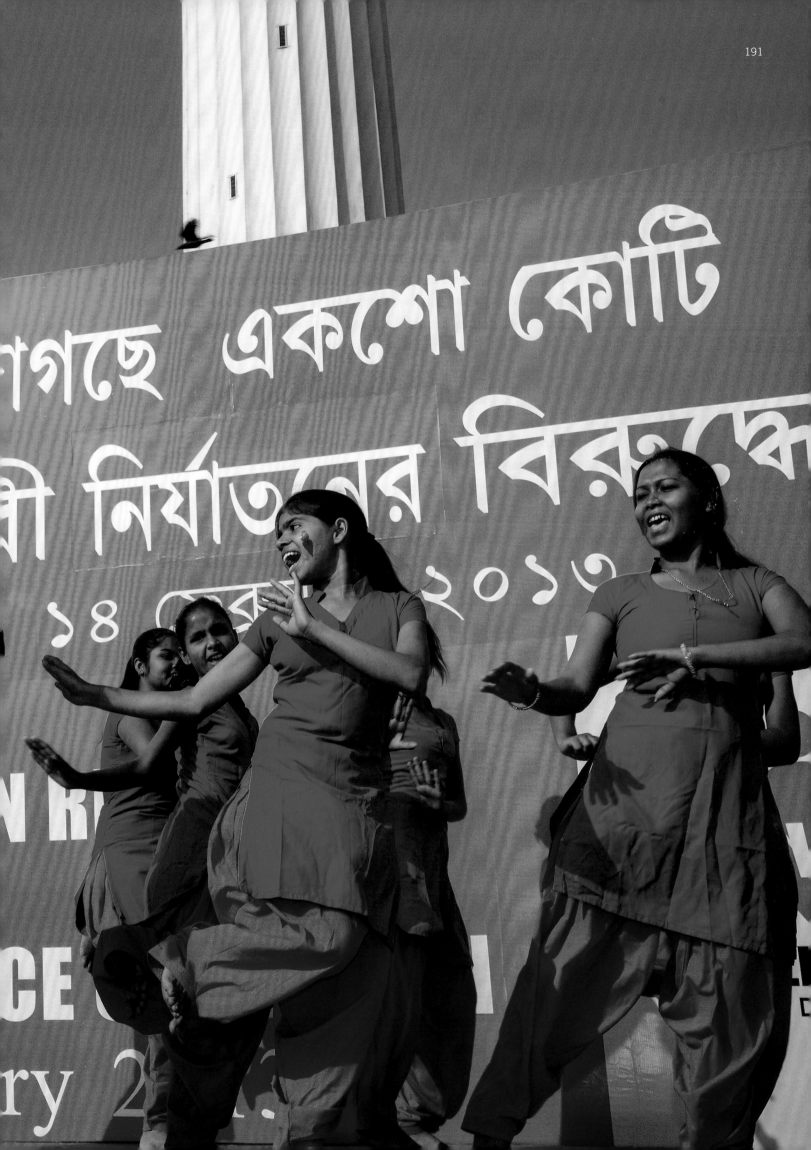

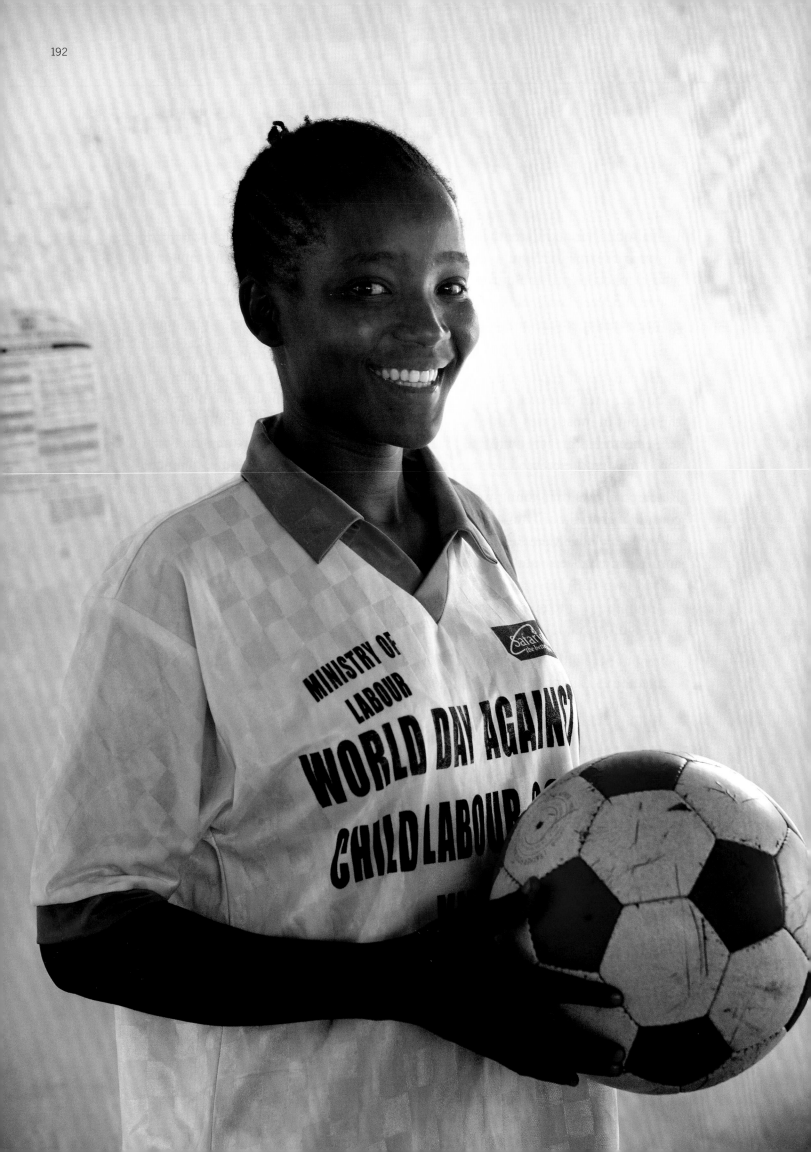

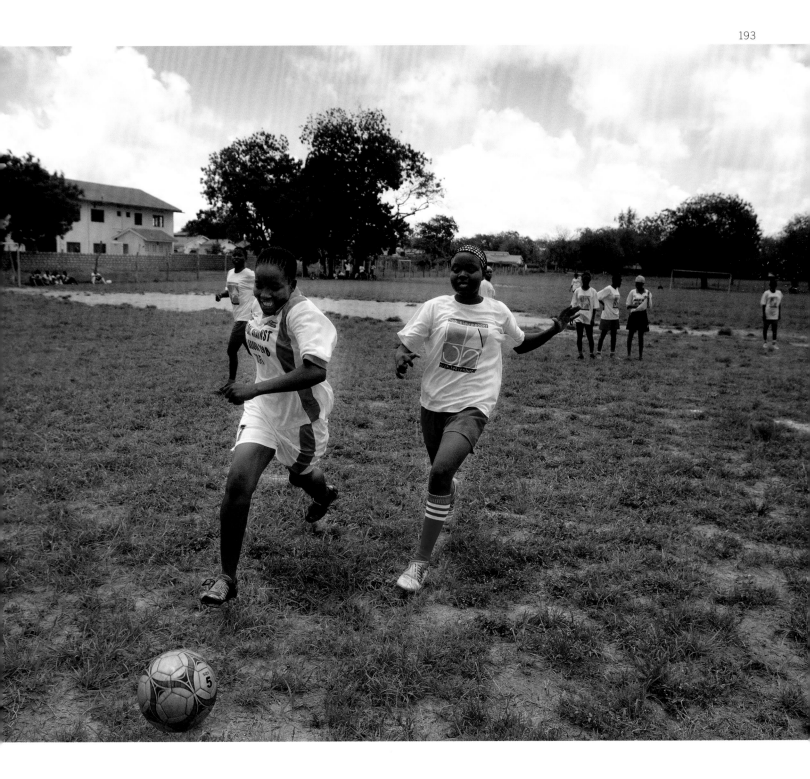

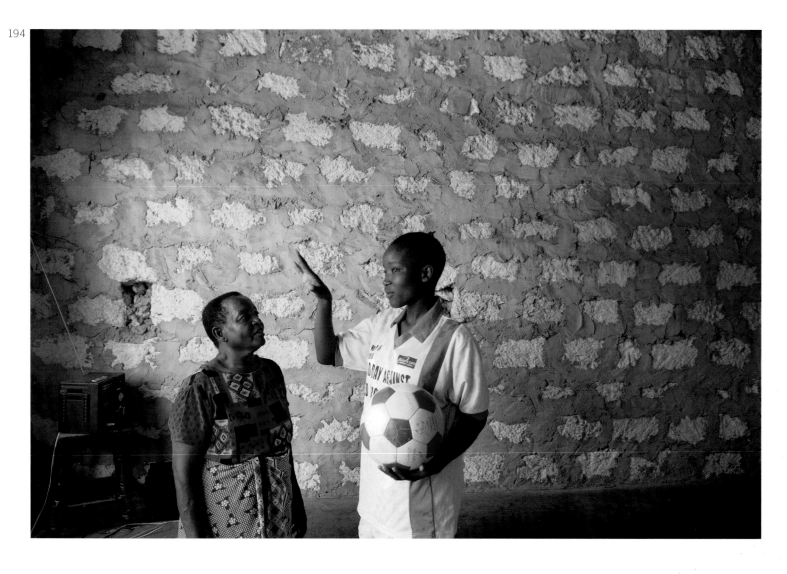

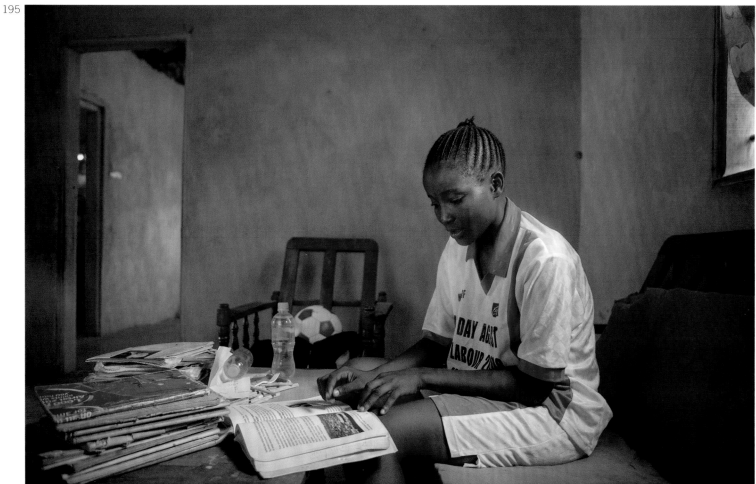

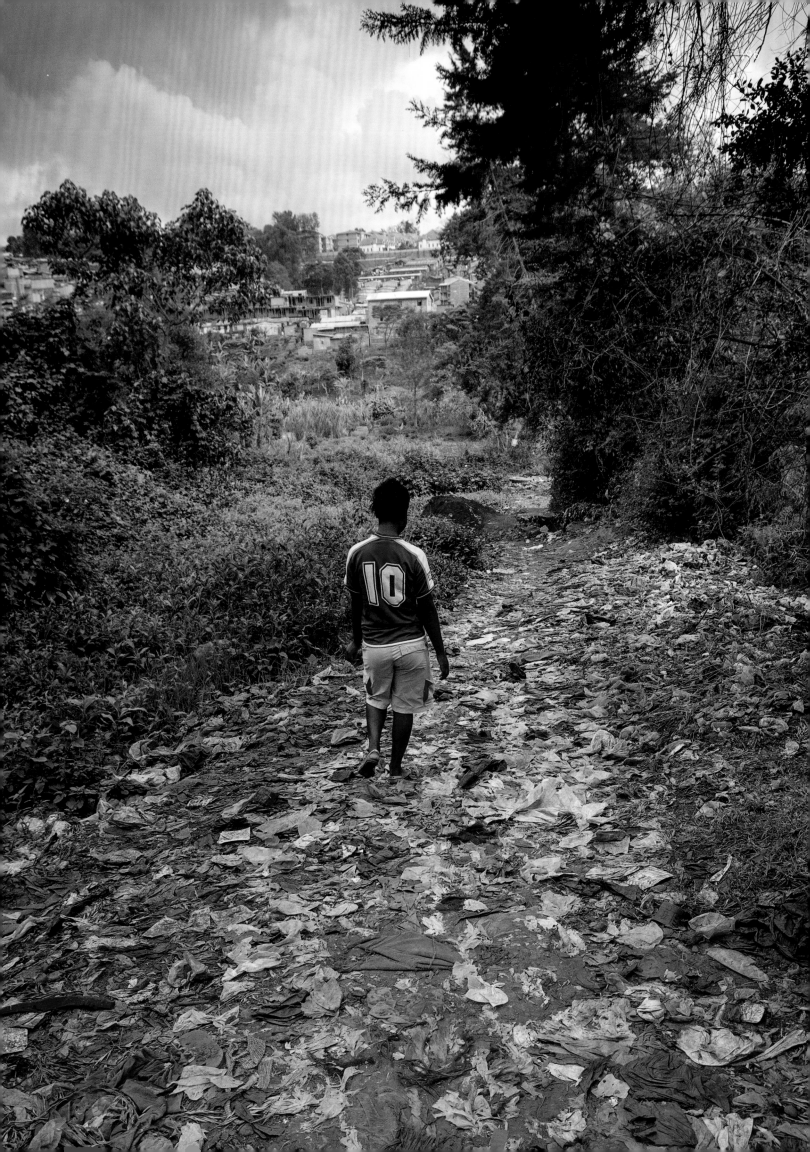

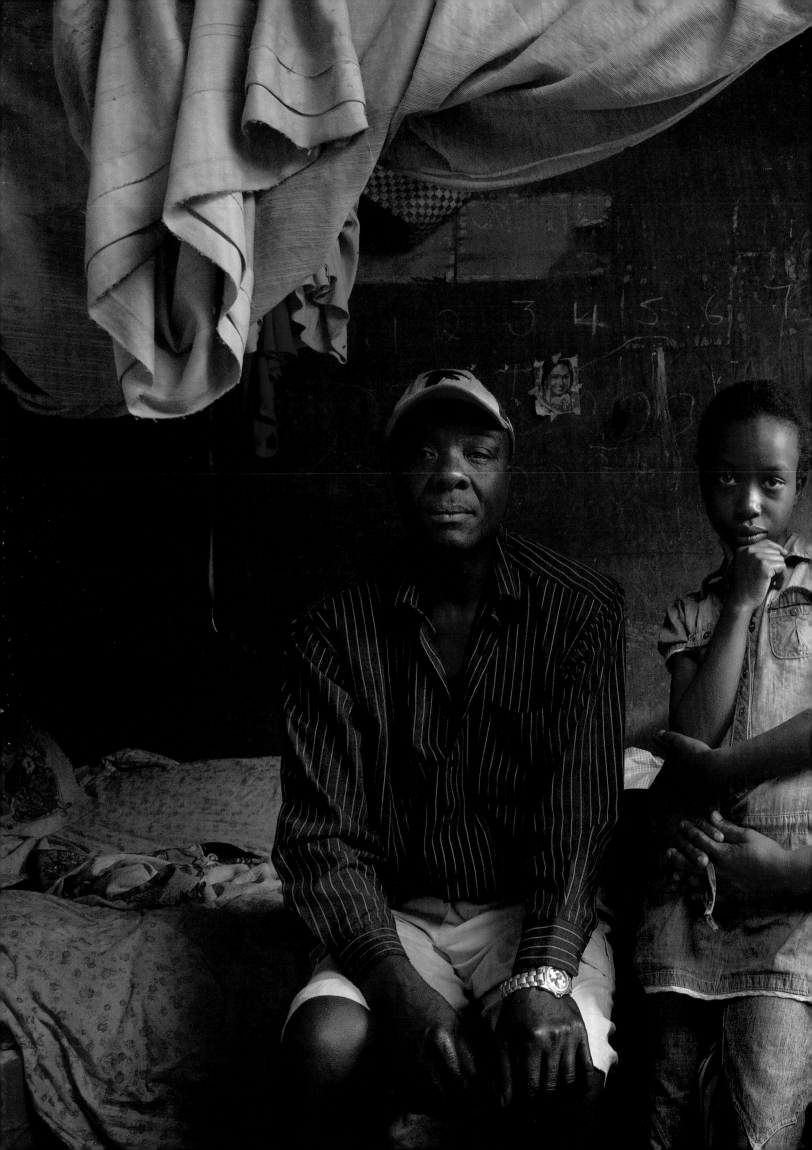

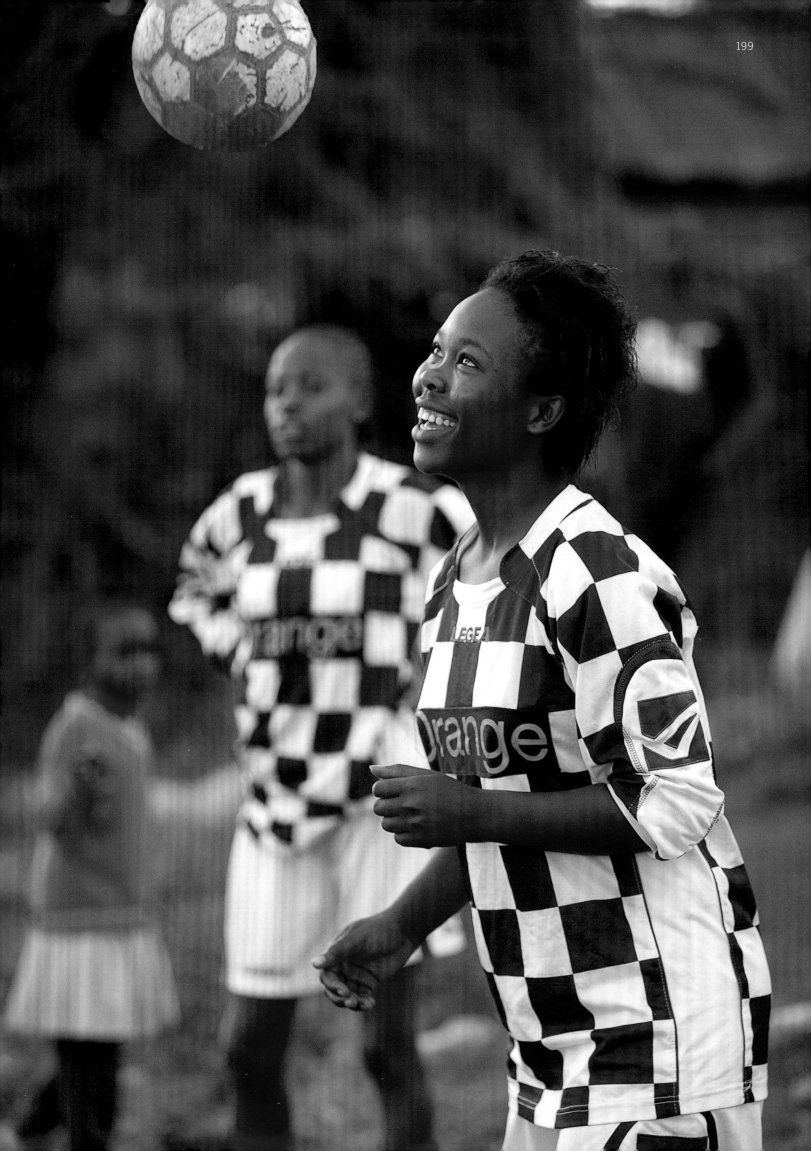

We should live in a world where "every pregnancy is wanted, every birth is safe, and every young person's potential (especially those of young girls) is fulfilled."

UNFPA

Faces of Hope

Faces of Hope

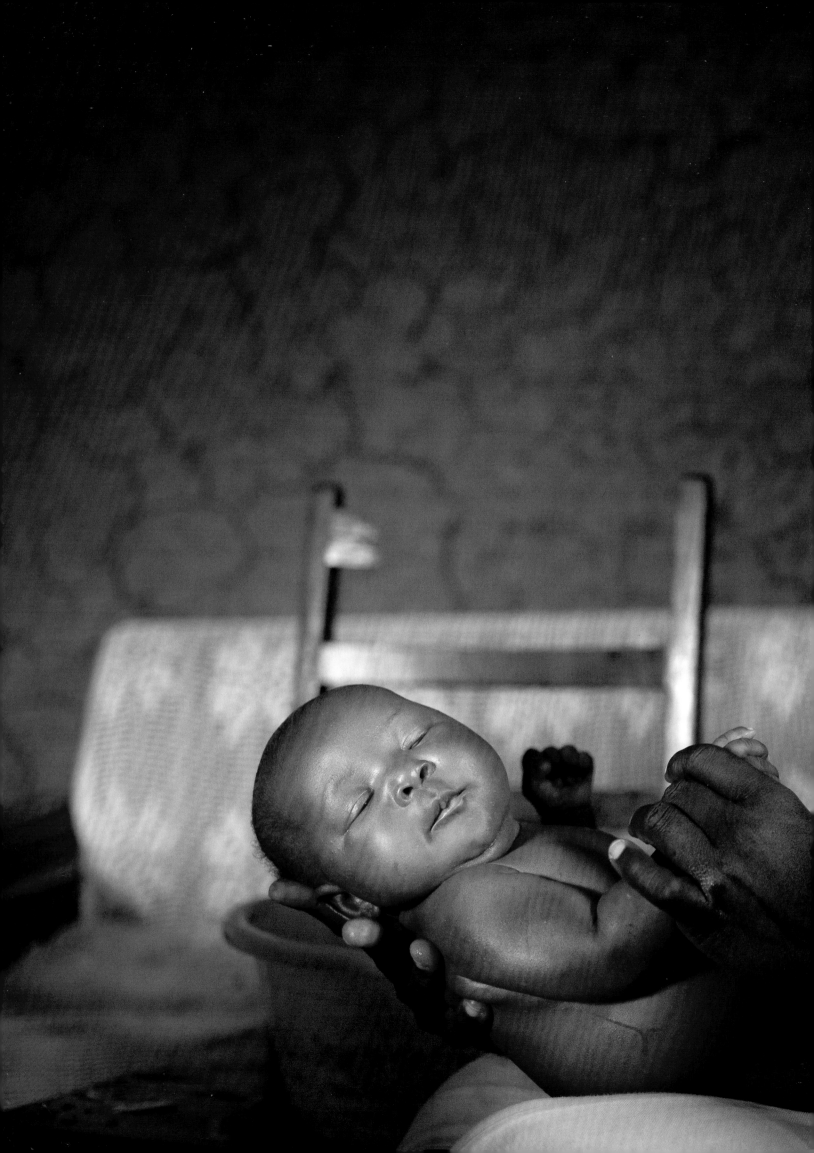

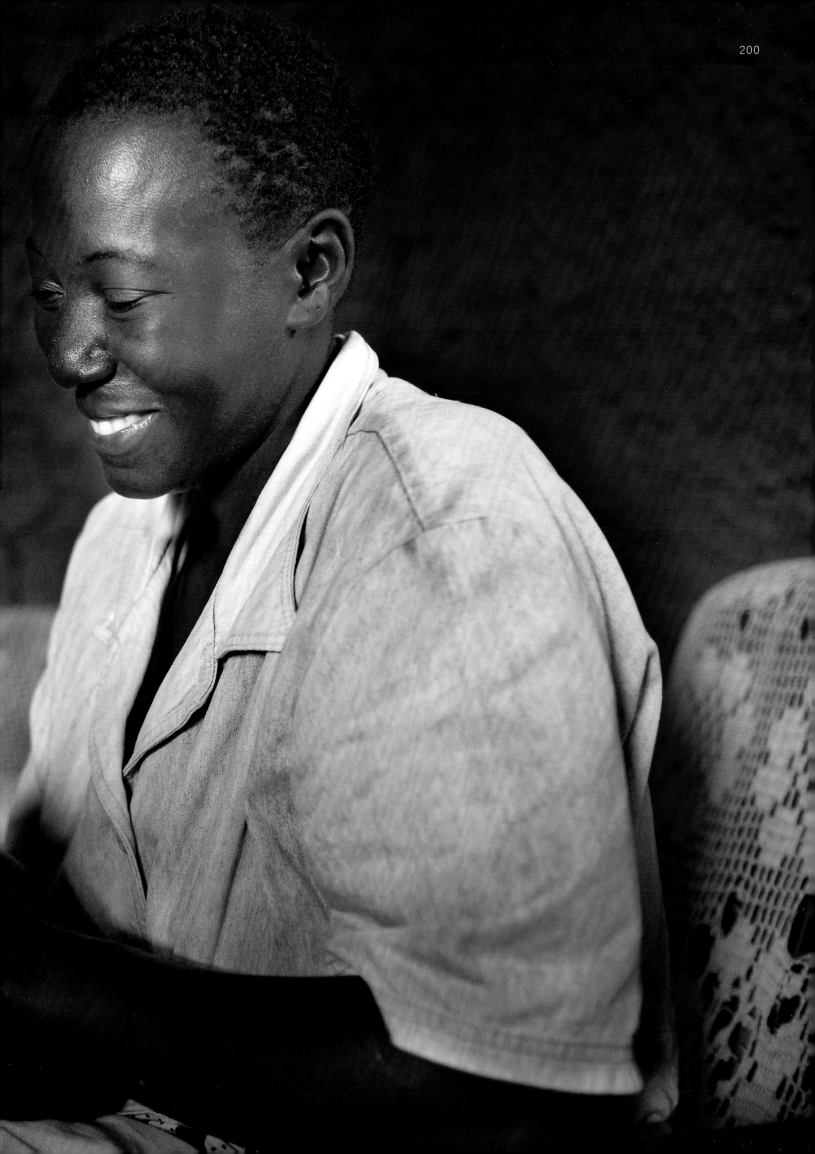

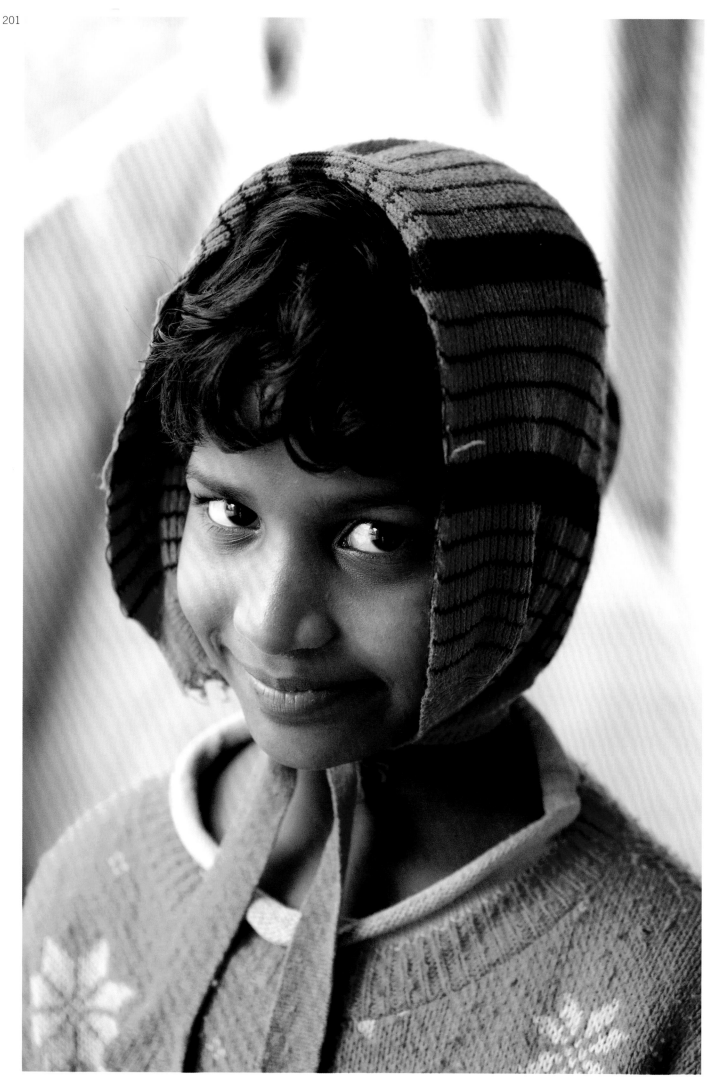

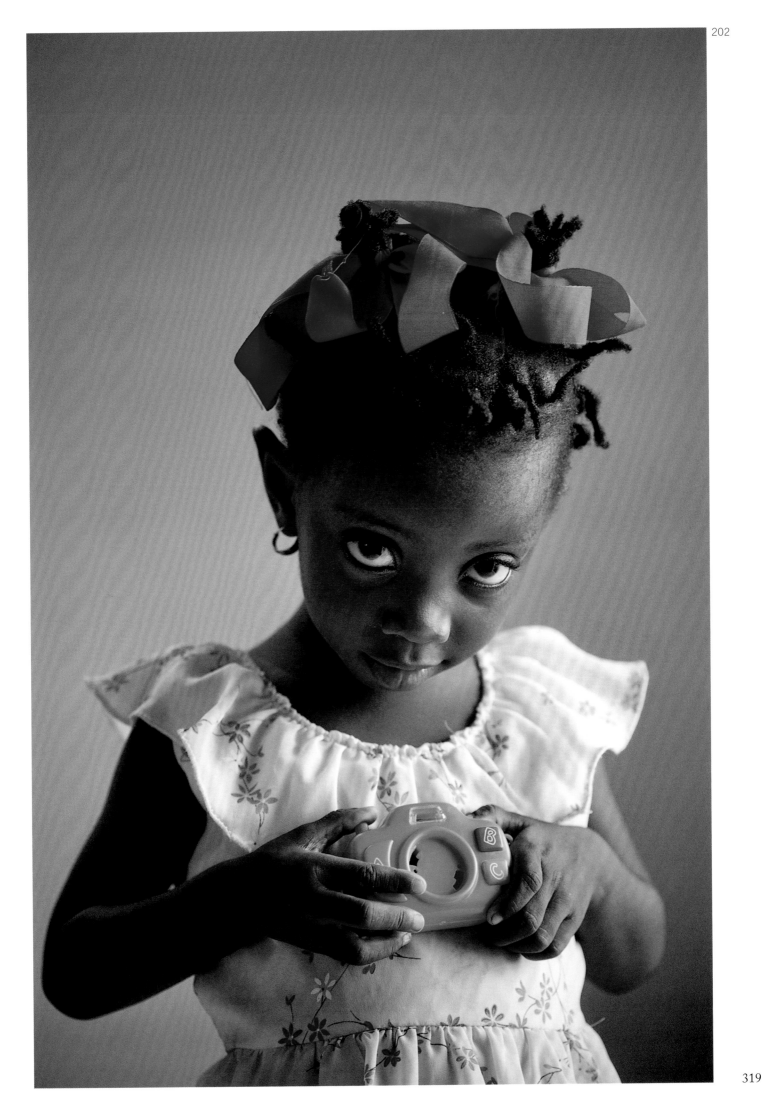

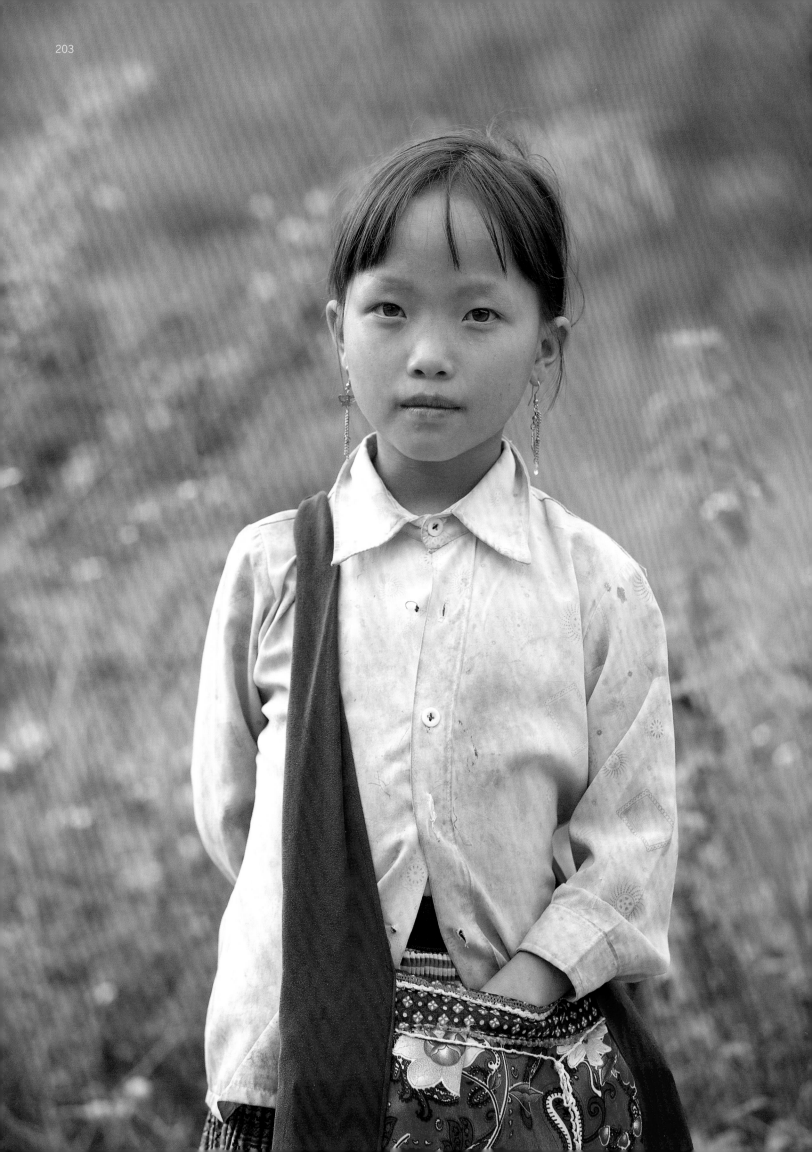

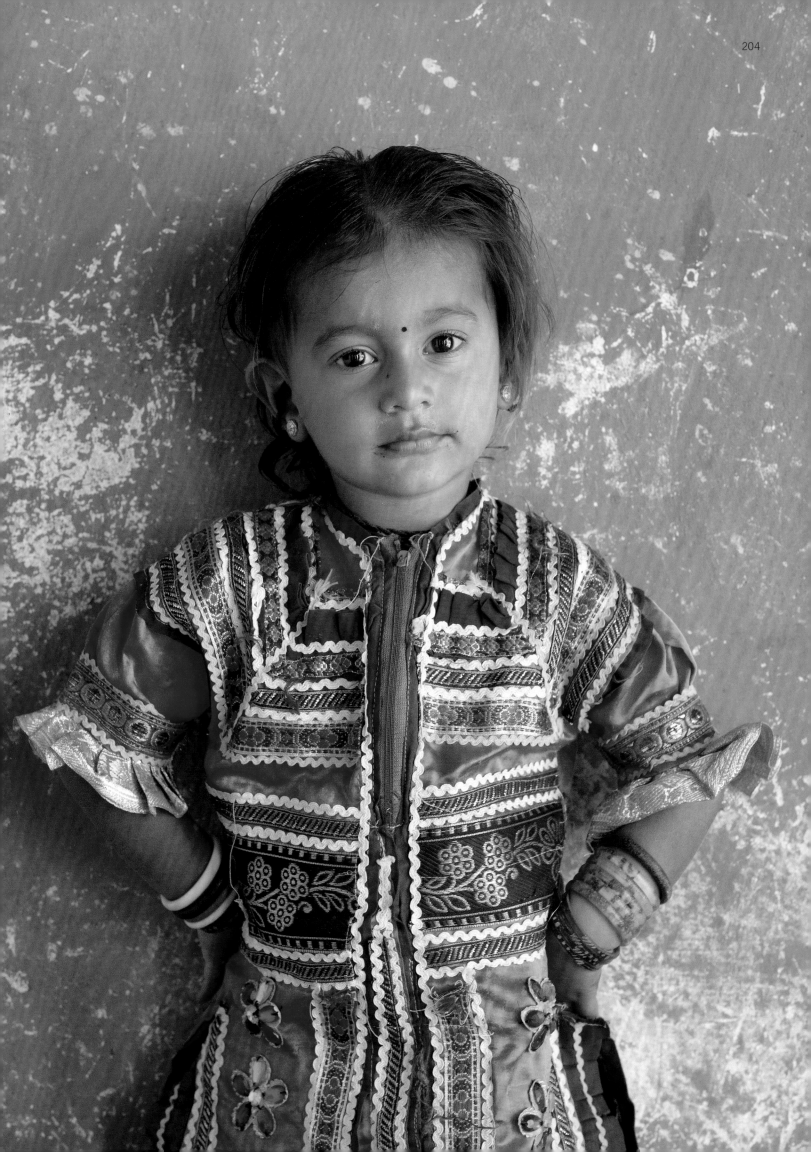

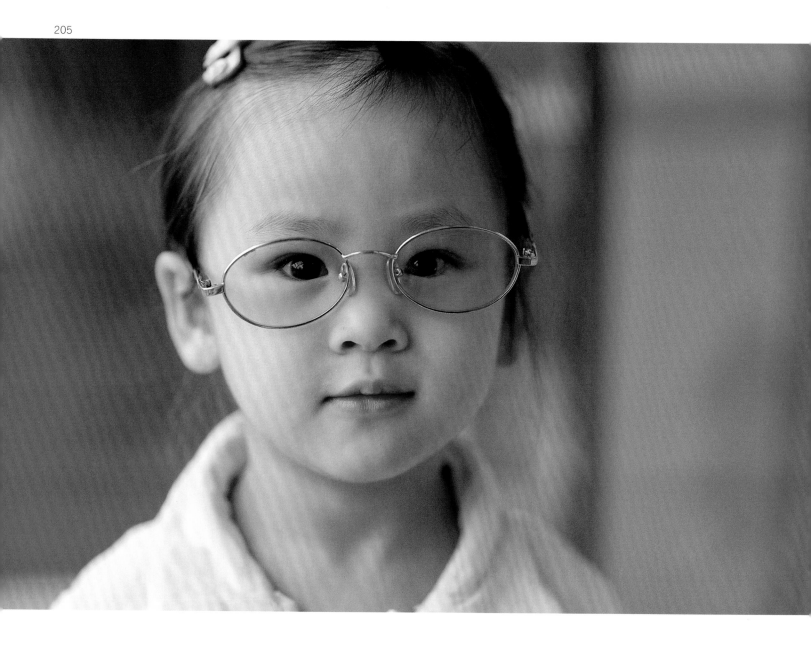

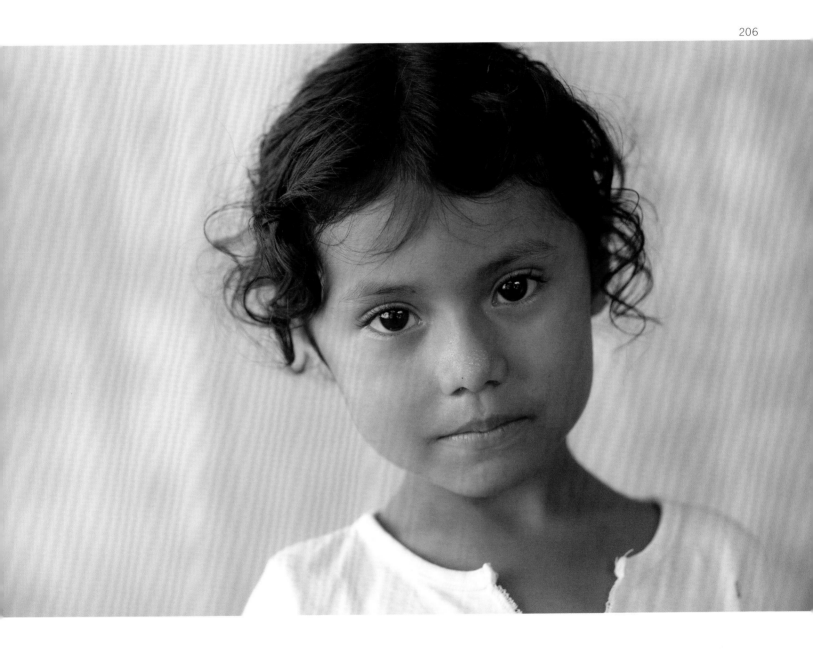

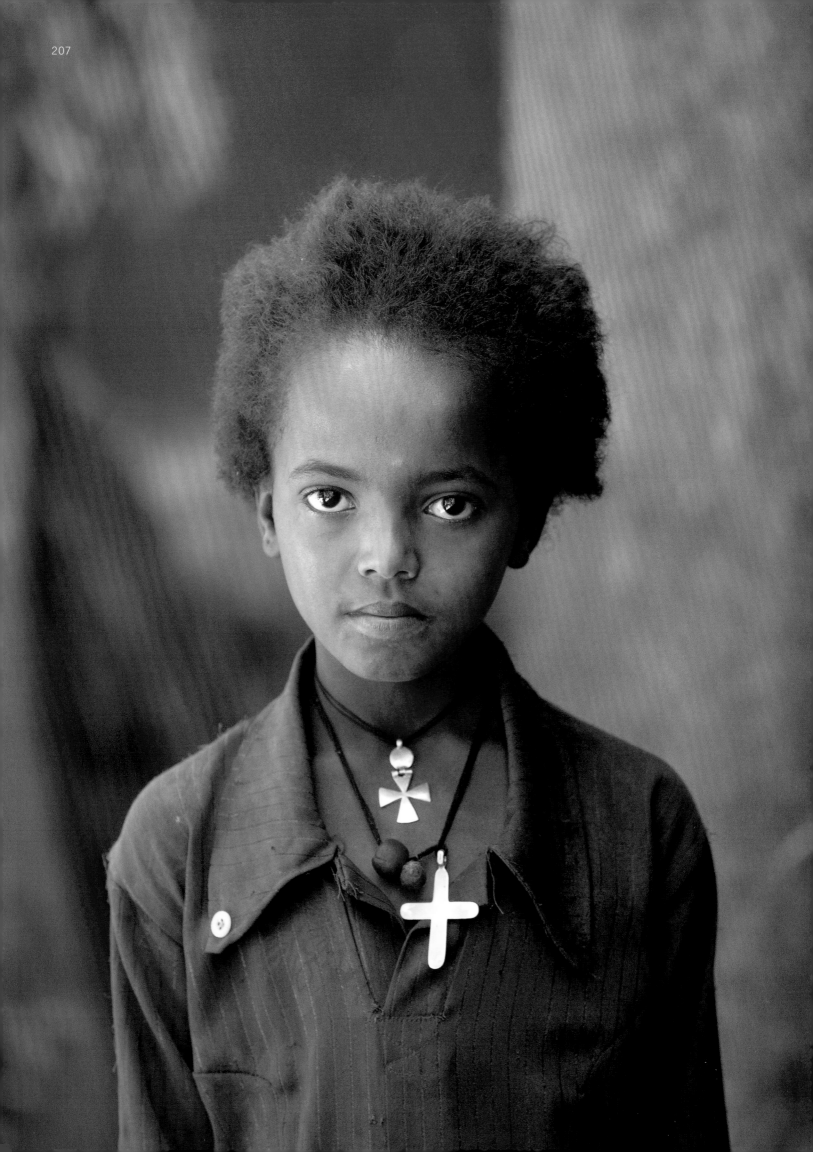

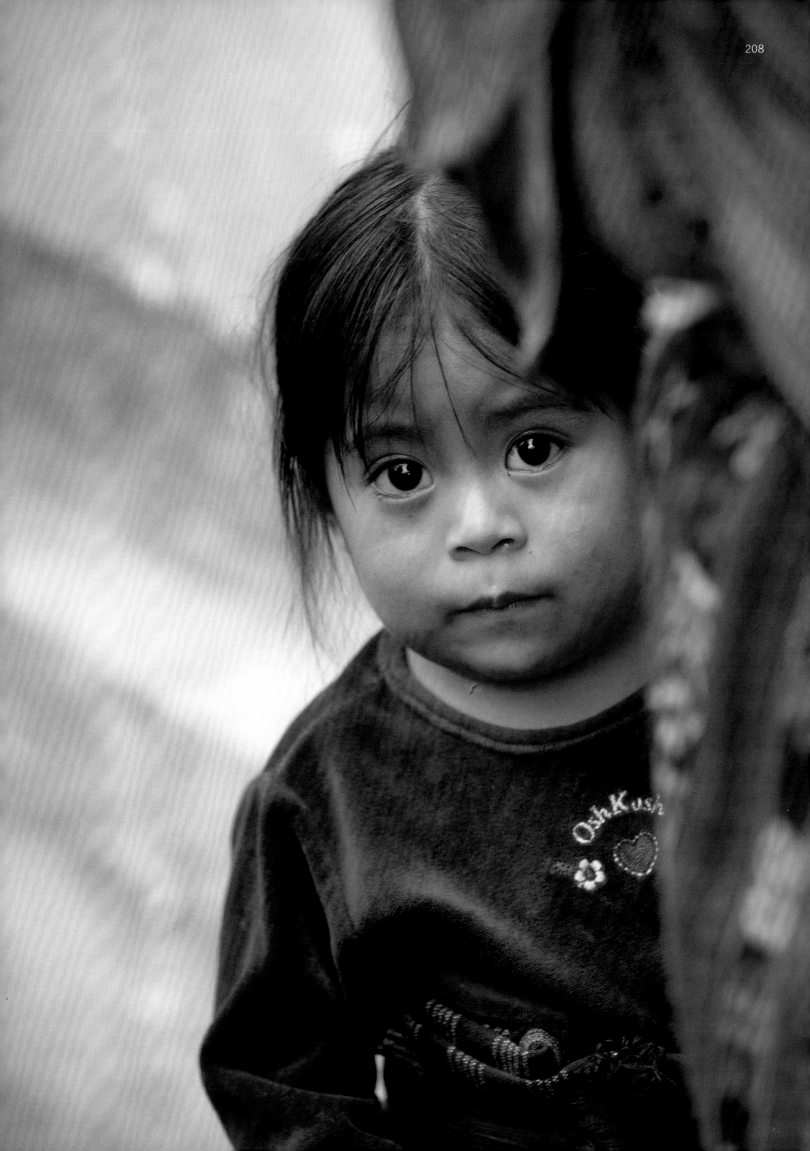

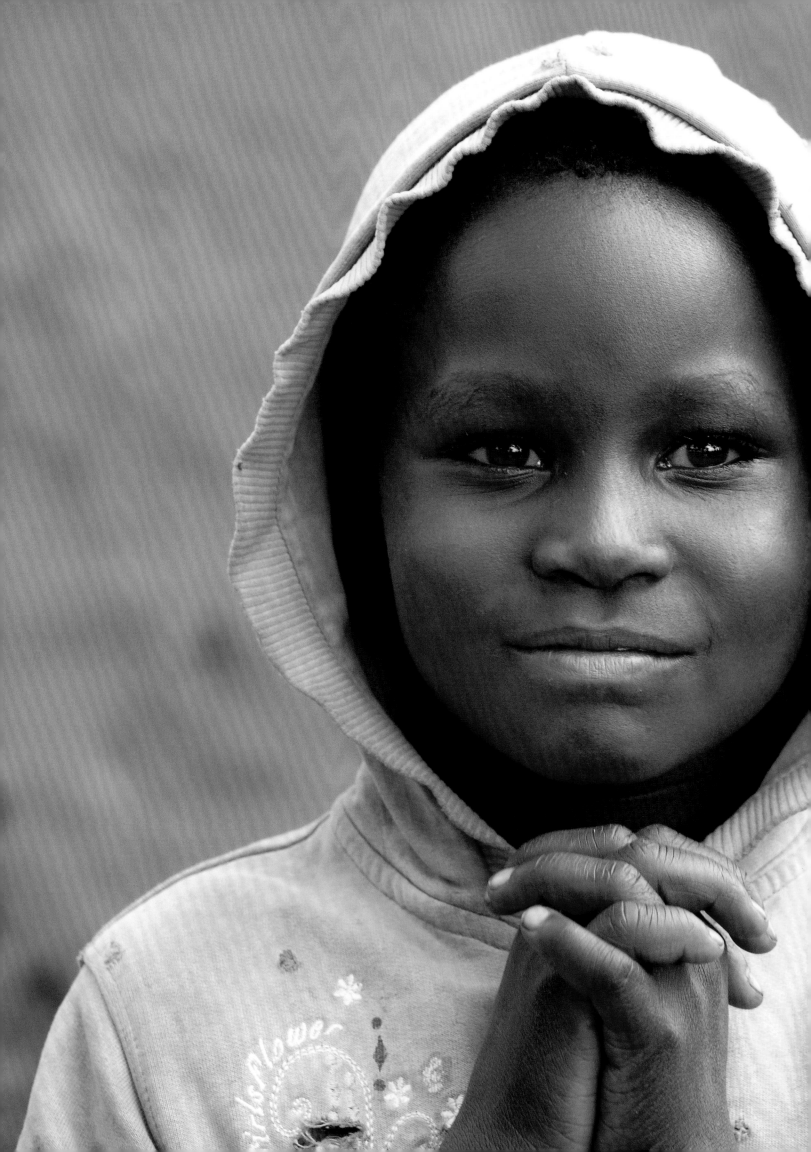

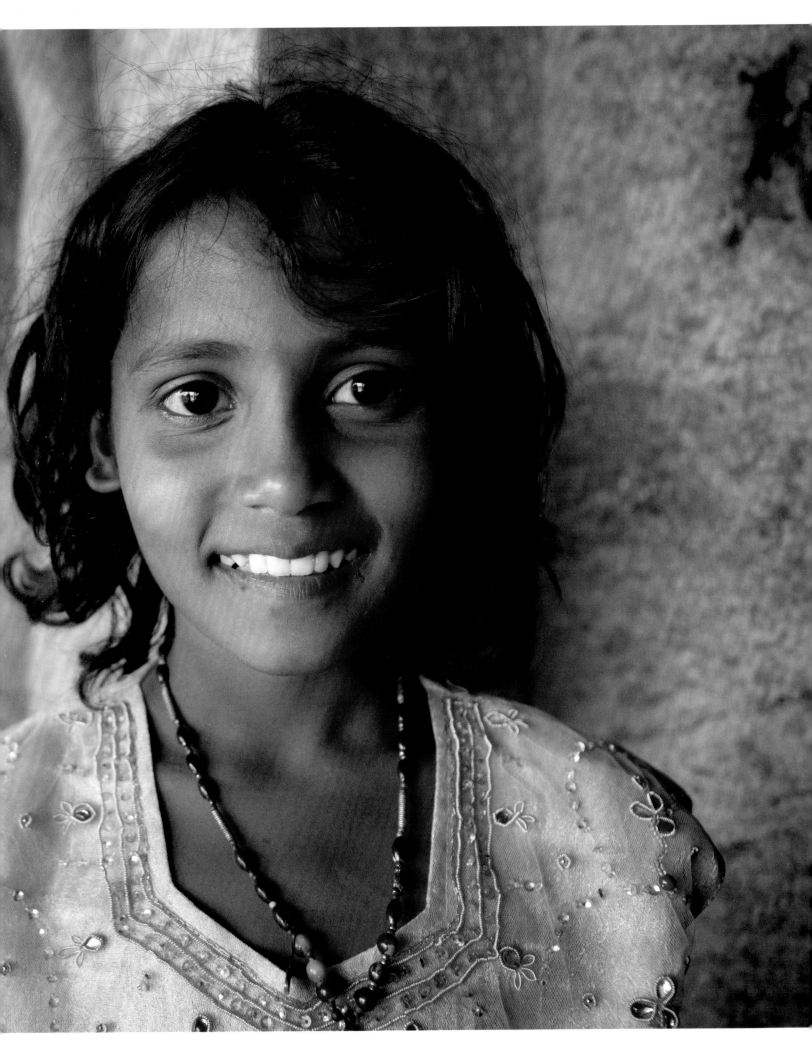

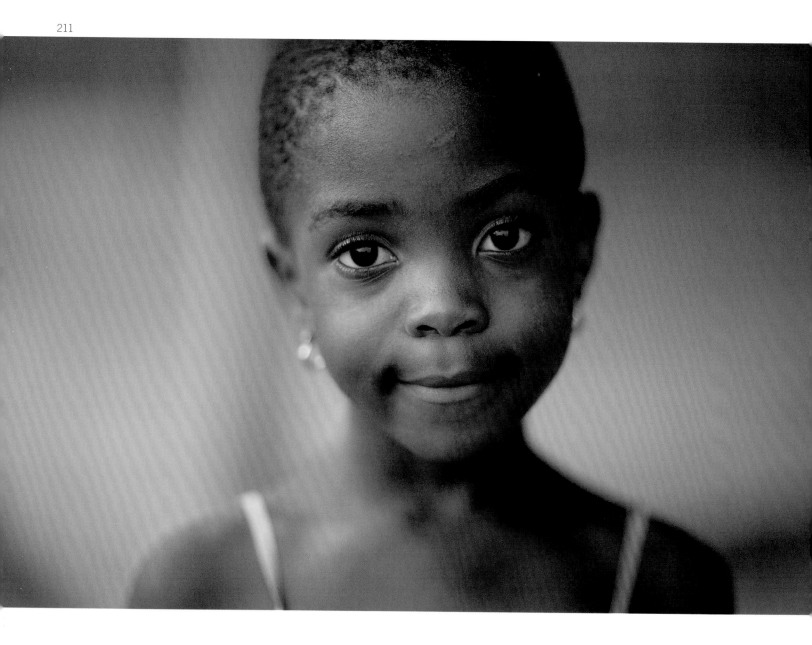

FACES OF HOPE

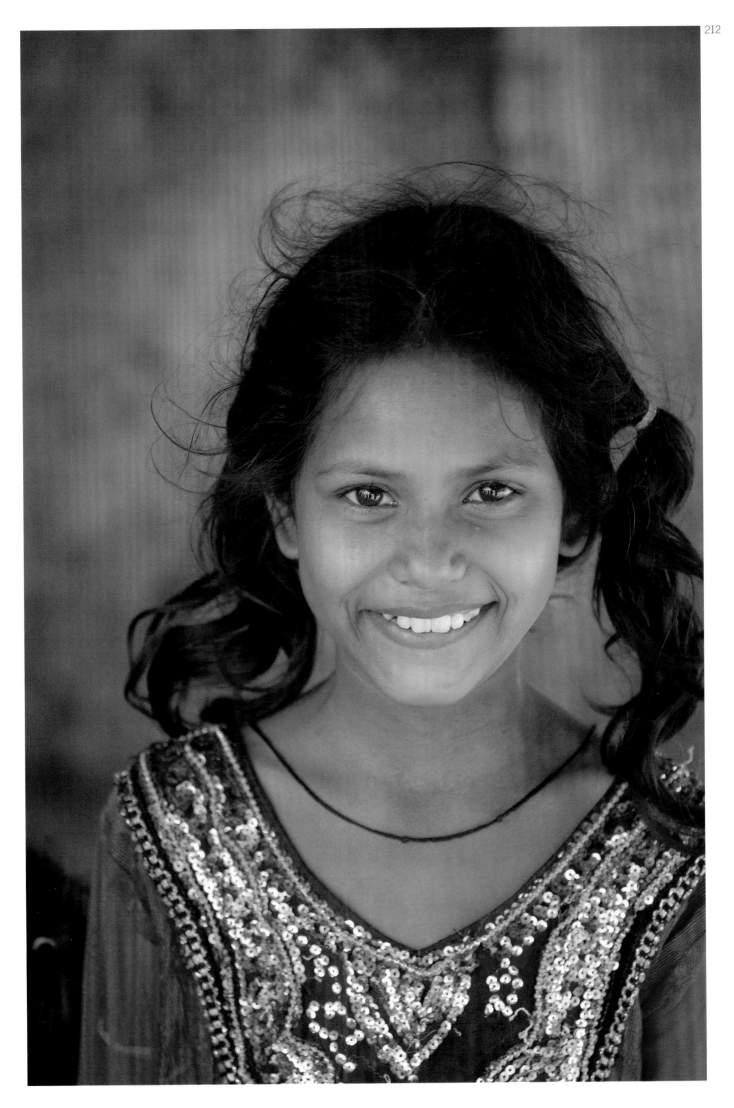

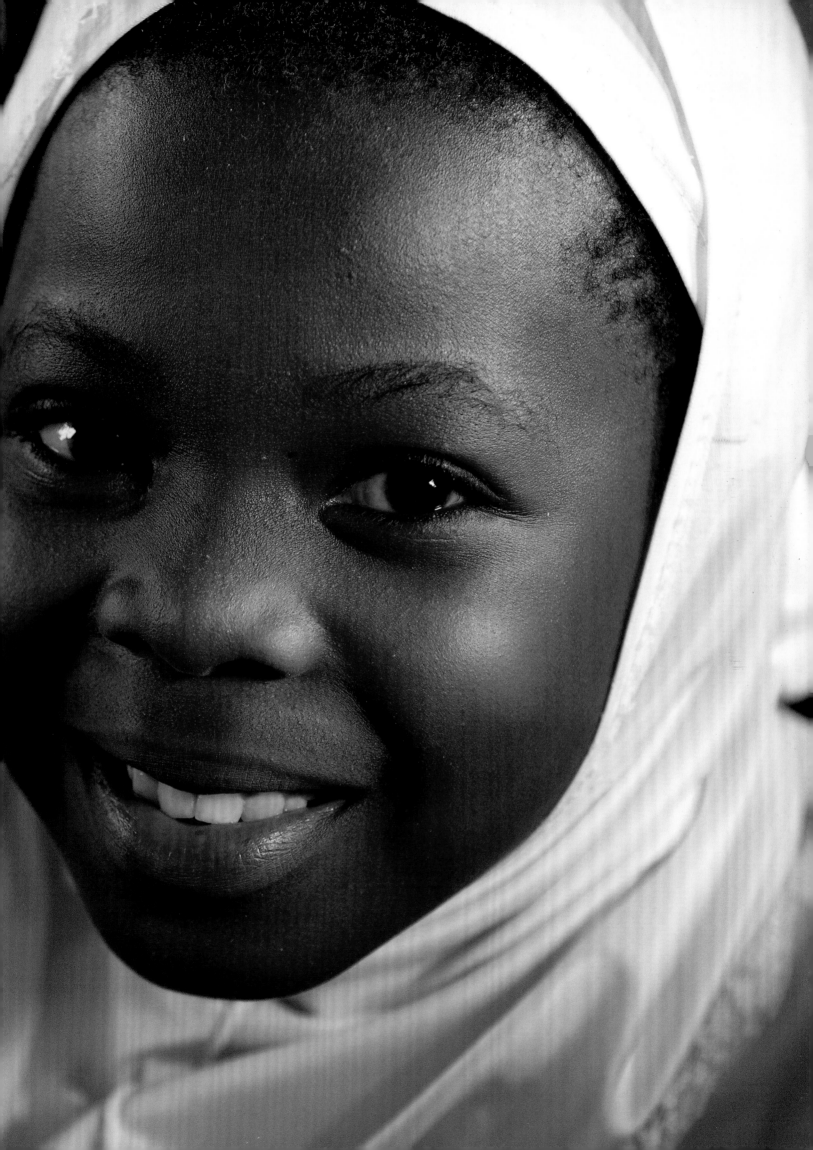

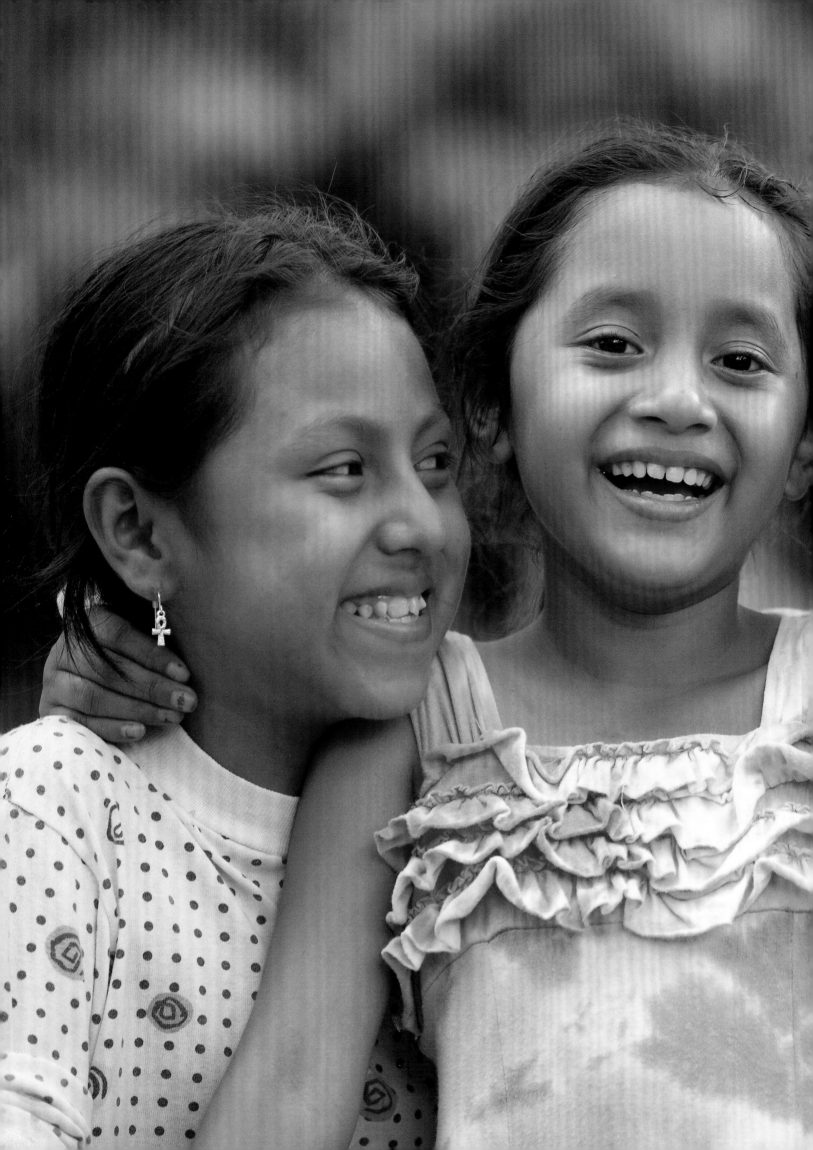

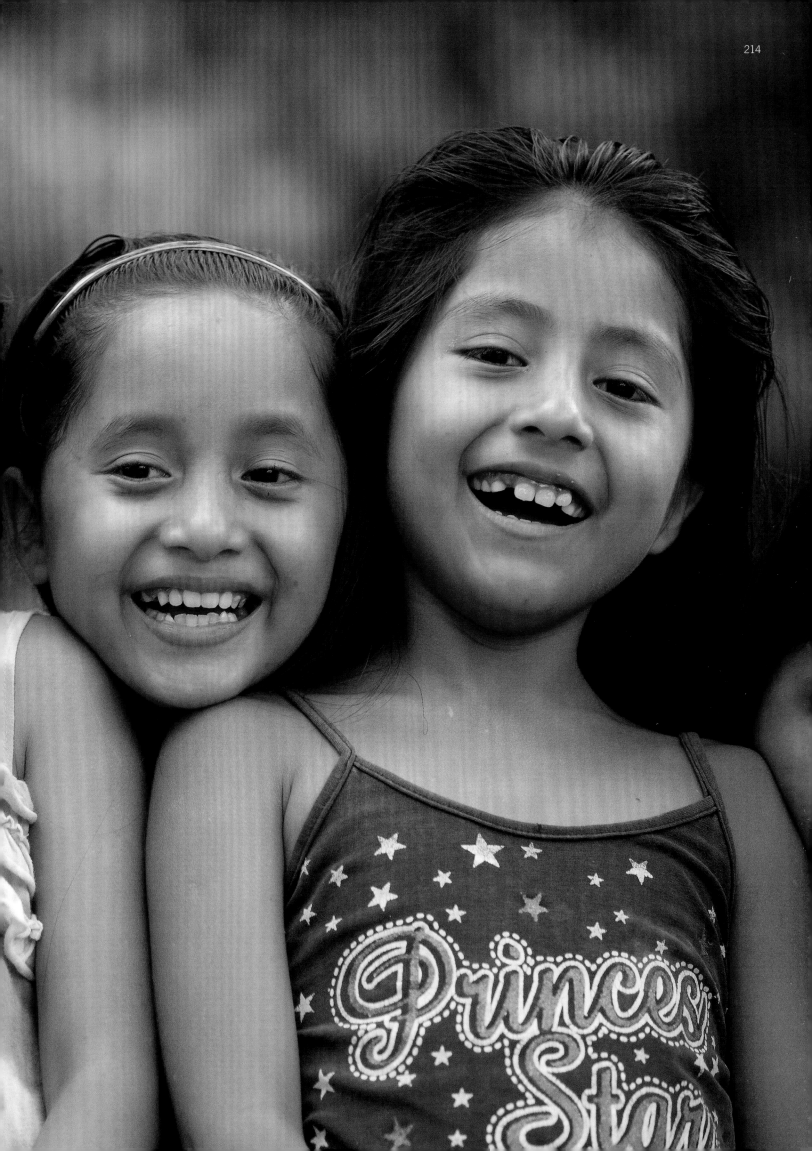

Acknowledgements

In today's media environment, it's not easy to publish a photo-essay as a printed book. It took more than a village to produce *Faces of Courage,* and so it is difficult to know where to begin in acknowledging all of the people who helped make this book possible. But I would like to start by thanking the hundreds of women and girls who trusted me to photograph them and tell their stories. I hope my photographs do justice to their resilience, courage and fortitude.

Paul Chutkow, my editor, publisher, and friend, has constantly been incredibly supportive and has had great faith in my ability to share this work with a wider audience, despite my periods of doubt and frustration. I would also like to thank Milton Glaser and Sue Walsh for their great care and skilled efforts in designing the look and feel of *Faces of Courage.*

I made all of the images presented in the book while on assignments for NGOs, foundations, or corporate social responsibility programs. For providing me with opportunities to document their good works, I am indebted to Musimbi Kanyoro and Kavita Ramdas of the Global Fund for Women, Sandra Bass and Amy Iftekhar of the Packard Foundation, Leila Darabi from Planned Parenthood Global, Dana Dakin from WomensTrust, Nadine Gasman from the UNFPA, Theresa Kim from EngenderHealth, Ruth Messinger, Stuart Schear, and Dan Bloch from the American Jewish World Service, Lynn Freedman from the Columbia School of Public Health, Barbara Ayotte and Christine Rogers from Management Sciences for Health, Patrick McCrummen and Sharon D'Agostino from Johnson and Johnson, Nadine Schecker from Novartis, and Kim Frawley from Pfizer. In addition, I'm grateful to Jill Sheffield from WomenDeliver, Glenn Ruga of SocialDocumentary.net, Gayle Petersen from Partners4Change, Suellen Miller from UCSF's Safe Motherhood Program, and Alvaro Serrano, Janet Jensen, Christian del Sol, and Richard Kollodge from the UNFPA for helping to promote my photography. Anne Firth Murray also gave me invaluable insights into the issues documented in *Faces of Courage.*

Throughout the decade in which I worked on this book, my friends and colleagues were always a tremendous source of encouragement. For the past

eight years I've participated in a photography group that has provided a wonderful forum in which to share my work and receive feedback. I owe Robert Kato, Marvin Wax, Larry Stueck, Bruce Beron, Rafael Riquelme, Oliver Klink, Tony Williams, Cathy Cakebread, Steve Johnson, Joel Simon, Rick Saal, Dany Suk, Bill Jackson, and Gil Draper many thanks for critiquing my work and helping me to become a better photographer.

I honestly do not know if I would have had the grit and determination to complete this book without the encouragement of my friends and family, including Bob and Naomi Mindelzun, Ceevah and Irwin Sobel, Paul and Berta Rovner, Joe Tuschman, Marcy and Jeff Abramowitz, Julia Kasle, Roy and Carol Blitzer, Herman and Rene Winick, Dov and Cathy Rosenfeld, Lew and Susan Wexler, Dennis and Michelle Hegyi, Marge and Robert Abrams, Ian Summers, Francine Freeman, and Caroline Lovell. I was also greatly motivated by the encouragement of Richard Morgenstein, John Blaustein, Bob Holmgren, Merrie Asimow, Joan Hausman, and Paul Pruneau.

And then there was the Kickstarter campaign. I consider Jonny Miller and Dorothy Sanders from Maptia my guardian angels; they gave me great counsel, completely re-designed my Kickstarter profile, and provided me with great marketing graphics that contributed to our successful fundraising. The video in the Kickstarter campaign was filmed and produced by Douglas Kreitz, who, with incredible patience, spent many, many hours creating a compelling narrative. And Justine Stacey was invaluable in helping me navigate, and spread the word through, the unfamiliar landscape of social media. I owe my collaborators immeasurable gratitude. Without the campaign's 500-plus backers, you would not be holding this book in your hand.

The following pages acknowledge the book's main donors. Some of these donors devoted many hours of their time to the fundraising campaign. These generous people include Diane Wexler, Lynore Banchoff, Irene Searles and Malcolm McGinnis, Jill Sheffield, Mahmut Keskeci and Norma Dettamanti, Emmett and Karen Cunningham, Cathy Cakebread, Alice Newton, Carole and Alan Kushnir,

Denise Dunning, Lenore Cymes, Patricia McClung, Oliver Klink, and Lisa Parsons. Renee Marchol and Joanna Hoffman also worked diligently to promote the Kickstarter campaign on social media. My daughter Eva and son Avi helped me in innumerable ways, with media strategy, editing content, publicity, analytics, and correspondences. Danika Kehlet conducted research and prepared initial notes on many of the topics covered in the book's essays. Joyce Ho also contributed heavily to the section on Moving the Goalposts.

Although every dollar counted toward making this book a reality, I am especially thankful to some extraordinarily generous donors: Terri Bullock, Shawn Byers, Brian Shepard, Pamela and David Hornik, Carol Malnick, Christine Currie, and Paul and Sharon Schulte. I'd also like to acknowledge the generosity of Adam L. Stock, Shelly Moran, Kate and Geir Jordahl, Laurie Minsk and Jerry Dunietz, Jim Poppy and Mary Sylvester, Jacqueline Faulkner, Joe Tuschman, Lisa Rodondi, Karen and Emmett Cunninghman, Lil and Todd Johnson, Heyward Robinson and Joanna Mountain, Bill Slavin, and Ruth Owen.

Foundations and NGO's where you can learn more about the work these organizations are doing to empower women and girls.

American Jewish World Service
www.ajws.org

Bixby Center for Global Reproductive Health
www.bixbycenter.ucsf.edu

Columbia University Averting Maternal Death and Disability Program
www.amddprogram.org

Educate Girls Indi
www.educategirls.in

EngenderHealth
www.engenderhealth.org

Family Care International
www.familycareintl.org

Family Health International
www.fhi360.org

Fistula Foundation
www.fistulafoundation.org

Girls not Brides
www.girlsnotbrides.org

Global Fund for Women
www.globalfundforwomen.org

Kupona Foundation
www.kuponafoundation.org

Let Girls Lead
www.letgirlslead.org

Management Sciences for Health
www.msh.org

Packard Foundation
www.packard.org

Planned Parenthood Global
www.ppfa.org

Project Zawadi
www.projectzawadi.org

WomenDeliver
www.womendeliver.org

WomensTrust
www.womenstrust.org

United Nations Population Fund
www.unfpa.org

KickStarter Contributors

$1000 or greater

Terri Bullock
Shawn Byers
Christine and Frank Currie
Pamela and David Hornick
Carol Malnick
Paul and Sharon Schulte
Brian Shepard

$400 plus

Lisa Chun Rodondi
Emmett and Karen Cunningham
Jerry Dunietz and Laurie Minsk
S. Osborne Erickson
Jacquie and Bill Faulkner
Lil and Todd Johnson
Kate and Geir Jordahl
Johnny Law
Irene Searles and Malcolm
McGinnis
Heyward Robinson and Joanna
Mountain
Martha and Bill Slavin
Mary Sylvester and Jim Poppy
Joe D. Tuschman
Herman and Rene Winick

$200 plus

Abramowitz Family
Robert & Marge Abrams
Maria Amundson
George Bazlamit
Bruce Beron and Diane Wexler
Lisa Douglass

Nadine Gasman
Alyce Kaplan and Meridith Walsey
Charles M. Lee
Liebner Family
Margy & Art Lim
Menlo Hardwoods
Jane Mallory
Elaine & Craig McGreight
Louise Nicholson
Kimberly Oxholm
Susie Richardson
Theresa and Karl Robinson
Richard Rose
Paul Sack
Jill W. Sheffield
Steve & Paula Smith
Irwin and Ceevah Sobel
Adam Stock & Shelly Moran
Sharon Spriggs Walter

$100–200

David Aebi
Laurie Allwyler
Doug and Sheri Baer
Ann and Chris Banchoff
Lynore Banchoff
Lynne F. Bernatowicz
Mara Blitzer
Cathy Cakebread
Liesl Capper
Fay Clark
M. Bernadette Castor
Shirley Chen and Jeff Chow
Mary Coady
Craig and Rachel Cohen
Peter J Cohen
Sarah Coleman
Kate Collie

Lorraine and Harlan Crowder
Peggy Dalal
Stephanie Danforth
Tim and Patricia Daniels
Christy Davis
Mary desJardins
Marshall Dinowitz
Jeanne DuPrau
Nancy and Bill Ellsworth
Beth Emanuels
Richard Feldheim
Craig and Sheri Forsdick
Lynn Freedman
Francine Freeman
David and Lisa Fry
Stephen Galpin, Jr.
Margery Goldman
Marilyn V. Green
Elaine Heron
Maya Herstein
Christina Holmes
Andreas and Jennifer Judas
Robert Kato
Suzie Katz and PhotoWings
Lisa Keamy
Mary Kenney
Michele Kirsch
Stans Kleijnen
Lee and Steve Kleinman
Douglas Kreitz
Willow and Ana Kreutzer
Carole and Alan Kushnir
Nick LaHowchic
Rob Lancefield
Kathy Leisses
Jan and Philip Lewis
Carol Liebner
Caroline Lovell
Catherine Lucas
Patricia McClung

Ron McGinnis
Patti Masarek
Lauren Miller Rogen
Bob and Naomi Mindelzun
Ian and Sophie Morgan
Richard Morgenstein
Thomas Muthig and Judy Kasle
Charla Neuman
Kerry O'Connor
Tamara Ogorzaly
Kendra S. Plat
Giorgio Riga
Deborah S. Rose, M.D.
David Rosner
Sheila and Chuck Rosner
Suzanne Rubenstein
Doniece Sandoval
Susan Schaps and Rob Shelton
Linda Schlein
John R. Schwabacher
Madeline Sheron
Elaine Smith
Sherilyn Stolz
John Tuschman
Libby Tyree-Taylor
Laura Vais
Damon Vander Lind
Vaneeta Varma
Mrinalini Venkatachalam
Corinna Vigier
Kerry Watkins
Lisa Wenger
Susan and Lew Wexler
Joseph Yacinski

Single Books

Vanina Abecassis
Gretchen Addi

Vanya Akraboff
Alex
Carol Allen
Charles K. Altholz
Merrie Asimow
Celia Aufdemberge
Suzanne Avila
Foli Ayivoh
Ari Azhir and Alan Engelberg
Marsha Balian
Mary K. Baumann
Doug Bercow
Robert and Lucy Berman
Diane and Ed Bernbaum
Friz Bernhard
Deborah Bishop
Carol and Roy Blitzer
Sheila and David Botein
Michelle Box
Susan Bradley
Juliet Bradley
Alex Brem
Bridget Brennan-Botero
Tony Brinton
Daisy Carlson
Kerry Carrington
Diane Cassidy
Gina Catena
Paul Chutkow
Shoshanah and Collin Cohen
Barbara Collins
James Colton
LouAnn Conner
Marcia Cooper
Marcia Cox
Carol Craford
Christopher Crump
Lenore Cymes
Leila Darabi
Laura Beth Davis

Paula Stamps Davis
Marty and Judy Deggeller
Susan Dentzer
Emilie Dettamanti
Tiffany Dreher
Karen Drexler
Sheila and Jack Dubin
Kristin Duriseti
David and Lynnae Evans
Dorothy and Jim Fadiman
Kelly Fergusson
Virginia Fitzgerald
Lolly Font
James M. Fox MD
Jim Fox
Frawley Family
Stephanie Choi Freeman
Maria Fregoso-Wood
Gordon Frierson
Marc and Sherry Gabay
Susan Gadoua
T. M. Galvan
Kim Garlinghouse and Eliott Jones
Romola Georgia
Stephen Gibbon
Jessica Gilmartin
Sandeep Giri
Lori and Hal Luft
Janice Glick
Rachel Goble
Joanne Goldberg
Helen Golden
Paul Goldstein and Dena Mossar
Shana Goss Henze
Jon Grant
Wendy Hannum
Sarah Hans
Joan Hausman
Judy Sperling Hechter
Michelle and Dennis Hegyi

Matt and Avery Heltsley
Heather Henbest
Susanne Henderson
Ron Herman
Kim Holl
Will Hopkins
Jonathan Hummer
Amy and Adnan Iftekhar
Indrani's Light Foundation
Tracey Ireland and Sanjoy Dutta
Neal Izumi
Bill Jackson
Laura Jason
Graceann and Bob foliJohnson
Janet Jones
Bob Kahn
Heather Kantor
Nancy Kaplan
Jean Karotkin
Marcia and Richard Kashnow
Julie Kasle Brown and Kent
Brown
Ruth Kasle
Mahmut Keskekci
Marilyn Keller and Jeff
Greenfield
Kepler's Books
Matthew Klein
Oliver Klink
Stephanie Klipple
Joanne Koltnow
Tracy Koon
Judy Kramer
Anne Marie Krogh
S. Kumaishi
Hilary Kushins
Brian Kushnir and Becky Schimpff
Francis Lam
David Landis
Ruth Landy

Grayson and David Lane
Marco Maria Lauricella
France Leclerc
Cathie Lehrberg
Susan Leonard
Let Girls Lead- Champions for
Change
Nancy Levine
Laurie Zucker Lindbloom
Val Litichevsky
Debi Lorenc
Lynn and Ned Lubell
Glenn Lyons
Joan Mackey
Gracia Mahan
Doreen Maller
Maptia Team
Carol Matre
Bob and Linda Matsumoto
Bob Mazawa
Margo McAuliffe
Susan McConnell
Kristin McDonnell
Ulla Mcgee
Patricia Mckinnon
John McLachlan
Hal McMillen and Nancy Sullivan
Betty Meissner
Sally Mentzer
Suellen Miller
Catherine Misuraca and Jon
Freeman
Abby Mohaupt
Devon Morehead
Sheri Sprung Morrison
Ann Firth Murray
Elizabeth Murray
Leanne Nasser
Natalie Nasseri
Roger and Christine

Neill(Kingston)
Okey B.Nestor Jr.
Susan Neville
Louis Newman
Sara Newmann
Rachel Niederman
Dan O'Brien
Laria Odisio
Addison "Buz" Olian
Jodi, Daniel and Reene Paley
Doug and Caroline Palmer
Lisa D. Parsons
Sally Paynter
Anna Pivovarchuk
Stephanie Portman
Peggy and Jonathan Propp
Jody Jacobson Pruett
Michelle Quick
Dan and Helen Quinn
Ana Raducan
Meggi Raeder
Judith Raffel
Kamini Ramani
Jaana Rehnstrom
Mary Ann Ritchie
Heather Robertson
Larrie Rockwell
Ryan Rogers
Matt Rollefson
Bettina Rosenberg
Dov and Cathy Rosenfeld
Paul and Berta Rovner
Reva Rubenstein Cronin
Ellen and Jeff Rudy
Steve Ruley
Stephanie Rumold
Michael J. Rymer
Rick Saal
Eli Salomon
Rafael Sanchez

Sabeen Sattar
Julia and Greg Schechter
Margo Schmidt
Kristen Schuck
Amitai Schwartz
Dolores Seidman
Ruth Shaber
Sue Linville Shaffer
Shalinie Shanmugaranjan
Barbara Shapiro
Gary Sharron
Carolyn and Jeremy Siegel
Gil Siegel
Joel Simon and Kim Morris
Maureen Simons
Monica Sircar
Philip Smith
Steve and Paula Smith
Paul Snider
Ilene Sokoloff
Jeffrey Spahn
Justine Stacey
Robert Hare Stavers Photography
Brianna and Julia Stefanelli
Joyce Stewart
Pamela Stoner
John Straubel
Emily June Street
Larry Stueck
Dany Suk
Denise Sullivan
Ian Summers
Ram and Lakshmi Sunder
Surton Family
Nancy Svedsen
Leslie Swanson
Kathy and Andy Switky
S2-Dept. 8
Sara Todd
Avi Tuschman

Richard Tuschman
Tom Upton
Mayella Valero
Nick Ward
Elizabeth Weal
Leslie Webster
Jill Wegenstein
Lisa Weisman
Amanda Weitman
Wheeler Family
Don Whitebread
Michael Wiemeyer
Tony Williams
David Williams
David and Orit Wirtz
Ted Wobber and Linda DeMells
Caryn Huberman Yacowitz
Sophie, Carolyn and Robert Yasharian
Diana Yeo
Mary Lou Zoback